FRIDA KAHLO

FRIDA KAHLO

A Bulfinch Press Book
Little, Brown and Company
Boston New York London

First English-Language Edition
First Published in Mexico by Landucci Editores, S.A. de C.V.

ISBN 0-8212-2766-1

Library of Congress Control Number 2001089093

Spanish-language publisher: Landucci Editores, S.A. de C.V.
Colima 233, colonia Roma
06700 México, D.F.
Tel. 52 55 14 23 23
Mail: landucci@attglobal.net

Editorial Coordination by Leonardo International, Milano
General Coordination: Gabriella Piomboni, Marta L'Erede
Technical Coordinator: Giorgio Gardel

Translated from the Spanish
by Mark Eaton and Luisa Panichi
for Scriptum, Rome

Designed by Azul Morris

Bulfinch Press is an imprint and trademark of
Little, Brown and Company (Inc.).

Printed in Italy

Contents

Foreword — 9

Introduction: Frida in the Land of Self-Portraits — 10
Carlos Monsiváis

The Esthetic Universe of Frida Kahlo — 18
Luis–Martín Lozano

Iztaccíhuatl in the Valley of Anáhuac — 170
Antonio Saborit

Frida Kahlo and Mexican Art — 233
Diego Rivera

Brief Biography — 236

Foreword

Nearly five decades after her death, Frida Kahlo has become the most universally admired Mexican artist. In the last decade in particular, she has been a great ambassador of Mexican art and culture. The complexity and depth of her human and esthetic dimension have made her a universal symbol. Is it that her free personality, her creative talent, and her great ability to overcome physical and emotional adversity are sources of inspiration for young generations? Most certainly. Frida Kahlo is a cultural phenomenon of unexpected proportions.

Her paintings sell for millions of dollars at auctions, and her face is an international icon. She gave shape to an esthetic and everyday world in works that combine affection and humor, sadness and sarcasm, the intimate and the collective. Indeed, her creations reveal an artist who deserves to have her own special place in twentieth-century Mexican art.

This book brings together paintings, drawings, and photographs that have seldom been published all together. Works from private collections in Europe and the United States, Mexico, and South America, some of which are difficult to view, are reproduced here with unprecedented attention to the richness of their details. For this reason, Grupo Financiero Bital is pleased to publish this book, which undoubtedly contributes to the understanding of one of the most emblematic women painters of our time.

Grupo Financiero Bital

INTRODUCTION
FRIDA IN THE LAND OF SELF-PORTRAITS

Carlos Monsiváis

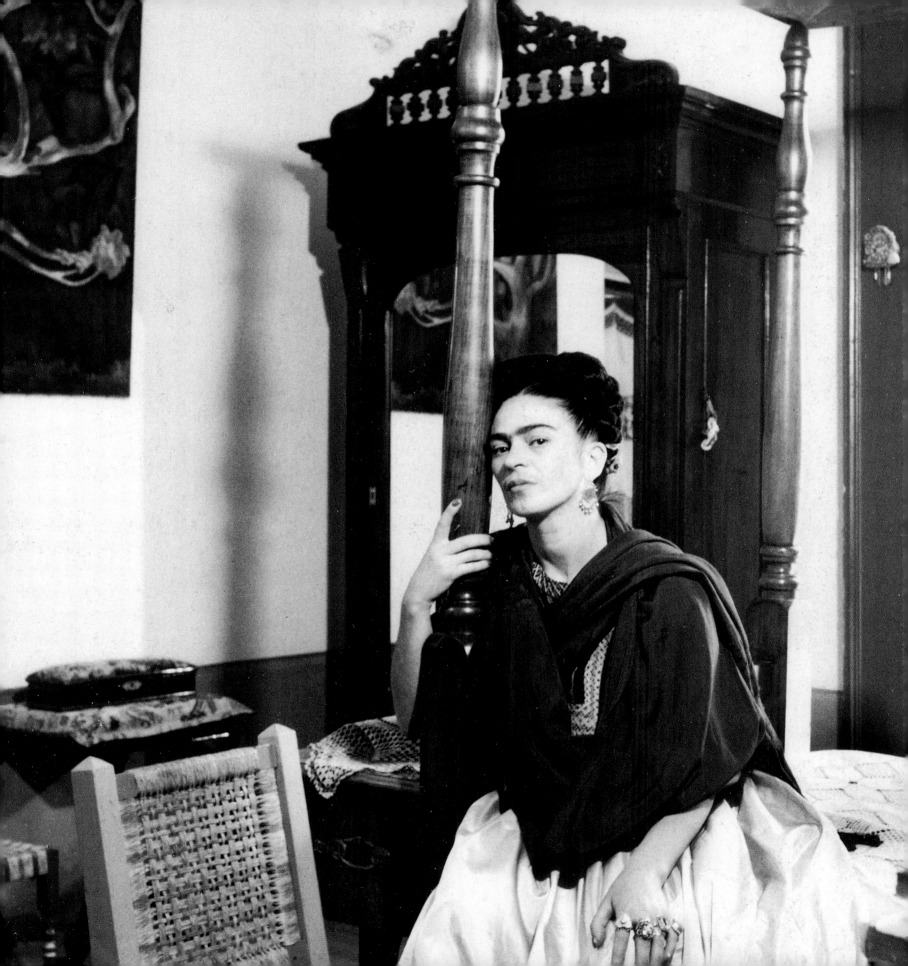

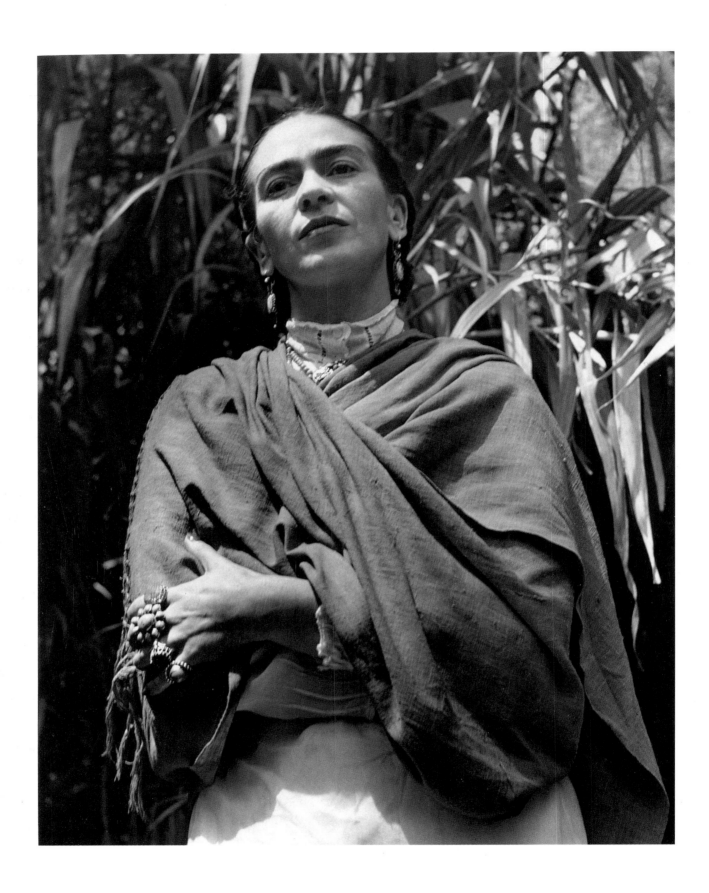

FRIDA KAHLO IN 1951

PREVIOUS PAGE:
FRIDA KAHLO CA. 1945

In the imagination of the world, Frida Kahlo *is* a succession of self-portraits and portraits. More important than her fame and abounding legends, there is her photogenic and—if we can coin the term—"portrait-genic" quality, an aptitude for always conveying memorable features. Frida is a myth in the sense that she represents to a host of different groups and individuals certain values and deep emotions; and she is the visual and existential consequence of a whole range of stimuli. Although at this point it is impossible to know which came first (the myth or the person of the same name), one thing is certain: In the complex phenomenon that is Frida Kahlo, the self-portrait is a constant distinguishing element.

Making a portrait of Frida—consider the extraordinary series by Lola Álvarez Bravo—means embarking on a process that seeks to capture in images the spell or singularity of a being who is as fragile as she is powerful. For her part, Frida chooses a powerful method of isolation from and relationship with the world: the self-portrait, idealization that is materialization, the reflection that becomes the cruelest of mirages ("Here I, Frida Kahlo, paint myself, the image in the mirror"). In her pictorial versions of herself, Frida opts for a game of substitution. Allegory, according to Helena Beristáin in her *Dictionary of Rhetoric and Poetics*, is the disappearance of an apparent or literal meaning in favor of another, deeper meaning. In this sense, Frida is the face that is effaced, that makes way for the emblematizing of melancholy, of the woman whose mask is her true face, of the creator who recognizes herself only in the crystalline surface of the canvas, of the woman who is solitary out of necessity and who has been alone so much she must create her double. "If the water is good / drink / don't ask where it comes from," writes Juan Ruiz de Alarcón; to which Frida might have added, "If the symbol is pleasing / look / don't ask where it leads."

As a Baroque poet might have said, when you are no longer what you see, you have become what you have painted. Without resorting to such rhetoric, Frida nonetheless favored allegory as the concrete rendering of an abstract idea. Like all great self-portraitists, she ceases to be an abstraction only when she paints herself; she abandons unreality only when she turns herself into *fábula*. Her most powerful and celebrated body of work is also the richest in meaning. In her self-portraits, Frida is:

self-worship explained and rationalized by the dying trance;

suffering, for which the painting is a lay confessional ("I confess before you, witness of this painting, in order to attain the serenity needed to vanquish pain");

Mother Nature surrounded by monkeys, creatures that literally fly in the face of paralysis;

the queen who has chosen enormous braids for her crown;

the contented pride of the owner of a single, defiant eyebrow;

the transformation of traditional dress into an ornamental nation;

the eruption of Christian suffering into landscapes filled with empathic animals;

the woman who requires her double, the Frida who is herself and the other, in spite of the linking of their hearts;

the renunciation of a part of herself (her long hair) as a sign of casting off her self-love: "If I loved you, it was for your hair, / now that you are bald, I don't love you";

the sick woman in bed brought face to face with her dreams by a cardboard effigy of Judas, that is, a skeleton that is an arsenal of fireworks and an act of faith in death;

the Mexican woman who looms gigantically over the border

between Mexico and the United States, that is to say, between the cosmogonic past of tradition and technology with its new ceremonial centers;

the fruit of the genealogical tree blended in with landscapes and buildings;

the center of a popular culture of sumptuous clothing and flower offerings, of delightful handicrafts, Xoloitzcuintle dogs, and dolls;

the creature observing as the water in the bathtub overflows with autobiographical references, with drowning women, erupting volcanoes, predictably monstrous feet, the artist's parents, a Tehuanan dress, enormous flowers, the pair of Fridas;

the serenity before, during, and after the storm;

the little Frida-deer shot through with arrows, wounded by the marks of identity.

"And you, long-suffering horizontal line." (Carlos Pellicer)

If to the photographic camera Frida radiates her pictorial qualities ("I am a person, taking photos of me comes close to making a painting," could be her message), her self-portraits, guided by a remarkable intuition, overflow with symbols that may or may not be explained and that last like hallucinations. She is severe when she is tender and tender when she is harsh, she paints herself calmly so as not to admit emotions without pretext, and she ridicules herself and the ideas that people have about her. Frida—the Lovely Lady Without Pity, even for herself—records her *raison d'être et de souffrir*, her heraldic motto, the strength and center of her frailties: the refusal to distinguish between dream and nightmare, foreboding and suffering. As in few cases, the work is the exorcism evoked by suffering and rage in order to relieve a body that harbors so much malignity; as in few cases, Frida's oeuvre translates inexpressible injury into visions of rebirth. Surviving tragedy is the first principle of resurrection.

As we know, Frida also worked with other themes, producing portraits for friends and on commission, as well as still-lifes, political fantasies, and cosmic panoramas. But her self-portraits are her great-est achievement, the distillation of all her wisdom, love, resentment, and floral and faunal inventions, and the element without which everything else would be forgotten: her great plastic talent. It is that brilliant instinct that reworked the figure of Frida Kahlo, the Mexican, the partner of artist Diego Rivera, the woman eager for diverse amorous experiences, and turned it into an obsessive reference to one of the female creators of the twentieth century who begins as a marginal note and ends up in a central position. It did not take long after her death for her project to become clear. The key to her work is found in the way the author depicts herself to the world.

Her whole discourse is encoded: the parents and grandparents; the nanny who is Earth and Tradition and the assurance of perpetual childhood; the recounting of her operations; the fetus as the family tree cut down by misfortune; and—the axis of life and of her mythology—her obsession with Diego, which can be seen as emotional dependence and symbolic desire. Diego portrayed on Frida's forehead is not so much the binding together of two beings as a public rejection of isolation. The strong link with Diego is moreover the couple's complementation of two extremes: minute Eve and gigantic Adam; inconceivable Romeo and sacrificial Juliet; the man whose vocation is Genesis and the woman already living the Apocalypse.

"The miracle that travels through the veins of the air."

In the retablos and ex-votos, Frida learns to construct a subverted Eden where the meaning of forms depends on the relationship between innocence and the desire for a reconciled return to childhood. In some of her most portentous canvases—*La columna rota* (The Broken Column) and *Sin esperanza* (Without Hope), for example—the destruction of the body and the ingestion of entrails goes against any utopian, romantic, or sentimental vision; in other paintings, the evocation of retablos permits the equivalent of an act of thanks for grace received. In this sense, *Viva la vida* is an ex-voto without theology but overflowing with mysticism; so, too, is *Árbol de la esperanza, mantente firme* (Tree of Hope). In this last work the tradition of ex-votos is magnificently transformed: one Frida, on

the edge of a geological fault, holding her corset and a sign on which the lyrics of the song *Cielito lindo* are tantamount to a proclamation, accompanies the other Frida, who is lying on a stretcher in a fractured landscape, traversed by shadows and shining celestial bodies. Life goes on, and this explains the religious undertone; but life is also a form of art, and this demands elements that crush optimism without eliminating it completely.

Poliomyelitis, hypertrophic leg, rigid foot and bent, clawlike toes, plaster casts, open ulcers, the resolute blood of everyday life ("My blood," she tells Diego, "is the miracle that travels through the veins of the air, from my heart to yours"), orthopedic corsets, a fixation on the graft at the base of her spine, scoliosis, or curvature of the spine, painkillers . . . This horizon of illness is transferred to the paintings in order to suppress self-delusion and, at the same time, erase the boundary between art and tortured physiology. The strategy is extraordinary: It never guarantees relief (though some relief is gained), but rather it produces paintings detached from the suffering that is never completely neutralized. Here, indeed, is an indication of the artist's timelessness. Despite hundreds of thousands of reproductions and retrospectives in major museums, publications, and films, the essence of Frida Kahlo's painting cannot be reduced to causes, to "national traits," to admiration for a life at once so tragic and marvelous. How can we "assimilate" a painting like *Mi nacimiento* (My Birth), in which Frida comes into the world at once an adult and stillborn? How can we incorporate this mixture of rejoicing and pain?

From very early on, Frida perceived illness as a visionary state. In a letter to her first boyfriend, Alejandro Gómez Arias, written one year after the terrible accident, she describes the bitterness of her convalescence:

Why do you study so much? What secret are you looking for? Life will reveal it to you very soon. I already know everything, without reading or writing. Not very long ago, maybe only a few days back, I was a girl going her way through a world of precise and tangible colors and forms. Everything was mysterious, and something was always hidden; guessing at nature was a game for me. If only I had

known how hard it is to gain knowledge so suddenly, as though the Earth had been elucidated by a single ray of light! Now I live on a planet of pain, transparent like ice. It is as if I'd understood everything all at once, in a matter of seconds. My best friends and the girls I know have slowly become women. I grew old in a few seconds, and now everything is bland and flat. I know that there is nothing else, because if there were, I would see it.

The cost of sudden knowledge is very high, and much of Frida's work must be understood as her effort to turn lucidity into prophecy, to express extreme suffering pictorially, without allowing for pity or self-pity.

"Nothing is more ridiculous than tragedy."

For Frida, painting takes on the inevitable form of physical and allegorical liberation from sickness, from corsets, hospitals, and numerous operations, including the amputation of her left leg in 1953. She tries to transform pain into artistic expression, routine everyday suffering into creative effort, memories into love scenes, and does so by combining her remarkable formal intuition, her all-pervasive lyricism, and provocative energy. Here, in this fusion of opposites, she immerses herself in the light her body refuses her, splits herself into desire and redemption, takes root and reverberates in her mutilations, finds refuge in the images she has appointed to represent her. She is free in her illusion and in the verbal and pictorial imaginings with which she counters suffering. She writes in her diary:

"Nothing is more important than laughter." Laughing and letting go and feeling lighter give one strength. *Tragedy* is the most ridiculous thing "man" has, and I am sure that however much *animals* "suffer," they never exhibit their "pain" in open "theaters" or "behind doors" (in their "homes"). Their *colors* are *truer* than any *image* that any man may "represent" as painful.

How is it possible to uphold the extreme statement that "Nothing is more ridiculous than tragedy"? As an antidote to her physical condition, Frida has a store of images, sensations, feelings, and situations that quickly become dispensations from tragedy. At the center is Diego Rivera, the adoptable child, the being that can be generated, more a depository of words and tumultuous emotions than a person:

16

Diego:
Nothing compares to your hands, nothing compares to your gold-green eyes. My body fills up with you for days and days, you are the mirror of night, the violent flash of lightning, the Earth's humidity. The hollow of your armpit is my refuge, my fingertips touch your blood. All my joy is in feeling life flow from your spring-flower, filling all the paths of my nerves, which are your own.

The metamorphosis of Diego, one of the axes of Frida's work, is unending. For Frida, Diego is creative impulse, terra firma, the lost creature in the great orphanage of time ("children are days," insists Frida). She baptizes him, reverently, the "mirror of night": "You will be called AUXOCHROMOS, he who attracts color. I am CHROMOPHOROS, she who gives color. You are all the combinations of numbers. You are life." In Frida, there is the rational delirium of a spirit that uses mysticism as a deposit for its afflictions. In this small, immense world, in this sphere of contradictions, the real Diego and the one invented by Frida's loving mythomania, is religious worship, the transcendent answer to pain; he is the whole that, without paradox, is protected by one of the parts. "Nothing is *absolute*," claims Frida, and yet beyond this dialectical blueprint she does represent Diego as absolute, as diversity in unity, as the universe. In her rosary of attributes (*"Diego*—the beginning, *Diego*—the constructor . . . "), Frida does not intend to be taken seriously, for, in converting to a religion where God, the saints, and the temples are named Diego Rivera, she passes through love to a cosmogony, from affliction to meditation:

No one will ever know how much I love Diego . . . if I had health I would give it all to him; if I had youth, he could have it all. I am not only his mother, I am the embryo, the seed, the first cell from whose potential he was engendered. I am he, beginning from the most primitive . . . ancient cells, which over time have become "feeling."

"I am Melibeo," says Calisto in a similar context in *La Celestina*. In Frida's case, however—and there are numerous examples—pain is so ruthless that the amorous conversion becomes a pact with feelings, the coherent or rational thought that a belief will concede to its faithful. In order not to compete verbally with tragedy, Frida assumes the sanctity of (provisional and definitive) love, placing galaxies in ex-votos in which one glimpses the wonder of the resurrection in the simple act of unconditional love: *Árbol de la esperanza, mantente firme* (Tree of Hope). Frida expresses herself with tenderness, compassion, and frenzy, with her "eyes open, her Diego feelings"; she uses lively colors to brighten her spirit, draws pyramids and suns and moons and Fridas and eye lizards and dogs. She turns repeatedly to her religious obsessions, which may take the form of Lenin, Stalin, or Mao. While politics for Frida never is and never can be everything, politics does eventually become the most prestigious form of religious expression, the coal seller's faith (historical materialism), the belief that imposes itself on the barely heard barrage of information. Stalin died in March 1953, and Frida, with the anguish of a believer whose own life has merged with the conditioned reflexes of faith, wrote: "THE WORLD, MEXICO, ALL THE UNIVERSE have lost their balance with the loss of Stalin."

Frida had an affair with Trotsky, bore witness to the monstrous Stalinist persecutions of Trotsky and Rivera, and knew about the Moscow Trials. Nevertheless, in the world of such personal and fantastic images and words, she proudly includes the most oppressive representations of history. "Faith," according to St. Paul, "is the substance of things that are wished for, the proof of things that cannot be seen." Faith in humanity, to be reborn as a particle among the masses, and in collective awareness, which will displace individual pain, leads Frida to apologize:

I am very uneasy about the enterprise of my painting—especially because [I want it to be] *useful* to the Communist revolutionary movement. Until now I have painted only the expression of myself—honestly, but totally removed from the need for my painting to serve the Party. I must fight with all my strength to turn what little positive energy my poor health has left me toward aiding the revolution. The only real reason for living.

I don't doubt Frida's sincerity in this passage, but I cannot deny the evidence of her work, where reasons both for living and for despair intertwine and do battle. In Frida's case, the revolution is at once a genuine passion and the promised land, but this militant zeal (the great embellishment of an existence guided daily by other premises) is by no means a central impulse. If faith, for Frida, is synonymous with Communism and with history and with the struggle against imperialism, at a certain level (that of destiny, which becomes clearer even as the emotional structure is defined by agony) faith is also the transformation of desire into something planetary; it is consolation through images and the poetic word. In one drawing, she boasts about her flights of spirit, declaring: "Feet, why do I want them, when I have wings for flying"; and in a text written after the loss of her leg in July 1953, the Frida-angel trembles, renounces her symbols but not her freedom:

Points of support
For my whole figure there is only *one;* I want two.
To provide me two they had to cut off *one.*
The *one* I don't have is the one I need to have
in order to walk. The other is already dead!
I have more than enough wings.
So cut them.
I'll fly away!

In this singular religiosity there is a constant yearning for poetic expression. If, at times, Frida appears, despite her denials, to lean toward surrealist forms and techniques, this is due not only to her personal contacts and the influences of her time but also to her love for poetry, which is, for her, the perfect language, the way to connect with art: "Don't let the tree go thirsty / you are its sun / it has stored up your seed. / The name of love is 'Diego.'"

Love is the territory *par excellence* of the poetic—which, for Frida, meant that which could not be contained. In her vision of verbal beauty, even new poetic words are justified, as long as the essence (the delivery) remains. Frida writes: "'Classical' love . . . / [without arrows] / only / with sperm."

Frida Kahlo has been an exotic fashion and is today the durable synthesis of many distinct realities, as evidenced by her painting, by the multiple aspects of her life (as artist, invalid, lover, Trotskyist, Communist), and by the various ways in which her work resonates. Frida notes: "You rain me—I sky you," and this surprising metaphor can be translated to the paintings, in which with supreme vigor it rains and skies. Like Icelti, Frida is "she who gave birth to herself," she who engenders the unique and diverse character of the self-portraits, where narcissism is dissolved in service of the miraculous image of the retablo, where she who suffers and loves and is surrounded by animals gives thanks to art for the radical continuity of her existence and cries out for the supreme harmony of fragments: "I AM DISINTEGRATION."

Frida explains: "Nothing is so natural as painting that which we haven't achieved," and in her case this means the development and multiplicity of the *I.* In a self-portrait from her diary, Frida, who is depicted as a broken vase, bellows: DON'T CRY FOR ME!, and in the next drawing, she replies: I WILL CRY FOR *YOU!* Pain is the supreme militancy, the cause she embraces and battles, the point of departure, the hell that will abolish death. In her pictorial and written invocation, the *I* rains down, the *I* splits and proffers light, the *I* descends into the penumbra, furnishing it with shape and color. In Frida there is a coexistence of "despair no word can describe," mockery in the face of death, conflation of memories imagined and true, the solitude of the body imposing itself on the gregarious spirit, the driving need to seize the poetic (the spirit in full transcendence), and the extraordinary work—the desire to be sustained by what is irrefutably a succession, a bloodline, a landscape of lasting images.

THE ESTHETIC UNIVERSE OF FRIDA KAHLO

Luis-Martín Lozano

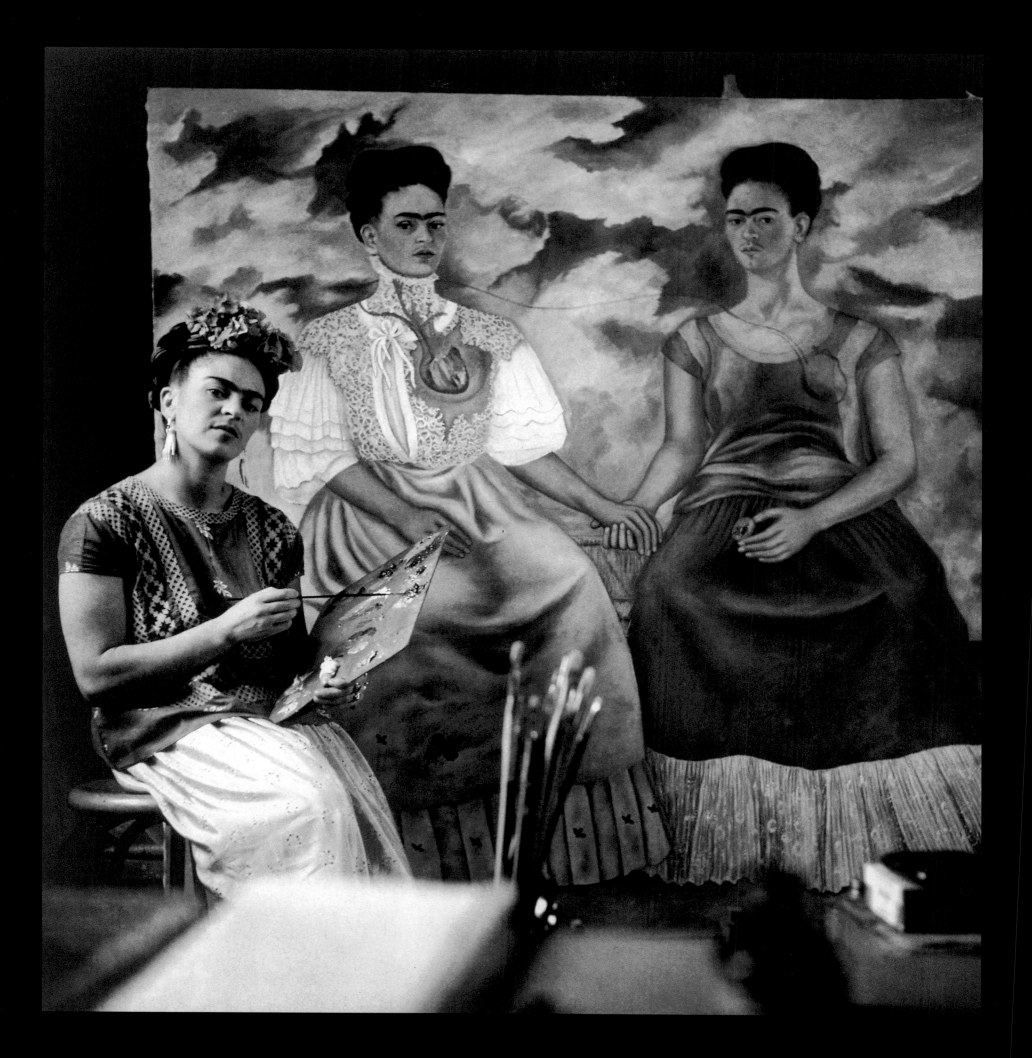

Take from life whatever it may offer you,
as long as you are interested in it
and take pleasure from it.

Diego Rivera, Toad-Frog,
to his little girl, Frida Kahlo.
December 3, 1938

I

Las Dos Fridas (The Two Fridas) is probably the biggest draw at the Museum of Modern Art in Mexico City. Indeed, whenever I go through the rooms of the permanent exhibition I nearly always come across a few solitary admirers gazing, in a state of rapture, at the two faces of the painter. What is the disturbing element here? Is it the fact that someone can paint herself and a copy of herself at the same time? Is it the fact that the two Fridas are linked together as they hold hands and as blood flows in the veins they have in common? The size of the painting also has something to do with it. Kahlo has painted herself with a distant, slightly haughty look; she is serious and absent-looking despite her virtual status. And she has done this twice. The impact can be terrible. We can never feel indifferent toward a painting that is questioning us with such inquisitiveness. As we are absorbed by the self-portrait, it is easy to agree that Frida Kahlo achieved her goal: to transcend reality through art.

This painting was executed in 1939 in the studio in her house in Coyoacán, surrounded by the esthetic universe that evolved around her. The painting was completed for the Fourth International Exhibition of Surrealism, which was held in the legendary Gallery of Mexican Art. It would be fair to say, therefore, that she put considerable effort into it. Or even that she risked everything, bringing together the final synthesis of her existence as a woman and as an artist. It is the manifesto of an artist, the final gesture of an existence that has found its destiny, if only briefly. It was not, however, an overnight process. Her career was long and marked by adversity, real and imagined, as the myth surrounding her suggests. Indeed, it is this mythicizing that prevents us from fully understanding the complexity of Frida Kahlo—how she became an artist and what the conceptual and visual influences on her development were. In the case of Kahlo, it is hard to determine where the artistic process begins and the fable ends insofar as she was unconventional, complicated, and to a certain extent, difficult to understand. The painter, however, is there in every painting she has left us, and each image is a document that we can study and decipher. This is what this essay aims to do.

There is no need to start with her childhood, although her childhood, her adolescence, and even her birth may be of interest from a psychoanalytical point of view in explaining the content of some of her paintings. It is instead the sociocultural context that explains the artist's beginnings. Her father, German photographer Wilhelm Kahlo, played a fundamental role in giving direction to her vocation, developing an esthetic outlook in the most dearly loved of his offspring: "Frida is the most intelligent of my daughters." "She is the one who is most like me."[1] From her father Frida certainly developed a love for the classics, for literature and philosophy, for scientific and medical books, and in particular for the biographies of famous men and women from history, like Catherine de' Medici, whose life had been the subject of detailed analysis. Frida Kahlo also read, for example, *The Life of the Heart* by Frances Winwar and *Treaty on Human Embryology* by A. Fischel. She studied her father's art books on Brueghel, Cranach, and Grünewald and absorbed all the pathos of the German painters; it is no coincidence that she chose to sign her first paintings with the German spelling of her

[1]Hayden Herrera, *Frida: A Biography of Frida Kahlo* (New York: Harper and Row, 1983), p. 18.

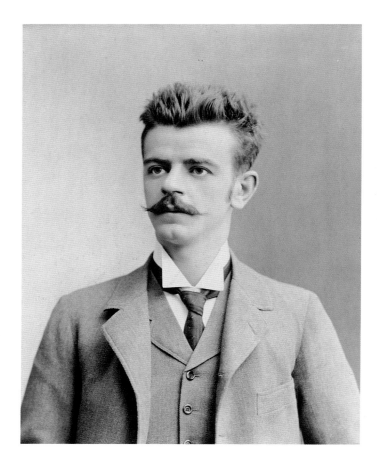

WILHELM KAHLO, *MY FATHER'S PORTRAIT*, 1951.
CA. 1893 OIL ON CANVAS,
60.5 x 46.5 CM

name, Frieda, and in 1951 she painted a proud "Wilhelm Kahlo . . . professional photograph artist, generous in character, intelligent, and distinguished. He showed courage in his sixty-year struggle with epilepsy, never stopped working, and fought against Hitler."

For Frida, her father was indeed a model figure. He was an example of the personal stoicism that enabled her to overcome her physical defects with dignity, and of the need to keep order and to respect oneself by loving one's craft. The German influence was, without doubt, the basis for her empirical approach to the world and for the development of a rationalist vision that led to an interest in scientific analysis and botanical investigation. It is my belief that it was from her father that she gained the necessary patience for posing for hours in front of a mirror and for noting every minor detail of her face. He, too, did the same with his models. Wilhelm Kahlo's photographs may be viewed as a basic and important source for her study of composition, as the early portraits she painted seem to indicate.[2]

It was indeed thanks to one of Herr Kahlo's friends that Frida started, in about 1925, doing commercial engravings in the workshop of Fernando Fernández.[3] It was this experience that awakened her drawing skills, which until then had not completely developed. The surviving pencil-and-ink sketches from this formal training period testify to her innate ability to reproduce shapes and space through drawing and to the way she handled light. Drawings like *El viejo* (The Old Man), copied from an engraving by Anders Zorn, are an indication of the kind of European art Frida Kahlo admired. They are also early examples not only of the exaggerated naturalism with which she drew the human figure but also of her ability to project contained nerv-

[2] "Mr. Kahlo wanted Frida to study photography, and he taught her how to handle a camera and develop pictures, but she never took to the precise and geometric framing and the sharpness and accuracy of taking photographs" (Alejandro Gómez Arias, "Un testimonio sobre Frida Kahlo," in *Frida Kahlo: Exposición nacional de homenaje*, exh. cat., Museo del Palacio de Bellas Artes, Mexico, 1977.)

[3] As noted in Fernando Fernández's letter on display at the Frida Kahlo Museum in Mexico City.

Engravings by Anders
Zorn and drawings
by Frida, now at the
Museo Frida Kahlo

Portrait of a Woman,
1925.
Ink and pencil on paper,
12.7 x 11.5 cm
(copy of a work
by Anders Zorn)

Musician, 1925.
Ink and pencil on paper,
11.5 x 18.5 cm
(copy of a work
by Anders Zorn)

ous gestures, as can be observed in the confident, expressionistic strokes with which her drawing goes beyond the engraving that initially inspired her.

Drawing was the first esthetic field Kahlo experimented with, as indicated in her early letters written between 1923 and 1925 to her boyfriend of the time, Alejandro Gómez Arias, and to other friends, like the poet Miguel N. Lira. In these letters there are lots of tiny drawings in which, though they are only sketches, she already displays the need to draw herself and to send secret messages. These were the years when a certain method of teaching drawing became popular in primary and technical schools in Mexico City.[4] As part of the educational policy of the minister José Vasconcelos, the approach of the Mexican artist Adolfo Best Maugard (1891–1964) was followed. Best Maugard had developed a method that aimed at recovering the popular art tradition in Mexico—in a philosophical framework that linked Mexico to the East and

[4] See Karen Cordero Reiman, "Para devolver su inocencia a la nación," in *Abraham Ángel y su tiempo*, exh. cat., Museo de San Carlos, Mexico, pp. 8–21.

THE OLD MAN, 1925.
INK AND PENCIL
ON PAPER, 17 X 12.5 CM
(COPY OF A WORK BY ANDERS ZORN)

West—based on his experience of European avant-garde movements. The didactic approach was summarized in a book entitled *Método de dibujo: tradición, resurgimento y evolución del arte mexicano* (Drawing technique: tradition, renaissance, and development of Mexican art) that Kahlo was probably familiar with, judging from some of the watercolors she painted around 1925.[5]

Kahlo gave some of her early work to her friends as presents, in particular to Chong Lee (Miguel N. Lira) and Ángel Salas. Several pieces have survived to this day and can be found in the Instituto Tlaxcalteca de Cultura (The Tlaxcaltecan Institute of Culture). In this work we can observe the same

freshness and emotional candor as in the work of the young students who followed the Adolfo Best Maugard drawing method: a sort of naive simplicity mixed with numerous innocent details in a provincial environment, just like the environment of the villa in Coyoacán where Frida Kahlo was born. Kahlo, however, was not the only one to have ties with the esthetics of the Best Maugard movement. Indeed, many other painters can be named, such as Rufino Tamayo, Julio Castellanos, and Augustín Lazo, and women like Bertha del Río, Dolores Serrano, Carolina Castañeda, Marina Rosas, Beatriz Peimbert, and Esperanza Paz y Puente, child artists whose names remain only as vague references in the history of Mexican art.

The influence of Best Maugard was only a passing phase for many artists who were progressing through logical stages of their experience. However, the freedom of gestures encouraged by the Best method was very attractive, since it stimulated the technical side of drawing, and encouraged the authentic emotion of the surrounding world. It achieved effects of chromatic purity that, at times, are reminiscent of the *fauves* in Paris. The priority of the educational policy was not to create artists out of every child or student who followed the method, but rather to turn out useful citizens who would one day be the engineers, architects, and artisans the country needed. Apart from this, however, it also produced artists with enormous potential, such as the short-lived Abraham Ángel (1905–1924), known as the Child Painter because he died at the age of nineteen, who produced a corpus of captivating work unparalleled in the history of Mexican figurative art. He created idyllic images of his nation and its inhabitants that gradually changed in the wake of a cruel revolution. The underlying metaphor in many of his paintings is the rebirth of tradition, which, for the painter, represents the conflict between his own need to grow as an artist and a promising

[5] She might have also seen Adolfo Best Maugard's work on his drawing method in an exhibition held on June 13, 1924, on the ground floor of the Ministry of Education building.

Have Another One,
CA. 1925.
WATERCOLOR ON PAPER,
18 X 24.5 CM
(DEDICATED TO ÁNGEL SALAS)

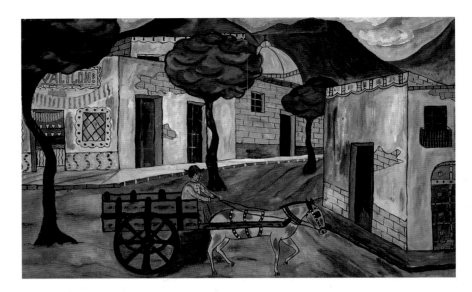

ABRAHAM ÁNGEL,
THE LITTLE MULE, 1923.
OIL ON PAPER,
76 x 120 CM

ABRAHAM ÁNGEL,
*PORTRAIT OF
CRISTINA CRESPO*, 1924.
OIL ON PAPER,
136 x 120 CM

FRIDA IN COYOACÁN,
CA. 1926–1927.
WATERCOLOR ON PAPER,
16 x 21 CM

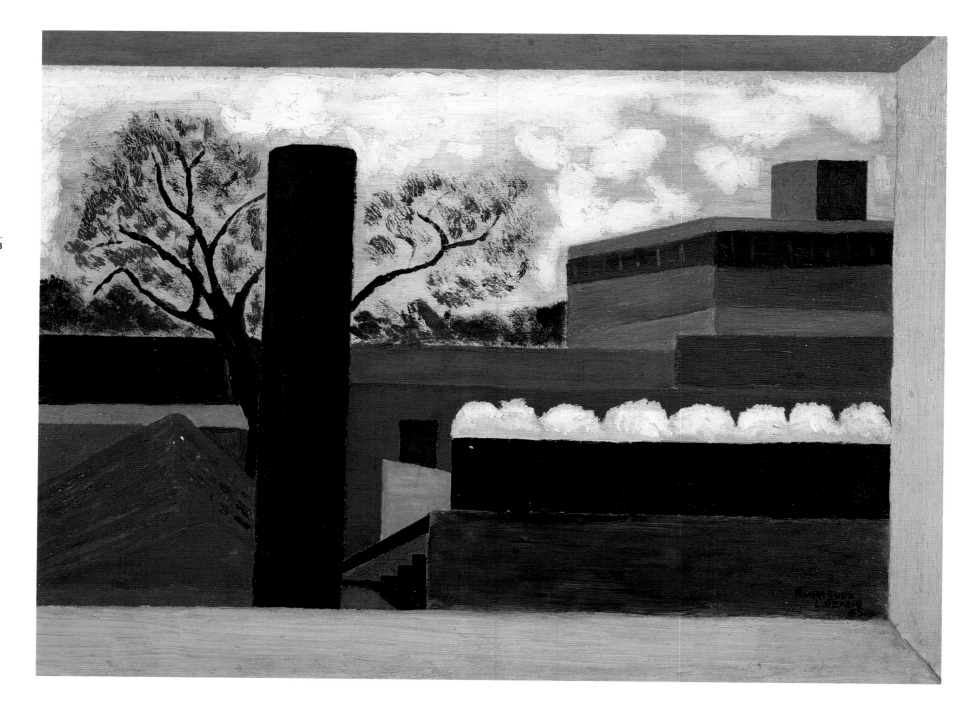

Manuel Rodríguez Lozano,
Landscape (Roof), 1925.
Oil on canvas,
23 x 28.5 cm

future for postrevolutionary Mexico. It is not surprising that the young Kahlo identified with these ideals, so much so that she studied and revisited the work of the Child Painter. When one compares Abraham Ángel's *La mulita* (The Little Mule) of 1923 with one of Kahlo's early watercolors, it would appear that Frida's painting is executed from the same perspective. She painted herself opposite the tram tracks that connected Coyoacán to Mexico City. In the background we can see three trees in a line, exactly as in Abraham Ángel's painting.[6]

This empathy between them did not occur by chance but rather was the result of the artistic environment in Mexico in the 1920s. Painters like Manuel Rodríguez Lozano and Gabriel Fernández Ledesma wanted to depict the transition to modernity that their country was going through. The passage from country to city, from rural to urban, from primitive to industrial was a constant iconographic element of the time. Frida Kahlo and Abraham Ángel are only two examples of the young artists who suffered, also emotionally, this generational bewilderment that had them trapped in a sort of timeless Arcadia. Out of a need to be with people of her own age, Kahlo painted watercolors that reflected the spirit of the age and that, in the words of the photographer Lola Álverez Bravo, captured "a world of affected beauty, a sort of Coyoacán in flower and peaceful, with peasants and servant girls out on a Sunday in their flowery skirts and lace blouses."[7] It is easy to understand how the new chaotic and bustling city life was greeted enthusiastically by the young Kahlo, who set about representing the symbols of this newfound modernity in her early paintings. One particular painting, which her family kept and which now belongs to a private collection in Mexico, is an example of this approach. It is a small oil painting from 1925 that is very different from the paintings Frida did later on. Without doubt, this *Paisaje urbano* (Urban Landscape) is indicative of Kahlo's esthetic concerns and the themes she was exploring before she met Diego Rivera. It is also the first painting to be executed with a sophisticated structure.

The composition takes on the challenge of handling concrete geometrical volumes as if it were a cubist painting, and

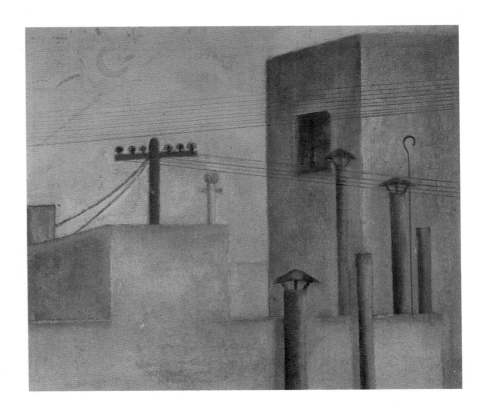

URBAN LANDSCAPE, CA. 1925.
OIL ON CANVAS,
34.4 x 40.2 CM

for this reason color is kept to a minimum. There is a visual purity in her work that moves Kahlo away from the Mexican Proarte movement led by Adolfo Best Maugard and the outdoor painting schools promoted by Alfredo Ramos Martínez from 1913 onward. She concentrates her attention on the problems of form and content; she alludes to a utopian vision of an urban landscape where electric cables, telegraph poles, heating vents, and chimneys dominate and call into question the process of modernization of the country. The artist is formally attempting to convey to the spectator that the desolate flat-roofed buildings are like cubes and rectangles in space. This is an indication of the expansion of Kahlo's visual influences and of the development in her attempts at complex

[6] This comparison is also described in a previous essay of mine in which I investigate the early works of the painter. (Cf. Luisa-Martín Lozano, "Frida Kahlo, or The Will to Paint," in *Diego Rivera-Frida Kahlo*, Martigny exh. cat., Switzerland, 1998, pp. 161–182.)

[7] See Olivier Debroise, *Abraham Ángel y su tiempo*, exh. cat., The Museum of San Carlos, Mexico, p. 29.

composition in well-assembled paintings that led her to achieve artistic expression worthy of such artists as Manuel Rodríguez Lozano, who in around 1925 painted similar industrial landscapes, though perhaps slightly more technically accomplished. Whatever artistic ambitions Kahlo may have had, they were to receive an unexpected setback when a disastrous accident on September 17, 1925, temporarily held back the aspirations of the restless painter.

<div align="center">II</div>

Much has been written about this terrible and traumatic experience. Kahlo described it to Raquel Tibol as follows:

> Buses in those days were extremely light; they had just started and were very popular. The trams were empty. I got on the bus with Alejandro Gómez Arias. I sat down in the corner next to the handrail, and Alejandro was next to me. A few moments later, the bus crashed into the Xochimilco Street trolley. The trolley pushed the bus onto the corner. It was a strange crash; it was not violent but rather muffled and slow, and it gave us all a good knocking about. It certainly knocked me about. . . . I was a clever young girl but not at all practical, despite the freedom I had gained. I underestimated the situation and the wounds I had received. The first thing I thought about was the pretty colored *balero* [Mexican toy] that I had bought that day and had with me at the time. I tried to look for it, thinking that there was nothing more to the incident. When you realize there has been an accident, it is not true that you cry. There were no tears in me. The crash had sent us flying toward the front, and the handrail went right through me like a sword through a bull. Someone noticed I was hemorrhaging terribly and lifted me and put me on a billiard table until the Red Cross came for me.[8]

Kahlo was certainly scarred for life, however, and the physical consequences were not even as great as the emotional implications. The accident came up in many different ways throughout the rest of her life and in her work. Without diminishing the suffering she experienced, the letters she wrote to her boyfriend during her convalescence are proof of a young woman who was clearly prepared to fight in order to overcome her adverse circumstances. "I intend to study everything I can, and now that I am getting better, I intend to paint and do lots of things, so that when you come I will be a bit better." These words contradict both the myth of Kahlo as a painter who was bitter with life and the romantic vision of Kahlo as a victim of life's circumstances.

Some of Kahlo's letters have been published in full or part and are often cited as evidence of the pain and despair she experienced. Her correspondence, of course, offers another kind of information, too, that is perhaps more interesting and sheds light on the painter's creativity and the esthetic referents she admired. She commented to her friends on the books she had read. She had read *John Gabriel Borkman* five times and Eugenio d'Ors' *La Bien Plantada* at least "six or seven" times; the same can be said

[8] Raquel Tibol, *Frida Kahlo: Una vida abierta* (Mexico City: UNAM, 1998), p. 39.

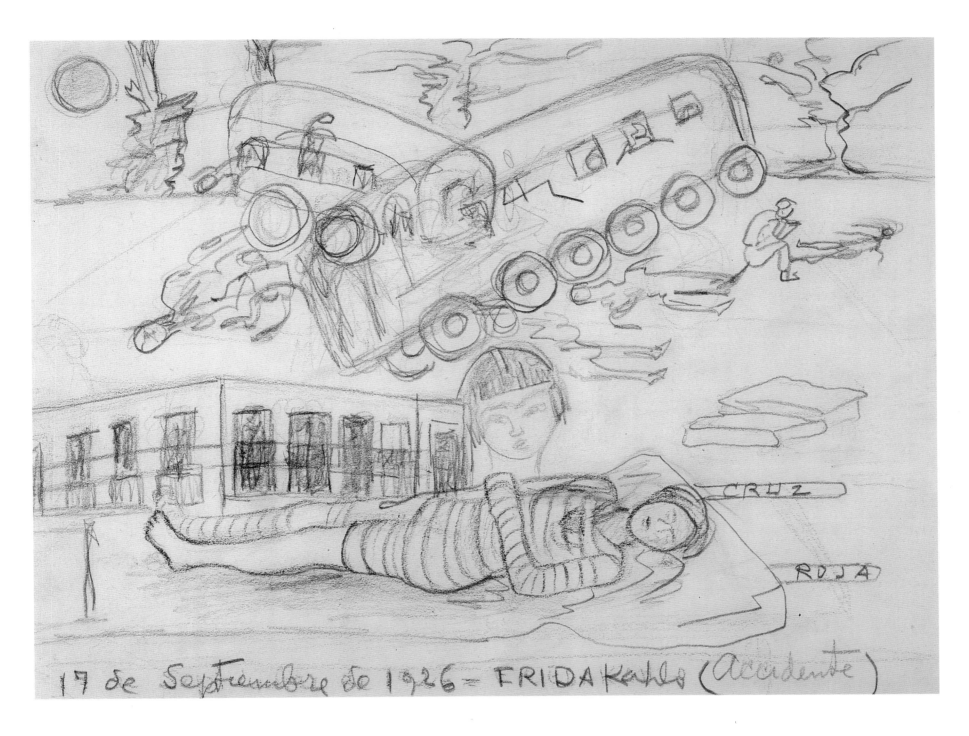

17 de Septiembre de 1926 = FRIDA Kahlo (Accidente)

PREVIOUS PAGE:
AGUSTÍN LAZO,
THE ACCIDENT, 1924.
WATERCOLOR ON PAPER,
30 x 43 CM

THE ACCIDENT, 1926.
PENCIL ON PAPER,
20 x 27 CM

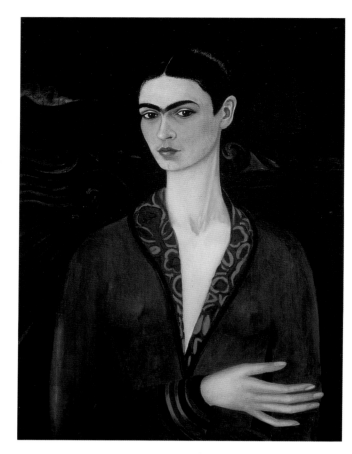

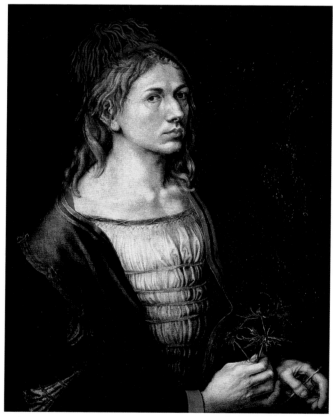

for *La lanterne sourde* by Jules Renard, Henri Barbusse's *Jésus,* and Konstantin Fedin's *Cities and Years.* In the face of everyday events and the frustration of being bedridden, what is most surprising is the sophisticated cultural vision the young woman possessed. She spoke of both Lucas Cranach and Dürer, she was fascinated by Paolo Uccello and El Greco, and she mentions the work, in particular, of Agnolo Bronzino.[9] Her knowledge of European art was much wider than critics have so far acknowledged. In her studio in Coyoacán are copies of the books she read in her youth and several brief illustrated biographies of Holbein, Velázquez, Brueghel, Rembrandt, Van Dyck, and Leonardo da Vinci. Her library points most of all to a clear preference for German painting. Of all of her books there is one in particular that attracted my attention. It is a collection of the most beautiful female portraits by famous artists, which suggests that Kahlo was inspired by this iconographic tradition. It is not surprising, therefore, that when she returned to painting as a real vocation, the esthetic world she was aspiring to was that of the great masters and that painting was, for her, a means of spiritual outlet and salvation for her creative soul. Art and books were a means of satisfying her intellectual needs and a way of consolidating the cultural heritage passed on to her by her father. In addition to this, they enabled her to explain to the surrounding world the details of her sickness, her pain, her loneliness, and the contradictory needs she was confronted with. Her study of European art explains how in her deranged imagination she could conceive an imaginary son by the name of Leonardo—undoubtedly in honor of the master from Florence.

If we look back over some of her first portraits from those years, we may be able to determine the formal influences of many of her creations. Take, for example, the first important portrait we know of by Kahlo, *Autorretrato con traje de terciopelo* (Self-Portrait with Velvet Dress). She dedicated it to Alejandro

[9] I am grateful to the architect Enrique García Formentí for letting me view the letters.

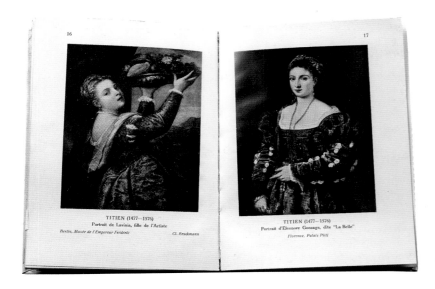

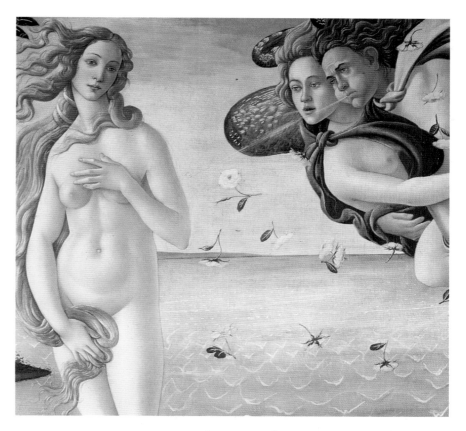

TWO FEMALE PORTRAITS SANDRO BOTTICELLI,
BY TITIAN, IN A BOOK *THE BIRTH OF VENUS*, CA. 1499.
FROM THE LIBRARY TEMPERA ON CANVAS,
OF FRIDA KAHLO 175.5 x 278.5 CM (DETAIL)

Gómez Arias: "For Alex. Frida Kahlo, at the age of 17, September 1926—Coyoacán—Heute Ist immer noch [Today is like always, or Today still goes on]."[10] The image represents her intention to make sure she was not forgotten. Following the accident, Gómez Arias kept his distance from her. It is also a fact that Kahlo developed an obsession about keeping him close to her during her convalescence. In this way, in the absence of the object of her desire, she now could appear in a more permanent way, and each time Gómez Arias looked at the painting he would be confronted with the sphinx of his affections.[11] It is an image charged with different meanings, some hidden and others more obvious. Only the top half of Kahlo is visible, and she assumes a rather hieratical pose and an enigmatic expression. The anatomical proportions have been altered: She has a very long neck like an ivory tower; a sinuous hand with elongated fingers; firm breasts that look conical under the canvas; sagging shoulders with no support. The way she is standing is both artificial and decorative and underlines the great expressiveness of her face. Kahlo is looking at Gómez Arias questioningly, asking him about his affections, his absences, and if he can really see the turmoil she has inside; does he perceive the flow of tenderness and passion she is capable of giving and especially her desire to live and the frailty of her soul?[12] Frida Kahlo has exposed herself in a way she will never do again: She is a vulnerable being imploring another for love and reminding that person of the world they have shared together. Her skin contrasts

with the darker background, which depicts an intensely blue sea with waves and a stormy sky suggestive of tragedy. It is the Mediterranean Sea that Gómez Arias talked about in his letters: "According to what you've told me . . . it is wonderfully blue. Will I ever get to see it?" It is a sea painted in the *Jugendstil* manner, like the fresco of the Ex Templo de la Encarnación by Roberto Montenegro in the Biblioteca Iberoamericana, which Kahlo must have seen in about 1924. It is also the ocean as a symbol of life, "that sums up life, my life," she once wrote. "I

[10] I am grateful to Andrea Kettenmann for helping me with the translation in an attempt to understand this cryptic sentence, which, without doubt, refers to the hope that Alejandro Gómez Arias would love her forever and as before, if he ever really did love her.

[11] Frida Kahlo asked Alejandro Gómez Arias to place the painting at eye level so that he could look at her as if they were face to face. (Cf. H. Herrera, *Frida*, p. 60.)

[12] All these feelings emerge from the letters Frida Kahlo sent Gómez Arias.

who have so often dreamed of being a sailor and traveling!" "You haven't forgotten me, have you? It would be unfair, don't you think?"

At a conceptual level, Kahlo's self-portraits work like those Albrecht Dürer painted in the sixteenth century, in which the master presented himself to his viewers in order that they might get to know him and, perhaps, admire his good looks, intelligence, and sensitivity as an artist. Dürer liked to portray himself from the waist up so he could show off his hands, which were masculine yet sensitive and useful in interpreting the world around him. He adored his body, and several drawings of him naked are known; often his skin is healthy looking and sensual, not very different from Frida Kahlo's skin around the neckline of her dress. Both painters reproduce the details of their faces: the slightly pronounced chin, the soft, elegant outline of their jawbones, their prominent yet elegant nostrils, and their extremely sensual lips. It is, however, in their eyes that Frida and Dürer come together and share the same desire for recognition and appraisal.

From Kahlo's letters to Gómez Arias other influences can be traced, other esthetic parameters to which she attached great importance. On more than one occasion she said her paintings were executed with Florentine airs, and she actually mentioned her *Self-Portrait with Velvet Dress,* which she called "Your Botticelli." While he was in Europe, Gómez Arias had visited the Uffizi Gallery in Florence, where not only was the portrait of Eleonora of Toledo on display but also the most famous paintings by Sandro Botticelli (1445–1510), including his *Birth of Venus.* Gómez Arias must have described the impact the painting had on him and, by doing so, turned it into a yardstick for Frida. He referred to Italian girls as "so exquisite they look like they were painted by Botticelli." What we know for sure is that Kahlo had this painting in mind when she decided to paint her image for her beloved. How could she not take note of the prototype of beauty he had so praised? In this sense it is not hard to work out the esthetic similarities that Frida wanted to establish with Botticelli's *Venus.* Both are apparitions of beauty incarnate. They are Neoplatonic symbols rather than carnal presences. Venus rises out of the clear water modest and virtuous, as the breath of life from the gentle breezes greets her. Likewise, Frida Kahlo is born again following her accident—out of turbulent waters, clean and redeemed as she offers herself to her beloved; both images appeal to the goodness of the spirit or rather to the internal beauty of the soul. Through her painting, Kahlo had the opportunity of starting out again, of reinventing herself, of coming back to life and starting a new cycle of an existence that, although not entirely happy, certainly had a lot more to offer. In this state of mind, she wrote in October 1927, "My Alex . . . life is ahead of us. It is impossible to explain to you what this means. . . . In Coyoacán the nights are amazing." Frida Kahlo, however, will never again show herself to her viewers this way. In her subsequent work she is a constant cryptic invention, a woman searching for her destiny, an artist looking for the secrets of painting, a painter with the desire to transcend through art the art of painting herself.

Between 1925 and 1928 Kahlo painted at least three self-portraits and nine portraits, nearly all of which were of her circle of intimate and close friends. We can identify with certainty four of them: one was of Alejandro Gómez Arias, one of Miguel N. Lira, one of Alicia Galant, and one of her sister Cristina.[13] The painting of Gómez Arias is rather conventional and follows the typical portrait model and is not dissimilar to a photograph, whereas the paintings of her friend Alicia Galant and of Cristina Kahlo reveal different esthetic tastes. The latter was painted in 1927 and dated and signed in Coyoacán and is rather large, nearly 1 square meter. As in her *Self-Portrait with Velvet Dress,* this painting also has a noc-

[13] The painting entitled *Girl Seated with Duck,* painted in 1928, might well be a retrospective self-portrait, and was put up for sale by auction by Sotheby's in 1981. In December 1926 she painted a portrait of her sister Adriana and between January and June 1927 another one of her friend Ruth Quintanilla and one of her friend Ángel Salas, who was studying music; the whereabouts of all three of these paintings is unknown. She did another one of Jesús Ríos y Valle, which Kahlo burned "like Joan of Arc" because she was disgusted by it. Another portrait she painted was of Agustín M. Olmedo, now in the Frida Kahlo Museum in Mexico City. See the complete record of Frida Kahlo's work published as an annotated catalog: Helga Prignitz-poda, Salomon Grimberg, and Andrea Kettenmann, *Frida Kahlo: Das Gesamtwerk* (Frankfurt: Neue Kritik, 1988).

turnal background and displays the decorative sinuosity of fin de siècle symbolism. The distinguished image underlines a certain cold and distant beauty, which, coupled with its artificiality, is rather reminiscent of the mannerism of Bronzino (1503–1572), a painter Kahlo admired greatly, as we can tell from some of the details of her paintings. Bronzino was, without doubt, the best-known portrait artist of the European courts in the sixteenth century. His pictorial style is characterized by the elegance of his characters, by their cold and constrained beauty, which contrasts with the ornamental pomp of their clothes that the painter took delight in painting in great detail. Like Jacopo Pontormo (1494–1557), Bronzino took pleasure in distorting anatomical detail, and in his portraits we often find large hands with long thin fingers that are more in keeping with an ideal of sophistication than the essence of the Renaissance, a visual device celebrated in the history of art as a symbol of international courtesan mannerism.

In the Uffizi Gallery, Gómez Arias was able to admire the portraits of Cosimo I de' Medici and his pretty wife, the Spanish Eleonora of Toledo, whom Bronzino painted several times between 1540 and 1546, as he did her children, Maria, Francesco, Isabella, Lucrezia, and Giovanni. Gómez Arias's visit to the Uffizi was celebrated by Kahlo on several occasions, after he told her he had seen some of her favorite painters: ". . . all of Lucas Cranach and Dürer and especially Bronzino and the cathedrals. . . . You don't know how pleased I was to hear you had seen the beautiful portrait of Eleonora of Toledo and everything you have told me."[14] Frida shared Bronzino's taste for long necks framed by robes and fine hands with fingers arranged in capricious postures. Both of these painters' subjects are a distant presence with an absent and thoughtful look and with a strange haughtiness somewhere between politeness and distractedness. The severe and inscrutable expression, the neck, the shoulders, and the hands of the portraits of Alicia Galant and Cristina Kahlo can be compared with the portraits painted by Bronzino. No less striking is the comparison between the portrait of Giovanni de' Medici and the little Isolda Pinedo, the niece whom she painted in 1929.

[14] Letter dated Saturday, June 4, 1927 (R. Tibol, *Frida Kahlo*), p. 53.

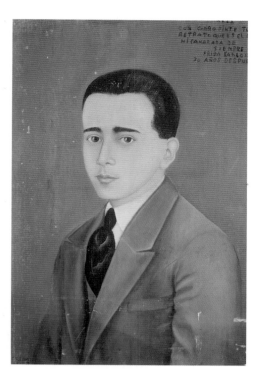

PORTRAIT OF ALEJANDRO GÓMEZ ARIAS, 1928. OIL ON WOOD, 61.5 x 41 CM

FRIDA KAHLO ON FEBRUARY 7, 1926

FOLLOWING PAGES: *PORTRAIT OF ALICIA GALANT*, 1926 (DETAIL)

SELF-PORTRAIT WITH VELVET DRESS, 1926 (DETAIL)

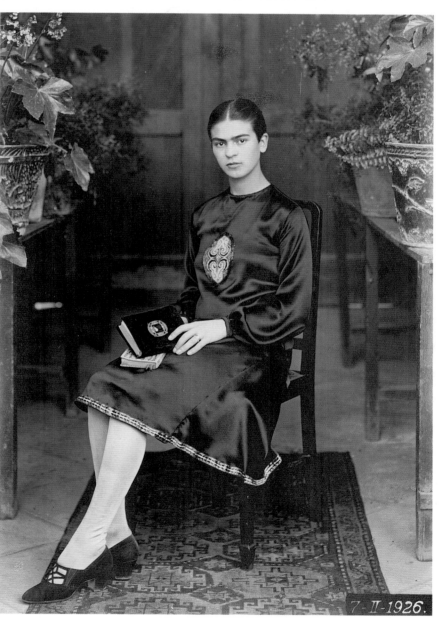

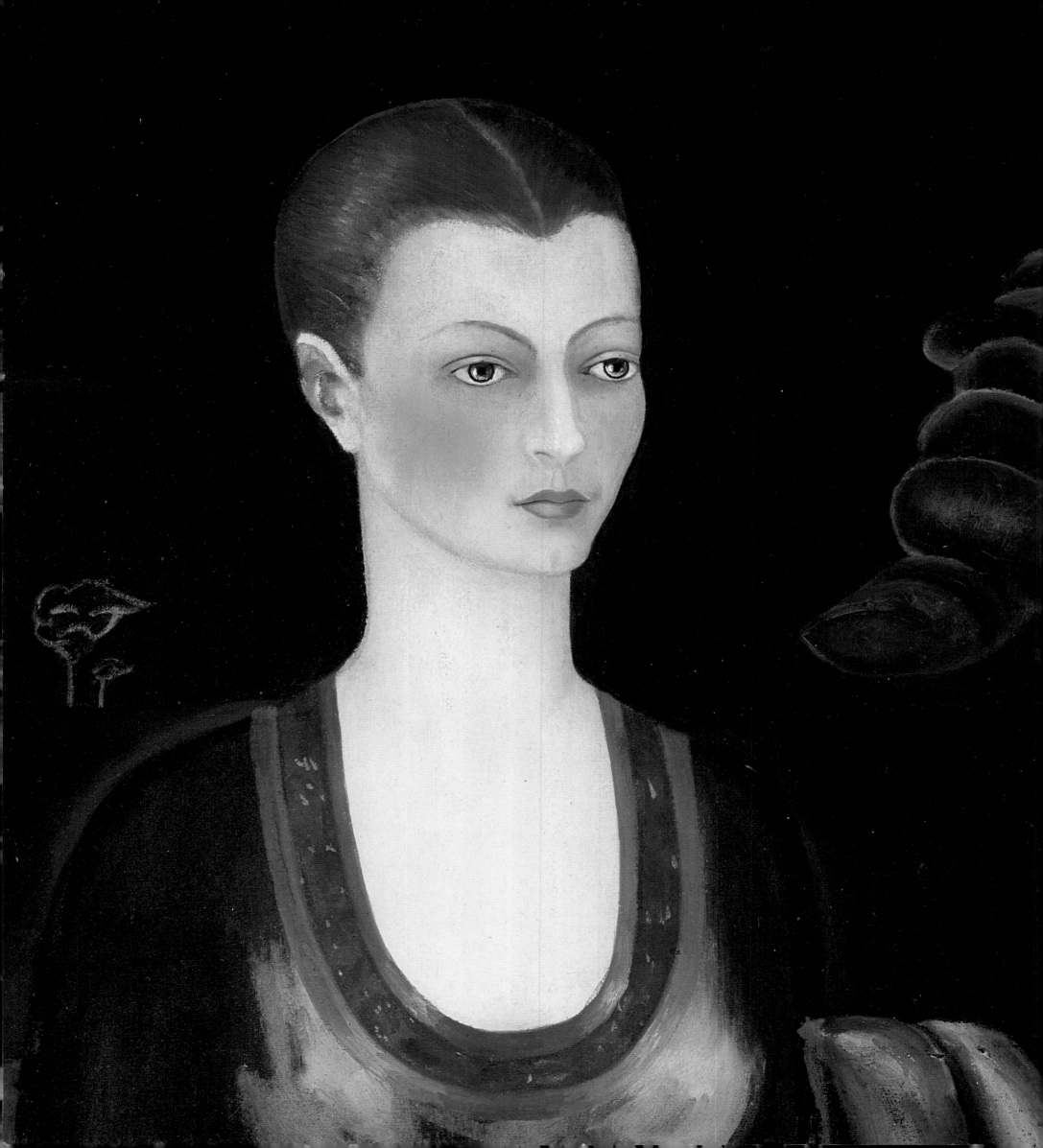

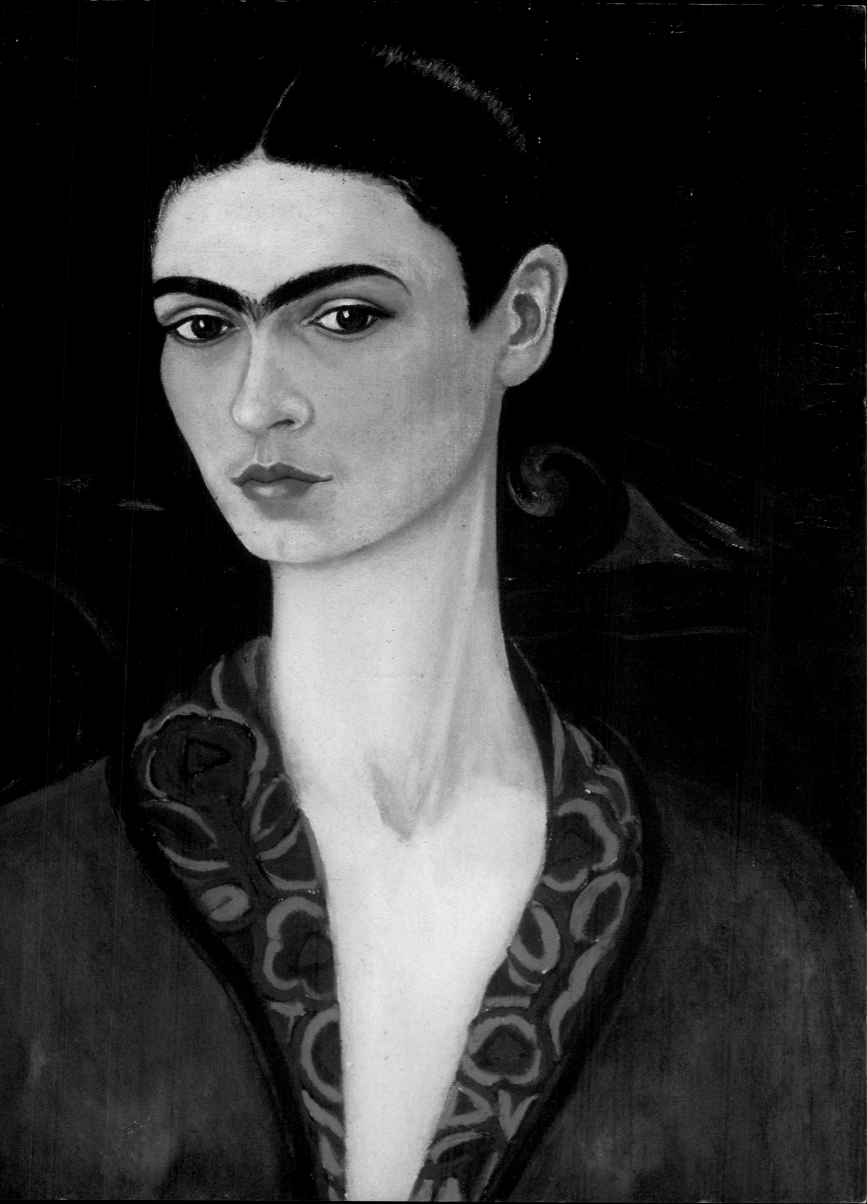

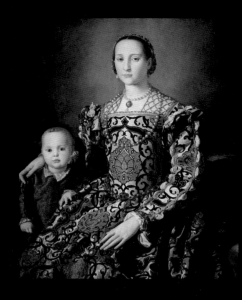
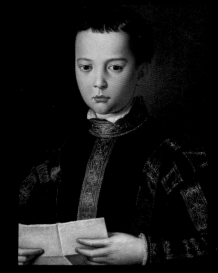
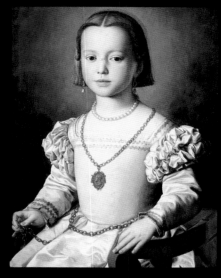

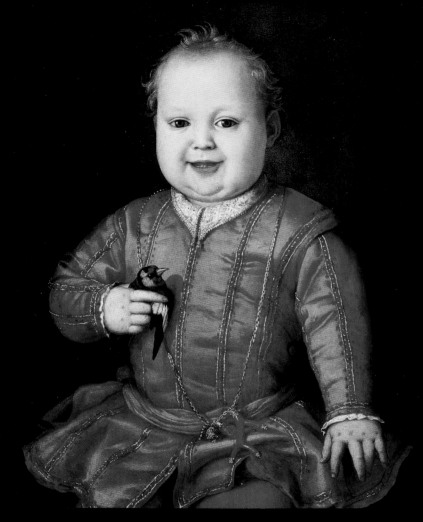

AGNOLO BRONZINO,
PORTRAIT OF ELEONORA
OF TOLEDO AND HER SON
GIOVANNI,
CA. 1545.
OIL ON WOOD,
115 x 96 CM

AGNOLO BRONZINO,
PORTRAIT OF FRANCESCO
DE' MEDICI AS A BOY,
CA. 1543-1545.
OIL ON WOOD,
58.5 x 41.5 CM

AGNOLO BRONZINO,
BIA DE' MEDICI
AS A GIRL,
CA. 1543–1545.
OIL ON WOOD,
63 x 48 CM

AGNOLO BRONZINO,
GIOVANNI DE' MEDICI,
CA. 1543–1545.
OIL ON CANVAS,
58 x 45.6 CM

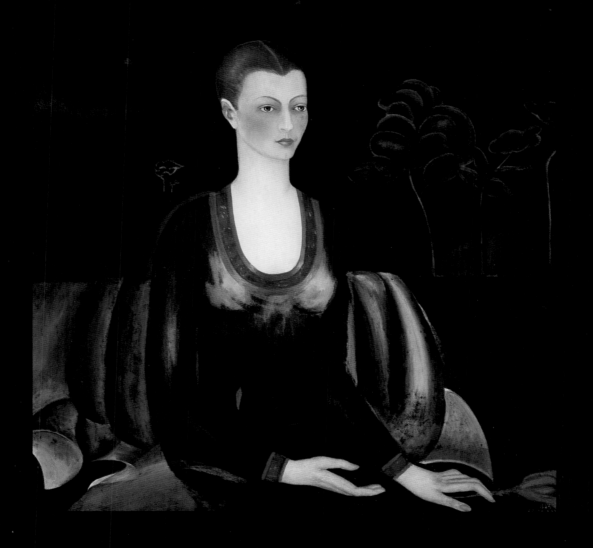

PORTRAIT OF ALICIA GALANT, 1926.
OIL ON CANVAS,
107 X 93.5 CM

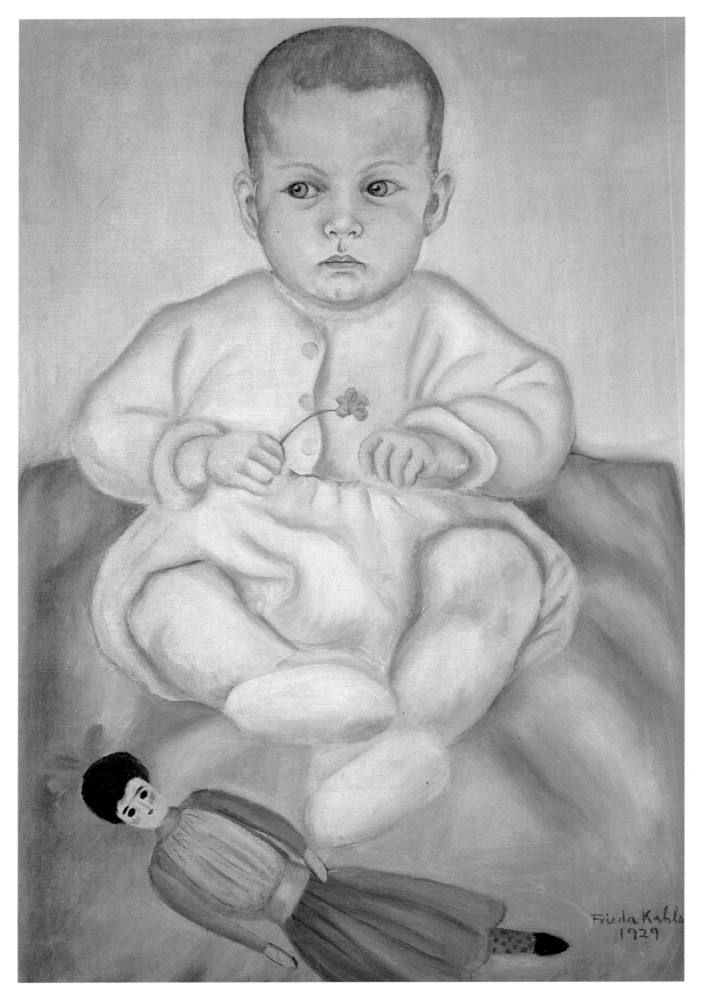

GIRL IN DIAPER, 1929.
OIL ON CANVAS,
65.5 x 44 CM
(PORTRAIT OF ISOLDA PINEDO KAHLO)

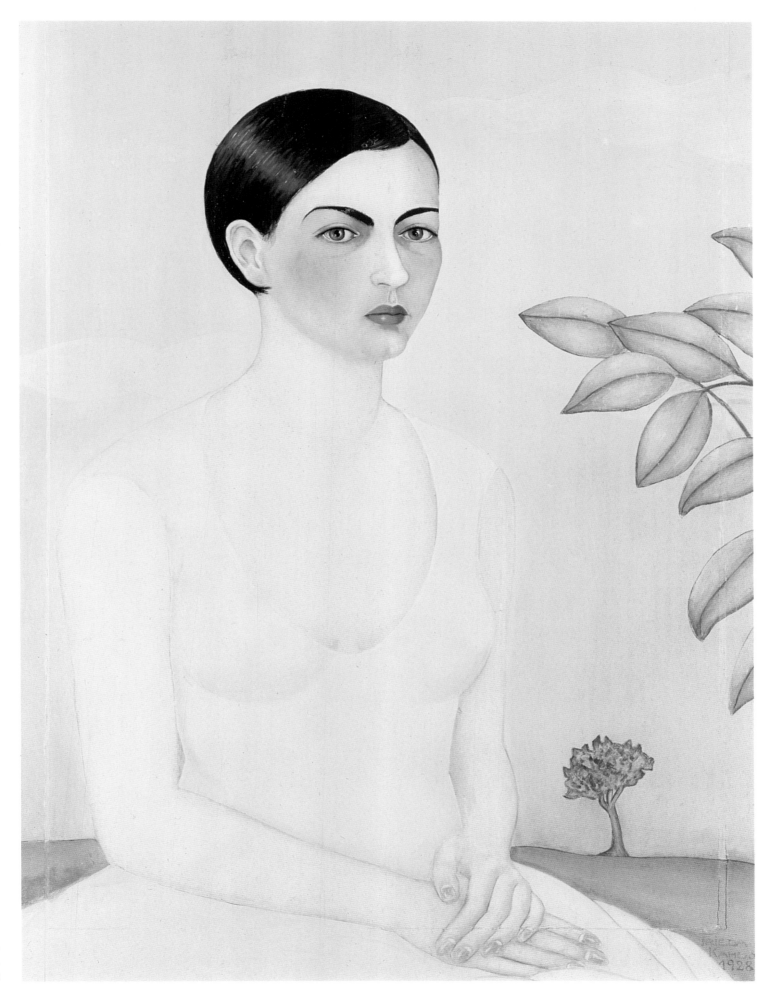

PORTRAIT OF CRISTINA,
MY SISTER, 1928.
OIL ON WOOD,
79 X 60 CM

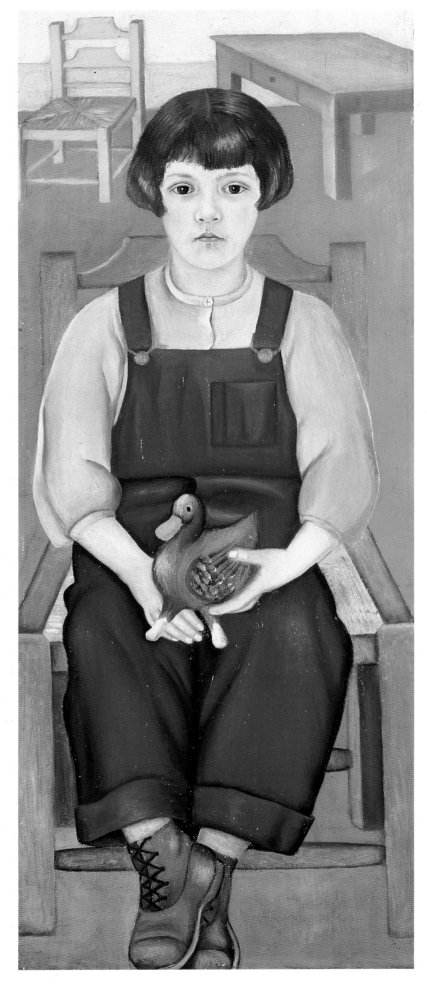

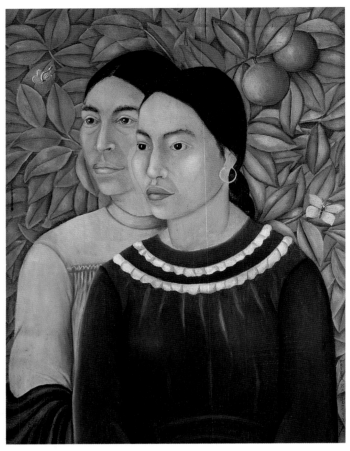

Sitting Girl with Duck, 1928.
Oil on canvas,
100.3 x 40.3 cm

Two Women, 1929.
Oil on canvas,
67.5 x 53.5 cm

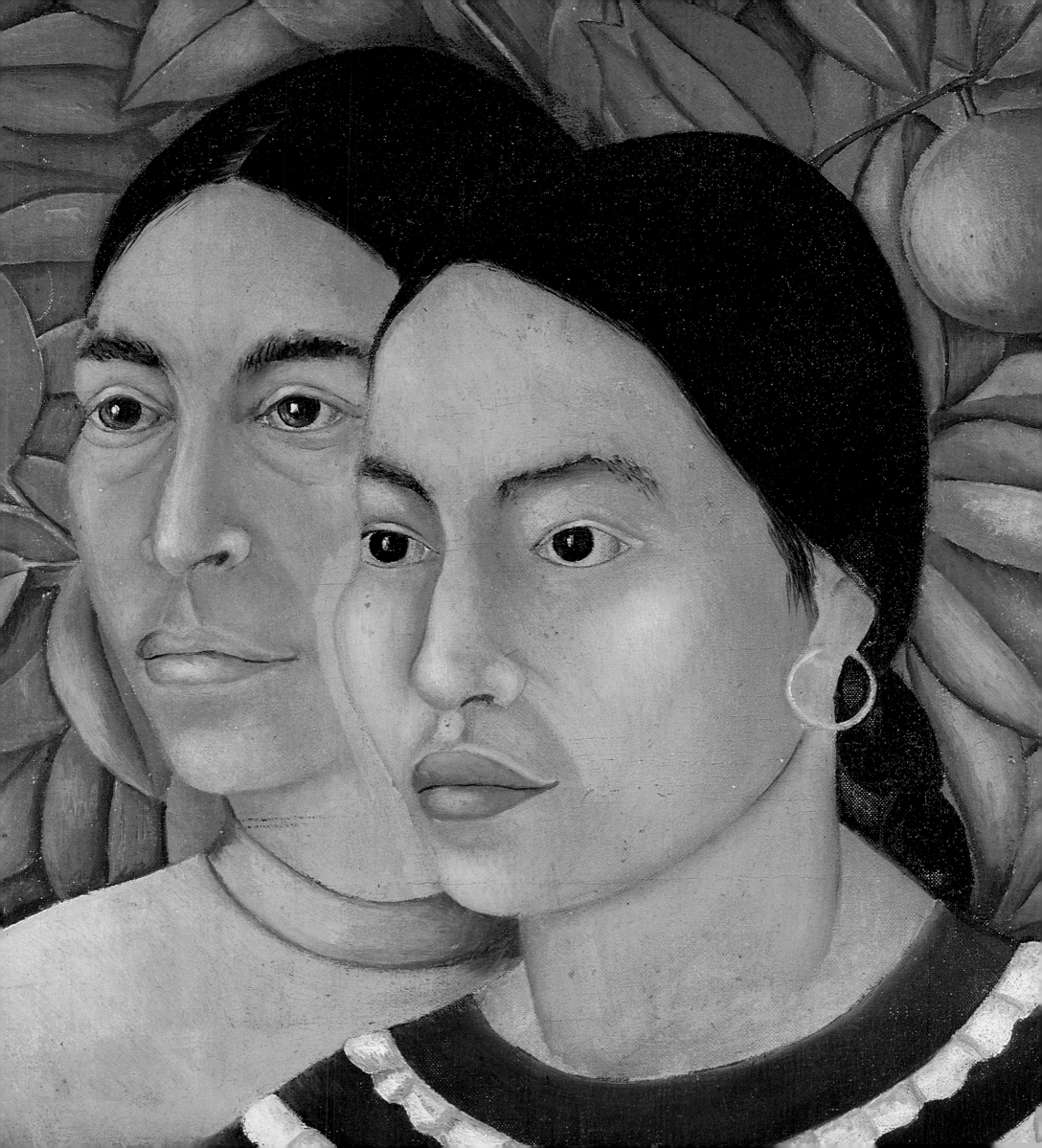

ALEJO ORTIZ, *FRIDA KAHLO,
COMMUNIST COMRADE,* 1929.
WATERCOLOR ON PAPER,
30.3 X 20.3 CM

RAMÓN ALVA DE LA CANAL,
CAFÉ DE NADIE, CA. 1924.
OIL AND COLLAGE ON CANVAS,
78 X 64 CM

III

In order to understand how Kahlo's experience at the Escuela Nacional Preparatoria influenced her creatively, we need to go back to Mexico in the 1920s, to a generation of Mexicans who were born during the armed conflict of 1910 and who adopted in one way or another the idea of a new nation trying to leave behind the excesses of the politicians and the middle classes under the presidency of Porfirio Diaz, a period known as the Porfiriato. Frida's family belonged to that middle class insofar as her father was employed professionally by the regime as a photographer. This meant that they benefited indirectly from a dictatorship with progressive plans. The young people of this generation believed strongly in the need to establish a new political and social order that would embrace all kinds of cultural initiatives, including those for the arts. Although when she entered the Escuela Nacional Preparatoria, Kahlo was only an adolescent wearing the uniform of a schoolgirl and an innocent straw hat decorated with ribbons, she quickly grew and matured intellectually at the school and belonged to "a generation illuminated by the last glows of the armed revolution."[15] During those years Kahlo read everything she could get

her hands on, reflecting her eager commitment to embrace the ideals of the generation of change. We know she was soon part of a group of restless young people called *Los Cachuchas,* and it was then that she developed her first revolutionary ideals, entering the Communist youth movement, Diego Rivera tells us, at the age of thirteen. It is not surprising, therefore, that she would be reading news by Aleksandr Kerensky on the Russian Revolution and that she was interested in the events in Shanghai. Through *Los Cachuchas* she came into contact with a wider circle of men and women who were putting all their energy into trying to create a modern Mexican culture that would be authentically revolutionary and also universally relevant. This is when Kahlo became friends with Salvador Novo and the poet Miguel N. Lira, who taught her to appreciate literary and artistic magazines like *Forma* and *Panorama,* which contained not only reproductions of work by Diego Rivera and Roberto Montenegro but also information on new developments in art.

Kahlo studied not only the Mexican muralist move-

[15] A. Gómez Arias, "Un testimonio."

ment—her friendship with José Clemente Orozco[16] and her first references to Diego Rivera probably date from that time—but also the various artistic proposals promoted by the Department of Fine Arts at the Ministry of Education, among which was the Adolfo Best Maugard drawing method mentioned above and the outdoor painting schools, which were probably the most revolutionary artistic and pedagogical experiments of those years. Without a doubt, a number of works produced between 1925 and 1929 prove that Frida was aware of another esthetic tendency in Mexico: *estridentismo*. This movement emerged in December 1921 as an innovative wind of change among the avant-garde that aimed to develop an artistic awareness that went beyond decorative nationalism. To the proponents of a natural art its followers replied by saying there was a need to become more cosmopolitan, because "it is no longer possible to adhere to the conventional compartments of national art." Its members used the language characteristic of the European avant-garde movement; it was demanding and rather coarse, totally anti-intellectual, and profoundly rebellious and nonconformist. Although it was not an artistic movement per se but rather a literary trend, it embraced the imagery of the avant-garde movement not only in its written work but also in its art, which evoked cubism, orphism, and Italian futurism in a very basic way. *Estridentismo* was basically an innovative esthetic trend that might be considered the first spark of the avant-garde movement in Mexico. Led by the poet Manuel Maples Arce, the group had intellectual ties with Filippo Tommaso Marinetti and Spanish ultraism as well as with the surrealist poets and the Russian cubo-futurist Vladimir Mayakovsky, who visited Mexico in 1925.[17] It was a rather small and heterogeneous group, and it certainly caught the attention of artists like Diego Rivera, Ramón Alva de la Canal, Fermín Revueltas, and Tina Modotti, who would meet in the city cafés in the Bohemian tradition and take part in debates. These painters embraced the same iconography of the city and its hypothetical future as one of progress and machinery and attached, for example, unusual importance to the development of contemporary photography.

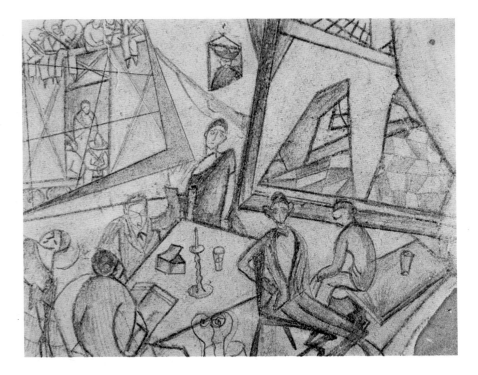

SKETCH FOR PANCHO VILLA AND ADELITA, CA. 1926.
PENCIL ON PAPER,
21 x 28 CM

The *estridentistas,* or followers of the *estridentismo* movement, like their contemporaries in Europe, were trying to build a new society by eliminating the old order or regime. It is easy to understand how these ideas caught the attention of *Los Cachuchas* and the young and restless Frida Kahlo.

Kahlo thus created paintings that capture the style and dichotomy of the ideals of the *estridentismo* movement in Mexico.

[16] Teresa del Conde points out that José Clemente Orozco "became aware of her [Frida] at that time and also admired her as a woman" (Teresa del Conde, *Frida Kahlo* [Mexico City, Secretaría de le Presidencia, 1976]). It may be worth noting that Raquel Tibol wondered whether Orozco actually met Frida before 1928. (See R. Tibol, "Respuesta a una carta abierta," *Proceso* 843 [December 28, 1992]). In recent conversations I have had with Salomon Grimberg, he mentioned an unpublished interview with Frida Kahlo in which she mentions having met, as a teenager, Orozco, who certainly admired her painting. I am grateful to Grimberg for sharing this piece of information with me and hope he has it published soon.

[17] See Stefan Baciu, "Los estridentistas en Jalapa," *La palabra y el hombre* (University of Veracruz Review) (October–December 1981).

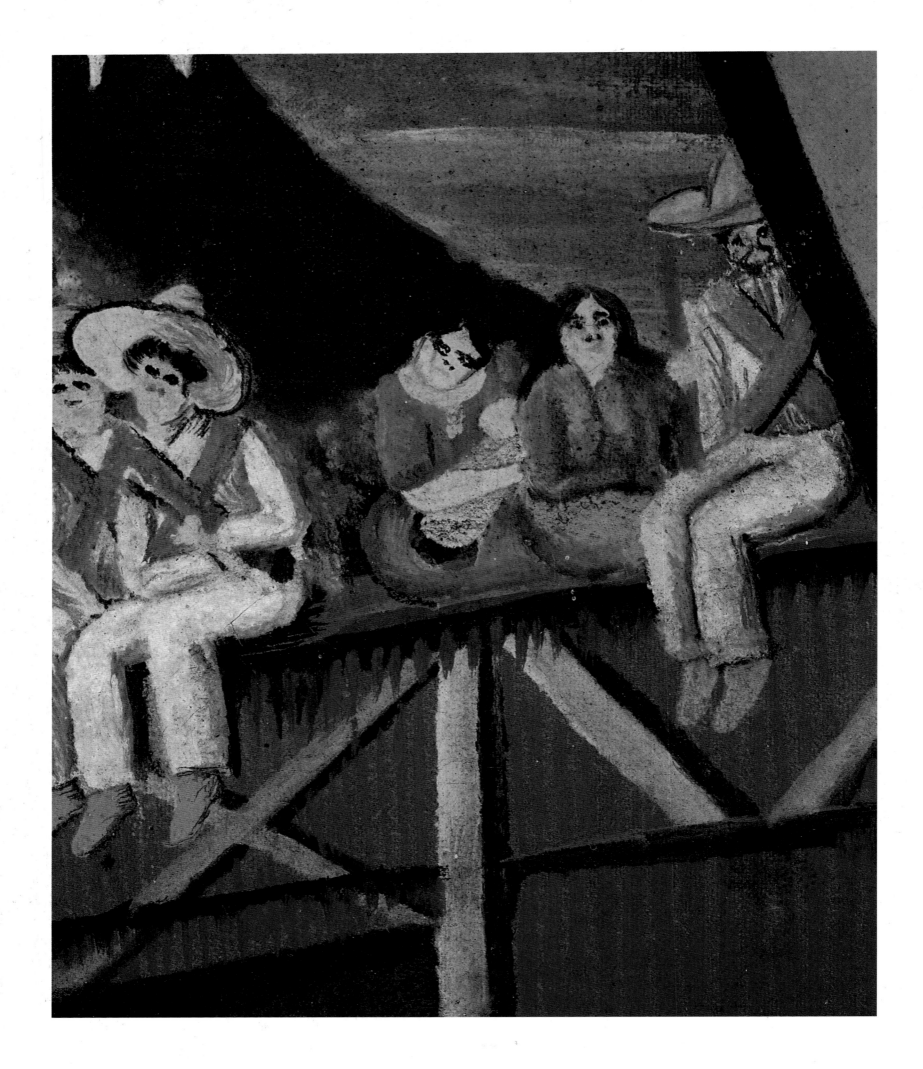

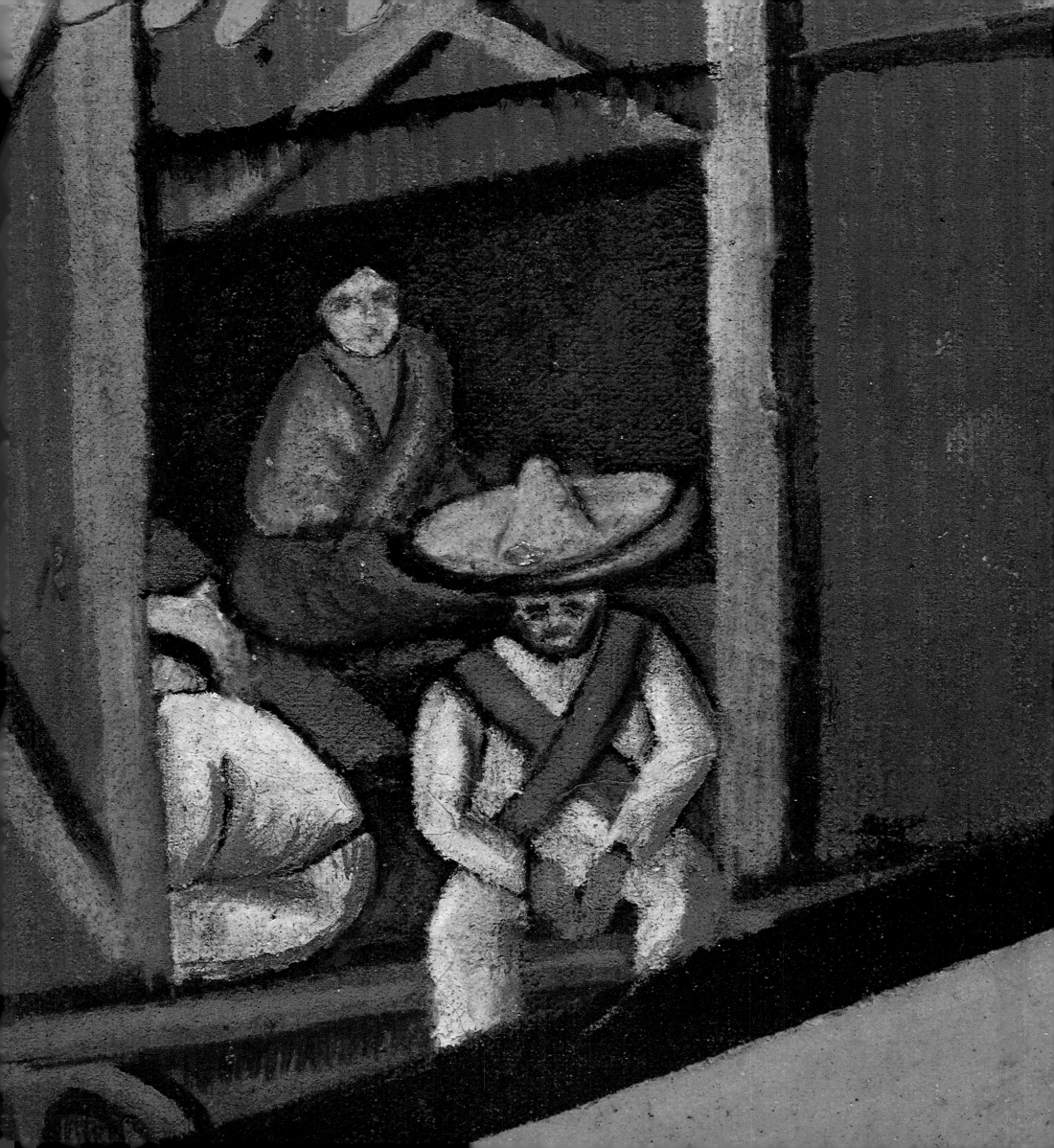

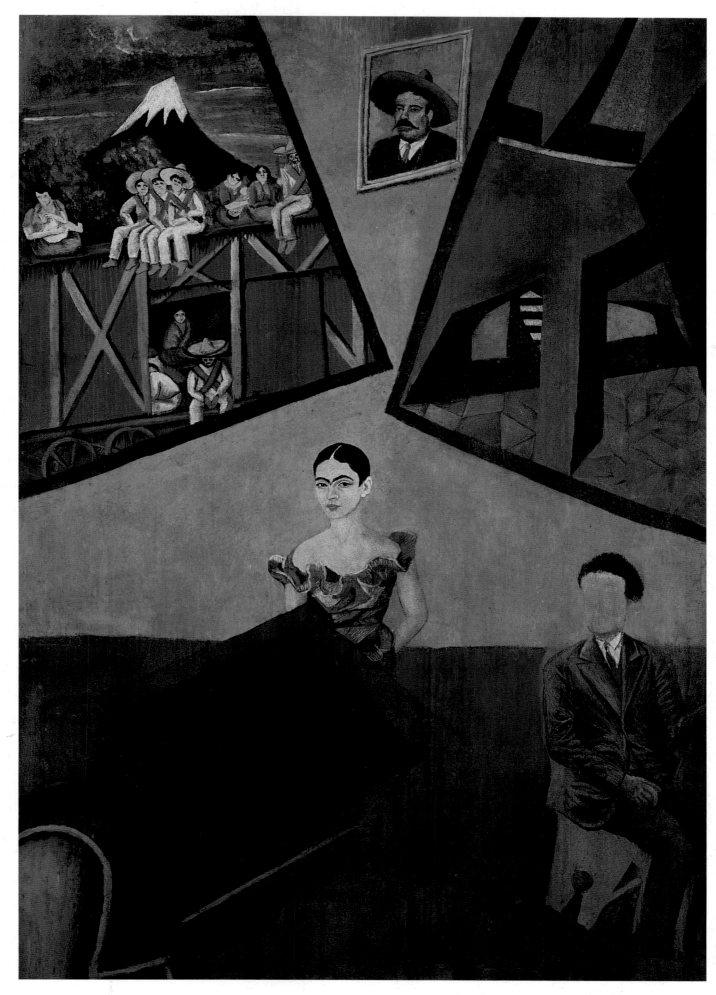

Pancho Villa and Adelita,
CA. 1927.
OIL ON CANVAS,
65 X 45 CM.

PAGES 46–48:
Pancho Villa and Adelita,
CA. 1927 (DETAILS)

A small drawing, which appears to have been part of the Rubén García Vadillo collection, would seem to give a very accurate description of the *estridentista* environment and is a study for an unfinished painting that she planned probably before 1927. The drawing shows one of those meetings, halfway between an informal discussion group and a debate, taking place at a candlelit café table and accompanied by drinks. Judging from the modern clothes and the geometrical breakdown of space and figures, the atmosphere is jovial and cosmopolitan. The central scene is marked by two visual referents divided by a rifle and a picture of a revolutionary. The drawing reveals a language of lines similar to the cubist and futurist ink paintings of the *estridentista* artists Fermín Revueltas and Ramón Alva de la Canal, which Kahlo tried so hard to make her own. The sketch is the outline of an unfinished painting in which substantial changes can be noted.

In the unfinished oil painting, the central figure is Frida, who has painted herself looking directly at the viewer rather than taking part in the debate in the café. The painting is entitled *Pancho Villa y Adelita* (Pancho Villa and Adelita) and is a meeting place of opposites, the simultaneous vision of two of the most important parameters in the debate of the intellectuals of the day: whether to adhere to the nationalist movement, which was a product of the Revolution of 1910, or to abandon cosmopolitan tendencies, some of which were a legacy from the Porfiriato period and had always been part of Mexican culture. The theme of the debate between the *estridentista* artists became a personal dilemma for Kahlo: Should she become a modern artist in the avant-garde spirit or commit herself entirely to the social requirements that the modern history of Mexico was demanding of her?

In the painting, the dilemma can be seen in two metaphorical images. The first is a convoy of revolutionary Zapatistas crossing the valley of Mexico, in the background of which is a volcano covered in snow; the second is a modern piece of abstract architecture of fantastic and illusory proportions. Its use of perspective is reminiscent of cubism, with strong diagonal lines and a geometrical environment. The seductive body of Frida Kahlo is placed in the middle between both scenes, and the portrait of Pancho Villa is like that of an ancestor or someone who

is caught between two poles and cannot decide which path to take. Perhaps she is aware that both positions in the background complement each other, just as she herself is genetically the fruitful synthesis of two ethnic groups and of two ways of viewing and understanding the world. This duality will be a constant element in her paintings and will appear at times as an indication of her internal conflict.

The dynamic cultural life of Mexico with its numerous ideas and its constant questioning is part of the spirit that dominates the portrait that Kahlo executed of the poet Miguel N. Lira. Despite the fact that she considered her creation a stiff, cardboard effigy—"complex" and "fantastically horrible"—this painting is actually the most impenetrable of those she executed during her early period. Lira appears to be surrounded by a symbolic world, undoubtedly connected with the interests of his literary work, which Kahlo knew well and some of which was full of oriental symbolism.[18] A lyre, echoing Lira's name, heads the iconographic symbols and is placed over a bell making a TAAAAAAAAANN sound, actually written on the canvas; a skull sits above his name, which is written vertically in capital letters: MIGUEL; the figure is guarded by an angel behind an open book with images of fertility and Hebrew letters.

Kahlo reveals in her letters that the painting was solicited by Lira, who asked for a "Gómez de la Serna style" background, which suggests that he envisioned a painting influenced by the avant-garde movement. He referred unambiguously to the expression "*ismos,*" which was coined by De la Serna, and, in concrete terms, to the cubist painting Diego Rivera had painted of De la Serna in 1915. This European work by Rivera was an example of iconoclastic cubism, with surrealist and fantastic touches; it portrayed the author surrounded by the *objets trouvés* of his studio.[19] Whether Kahlo was familiar at that time with the cubist painting by Rivera is not certain; however, the similarity of the dynamics of the two paintings is noteworthy. Frida's

[18] The book of poems given to her by Miguel N. Lira can still be seen in her bedroom showcase.

[19] For further details on this painting, see Ramón Favela, *Diego Rivera: The Cubist Years,* exh. cat., The Phoenix Art Museum, Phoenix, 1984.

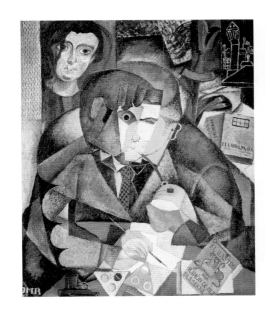

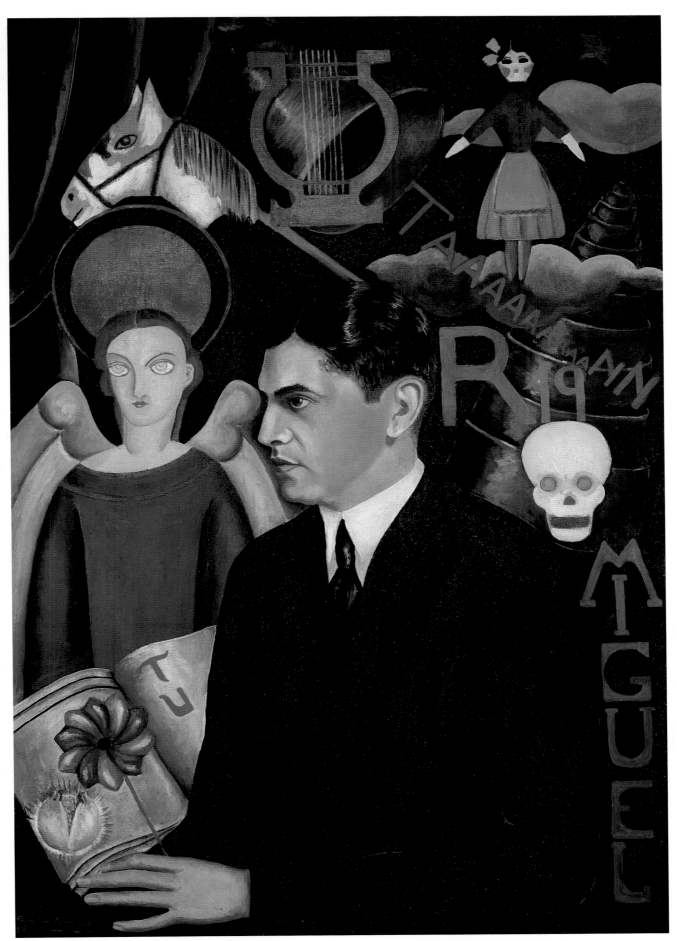

Diego Rivera,
Portrait of Ramón Gómez de la Serna, 1915.
Oil on canvas,
109 x 90 cm

Portrait of Miguel N. Lira, 1927.
Oil on canvas,
96 x 65 cm

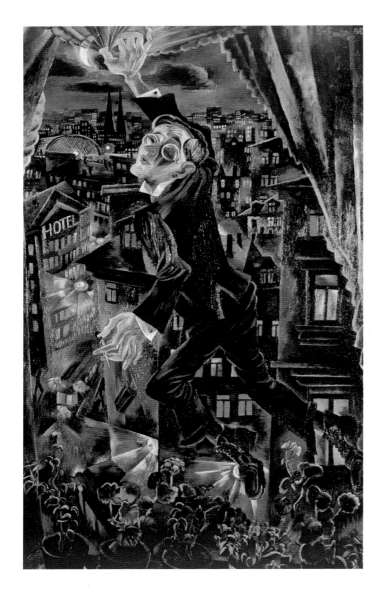

CONRAD
FELIXMÜLLER,
*THE DEATH
OF THE POET
WALTER RHEINER,*
1925.
OIL ON CANVAS,
180 x 115 CM

real things and revealing the internal condition was called magic realism by Franz Roh; his book *Magic Realism: Post-Expressionism* was published in Germany in 1925 and translated into Spanish in 1927, becoming one of the theoretical references of the *estridentismo* literary movement and of the *!30-30!* movement in Mexico.[21] The portrait was one of the favorite modes of expression of the New Objectivity painters, in that it enabled the artist to go beyond mere appearance and delve deeper into the indefinable state of the soul. In the face of the brutality of the war and the catastrophe of Western civilization, portraits enabled artists to assert the individual condition of existence and the uniqueness of personality, values that can be seen in Kahlo's *Retrato de Miguel N. Lira* (Portrait of Miguel N. Lira).[22]

In the artistic approach promoted by *estridentismo* and the *!30-30!* movement in Mexico, engraving was also considered a means of spreading its esthetics. Published in 1933 but probably executed before that was the only lino engraving by Kahlo that has survived to this day. It was an illustration for a book by Ernesto Hernández Bordes entitled *Caracol de distancias,* published by Miguel N. Lira.[23] The engraving is executed in strong avant-garde language in the manner of German expressionism,

painting, on the other hand, does have its own artistic merits and is evidence of how much she had matured intellectually as an artist. She was probably not as directly influenced by cubism and futurism as she was by the *estridentismo* movement and by some of the esthetic ideas of German painting inherited from expressionism and the *Neue Sachlichkeit* (New Objectivity) movement.[20]

After the First World War, German society and culture were deeply disrupted, and painters like Otto Dix (1891–1969), George Grosz (1893–1959), and Conrad Felixmüller (1897–1977) devoted themselves to the workings of the imagination as the only visual language capable of communicating the contradictions of European civilization. The visual tendency to reestablish the objective order of reality by freeing the essence of

[20] On the term *New Objectivity,* see Marlene Angermeyer-Deubner, *Neue Sachlichkeit und Verismus in Karlsruhe. 1920–1933* (Heidelberg: Verlag C. F. Müller, 1988).

[21] I am grateful to Laura González Matute for directing my attention for the first time to this esthetic tendency and sharing with me a photocopy of a book translated in 1927 belonging to Fernando Leal. On this topic, see Juan Manuel Bonet et al., *Realismo mágico. Franz Roh y la pintura europea. 1917–1936,* exh. cat., Instituto Valenciano de Arte Moderno, Valencia, 1997.

[22] Kahlo was particularly interested in modern German painting. In her library she kept a book called *German Painting and Sculpture* published in 1931 by the Museum of Modern Art in New York.

[23] I am grateful to María Estela Duarte for her tireless research, which allowed her to track down a copy of the book.

TWO WOMEN, 1925.
LINOCUT ENGRAVING,
10 x 7.5 CM

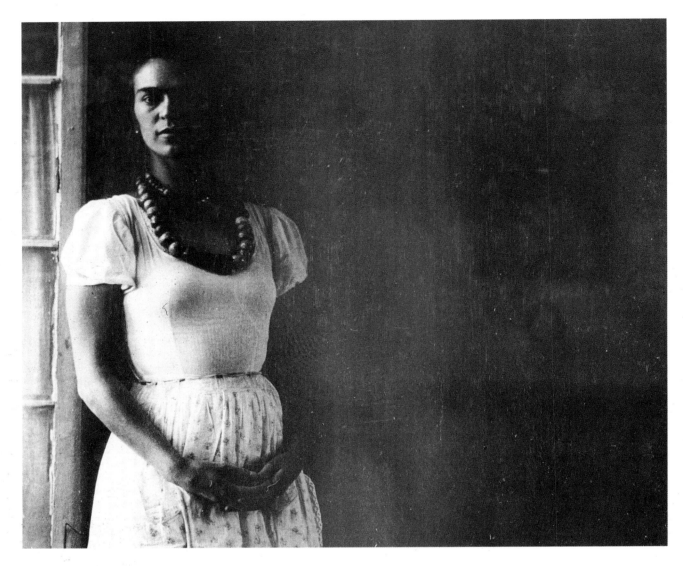

FRIDA CA. 1929

reminiscent of the work of Frans Masareel, whose engravings were familar to Kahlo, as she had an album of his work in her library. In addition, Masareel was mentioned and talked about in the pages of the magazine of the *!30-30!* group. As in the work of Jean Charlot, Leopoldo Méndez, and Ramón Alva de la Canal, artists who did engravings within the context of the *estridentismo* movement, the force of the image is achieved by the positive-negative contrast and the use of geometrical lines that accentuate the modernity of the image.

This engraving, like all the other pieces of work that have been discussed here, sheds light on the art forms Kahlo experimented with before becoming involved in a stable relationship with Diego Rivera. Prior to this event, based on the study of the work of her fellow artists and their work prior to 1930, it

seems to me that the young painter was involved in an even more aggressive experimentation of styles. Certainly, although she had not acquired any particular style, she was more interested in experimenting and was not afraid of taking risks. Diego Rivera, however, can be seen as the person who redirected her artistic career and who greatly influenced the direction she took later on her own. Kahlo's work between 1923 and 1929 has been studied only superficially. Without doubt these were tentative yet particularly decisive years. Despite the myth Frida fabricated about herself—that her career as an artist started after her accident—it is a fact that she was restless before that, and the environment in which she matured from a young girl into a woman had a formative influence on her, so much so that she slowly developed into an artist in her own right.

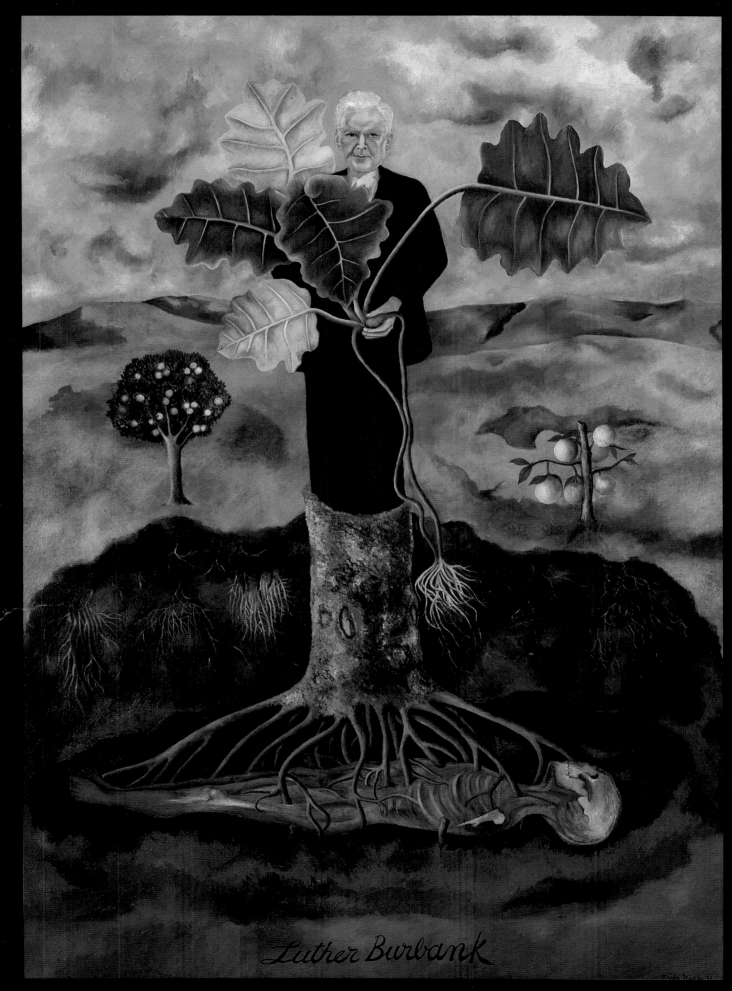

Luther Burbank

PORTRAIT OF LUTHER BURBANK, 1931.
OIL ON MASONITE,
86.5 x 61.7 CM

PAGES 55–56:
PORTRAIT OF LUTHER BURBANK, 1931.
(DETAIL)

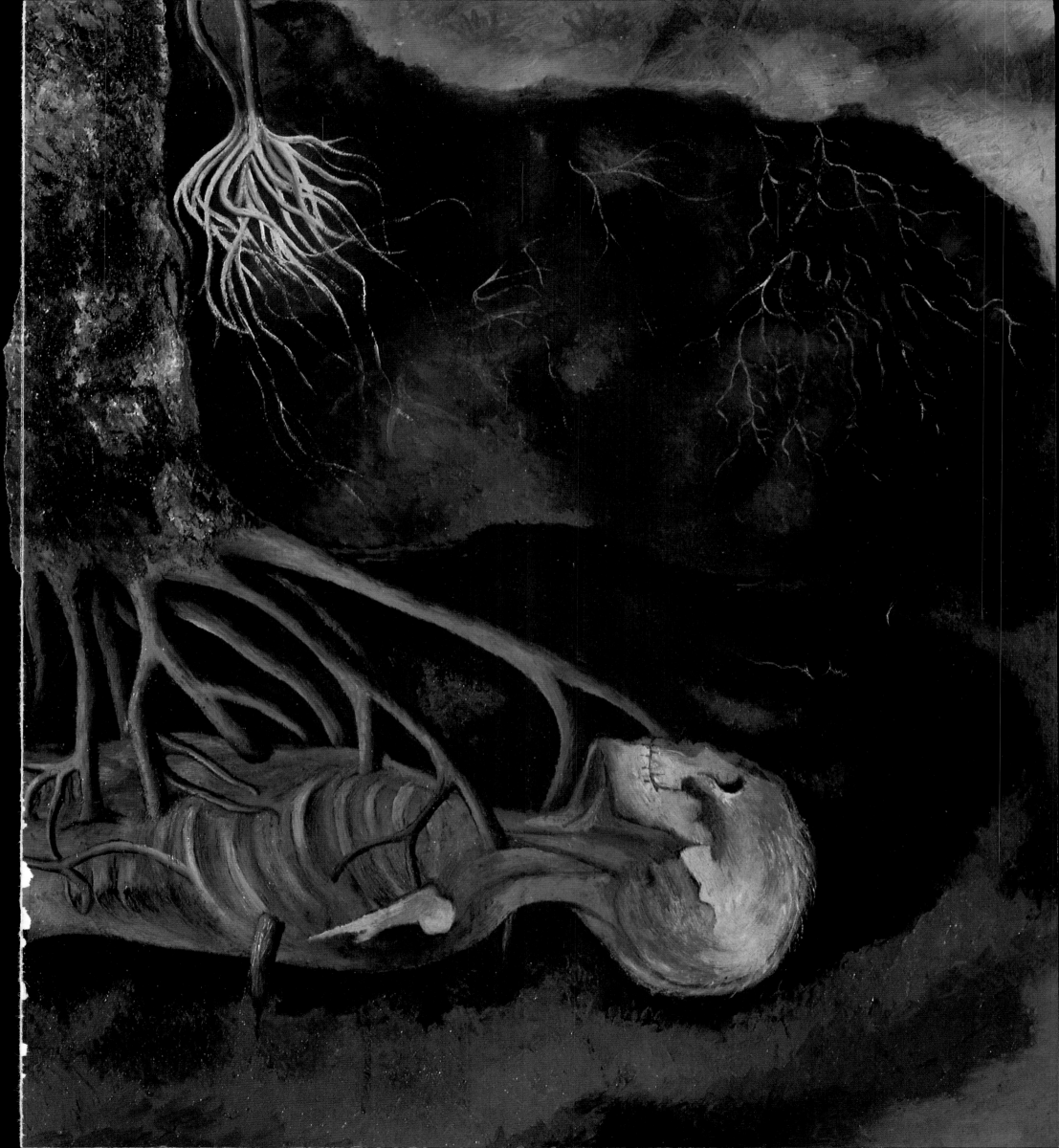

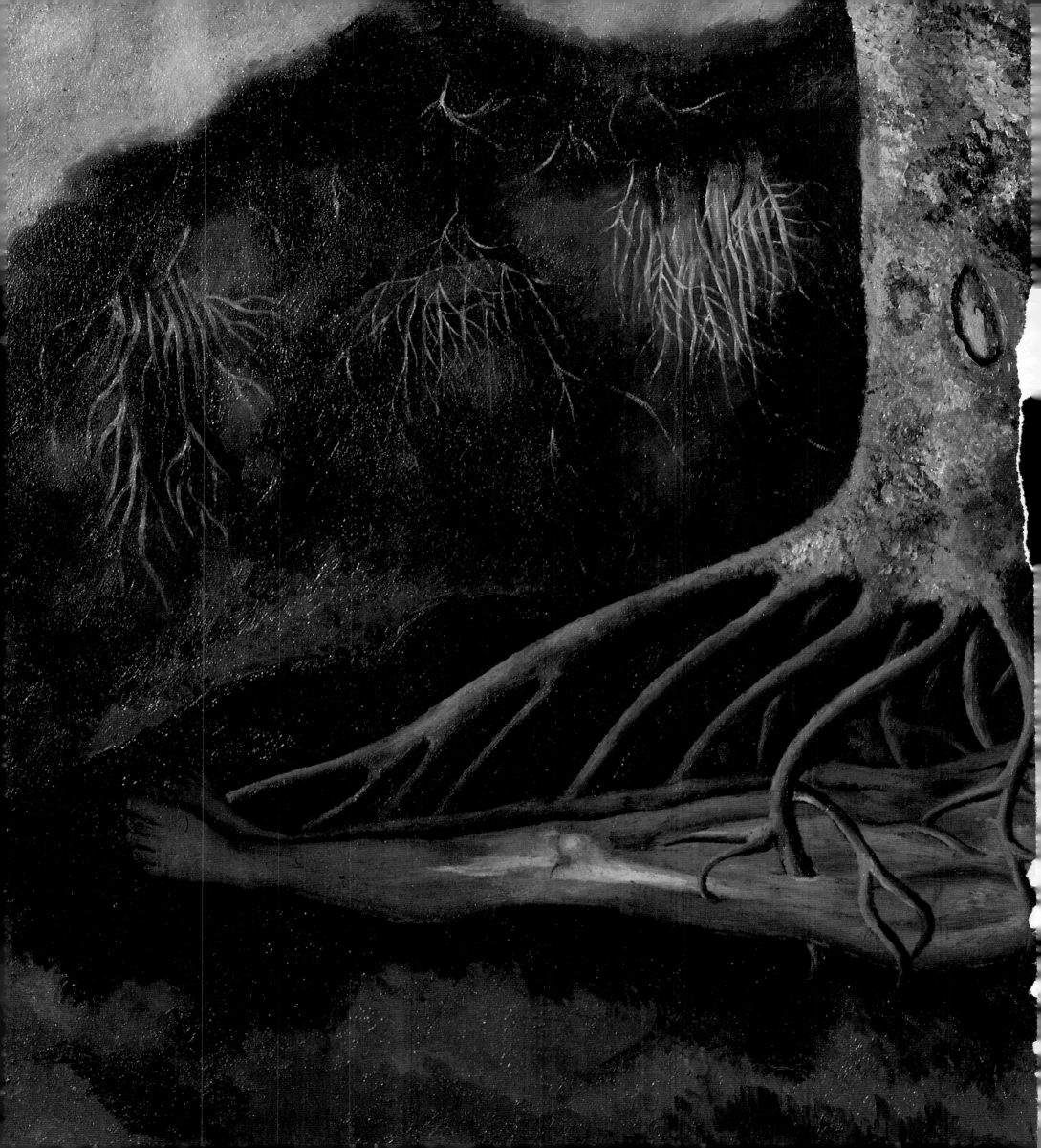

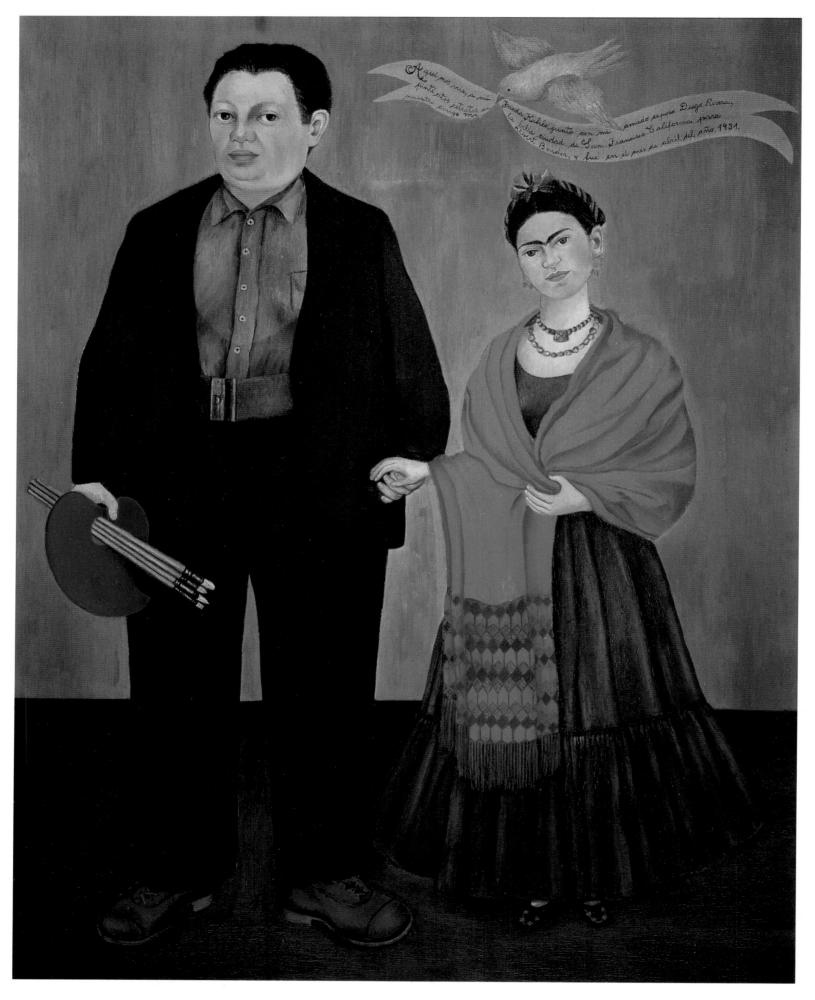

Frida Kahlo with
My Beloved Husband
Diego Rivera, 1931.
Oil on canvas,
100 x 78.7 cm

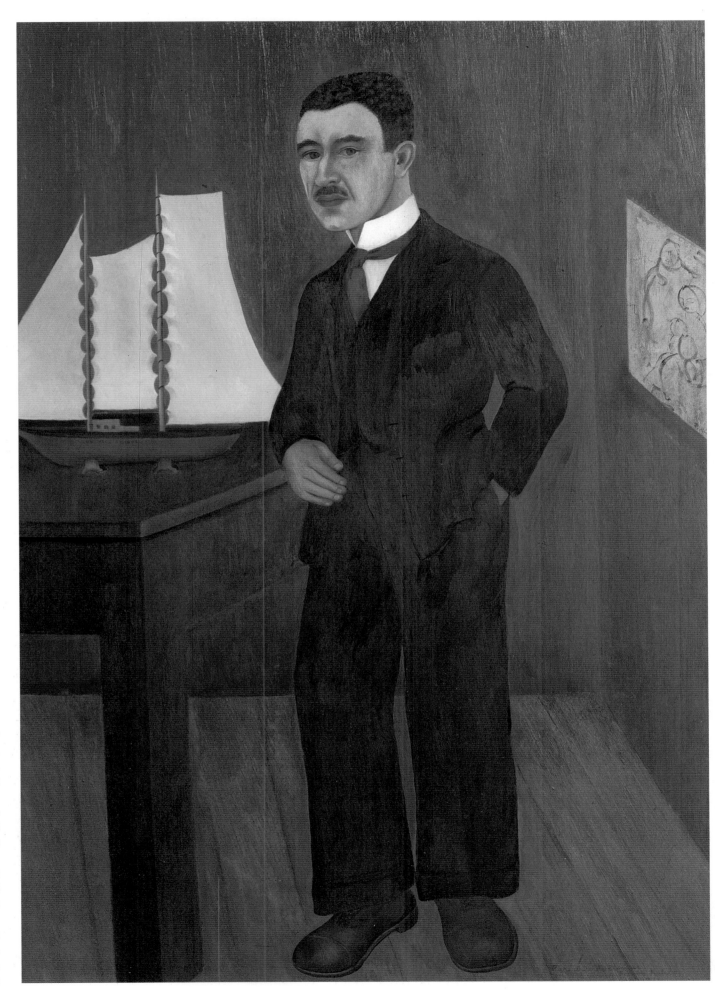

PORTRAIT OF
DR. LEO ELOESSER, 1931.
OIL ON MASONITE,
85.1 X 59.7 CM

PAGE 60:
URBAN LANDSCAPE, CA. 1925
(DETAIL)

PAGE 61:
THE BUS, 1929
(DETAIL)

PAGES 62–63:
THE BUS, 1929.
OIL ON CANVAS,
25.8 X 55.5 CM

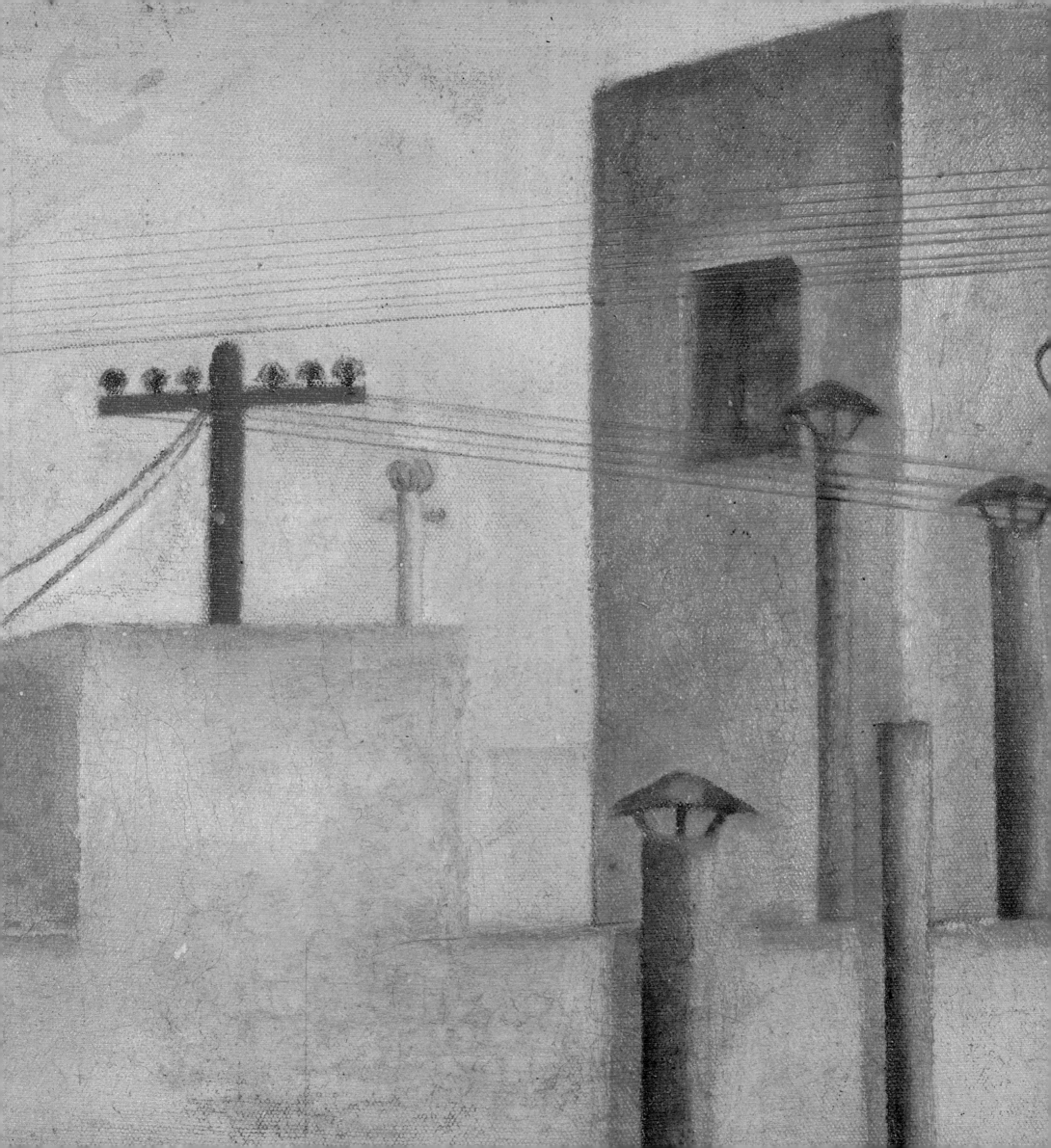

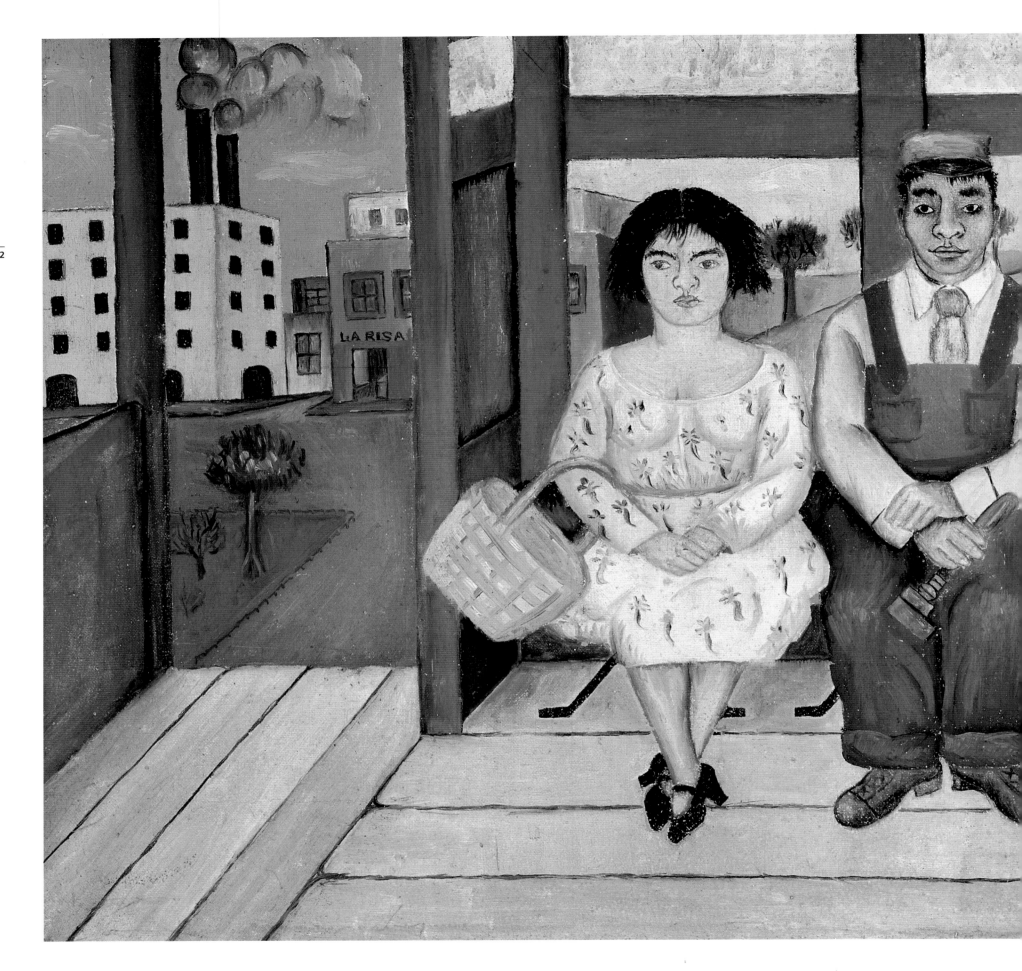

By 1931 Kahlo had become a very different woman, an artist with personal attachments that, although not totally stable, were at least concrete and realistic; she had overcome with flying colors the illusionary dimension of the dreams of her youth. Perhaps she got tired of imploring Alejandro Gómez Arias for his love, which he was either unable to give her or did not want to show in the face of Kahlo's possessiveness. He fell in love instead with a mutual friend, Esperanza Ordóñez.[24] Kahlo then took a giant step that would change her existence overnight: on August 21, 1929, she married the painter Diego Rivera. Was it an authentic gesture of love, or was it a means of salvation? It is something we will never know for sure. Perhaps it was a bit of both. From her letters it is easy to believe that Kahlo needed true love and magical experiences that would enable her to sail through imaginary worlds, that she needed someone who would enable her to reach the faraway stars, like the ones she had painted in the night sky in the portrait of Alicia Galant. Rivera, who was already a respected mural painter in Mexico, had previously been married to the beautiful and fickle Guadalupe Marín. That marriage, however, had been full of ups and downs, and marriage to Diego was certainly no guarantee of stability for Kahlo, as she must have soon realized. However, apart from all the difficulties the unconventional couple probably faced, the fact remains that Kahlo and Rivera built a solid relationship based on affection, and this is what is relevant in understanding her artistic development. Rivera became her husband and, above all, a companion who encouraged her to go on painting and who provided her with a public platform for her work, which she would never have been able to achieve with her own means. Thanks to Rivera, Frida was able to travel abroad, to experience a thousand different situations that enriched her as an artist, and to meet people who played a vital role in making her work known and appreciated. It is well worth remembering these facts, too, as much has been written about Frida as the victim of a selfish chauvinist—not to underestimate the pain that the numerous affairs Rivera had with other women, including her own sister Cristina, caused Kahlo.

Once married, Frida and Diego made an attractive couple, and they were exposed to the press and to the curiosity of locals and foreigners; this forced Kahlo to develop a personality of her own next to someone who loomed over her not only in size. Based on the portrait she painted in San Francisco in 1931, *Frieda Kahlo junto con mi amado esposo Diego Rivera* (Frida Kahlo with My Beloved Husband Diego Rivera), much has been said about the contrast between them. At first sight, Kahlo looks physically small in comparison with her husband, whom she presents as a real painter holding a palette. Kahlo painted herself as much more graceful, with small, pretty feet and adorned with brightly colored Mexican garments. She seems to be not only trying to attract attention but also trying to appear different from the personality of Rivera. He seems to dominate the space in the painting, but she is the main character. It is Frida Kahlo's debut, and she is using her husband to make it, calmly resting her hand on him as if she were taming a beast.

Little over a year after they got married, the Riveras moved to the United States, following the invitation the muralist received to paint for the San Francisco Stock Exchange. The experience was fascinating for Kahlo, and by May of the following year, 1931, she wanted to organize an exhibition of her own paintings. To her friend in Mexico, Isabel Campos, she confessed, "I have spent my life painting. . . . It has been very useful for me to come because the experience has been an eye-opener, and I have seen lots of new and wonderful things."[25] San Francisco must have seemed to her to be a most cosmopolitan city, and she made a point of visiting the museums and galleries as well as making new friends, like Dr. Leo Eloesser, and establishing contact with the local artists, like Lucile and Arnold Blanch, all of which contributed dramatically to widening her esthetic horizons. Everything would seem to indicate that instead of becoming dependent on Rivera, Kahlo set out to grow intellectually, and she found the courage to start painting again, clearly improving her skills and increasing the complexity of her subject matter.

[24] Cf. H. Herrera, *Frida,* p. 80.

[25] In R. Tibol, *Frida Kahlo,* p. 60.

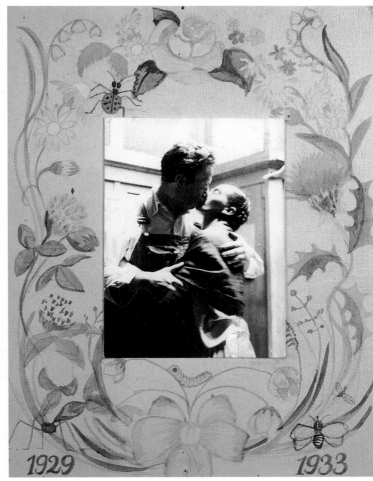

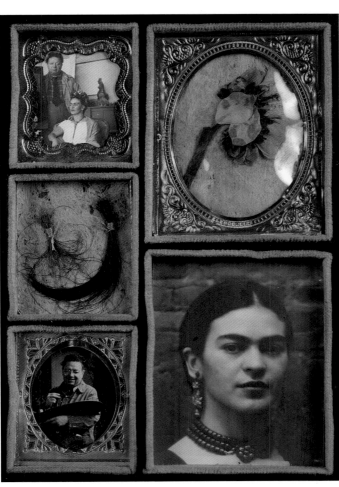

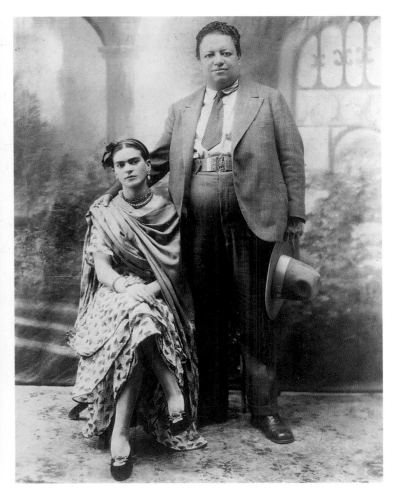

Frida Kahlo Rivera
in San Francisco, 1930

Diego and Frida, 1929–1933. Photo
framed by a watercolor
garland painted by Frida

The newlyweds Diego and Frida,
Coyoacán, August 21, 1929

Reliquary of Frida and Diego with
objects that symbolize her affection:
locks of hair, photographs,
a flower, and a love letter
concealed in the case

Diego and Frida ca. 1930–1933.

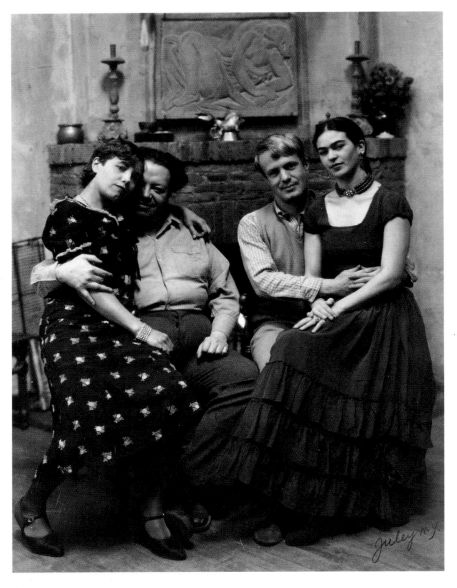

FRIDA AND DIEGO WITH LUCILE
AND ARNOLD BLANCH, CA. 1930

TIME FLIES, 1929.
OIL ON MASONITE,
77.5 x 61 CM

The early 1930s were a transitory yet decisive period in the development of Kahlo's mature style. Mexican culture continued to play an important role in the themes of her paintings. Despite this, however, I am convinced that Frida Kahlo became a painter with a world of her own, in the sense that she had exposed herself to a difficult context, a foreign country, which forced her to reexamine her sources and the strength of her cultural origins. Before moving to the United States, Kahlo painted a second self-portrait, *El tiempo vuela* (Time Flies), which must be viewed as a manifesto not only of her physical recovery from the accident but also of how she viewed herself before the new future that awaited her: that of a young and sensible wife with no further expectations. She has a straightforward appearance and a visionary look—like someone who has committed herself to achieving her goals—proud of her Mexican roots, of both her pre-Colombian ancestry and her Creole heritage, symbolized by the jade necklace and the gold earrings with aquamarine and amethyst stones. Behind her she placed two symbols of outright modernity, an airplane crossing the sky pointing upward and an alarm clock set at about ten minutes to three. Certainly both objects might be considered symbols of time: the past and the future. The clock might be alluding to her convalescence, when she suffered her most severe physical pain, by referring to Christ, who experienced the greatest suffering of all.[26] In the end, the alarm clock will close the metaphorical cycle of death and resurrection, that is, of a new dawn. In this reading, the airplane is connected to the promising future, like he who rises up to heaven, or like a phoenix that is reborn from the ashes.

[26] According to Matt. 27:46, when Christ was suffering extreme pain on the cross, "around the ninth hour" (three o'clock in the afternoon), he cried out, "My God! My God! Why have you forsaken me?" With her Judeo-Christian background and as the daughter of a devout Catholic, Kahlo might have been familiar with this passage of the Scriptures, which was also recited at the feast of the Passion during the Holy Week in Mexico. Throughout her work, Christ is a recurring symbolic icon, like, for example, when she provocatively wears a crown of thorns in at least two self-portraits of 1940: *Autorretrato con collar de espinas* (Self-Portrait with Thorn Necklace), painted for Nickolas Muray, and *Autorretrato dedicato al Dr. Leo Eloesser* (Self-Portrait Dedicated to Dr. Leo Eloesser). Christ tied to the column will be used in a picture of the portrait entitled *El difuntito Dimas Rosas* (The Deceased Dimas Rosas). Likewise, in his study of the painting entitled *Recuerdo* (Memory) or *El Corazón* (The Heart), painted in 1937, Salomon Grimberg examines the possible meanings associated with the devout iconography of St. Theresa and concludes that "whether she was aware of it or not, Frida used religious images as an inspiration for her paintings" (S. Grimberg, "Frida Kahlo's Memory: The Piercing of the Heart by the Arrow of Divine Love," *Women's Art Journal* 11, no. 2 [fall 1990–winter1991]: 3–7). Hayden Herrera also mentions that "Frida has amplified her personal misery by giving it Christian significance," and goes on to say that in her collection of colonial paintings Kahlo had a painting on the subject of Christ's Calvary. (See H. Herrera, *Frida*, p. 283.)

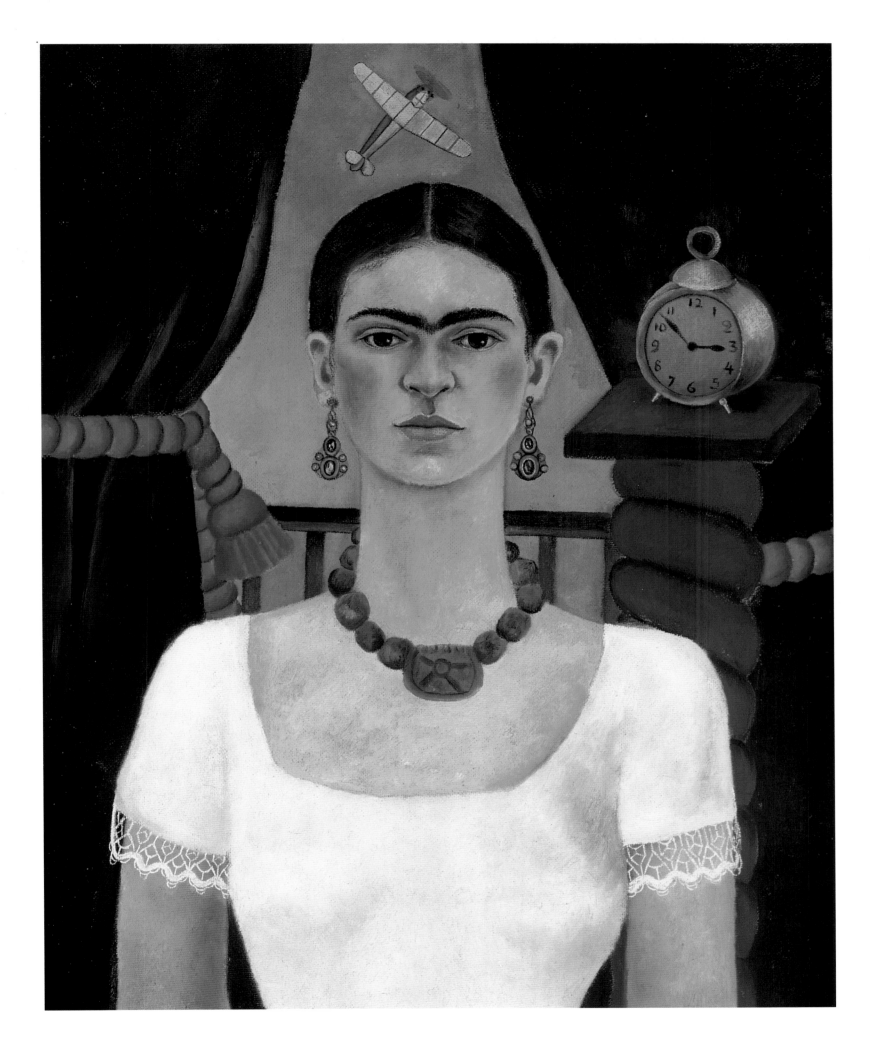

As is to be expected, these symbols did not belong to Kahlo's painting alone. Other artists, like Rufino Tamayo and María Izquierdo (1902–1955), had used them in their work. In the same year, 1929, María Izquierdo organized her first solo exhibition in the galleries of what was the unfinished Palacio de Bellas Artes. Izquierdo, unlike Kahlo, had taken professional training courses at the Escuela Nacional de Bellas Artes, and she was starting out on a publicly recognized career as an artist. For the exhibition, it was Diego Rivera himself who commented on her skills as an artist, writing the following: "María Izquierdo's talent is basically Mexican and she will prove to be one of the best plastic artists of this country. . . . In her portraits she expresses character with calm courage."[27] These characteristics also appear in *Time Flies*, as if Kahlo had wanted to achieve the same qualities Rivera had first recognized in Izquierdo. Both painters have the same sincerity of expression. When we compare some of their work, Izquierdo comes across as more lyrical and natural; indeed we know her paintings were inspired by photographs.[28] Kahlo, on the other hand, is more rigid, and her creative process was to copy her reflection in a mirror.

It is impossible to say whether Izquierdo and Kahlo were rivals or not. María Izquierdo always chose not to talk about Kahlo, despite the fact that she was asked expressly about her in her published interviews. Diego Rivera, however, who had praised Izquierdo in 1929, later made several statements criticizing her pictorial style, which certainly contributed to the cancellation of a mural project for the central building of the Departamento del Distrito Federal in Mexico. However, in 1930 the relationship among the three of them was cordial, as a letter from María Izquierdo to the Riveras in San Francisco indicates:

It is with great pleasure that I greet you and Frieda in that important city after not having seen or spoken to you, my dearest friends, for so long. I would be delighted to receive a few lines from you and to hear that you are well, as I am sure you are and as you deserve to be. I had the good fortune to open my exhibition in New York quite successfully, despite a few difficulties that forced me to move up the date of my return. I am now here at

Gómez Pedroza no. 1004, Tacubaya, and look forward to hearing from you. Manito [Tamayo] misses you a lot! I hope that dear Diego and my greatly esteemed friend Frieda are very well and that the great work our favorite artist has been commissioned to do is proving very successful. I respectfully salute you and send you my love. Your loyal friend, María Izquierdo.[29]

Izquierdo never mentions Kahlo's creative work, which means that either she was not aware of her painting or did not take her painting seriously at the time; on the other hand, she was prepared to talk freely about the success of her exhibition in New York. Shortly afterward, in May 1931, Frida wrote to her friend in Mexico and mentioned that what she really wanted to do was exhibit in the city of skyscrapers. Without doubt, between 1929 and 1930, Izquierdo's and Kahlo's paintings both display a kind of emotional anguish that was a direct result of their belonging to the same artistic context and of being exposed to the same influences.

It is interesting to compare a painting of María Izquierdo by Rufino Tamayo, a friend of both of them, which is currently part of the collection of the Chicago Art Institute. It is a fantastic painting with electrifying oneiric connotations and clear erotic allusions. Tamayo painted Izquierdo from the waist up sitting opposite the viewer; her eyes are shut and she is absorbed in her own thoughts, which take on visual form from the smoke of a cigarette and allude to intimate smells—like fish—while she is rubbing her smooth, white silk–gloved hands. The subject of this painting resembles an unfinished portrait by Kahlo of a young woman also seen from the waist up and wearing white gloves. However, while Tamayo is alluding to the free expression of Izquierdo's sexual thoughts, Kahlo's young lady is a yearning, taciturn virgin. Rufino Tamayo's influence on Frida Kahlo is quite understand-

[27] Archivo María Izquierdo, Mexico City.

[28] Some photographs are in the Archivo María Izquierdo. (Cf. L.-M. Lozano, *María Izquierdo [1902–1955]*, exh. cat., Museo Mexicano de Bellas Artes, 1996, p. 39.)

[29] *Luis-Martín Lozano Archivo de Investigación.*

able, as he was at the time one of the best-known painters in Mexico. Tamayo was aware of the esthetic ideas of the European avant-garde movement; he was very familiar with the secrets of Italian metaphysics, and he had openly confessed to being an admirer of Braque. Like Kahlo, Tamayo had briefly studied the Adolfo Best Maugard drawing technique and had assumed some of the formal techniques of the open-air painting schools. He knew about the *estridentismo* movement, and under its influence he painted objects that belonged to modern themes: boats, planes, telephones, and radios; these themes were also shared by María Izquierdo. They were the symbols of progress, even though it may have been a utopian concept of progress, far removed from reality. It was like a dream of unattainable modernity.[30]

The Riveras left San Francisco for Mexico only to find out that the Museum of Modern Art in New York City was interested in holding a retrospective exhibition of Diego Rivera's work and that he was invited to carry out a series of murals expressly for the exhibition. For Kahlo this meant the opportunity to try to organize an exhibition of her own work in the United States, as she had mentioned wanting to do. This, however, did not occur until 1938. Nevertheless, New York was a new discovery for the artist, and, as we would expect, she set out to visit galleries, to make new friends—some of whom, like Lucienne Bloch, became very close—and to go to the cinema, as the biography by Hayden Herrera tells us. Though we have no records, it would seem logical that she visited the art collections of the museum in which Rivera held his exhibition. This is where she probably came face to face for the first time with the artistic proposals of the avant-garde. For example, while the Riveras were there in 1931, the museum organized a vast exhibition of German art; Kahlo bought the catalog, which can still be found in her library. The "Modern German Painting and Sculpture"

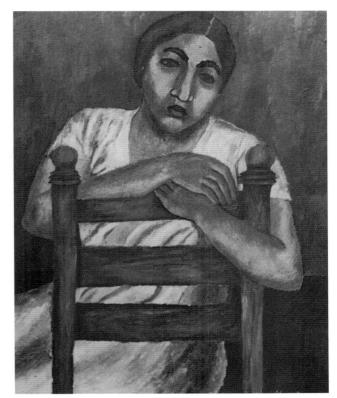

MARÍA IZQUIERDO,
*SELF-PORTRAIT,
SITTING IN A CHAIR,*
1929.
OIL ON CANVAS.

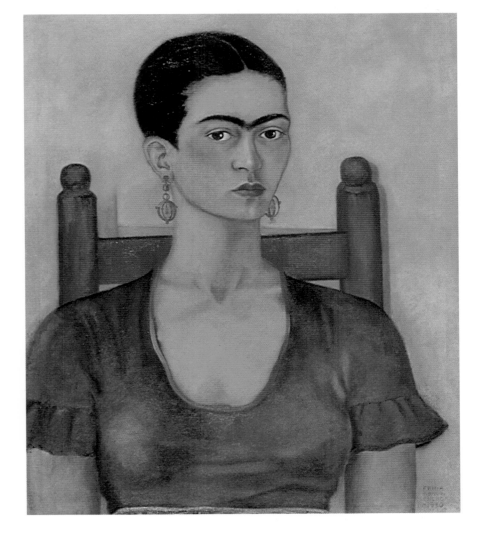

SELF-PORTRAIT, 1930.
OIL ON CANVAS,
65 x 55 CM

[30] *"El gran sueño"* (The Great Dream) was the title Olivier Debroise originally wanted to give to an exhibition that ended up being called *"Modernidad y modernización en el arte mexicano: 1920–1960"* (Modernity and Modernization in Mexican Art: 1920–1960). The paintings that were put together for that exhibition in 1991, organized by the Museo Nacional de Arte, highlighted this theme, which was shared by various artists.

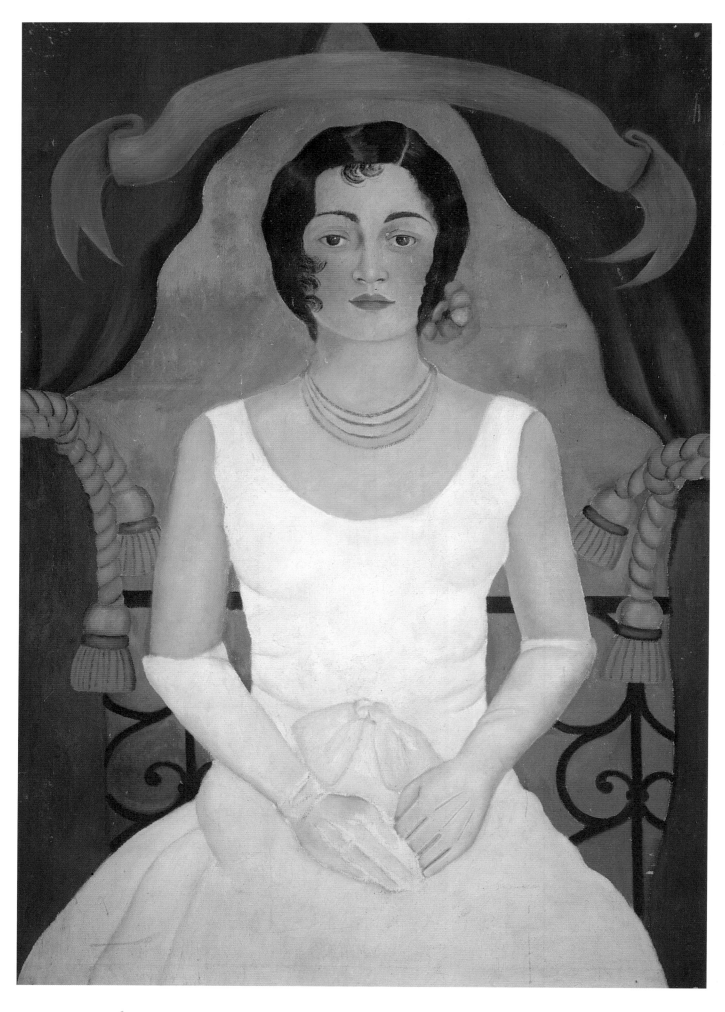

PORTRAIT OF A LADY IN WHITE, CA. 1929.
OIL ON CANVAS,
119 x 81 CM
(UNFINISHED)

RUFINO TAMAYO, *PORTRAIT OF MARÍA IZQUIERDO*, 1932.
OIL ON CANVAS,
75 x 64.8 CM

RUFINO TAMAYO, *AVIATION*, 1938.
OIL ON CANVAS,
57.4 x 45 CM

RUFINO TAMAYO, *ALARM CLOCK AND TELEPHONE*, 1925.
OIL ON CANVAS,
45 x 43.5 CM

exhibition would have allowed her not only to study the ideas of German expressionism, but also to get to know the members of the New Objectivity movement. Picasso and Braque certainly did not go unnoticed, and it would seem that Giorgio de Chirico in particular must have attracted her attention, since in 1931 Kahlo signed and dated a painting that she called *Aparador en una calle de Detroit* (Window Display in a Street of Detroit).

The title and the date of this painting are still problematic in that Frida Kahlo did not go to Detroit until April 1932.[31] As she was still in New York in December 1931, the most logical explanation is that she started the painting then and finished it the following year, when she gave it its title.[32] This would explain the marked presence of a metaphysical environment in the painting, as it would have been closer to the experiences she had had in the big city. It is in all respects an intriguing and mysterious piece of work, characterized by an extreme impenetrability,

[31] Thanks to the dedicated research carried out by Hayden Herrera it has been established that the Riveras flew from San Francisco to Mexico on June 8, 1931; they sailed from Mexico to New York on board the *Morro Castle* in mid-November and arrived on December 13; Rivera's exhibition opened on December 23, 1931, and ran until January 27, 1932; on March 31, 1932, the Riveras traveled by Pullman car from New York to Philadelphia for the opening of the Horse Power ballet, and on April 21 they arrived by train in Detroit. Later on, because of her mother's deteriorating health, Kahlo traveled back to Mexico by train with Lucienne Bloch and arrived on Thursday, September 8, 1932; by October 21, they were back in Detroit. All in all, she spent nearly ten months in Detroit. (Cf. H. Herrera, *Frida*, passim.)

[32] Perhaps Hayden Herrera did not realize that the painting had been already dated. He says the painting was executed in 1932, started before Frida had her miscarriage on July 4, 1932, and not finished until she had completed the *Henry Ford Hospital* painting. He bases his theory on the interview with Lucienne Bloch, who remembers that when she and Kahlo went looking for painting material, they came across the shop window that enchanted Frida and that Diego Rivera probably suggested she paint. The painting was undoubtedly dated in 1931. If Bloch was not mistaken and the painting was indeed the result of that experience, it might have taken place in New York, where Frida started to paint it in 1931. She finished it only later and put Detroit in its title. In keeping with this theory, the paintings she did in Detroit are dominated by the profound sadness of her miscarriage. The only painting that is not full of melancholy is *Window Display in a Street of Detroit*. (Cf. Ibid., pp. 150–152.)

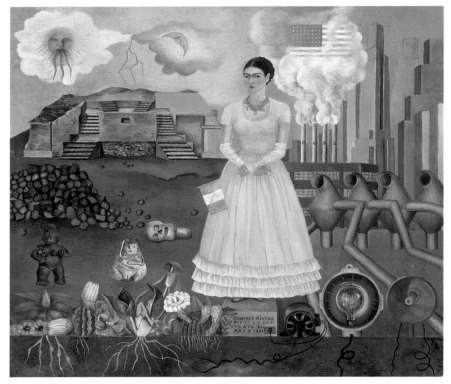

DIEGO, FRIDA, AND
FRIENDS IN DETROIT,
CHRISTMAS 1932

*SELF-PORTRAIT
ON THE BORDERLINE
BETWEEN MEXICO
AND THE UNITED STATES,*
1932.
OIL ON METAL PLATE,
31 x 35 CM

LION AND HORSE.
CERAMIC AND
TERRACOTTA
FIGURES FROM
THE COLLECTION
OF FRIDA KAHLO

very different from what she had painted up to that time. The way the objects are placed in the store window make it look like a still-life; the pieces seem to come together in an arbitrary fashion, and there is something of a fortuitous nature about it. Without doubt, the symbols relate to the experiences of the Riveras: the shop window is decorated with the colors of the flag in celebration of American patriotism, which is further established by a portrait of George Washington decorated around the edges by a torn festoon; there is also a shield in the window with an eagle spreading its wings and a roaring lion facing the viewer, both probably symbols of imperial power and influence. In the background there is a white steed crossing the room, empty-looking except for a map of the United States—and of a tiny portion of Mexico—hanging on the wall, a rolled-up map, paintbrushes and paints, a stepladder, and a mysterious hand wearing a white glove. In this sense we have the impression of a painting executed on top of another in the background. I do not think anything is gratuitous. I believe that Kahlo not only came across a shop window in New York or Detroit but that she was also creating a premeditated cryptic message, perhaps alluding to her deep feelings about being uprooted from Mexico in a foreign land while Diego Rivera was spending his time painting enormous walls in order to achieve success in the United States with the support of his white friends. Perhaps it is a criticism of Rivera in the sense that he was selling himself out to the gringos. Who can say? A letter Kahlo wrote at the time to her friend Dr. Eloesser in San Francisco would seem to shed some light on what she thought about her experience with gringos:

On the other hand, and this is my own personal opinion, despite appreciating the advantages for all kinds of work or activity the United States offers, I prefer Mexico. I think gringos are very "fat" with all their qualities and faults, which they also make a big fuss about. I think their behavior is quite "awful," their hypocrisy and their horrible puritanism, their Protestant sermons, their boundless righteousness, which means everything has to be "very decent" and "very

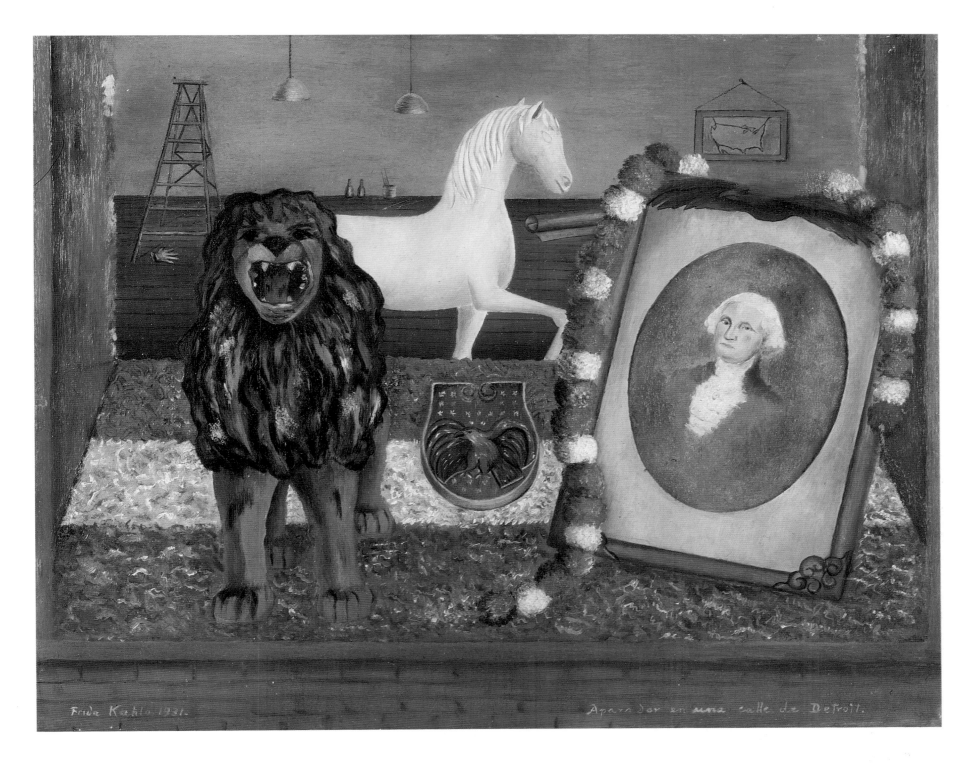

Window Display in a Street of Detroit, 1931.
Oil on metal plate,
30.3 x 38.2 cm

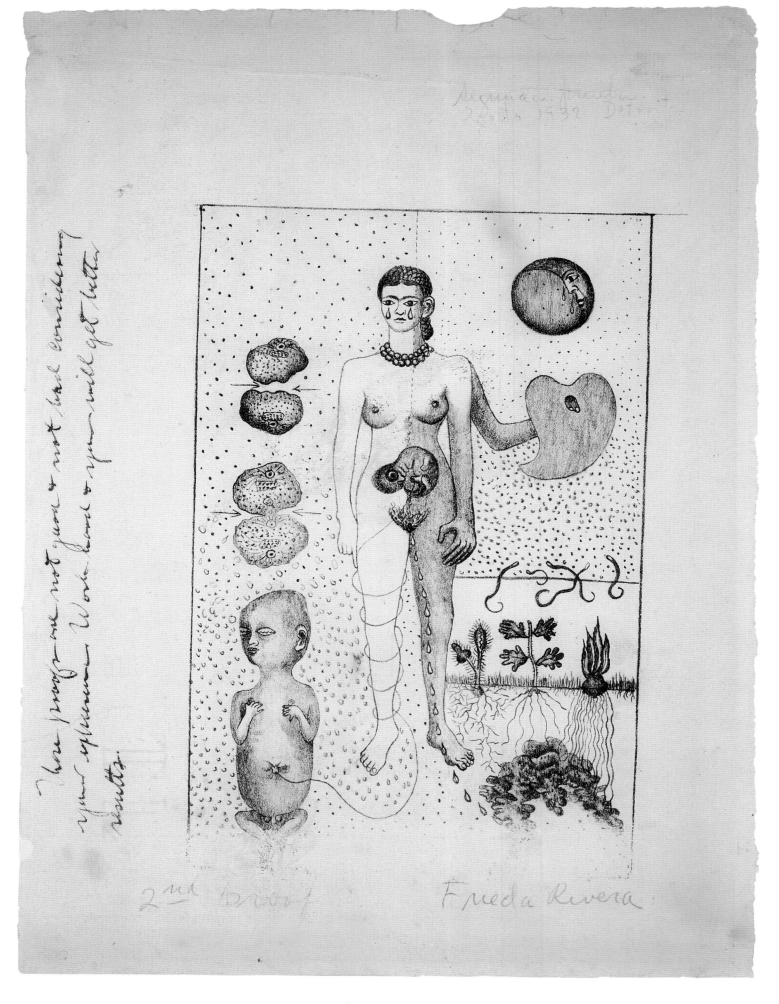

The Miscarriage, 1932.
Lithograph,
32 x 23.5 cm

proper. . . ." I know that the ones who are here [in Mexico] are dirty good-for-nothing crooks, son-of-bitches, etc. . . . but, I don't know why, even the foulest language allows for a bit of humor, while the gringos are really "pains in the neck" by birth, although they may be highly respectful and decent. Their way of life also seems to me to be shocking, those stupid parties where everything takes place after they have swallowed lots of silly little cocktails (they don't even know how to get drunk in a "mature" way), from the sale of a painting to a declaration of war, as long as the person selling the painting or declaring the war is "important"; otherwise they won't pay any attention to him at all because they only put up with "important people," they don't care whether they are sons of their "mother," and so I could go on with other similar opinions. You might well say that you can live there without silly cocktails and parties, but then you will be nothing but a green dog, and as I see it, the most important thing for everyone in Gringoland is to be ambitious and to become "somebody," and, to be honest, I don't have even the slightest ambition to become anyone. I couldn't give a damn about "airs," and I don't care at all about being a *gran caca* [a big shot].[33]

Kahlo had plenty of reasons for feeling that way– in the United States was where she experienced the trauma of a miscarriage and where Diego Rivera's mural *Man at the Crossroads,* which he had designed for the Rockefeller Center, was destroyed. Despite the fact that from a personal point of view her stay in Detroit and New York was frustrating and troubled, the experience was certainly vital for her development as a painter. By the time Rivera's exhibition closed in January 1932, the walls for the painting at the Detroit Institute of Art were nearly ready. The Riveras had to postpone their move because Kahlo was ill with the flu and Diego had planned to be present at the opening of the *Horse Power* ballet in Philadelphia. As far as we know, Kahlo arrived in Detroit with renewed spirits and planned to finish her

Window Display in a Street of Detroit. However, morning sickness caused by her pregnancy meant she was confined to her bed, and she did not pick up her paintbrushes until after the miscarriage.

In 1932 Kahlo produced a series of drawings and paintings connected with the loss of the baby in which her pain surfaced freely and spontaneously. Apart from the oil painting entitled *Henry Ford Hospital (La cama volando), Detroit, Julio de 1932* (Henry Ford Hospital [The Flying Bed], Detroit, July 1932), in the collection of the Dolores Olmedo Museum and one other, unfinished, which is known by the title *Frida y la cesárea* (Frida and the Cesarean Operation), on display in the Museo Kahlo de Coyoacán, the impressions that were closest to the event were the drawings she did before leaving the hospital.[34] Without a doubt, the piece of work that reflects her feelings most faithfully and that shows her projecting herself in a fantastic and experimental way is a lithograph she executed between July and August 1932 at the Detroit Society for Arts and Crafts. In this piece of work entitled *El Aborto* (The Miscarriage), Kahlo dissects some of the details of her miscarriage in a cycle of procreation, life, death, and resurrection that can be read in a pictographic form, as if it were in code. It proceeds from top to bottom, from left to right, narrating the following events that take place in a fluid of amniotic liquid: first two cells unite and the gestation of the fetus begins, which is attached to her body inside her womb; then comes the bleeding, which is slow and lasts for days and dissolves the unborn child's existence, which in turn feeds the seed of the fertile earth and covers it in plants and bulbs—painted so precisely that they are reminiscent of colonial herbaria—which starts off a new cycle of life. Kahlo, despite her nakedness and the loss of the life inside her, has the strength to lift a palette of

[33] The letter was published in Spanish by Teresa del Conde, *Frida Kahlo. La pintora y el mito* (Mexico City: UNAM, 1992), p. 120.

[34] They were a self-portrait and the sketch for the oil painting entitled *La cama volando* (The Flying Bed). They are dated July 9 and 10, five days after her miscarriage. Kahlo did not return home until April 17. They are in H. Prignitz-Poda et al., *Frida Kahlo,* pp. 199, 271.

paints and start over again as an artist amid the tears. All this takes place before a waning moon that bears witness to her tragedy and is crying.

This print has strong formal ties with her *Retrato de Luther Burbank* (Portrait of Luther Burbank) painted a year earlier in San Francisco. In that painting, for the first time in her iconography, we find the symbolic solution that life is the product of a cycle that includes death. The earth is a mother, and the hollow of her insides represents the womb of a mother from which life emerges into the hands of Burbank the horticulturist, whose body is growing out of a tree trunk as if it were the neck of a womb. In both works, Kahlo is visually elaborating on a discourse, drawing on medical, biological, and historical sources.

While Kahlo was convalescing in the Henry Ford Hospital, she asked to be granted access to books on gynecology and obstetrics in order to understand in greater detail what had happened to her.[35] Ever since she was a young girl she had been interested in books on medicine, biology, and anatomy, the very same ones that continued to be the iconographic sources for her art. It is also likely that Frida had in mind the popular colonial paintings about the ephemeral nature of existence when she conceived the thematic framework of the portrait of Burbank,[36] while the fertile duality of life and death in the lithograph of 1932 can trace its influence back to the pre-Colombian codices on the human body.

From that prolific period we possess a drawing dated 1932

and probably executed in the fall. Kahlo had just returned from Mexico, following a trip of about two months to visit her critically ill and dying mother. She started painting again and decided to move into the Detroit Institute of Art to make the most of the facilities they were offering her. She was given a small temporary studio while her husband was painting frescoes in the courtyard. Upon returning she was greeted by the news that Diego Rivera would be painting another mural in New York, this time for Nelson Rockefeller. Negotiations had been going on since May, but they had come to a standstill because the painter and one of the architects, Raymond Hood, could not reach an agreement. What their dispute amounted to was that Hood wanted Rivera's painting to be less colorful so it would not compete with the architecture, and this the painter absolutely refused to do.[37] Following a preliminary agreement according to which for $21,000 he would paint a fresco in the RCA building entitled *Man at the Crossroads: Looking with Hope and High Vision to the Choosing of a New and Better Future*, Rivera had to go to New York for a few days to present the original sketch and discuss some of the changes.[38] His absence apparently caused Kahlo to be somewhat preoccupied, and later she transformed those thoughts into dreams. Her dreaming resulted in two enigmatic drawings that she executed with the surrealist automatism technique. In one of these drawings, Frida is dreaming, naked, on a bed; her abdomen, which initially was bulging, has been modified and is now slimmer and firm. Electric wires flow up and down from her head and hair. The wires from her hair flow down onto the floor

[35] It seems she was not granted permission to read them, but Rivera found a way of getting them to her. (Cf. H. Herrera, *Frida*, p. 142.)

[36] Another influence worth noting for the *Portrait of Luther Burbank* (as far as the bottom scene of the decaying body is concerned) might have been the fresco entitled *La sangra de los mártires agrarios* (The Blood of the Agrarian Martyrs), painted by Diego Rivera on one of the walls of the Ex Capilla de Chapingo, where Rivera, and later Kahlo, would use the human shroud—in this case of Emiliano Zapata and Otilio Montaño—as fertilizers for the plants in flower on the earth's surface.

[37] See Diego Rivera, *My Art, My Life: An Autobiography* (with Gladys March) (New York: The Citadel Press, 1960), p. 125.

[38] According to Laurance P. Hurlburt, in a letter dated October 13, 1932, Rockefeller informed Rivera of their initial agreement. He signed the contract, it would seem, on November 2, 1932, in Detroit. On around Ñovember 15 Rivera went to New York to finalize details and to have the original sketch approved. Hurlburt says that upon leaving Rockefeller's office in New York, Rivera spoke enthusiastically to Kahlo and told her that "everything has been resolved and the project has been approved in full." See L. P. Hurlburt, *The Mexican Muralists in the United States* (Albuquerque: University of New Mexico,1989); cf. by the same author, "Diego Rivera (1886–1957): A Chronology of His Art, Life and Times," in *Diego Rivera: A Retrospective* (Detroit: Detroit Institute of Arts Founders Society, 1986), p. 85.

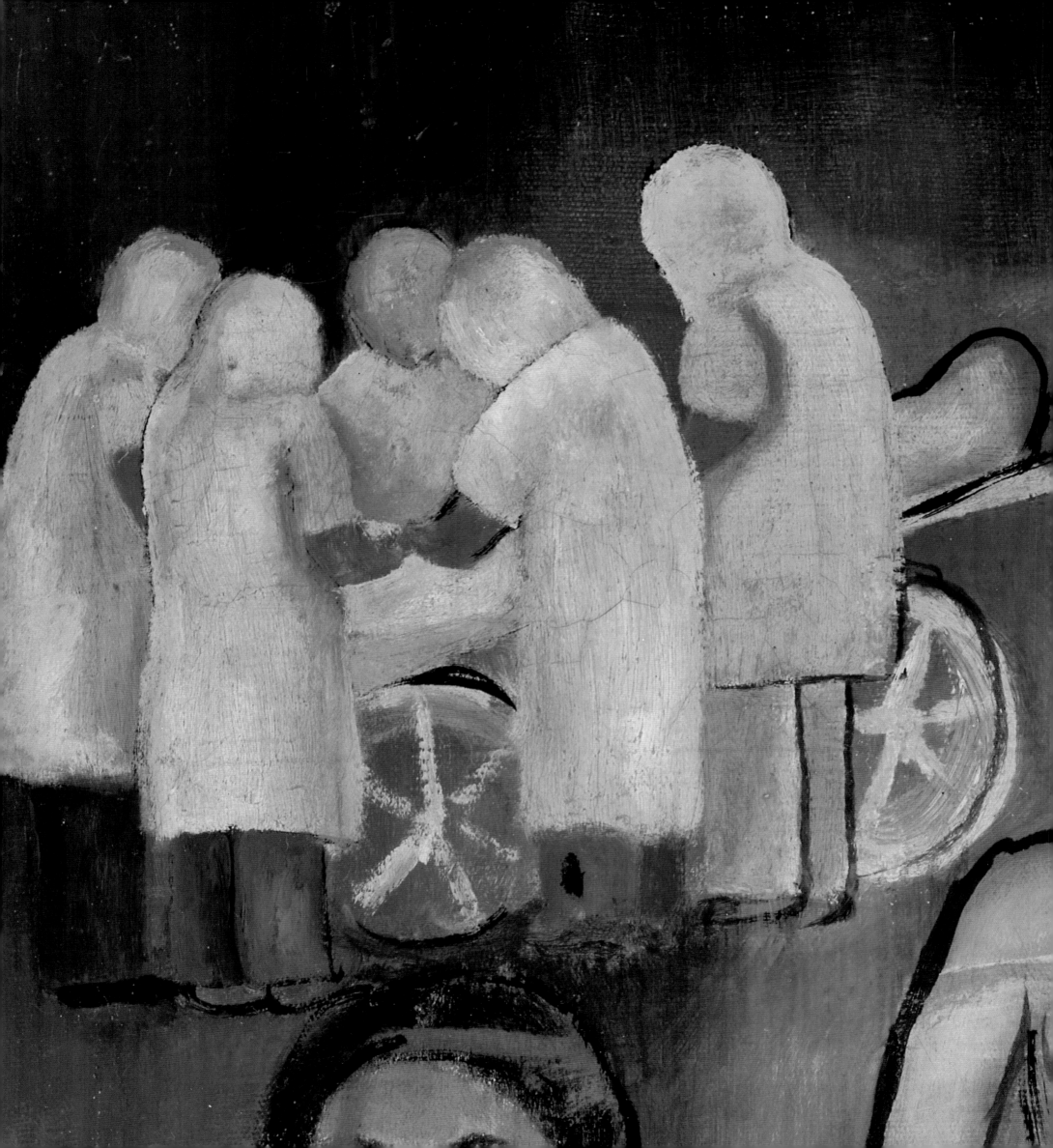

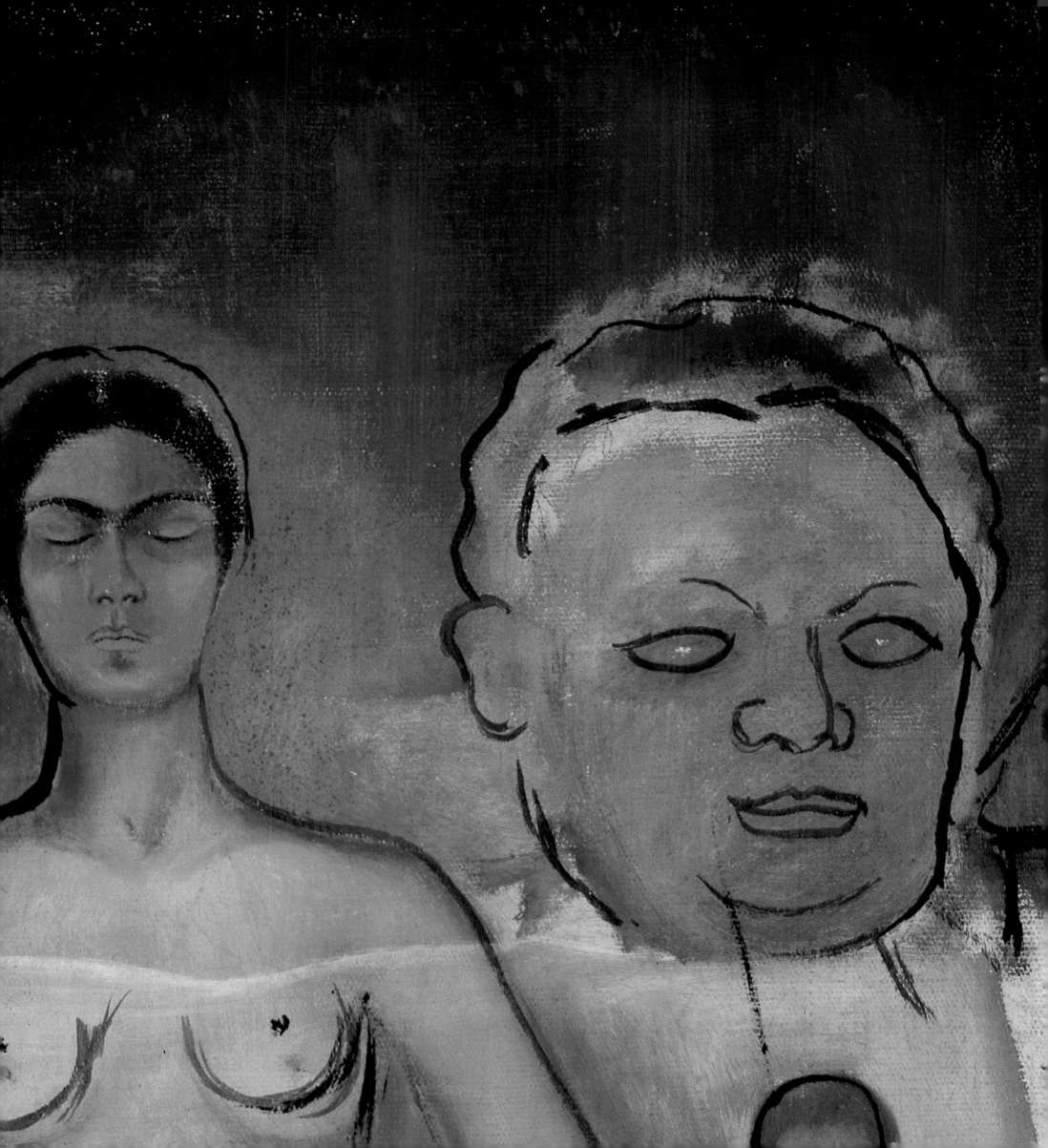

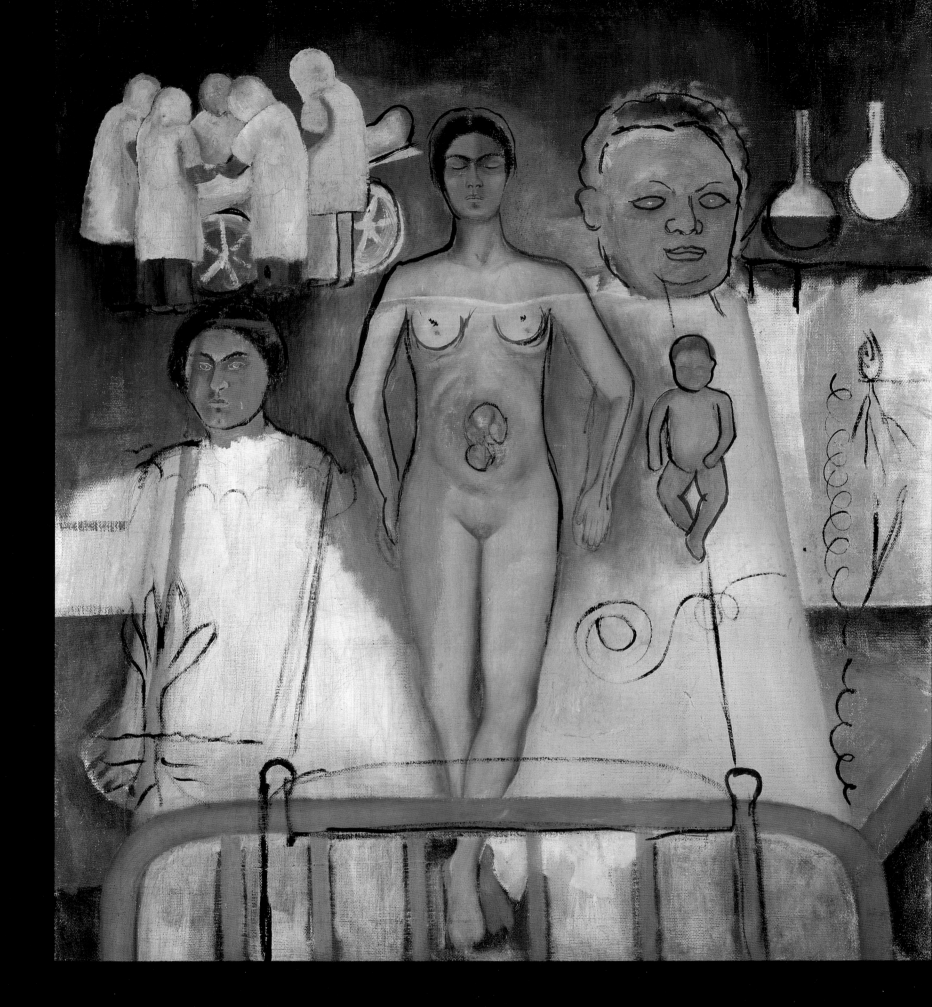

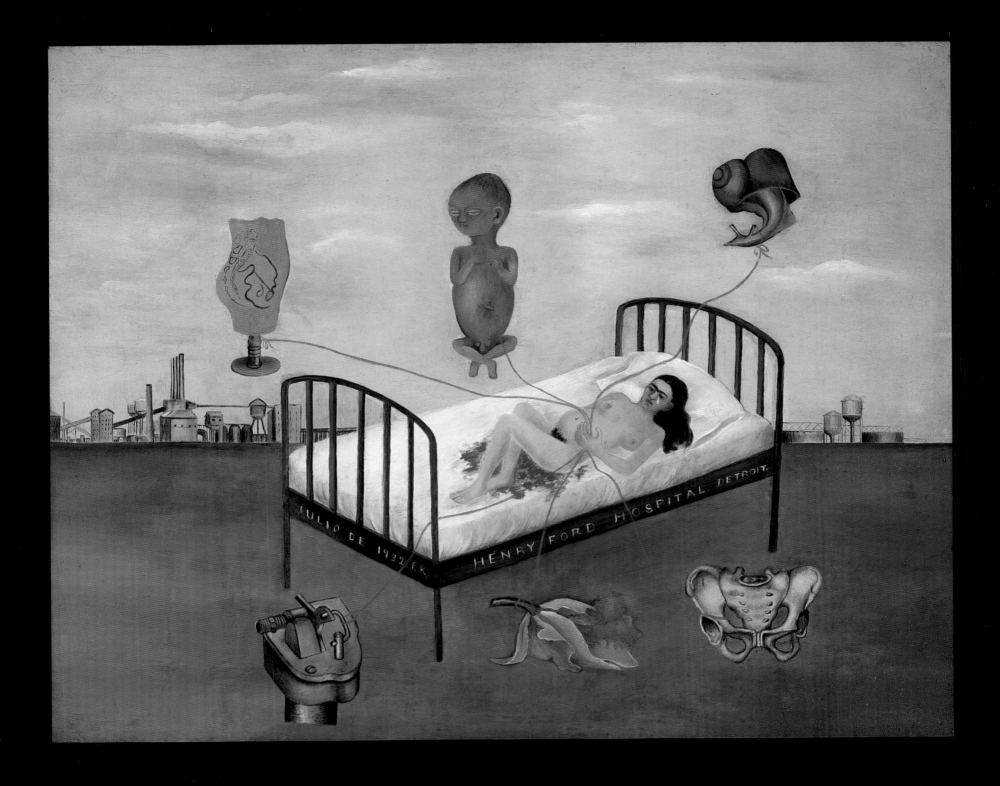

Henry Ford Hospital
(The Flying Bed), 1932.
Oil on plate,
30.5 x 38 cm

Pages 78–79:
Frida and the Cesarean
Operation, 1932
(details)

Page 80:
Frida and the Cesarean
Operation, 1932.
Oil on canvas,
73 x 62 cm

Pages 81–82:
Henry Ford Hospital
(The Flying Bed), 1932
(detail)

MAR APR MAY JUN JUL AUG SEP OCT NOV DEC JAN FEB MAR APR MAY JU
1932 1933

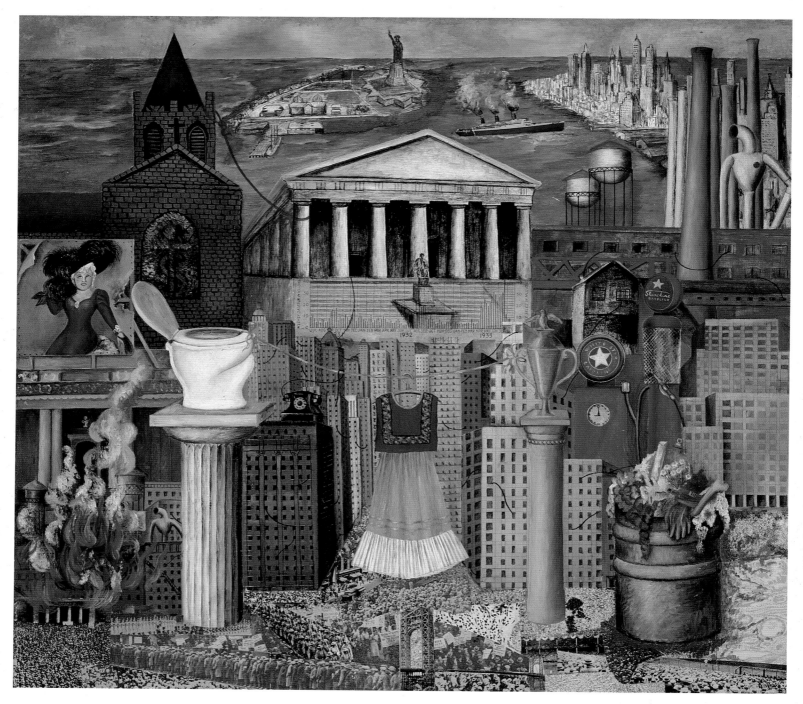

My Dress Hangs There, New York,
1933–1938.
Oil and collage on masonite,
46 x 50 cm

Diego Rivera,
Frozen Assets, 1931.
Fresco,
239 x 188 cm

Pages 84–85:
My Dress Hangs There, New York,
1933–1938
(detail)

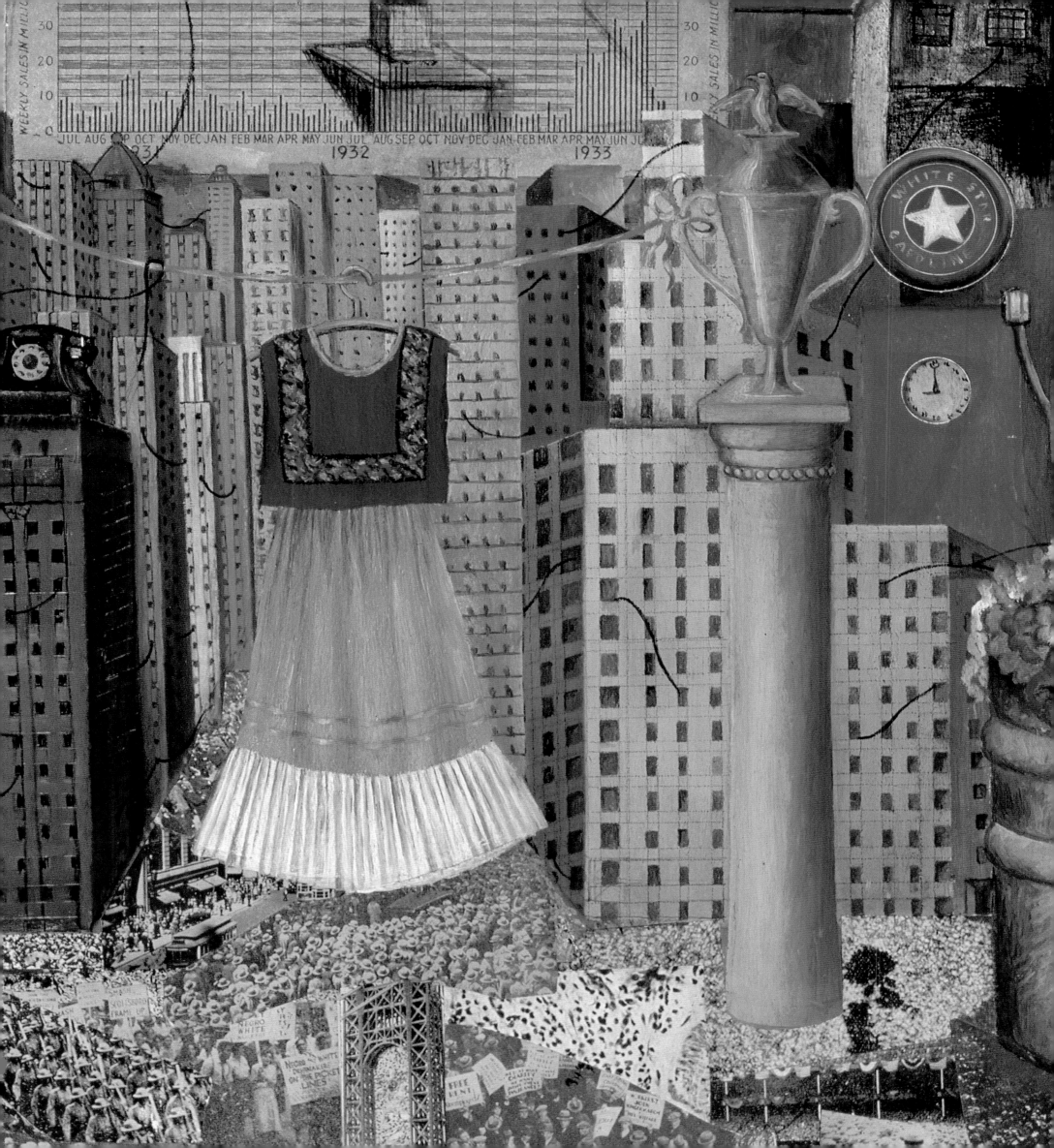

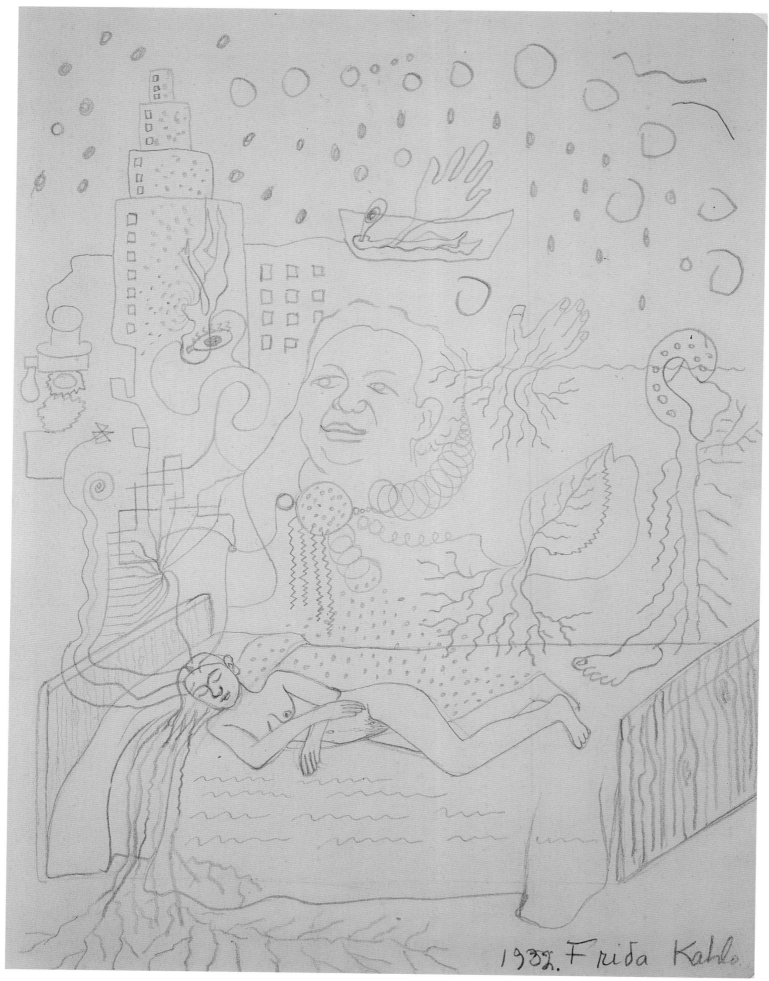

1932. Frida Kahlo

Sleep, 1932.
Pencil on paper,
27 x 20 cm

Next page:
*Between the Curtains
(Self-Portrait Dedicated
to Leon Trotsky),* 1937.
Oil on masonite,
76.2 x 61 cm

and take root in the ground, making it look as if she is floating on imaginary waters. From her head flow vibrations that change into a net of subliminal oneiric images in which the face of Diego can be made out among the skyscrapers of New York, microbiological beings, strange instruments, and indecipherable cryptic symbols.

In addition to revealing Kahlo's state of mind, the drawing is also a demonstration of the technical and intellectual skills the artist developed in the two previous years. The new interpretative energy of her painting had become clearer, and Rivera himself recognized it: "[Frida] had continued painting sporadically, in a disorderly fashion, producing work after long intervals [perhaps as was the case with *Window Display in a Street of Detroit*] which is 'surrealist' in a personal way but not in the academic sense. They are strange paintings, reflexive, fantastic, captivating, highly individual. They are much better than those she executed before losing her baby."[39]

The Detroit murals were finished in March 1933, and the Riveras moved to New York that same month. The troubled events that took place in April and May following Rivera's refusal to remove Lenin from the Rockefeller mural did not give Kahlo much opportunity to paint. After the mural was covered and the invitation to paint at the Chicago World's Fair was withdrawn, the muralist was caught in the midst of a controversy over artists' right to freedom of expression. Kahlo painted two paintings during these events that are indicative of the artistic and ideological maturity she had reached. Perhaps driven by the frustration Rivera was experiencing, she produced in *Allá cuegla mi vestido, Nueva York* (My Dress Hangs There, New York), a scathing criticism of capitalist society in the United States and the falseness of its social development. It is not a self-portrait in the strict sense, even though she appears in it through her Mexican attire: a Juchitán *huipil* blouse and a Tehuanan skirt. Her clothes are like a personal and cultural emblem that acts as a catalyst of different social forces and neutralizes the bastions of consumerism. False idols are represented by the artificial beauty of Mae West, by gasoline, seen as a panacea of progress, and by a gold trophy representing free competition, which is voracious and the only means of achieving financial gain. The painting's irony brings it

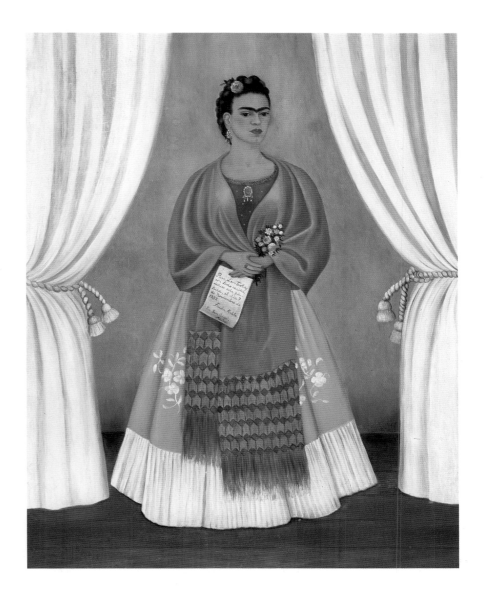

close in its intentions to the surrealist collages of Max Ernst, especially in the counterposition of the images from high and low culture, as in the combined technique of using oil paints with cuttings from newspapers and magazines and also in the use of photography. The picture has three main planes. In the background is an enormous luxury ocean liner about to dock in Manhattan in front of a small Statue of Liberty on Ellis Island, where the sinister detention centers can be seen and federal authorities check and select immigrants. In the middle plane are the ever-powerful institutions of the new era: the Church, which has sold itself for money, as shown by a window where the dollar sign has curled around a crucifix; the modern bank, represented by a large

[39] In Bertram D. Wolfe, *Diego Rivera: His Life and Times* (New York: Alfred A. Knopf, 1939), p. 347.

Parthenon and the ticker tape of the stock exchange; and last of all, the dehumanized factory that dominates the landscape. Between these objects and the masses is a wall of skyscrapers, one behind another. In the forefront are the masses, made up of endless rows of hundreds of thousands of unemployed people, marching in meetings and protesting in demonstrations. Never before had Kahlo taken such an open political stance. It is as if she were echoing the mural entitled *Frozen Assets* that Rivera painted in 1931 for the exhibition at the Museum of Modern Art in New York City. His vision of progress based on capitalism is apocalyptic and at the same time, from an esthetic point of view, an avant-garde work.

Following the above events, we can conclude that by 1934, when Kahlo was once again back in Mexico, she was a painter in her own right, with international esthetic references and a universal artistic language. She had discovered herself, as a woman and as an artist, with her own style, independent from Diego Rivera, yet, at the same time, with strong emotional ties, with physical limits but with unbounded potential as a painter. With convincing determination she painted herself in June 1933 in one of her clearest and purest self-portraits: the first self-portrait of her full maturity. With a direct approach and without unnecessary atavism, her expression is intelligent and her presence seductive. She is neither naive nor innocent, like in 1926 and 1929, but rather is experienced enough to openly declare how she views herself and how she wishes to be viewed by others.

Self-Portrait with Necklace, 1933.
Oil on plate,
34.5 x 29.5 cm

Between the Curtains, 1937
(detail)

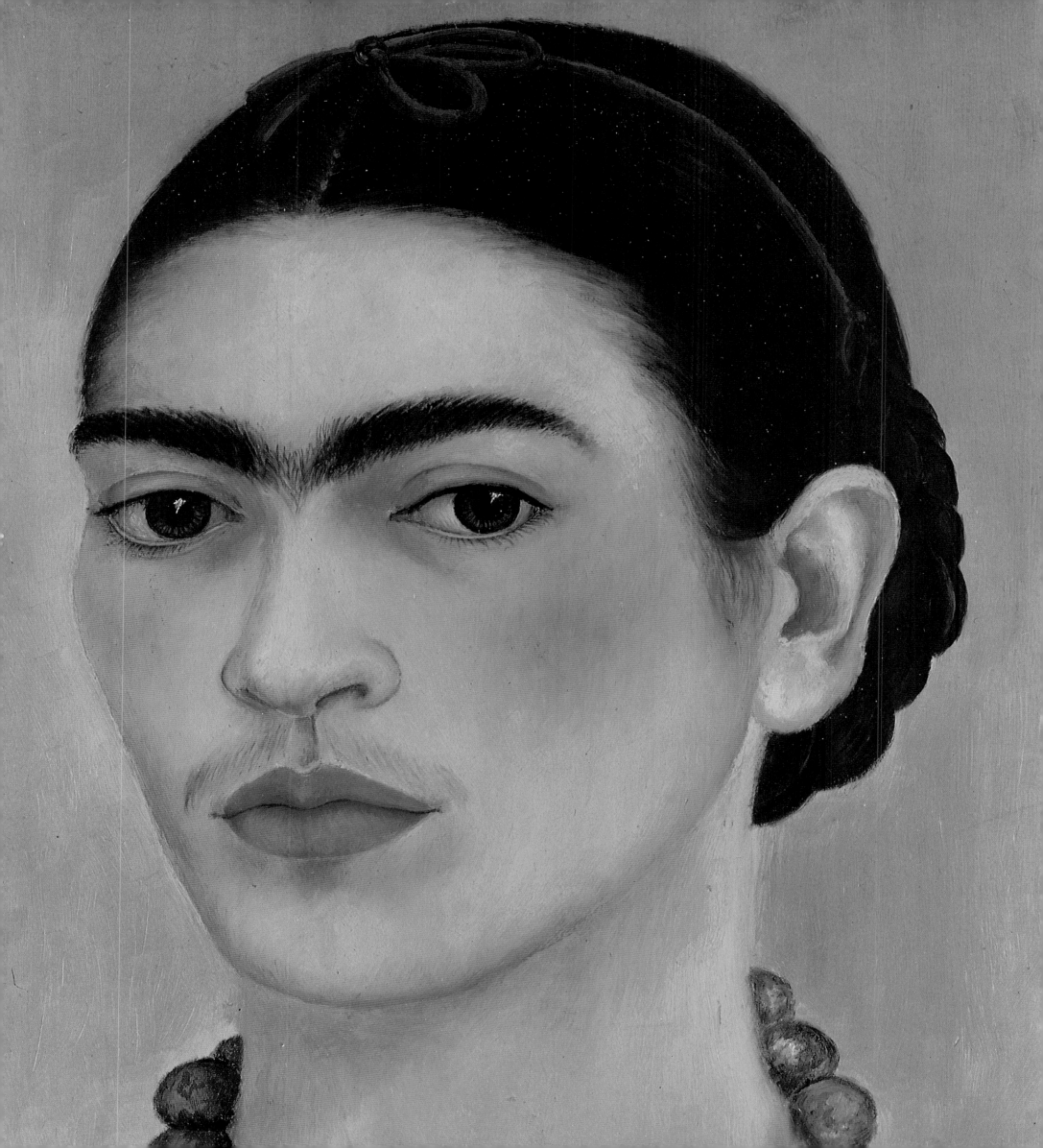

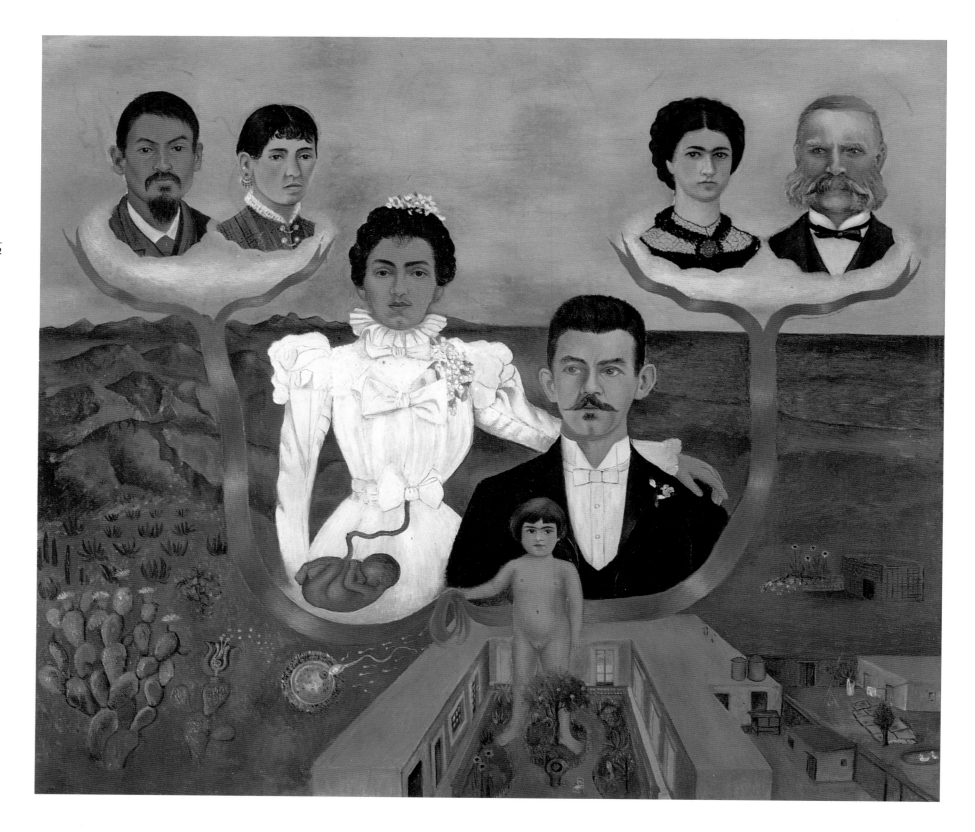

My Grandparents, My Parents, and I, 1936.
Oil and tempera on plate,
31 x 34 cm

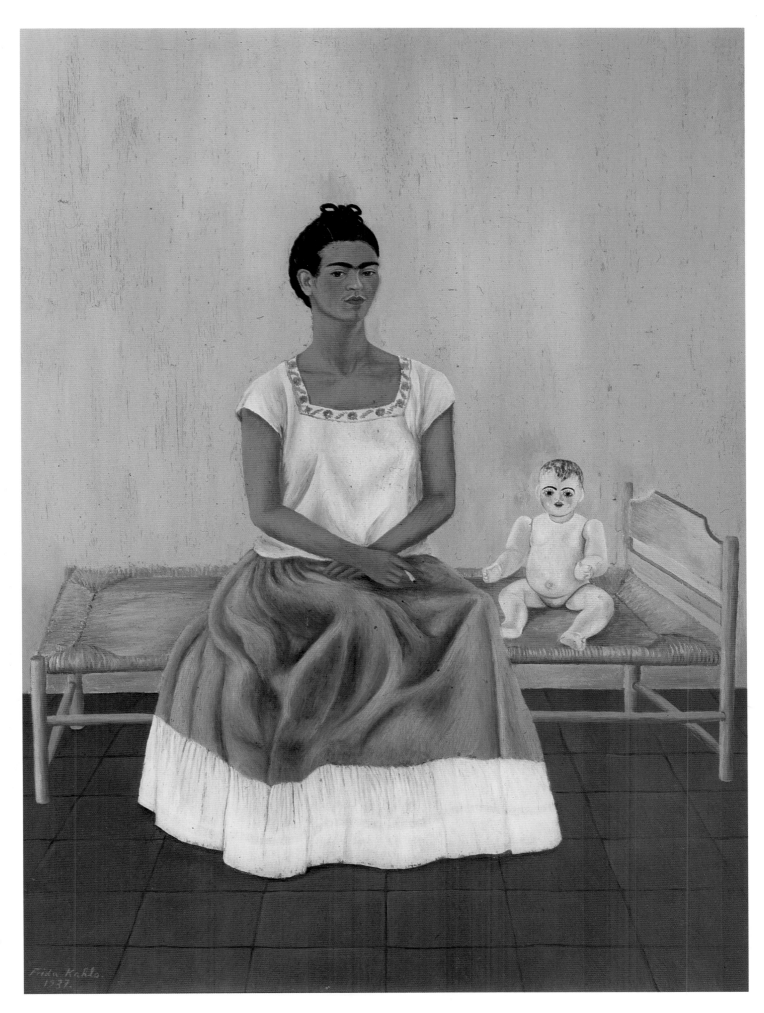

*ME AND MY DOLL
(SELF-PORTRAIT ON
THE BED)*, 1937.
OIL ON PLATE,
40 x 31 CM

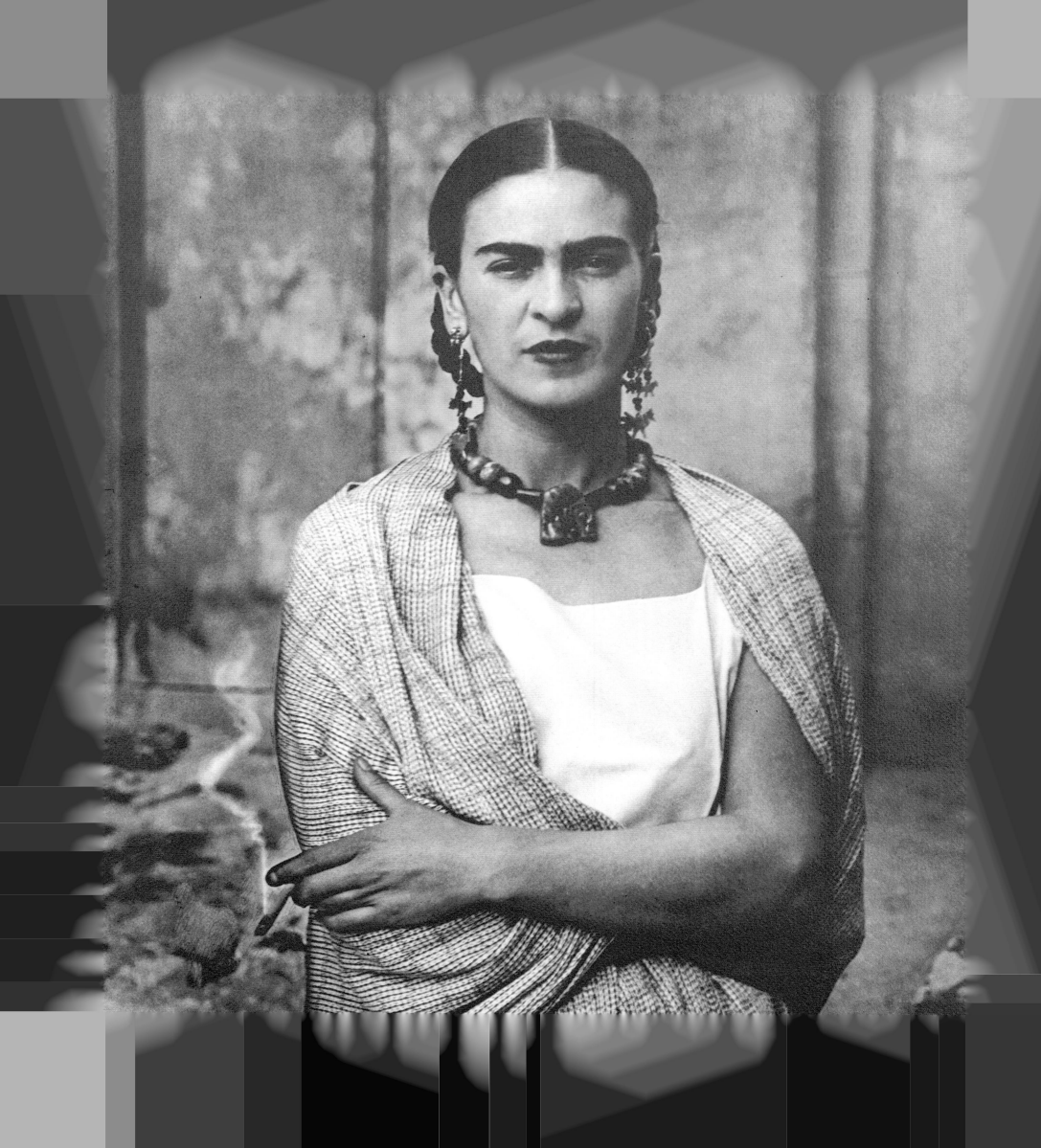

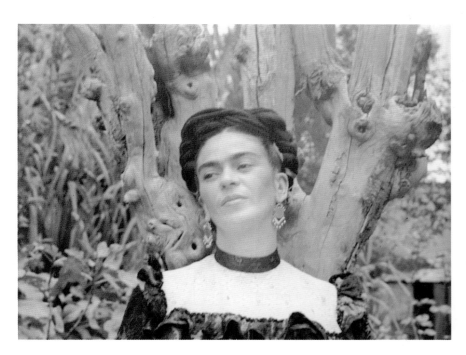

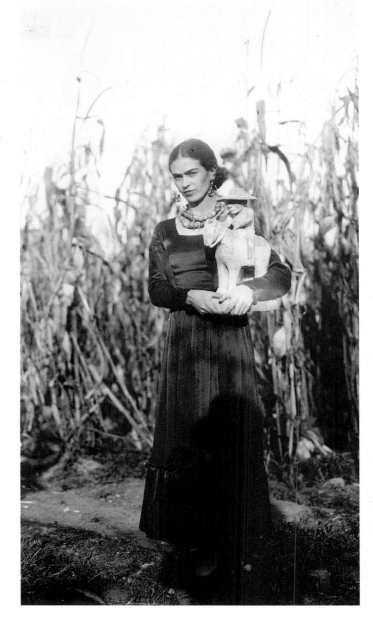

Frida in Coyoacán,
CA. 1944

Frida with a
sculpture by
Mardonio Magaña,
CA. 1934

Copy of the Art
Journal Forma, 1927

Previous page:
Frida, 1932

95

V

In Mexico, Frida Kahlo found the environment she needed to transfer the new knowledge she had acquired to her paintings, not only the esthetic sources that had nourished her unique sensibility but also the art of painting itself. From 1935 onward, Kahlo's palette becomes more harmonious, her paintings beautifully studied, and her brush strokes shorter but more accurate on canvas and plate. In short, she had become an artist with more sophisticated means, and her work had developed greater visual consistency. Knowing she had returned from an environment that was ultimately hostile to her must have been, in itself, encouragement enough to slip back into everyday life and finally into creative activity. In Mexico, Kahlo felt protected again, genuinely loved by her kind and valued in an artistic context in which her work was starting to achieve its own name and fame. Hers was not a case of misunderstood nationalism. Indeed, although she found some aspects of the people she pejoratively called gringos unpleasant, she also complained about the cultural cannibalism her husband was experiencing in Mexico; she was annoyed that although Diego Rivera was one of the painters who had achieved most and received the greatest recognition abroad—including in the period before she met him, with his experience of the European avant-garde—in Mexico, he was continuously attacked and accused of being painterly, of having sold out to the capitalists, and

SMALL MEXICAN HORSE, CA. 1927–1928.
WATERCOLOR ON PAPER,
28 X 34.4 CM

of monopolizing official assignments. She was aware that the criticism had some validity, though it was hard for her to accept, especially as an artist whose approach to her work was so genuine, an artist for whom there was no room for ideological or political concessions and for whom her esthetic compromise was with herself rather than with anyone else. She had fought to survive adversity like any other human being. She had been eager to experience the artistic world that surrounded her, and far from giving in to the idea that she was an artist lacking in formal study, she had worked hard at polishing her intellectual level and at learning something positive from each bitter experience.

The cultural context that developed in the postrevolutionary period left its mark on a whole generation of Mexican artists and intellectuals. It was hard not to see that the country had changed and that the cultural expressions of the people had been slowly absorbed into what was considered "high culture." Mexico had carried out a visual discourse that took back the forms and themes of the vernacular and popular Mexico, and in doing so had unfortunately ended up prostituting itself and promoting the pro-government national rhetoric. The ways in which cultural

training was organized were various, and it wasn't only the muralist movement that adopted this policy; the Adolfo Best Maugard drawing method also shared this ideological role to a certain extent, as did the open-air painting schools. In the same way, the books and magazines that were promoted by the state through the Department of Public Education were turned into organs for the spread of state culture. It is within this framework that Kahlo, from very early in the 1920s, had deliberately set out to promote local culture. She decided to wear Tehuanan clothes and pre-Colombian jewelry not only to please her husband but also because they represented the bulwark of her identity, which made her feel rooted to a time that bore witness to her moral values and validated her artistic choices. This is how one of her contemporaries, Gómez Arias, saw it on one occasion: "In her maturity [Frida] has reached an exceptional understanding of the social and political phenomena of her time. Her intelligence, however, has found its greatest expression in supporting the cause of the people."[40]

Frida Kahlo was a painter who genuinely appreciated the esthetic values of popular and pre-Colombian art in Mexico. When she decided to include in her artistic discourse some of its visual traits, the result was never picturesque or populist; nor did she fall victim to the transitory fashions of official culture. She appealed out of conviction to the dramatic visual language of vernacular painting, which was very direct and even violent, as we can see in the popular ex-votos, provincial portraits, still-lifes, and religious paintings, and in the prints of José Guadalupe Posada and the objets d'art that Kahlo and Rivera collected. From the beginning, Kahlo experimented by including in her work some very Mexican elements, like paper toys and artifacts. Around 1928 she executed two relatively small watercolors that were rather academic in the decorative conventionalism with which the space was structured around the objects. They are incipient works, and their main importance is to be found in her drawing skills and in the way she used color with a certain tech-

[40] A. Gómez Arias, "Un testimonio."

nical ease, despite the sugary and bourgeois taste.[41] One of them seems to have been influenced by the pages of the art magazine *Forma,* edited by the painter Gabriel Fernández Ledesma, which promoted the reevaluation of popular Mexican art forms and which discussed the borders separating official art from that produced by the people. This publication was not only a very important manifesto of the period but also a means of spreading and discussing the ideas and artistic trends in the context of the postrevolutionary cultural renaissance. It seems highly unlikely that Kahlo was not familiar with it, as she was a friend of the painter Isabel Villaseñor, Fernández Ledesma's wife, and such an eager reader at that time. She would spend hours turning the pages of magazines and art history monographs, and even drawing a little, in the Biblioteca Iberoamericana attached to the Department of Education.[42]

Not only did the Mexican context enable Kahlo to lay legitimate claim to popular art forms as her artistic sources, but she also had the opportunity of viewing them in the United States during her second stay in New York, from March to December 1933, in a rare exhibition at the Museum of Modern Art entitled "American Sources of Modern Art." The exhibition was organized by Holger Cahill, with the approval and direct participation of Alfred

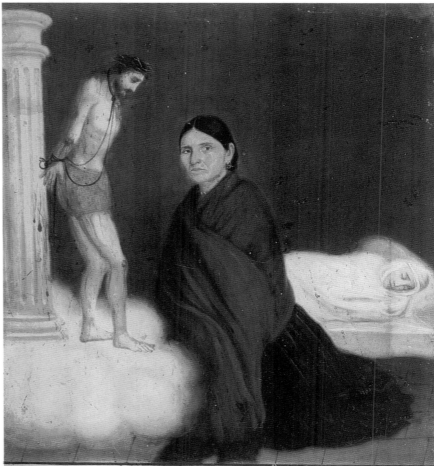

HERMENEGILDO BUSTOS,
*EX-VOTO OF MARÍA EDUARDA
GONZÁLEZ,* 1865.
OIL ON PLATE,
35 X 25 CM

[41] They were similar to the decorative flower paintings that Frida's father painted. Herr Kahlo was a Sunday painter with the sensitivity typical of the Porfiriato period who liked to copy advertisements from calendars and second-rate books. See *Guillermo Kahlo fotógrafo (1872–1941): Vida y obra* (The Photographer Wilhelm Kahlo [1872–1941]: Life and work), exh. cat., INBA, Mexico, 1993, passim.

[42] "She read tirelessly, not only from her father's collection but anything her school friends were reading and the books published by *Editorial Prometeo,* edited by Blasco Ibáñez. Later she read the small volumes with yellow covers published by *Colección Universal.* This is where the Russian novelists and the second collection of works by Juan Ramón were to be found. She read the *Revista de Occidente* (Review of the West), which was open, modern, and informative, and of course Mexican books, the pamphlets issued by *Editorial Cultura,* and its famous publications (*Zozobra* [Anxiety] was published in 1919 and *Campanas de la tarde* [Afternoon Bells] in 1922, but they were still available), and everything everyone else was reading, for pleasure or out of inertia, the green books by Vasconcelos, his classics" (A. Gómez Arias, "Un testimonio").

H. Barr, and it explored the relationship between ancient American art and the work of modern artists. It implicitly recognized the importance of these art forms as possible sources of international modernism. Thus Kahlo was able to study more than 230 pieces of sculpture, pottery, gold, silver, and textiles belonging to the following cultures: Olmec, Totonac, Huastec, Mixtec, Zapotec, Mexican, and Mayan, both from Mexico and from Guatemala and Honduras; there were also other examples from the Nazca and Chimú Inca cultures of Peru as well as of Ecuador and Costa Rica. It was an exceptional collection of pieces—most from private collections, museums, universities, and institutes in the United States—that were being compared with the paintings and sculptures of a group of contemporary American artists, mainly Mexican. Among the pieces of Central American art were watercolors by Carlos Mérida and Diego Rivera and, in particular, important paintings by David Alfaro Siqueiros. Kahlo thus realized that the validity of pre-Colombian and popular art was not limited to the Mexican postrevolutionary context, but rather that it was a primordial source artists had inherited and that it could legitimately become an undeniable part of their identity.[43] In this respect, Diego Rivera's painting had always been a lively, familiar example of its use, but Kahlo had never accepted it as the governing axis of her personalized esthetics, at least not until after 1934, when it started to appear forcefully and insistently in several of her most famous paintings, including *Mi nana y yo* (My Nanny and I), from 1937, *Cuatro habitantes de la cuidad de México* (Four Inhabitants of Mexico City), from 1938, *La mesa herida* (The Wounded Table), from 1940, and *Moisés* (Moses), from 1945.

In the same way, popular Mexican painting, both from the colonial period and from the nineteenth and early twentieth centuries, became extremely valuable to Kahlo. She and Diego Rivera started an interesting collection of ex-votos that were characterized not by the devout feelings of the images but by the open visual frankness with which the painters expressed their faith. Upon studying the ex-votos it is easy to see that the common thread that brought them together under the same roof in the Casa Azul in Coyoacán is that fact that they are all pieces in which the spatial makeup is not only new and experimental but also daring, totally unlike the traditional academic perspective; they are, moreover, pieces of free environments, innovative and influential for the visual world Kahlo was creating through her art. The use of these popular sources was not the exclusive domain of Kahlo and Rivera, and indeed, many other Mexican painters turned to vernacular art as a model of inspiration. María Izquierdo is the most eloquent case, but there were others, too, such as Gabriel Fernández Ledesma, Isabel Villaseñor, and Manuel Rodríguez Lozano.

The recovery of these traditions was not purely one of esthetic interest. They also had importance ideologically, that is, in legitimizing the achievements of the Mexican Revolution. As the country grew in stability, in around 1920 the exalting of a real Mexican culture as the consequence of the armed struggle of 1910 became an objective of the government and the political banner of some artists. With this model of thought—which later turned into fierce nationalism—the postrevolutionary intelligentsia created new historical and cultural platforms according to which nineteenth-century academic painting and the painting that was promoted during the Porfiriato period had been expressions of a decadent artistic period, mainly imitative and totally dependent on what was happening in Europe. They believed that only the popular art forms and the paintings of marginal artists were worthy of attention, and that they alone had been the real creators of Mexican art that authentically represented the people. This Manichaean vision of the history of Mexican art had terrible consequences for the conservation and study of many of the important nineteenth-century painters, and it ended up being a

[43] It would seem that Kahlo did not mention seeing the exhibition to anyone. It is not mentioned, at any rate, in her published correspondence. The dates of the exhibition coincide with her second stay in New York to accompany Rivera, who was painting his mural for the Rockefeller Center. It seems to me highly unlikely that Kahlo did not see the exhibition at the Museum of Modern Art, especially as it was on Mexican pre-Colombian art and as Rivera had some of his work on display there. Rivera and Kahlo would certainly have known Holger Cahill, as they included his name in the list of people Julien Levy was to invite for the opening of Kahlo's first solo exhibition in 1938.

destructive, isolating force for artists like Germán Gedovius, Alberto Fuster, and Ramos Martínez, who had trained during the Porfiriato period and had to change their artistic styles to conform to the times and avoid disappearing into oblivion.

The other side of the coin was that the nonacademic painters from all regions were studied and valued as never before. They merged into a less centralized and antihegemonic vision of what Mexican art had been. Thus painters like Roberto Montenegro, Gabriel Fernández Ledesma, and Gerardo Murillo (Dr. Atl) did a lot to recover the artistic memory of the nineteenth century and popular painting. Others, however, like Diego Rivera, went so far as to say that the popular paintings that decorated bars *(las pulquerías)* in Mexico were "the highest form of expression of Mexican culture" and the source of the Mexican muralist movement.[44]

Among the painters who were saved from oblivion were Hermenegildo Bustos (1832–1907) and José María Estrada (1810–1862), who are now part of an undeniable legacy in the history of Mexican art. Bustos in particular was an authentic revelation when he was rediscovered, and his painting became the subject of analysis by international critics of the stature of Walter Pach and of tributes in the Palacio de Bellas Artes of Mexico City.[45] One of the most surprising aspects of this painter was the isolation in which he worked during the second half of the nineteenth century based in Purísima del Rincón, in Guanajuato, a small village in the heart of the Mexican Bajío region. Bustos, despite his occasional academic claims and the marked influence of photography, managed to develop an unmistakable pictorial style that captured the psychological makeup of the people he portrayed, and hence

"DEAD ANGEL" DRESSED AS SAINT JOSEPH, PATRON OF NEW SPAIN, WITH THE BABY JESUS, CA. 1930

the aspirations, behavior, and mentality of the society of his limited space and time. Like other nonacademic regional artists, Bustos modeled the values, beliefs, and traditions of the inhabitants of the Mexican provinces, where religion was a powerful feature of the local identity, in both his portrait paintings and ex-votos. One of the Catholic motifs frequently represented by Bustos was the worship in Purísima del Rincón of the venerable and miraculous image of the Lord of the Column; one of the most painful stations of Christ during the Passion, which Kahlo also chose for one of her paintings in 1937: *El difuntito Dimas Rosas a los tres años de edad* (The Deceased Dimas Rosas at the Age of Three).

[44] In the magazine *Mexican Folkways* Rivera wrote in 1926, with his usual populist rhetoric and postrevolutionary demagoguery, that "for the national bourgeoisie —from the distinguished intelligent professional to the simple coarse capitalist in gaiters to the colorless people dressed inside and out the so-called European way— *pulchería* [restaurant/bar] paintings were one of the embarrassments of Mexico" (Raquel Tibol, introduction, notes, and biographical details to *Arte y política,* by D. Rivera [Mexico City: Grijalbo, 1979], p. 65).

[45] The painter Roberto Montenegro was perhaps the first to appreciate the artistic qualities of Bustos's portraits. Pach published an article in *Cuadernos Americanos* 6 (November–December 1946). The Fine Arts exhibition was presented in 1951. A more contemporary reading of Bustos is offered by Gutierre Aceves Piña in the catalog of the exhibition organized by the National Art Museum: *Hermenegildo Bustos (1832–1907),* INBA/Marco, Mexico, 1993.

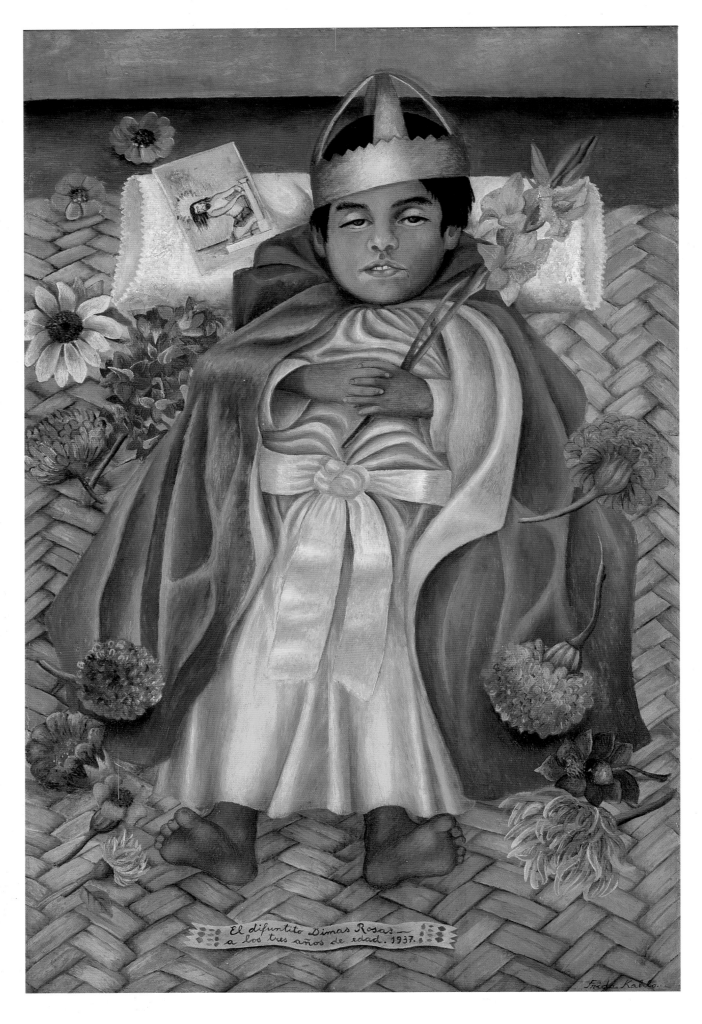

El difuntito Dimas Rosas —
a los tres años de edad. 1937.

*THE DECEASED DIMAS ROSAS
AT THE AGE OF THREE*, 1937. .
OIL ON MASONITE,
48 x 31.5 CM

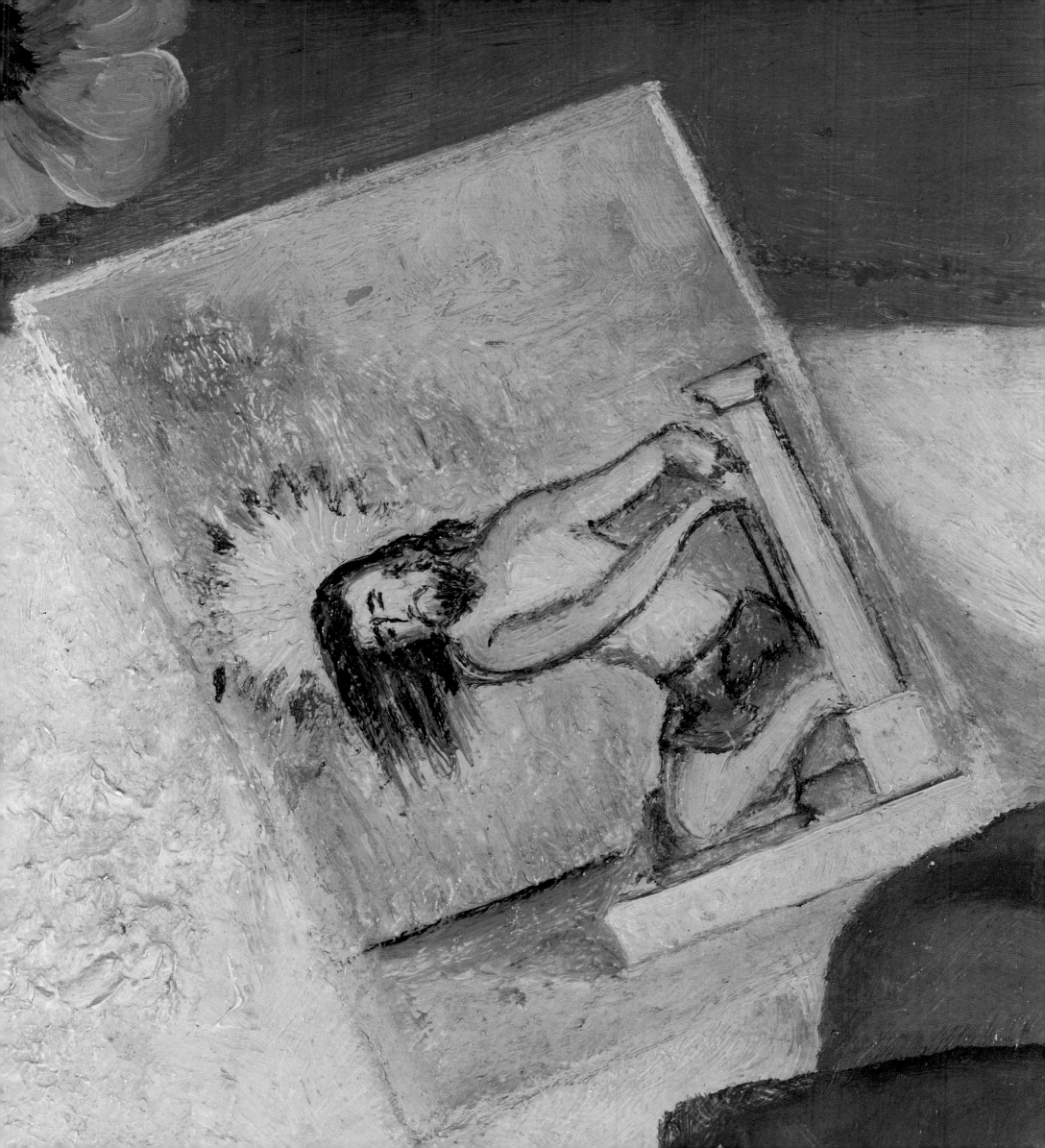

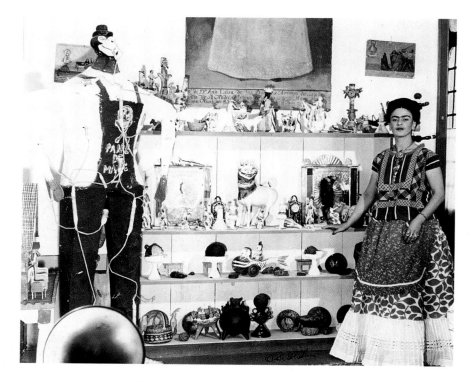

FRIDA KAHLO AT HOME,
WITH A JUDAS OF
PAPIER-MÂCHÉ, 1940.

NEXT PAGE:
KAHLO AND RIVERA IN THE
DINING ROOM OF THE CASA
AZUL IN COYOACÁN, 1941

life as a sort of intercessor between profane existence and divine aspirations. Kahlo had both these popular traditions in mind, the worship of the Lord of the Column and the tradition of the dead angels, and she followed the tradition of religious prints and photography that contributed to the widespread use of these visual models.[47] The dead child Dimas is dressed in honor of Saint Joseph, the patron saint of New Spain, with a crown on his head and a twig of gladiolus in his hands like a scepter. In the color of his clothes and the characteristics of the saint, Kahlo follows a definite iconographic model of the colonial period, which can be seen in the paintings of domestic worship by an artist of the caliber of Miguel Cabrera. Dimas's head is resting on a cotton pillow delicately decorated by hand around the edges, while his little body is lying on a carefully woven palm mat. The image is completed by Cempasúchil flowers, which are typical of the All Soul's Day Feast in Mexico, and a popular holy picture of the Lord of the Column—like the ones Bustos painted so many of—thus creating an eclectic universe of high and low culture, which forms a magnificent example of the synthesis of colonial customs and the survival of the indigenous world. At the same time, the overall composition of the painting makes it look as though it were taken from a photograph from the beginning of the century; photographs were very common in the provinces of Mexico, such as those taken by Juan de Dios Marchaín, a real artist of the lens who specialized in the genre of funeral portraits and was very creative in the backgrounds he produced to glorify the "dead angels."[48]

This painting by Kahlo continues a long tradition dating back to the end of the sixteenth century of painting a postmortem picture of a beloved child. In Mexico it had become a subgenre of portrait painting since the colonial period. However, in the nineteenth century it became extremely popular, thanks to the introduction of photography.[46] Artists like Hermenegildo Bustos painted these pictures, which were also called "portraits of dead angels," on commission from families who worshiped the child like a saint whose memory was valued in the context of everyday

[46] Not only in Mexico, but also in the United States and Europe. See Jay Ruby, *Secure the Shadow: Death and Photography in America* (Cambridge: MIT Press, 1995).

[47] Much has been written about the influence of Bustos and nineteenth-century photography in Kahlo's work. (Cf. L.-M. Lozano, "Frida Kahlo, or The Will to Paint," in *Diego Rivera-Frida Kahlo,* pp. 176-177.) Hayden Herrera appropriately points to the paintings by José María Estrada as visual references for *Autorretrato dedicado a León Trotsky* (Self-Portrait Dedicated to Leon Trotsky), which Kahlo painted in 1937, although he considers Estrada to be a *naïf* painter despite her academic

training and aspirations; it is important to distinguish between popular and regional Mexican painting and the term *naïf,* which implies self-awareness on the part of the painter about the validity of her work. (Cf. H. Herrera, *Frida Kahlo: The Paintings* [New York: HarperCollins, 1991], p. 61.)

[48] In Mexico, research carried out by Gutierre Aceves has highlighted the past and present importance of these images of dead children. (See Gutierre Aceves, *Tránsito de angelitos. Iconografía funeraria infantil,* exh. cat., Museum of San Carlos, INBA, Mexico, 1988.)

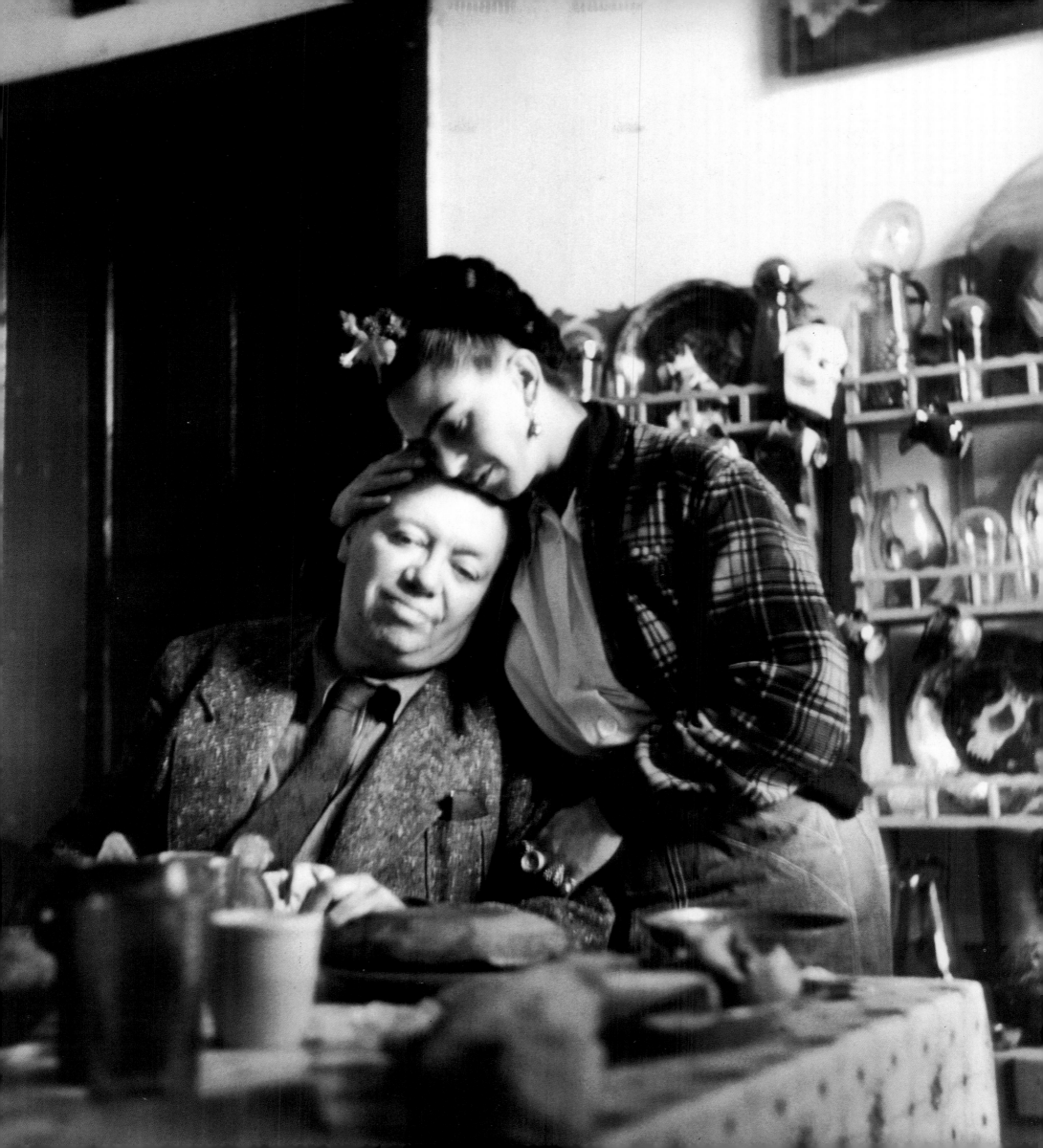

YVES TANGUY, DETAIL OF THE
UNTITLED, 1938. DEDICATION:
ACRYLIC ON PAPER, "POUR FRIDA, SON AMI,
10.5 X 30 CM YVES TANGUY 38"

vated to the level of art not only because of the technical quality of the composition and its unique character (it was never conceived of as mass production) but also for its history: It was painted while Kahlo was preparing for her own solo exhibition, and it went on display in New York at Julien Levy's surrealism gallery with the title *Dressed Up for Paradise*, which explains her interpretation of *"angelito muerto"* (dead angel); it was bought by Somerset Maugham and later displayed at the prestigious Art Museum of Philadelphia in 1943 with the title *The Boy King*, which stripped it of all the intellectual complexity Kahlo had put into it; it was later returned to the painter, who gave it to her sole Mexican collector, Eduardo Morillo Safa, from whom it passed on to Dolores Olmedo and finally into the hands of a museum. This piece of work is also intellectually valuable insofar as it was conceived during a period in which these forms of popular art were beginning to be studied and to take on new significance in light of social investigation. In the pages of *Mexican Folkways* magazine, of which her husband was the artistic editor, Kahlo most probably read the article by Elsie Clews Parsons published in 1930, "Entierro de un angelito" (Burial of a little angel), in which the writer describes the customs of the dressing and burial of dead children and analyzes the social and cultural meaning of the paraphernalia of the entire ceremony; among other burial traditions are the portraits of the dead painted in the nineteenth century, which included paintings executed years after the deceased had passed away. Some of the paintings depicted the dead with symbols alluding to their short lives, with ephemeral flowers in their hands and their investiture ceremony, as if they were baby adults. The process of making the dead person look alive and the living person dead appears in two of Kahlo's small portraits of children, one of which, *Niña con mascara de calavera* (Girl with Death Mask), now belongs to the permanent collection of the Art Museum of Nagoya in Japan. In these two portraits she put into practice some of the existing artistic codes of representation that had been conceived by the collective mentality of the previous century.

In her daily life, Kahlo surrounded herself with objects and

Although Kahlo's design draws on visual traditions with roots in the customs of the people, her portrait of Dimas should not be considered a popular or primitive painting; rather, it is an educated and intellectually sophisticated reading by someone who is observing, studying, and learning about the history of Mexican art and who is consciously making use of the esthetic models available in the artistic environment of the time. Kahlo, like other painters—Manuel Rodríguez Lozano, Juan Soriano, and Olga Costa, to name but a few—reworked a visual code that was still alive in the minds of the people, but with a different intention. Her work is ele-

paintings that were an extension of the artistic values of her own work. She believed not only that they had great artistic and at times sentimental value but also that they confirmed the esthetic values she had learned in her development as an artist, both in Mexico and abroad. In this sense, Kahlo's world was made up not only of her paintings but also of the environment in which she moved. The Mexican popular art that the Riveras managed to collect was the extension of her lifestyle, her tastes and affinities, her personality, her habits, and even her obsessions, just as pre-Colombian statues were for Diego Rivera. In what is known today as the Casa Azul of Coyoacán (The Blue House of Coyoacán), which houses the Frida Kahlo Museum, we can still see traces of the artistic and esthetic environment that Kahlo and Rivera created around themselves. The house is quite different now from what it was like when it was lived in, but some of the magical atmosphere was captured and preserved in the "museography" conceived by the poet Carlos Pellicer for the opening ceremony of the museum in July 1958. Frida Kahlo's house—which was also the home of the Kahlo Calderón family—opened its doors not only to honor the memory of the painter but also to display the exquisite collection of popular and pre-Colombian art that both husband and wife treasured all their lives and that Rivera decided after Frida's death to give to the people of Mexico. Today the objects on display succeed in keeping alive the memory and the taste of its famous inhabitants. As Dolores Olmedo once noted: "The signs of their presence . . . can be felt all over the place, in every corner of the house, in every turn in the garden, in every painting and in every detail."[49]

Among the items they both collected—apart from the ex-votos and pre-Hispanic objects—are handcrafted objects from the 1920s and 1930s, including fine lacquered trays, pretty jugs made of colored glass, animals made of terra-cotta and ceramic, masks, and fantastic toys (some of which appear in her paintings) from a world we will never fully understand. There is also a collection of paintings, though it includes only a few of Kahlo's paintings and very few, albeit important, pieces by Rivera; it does, however, include paintings and drawings by the

landscape artist José María Velasco, by Joaquín Clausell, and even by José Clemente Orozco. In addition, there is a portrait by Leopold Gottlieb, an oil painting by Wolfgang Paalen, a watercolor by Paul Klee, and many more by their friends, like the beautiful little icon with the following inscription: "para Frida, son ami, Yves Tanguy 38," an oil painting by the surrealist painter whom Kahlo met when she was in Paris. The collection also includes a particularly striking series of Mexican paintings of the nineteenth and early twentieth centuries hanging on the walls of what was probably the dining room and of the stairs: civil portraits, some religious paintings, still-lifes, and scenes from everyday life. There is a genre piece by the master from Jalisco, Abundio Rincón, and at least two still-lifes by a Mercedes Zamora, one of them dated 1896. The latter are of particular interest in that they are closely connected to the esthetics of some of Kahlo's still-lifes.

In 1938, in New York, Kahlo presented a painting entitled *Los frutos de la tierra* (The Fruits of the Earth), which depicts a plate of fruits and vegetables on a table with surrealist connotations in the way the space and the metaphysical environment dominating the composition are treated. Both the fruit and the naked veins of the wood are clear erotic allusions to the natural cavities of the human body. The shape of the fruit openly alludes to the male and female genital organs and is deliberate and studied, revealing yet again the synthesis of her educated and intellectual side and her use of native genres. Indeed, the esthetic of this work goes back to the popular still-lifes that Kahlo collected, like that by Mercedes Zamora, with whom she shares an irrefutable affinity in her playful treatment of the textures and juices. Both artists display seemingly carnal delight, as in the corn cob painted by Kahlo and the leeks that

[49] Introduction in a pamphlet of the Frida Kahlo Museum that the Organizing Committee of the nineteenth Olympic Games published in a guidebook in 1968.

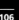

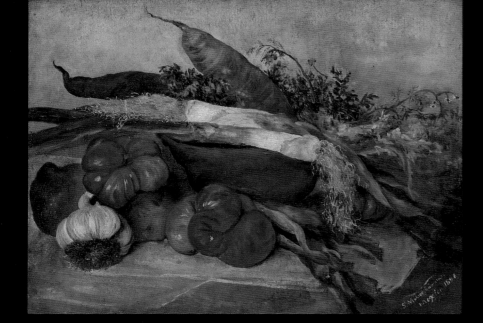

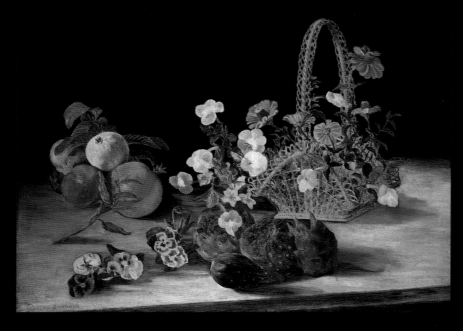

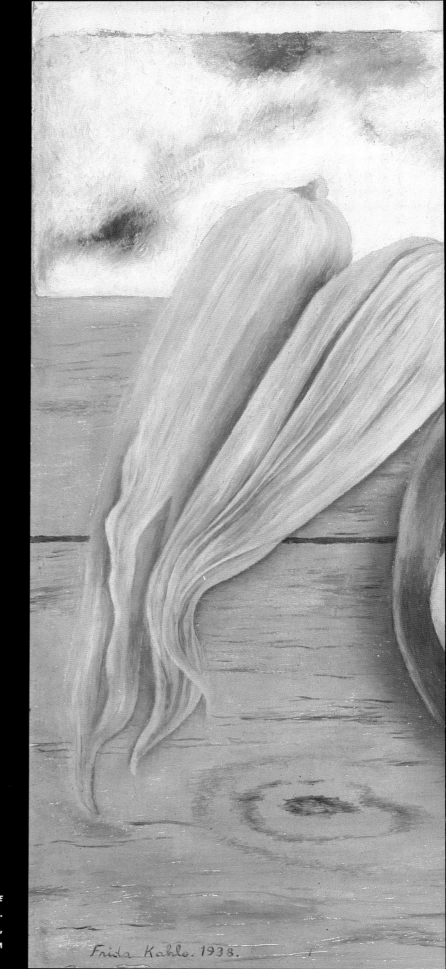

MERCEDES ZAMORA,
STILL LIFE, 1896.
OIL ON CANVAS,
30.5 x 40.2 CM

MERCEDES ZAMORA,
*STILL LIFE
WITH FLOWERS AND FRUIT*, CA. 1900.
OIL ON CANVAS,
40 x 60 CM

*THE FRUITS OF THE
EARTH*, 1938.
OIL ON MASONITE,
40.6 x 60 CM

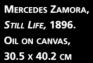

THE FLOWER BASKET, 1941.
OIL ON COPPER PLATE,
65 CM DIAMETER

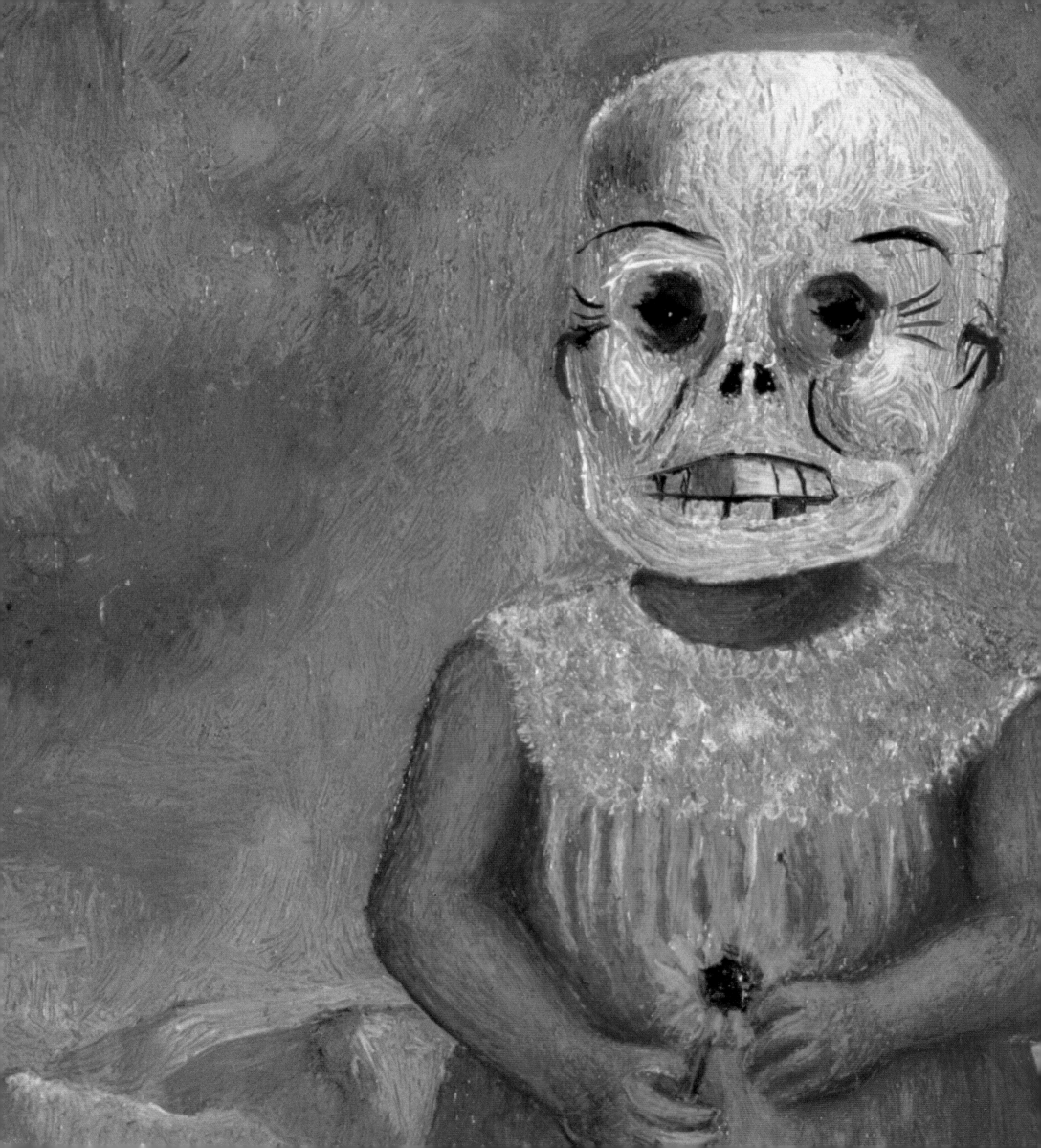

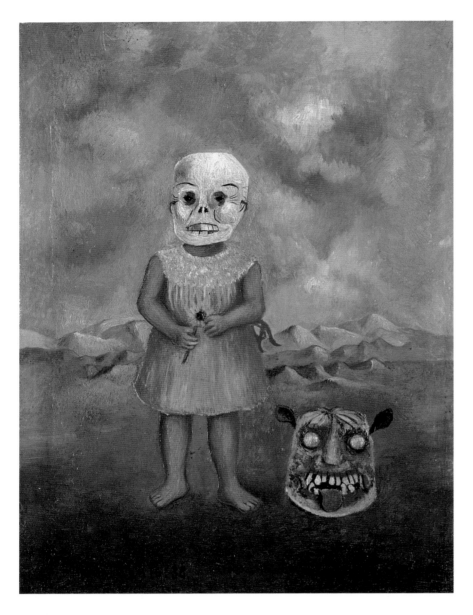

appear in the other, practically unknown painter's *Naturaleza Muerta* (Still-Life).[50]

A further example is to be found in another painting by Mercedes Zamora hanging on one of the dining room walls—a still-life with fruit and flowers arranged in a basket. The brush strokes here are not those of a painter with a solid craft, but those of a painter who is carrying on a still-life tradition inherited from sixteenth- and seventeenth-century Spanish and Flemish painting, a tradition that also influenced several nineteenth-century academic painters in Mexico, the most famous of whom was the colonist Agustín Arrieta.[51] The bucolic and festive atmosphere that emerges from these paintings of flowers and fruit was also captured by Kahlo on at least two occasions between 1941 and 1942. One of these paintings was executed for the American film actress Paulette Goddard, who was also painted by Diego Rivera at the height of her beauty.[52] Currently in a private collection in the United States, this painting is much more than just a simple composition of flowers; it is a seductive, subtly erotic celebration of life. Like the *vanitas* paintings of the seventeenth century that depicted the ephemeral pleasures of life contrasted with the promised glory of heaven, this still-life circular painting also has an edifying tone through the use of metaphors; in this case, however, it is an invitation to fleeting desire and an image of the futility of human virtue. Like the bumblebees, the butterflies, and the hummingbirds who of their own free will enjoy the nectar and pollen of the

[50] Mercedes Zamora probably painted in Mexico at the end of the nineteenth century. Like many women of her day, she studied under famous academic masters, like José María Velasco, and even succeeded in exhibiting some of her landscapes in the old Academy of San Carlos of Mexico, between 1891 and 1898. The little information we have about her is the result of the patient work of Leonor Cortina, who dedicated years to rescuing nineteenth-century Mexican women painters from oblivion. (See Leonor Cortina, *Pintoras mexicanas del siglo XIX*, exh. cat., Museum of San Carlos. INBA, Mexico, 1985.) The author correctly points out that "all the paintings we know of by Mercedes are signed and her name is preceded by an *S* or the term

Señorita," as is the case of the paintings in the Frida Kahlo Museum. I am grateful to Judith Gómez del Campo for having passed on this information to me as I was writing this essay.

[51] On Arrieta's knowledge of Flemish painting, see L.-M. Lozano, "La faceta culta del pintor Agustín Arrieta: cuadros de comedor y escenas de costumbres," in *Memorias* (Mexico City: Museo Nacional de Arte, 1995), pp. 48–59.

[52] As described in the Sotheby's auction catalog of May 1980: "property of Paulette Goddard Remarque, New York. *The Flower Basket*, signed and dated 1941, oil on copper, 64.5 x 65 cm. Provenance gift of the artist to the present owner."

flowers, Kahlo may also be referring to the open and intimate relationship that existed between herself, Rivera, and Paulette Goddard: The exotic beauty of the actress may well be represented by the intensely blue butterfly, the tireless painter of hundreds of fresco murals by the hardworking bumblebee,[53] and the beautiful hummingbird may be an accurate representation of Kahlo's free, yet fragile spirit.[54]

Religious paintings, photographs, drawings, and ex-votos; collections, books, magazines, and journals; sculptures, textiles, and pre-Columbian pottery; popular art and regional artists; still-lifes, dining-room paintings, and paintings of flowers and fruit—all of these make up the extremely wide universe of esthetic references that Kahlo had at her disposal and that she succeeded brilliantly in evaluating, understanding, studying, and summarizing so that they could be included in an artistic corpus that helped her develop into a painter with her own personality. And Mexico, because of the cultural renaissance of the time, was the country where all these influences could come together. In keeping with this view, Teresa del Conde put forth the claim—which, in isolation, may seem slightly nationalistic—that "none of [Kahlo's] paintings could have been born, as far as their spirit is concerned, in any country other than Mexico."[55]

113

[53] Interestingly enough, the bumblebee is a hymenopteran whose abdomen is larger than that of other bees and whose tongue is the same size as its body. In short, the bumblebee is a drone that does not help the worker bees build their honeycomb and a parasite; its role is purely reproductive, and when the fall comes, it is expelled from the hive to die of cold and hunger.

[54] I am extremely grateful to the owner for having shared with me the explanation Frida Kahlo gave her of having portrayed herself as a hummingbird. I was thus able to understand the logic behind the painting of flowers. (Conversation in Los Angeles with V.G., in March 1999.)

[55] T. del Conde, "Frida, la gran ocultadora," in *Frida Kahlo—Tina Modotti,* exh. cat., White Chapel Art Gallery of London, INBA, Mexico, 1983, p.16.

José María Estrada (attribution), *Portrait of Don Antonio Villaseñor Torres at the Age of Five,* 1858. Oil on canvas, 120 x 55 cm

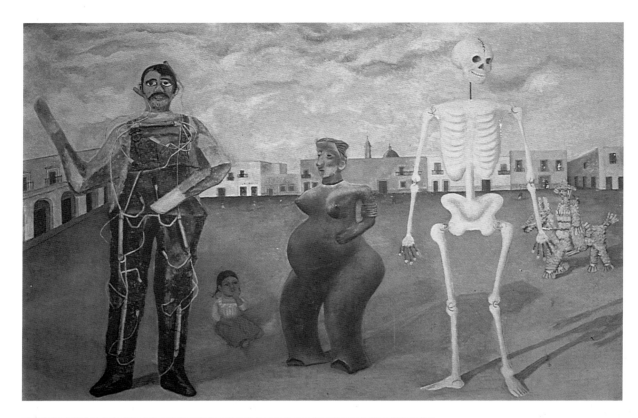

Four Inhabitants of Mexico City, 1937.
Oil on masonite,
31.4 x 47.9 cm

Revolutionary pony.
Mexican toy
belonging to Frida Kahlo

Self-Portrait, Drawing, ca. 1937.
Pencil and crayon
on paper,
29.7 x 21 cm

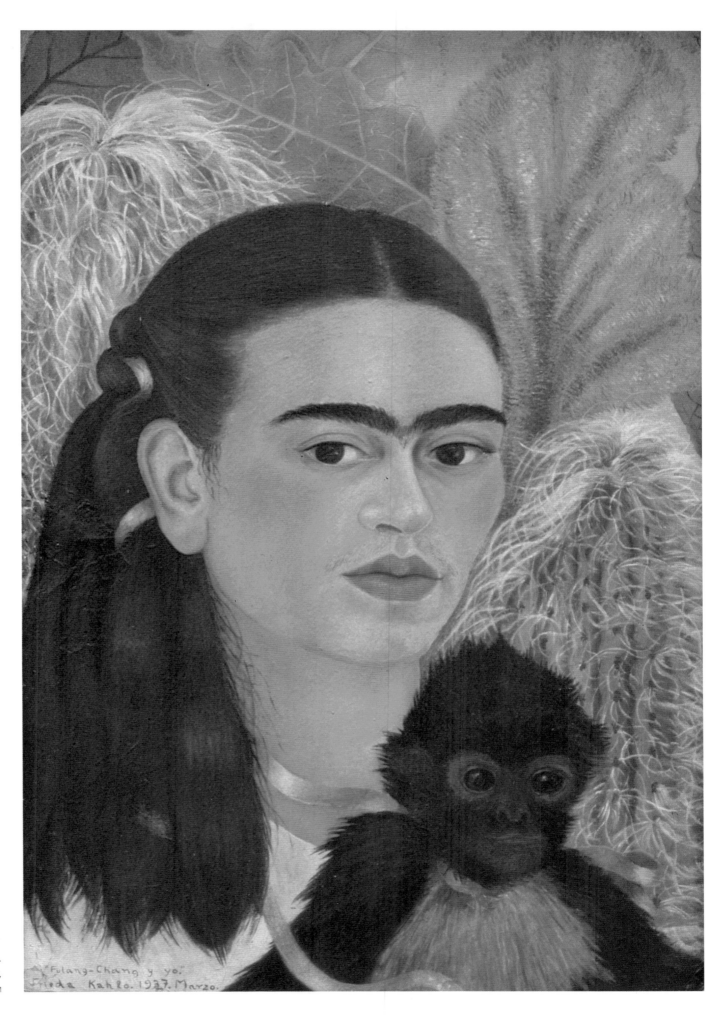

FULANG-CHANG AND I, 1937.
OIL ON MASONITE,
40 x 28 CM

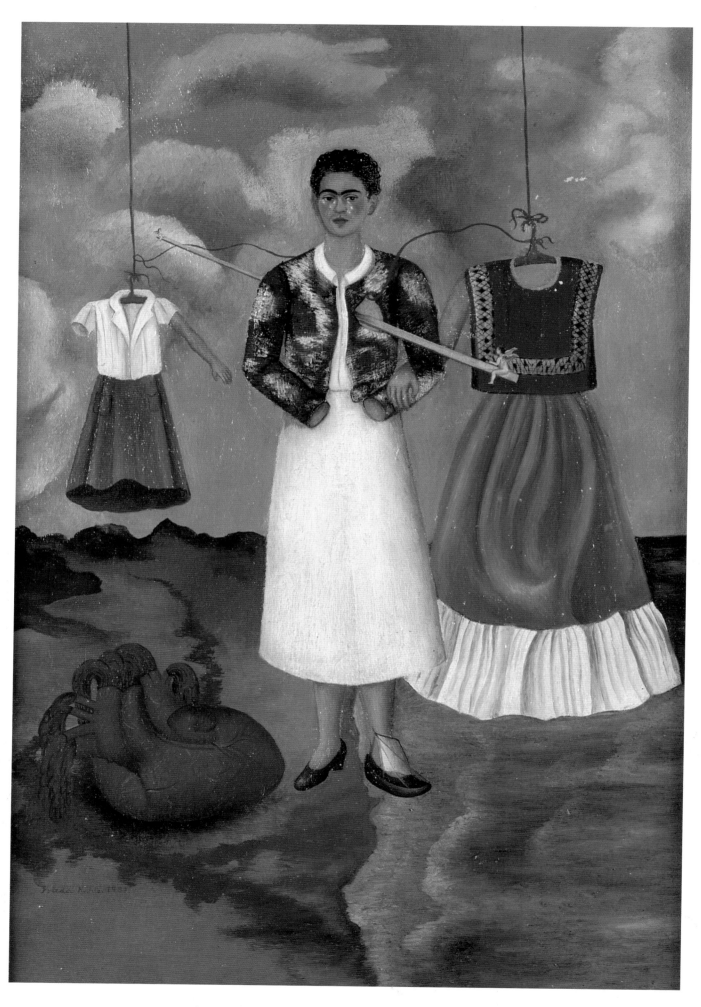

Memory, or *The Heart*, 1937.
Oil on canvas,
40 x 28.3 cm

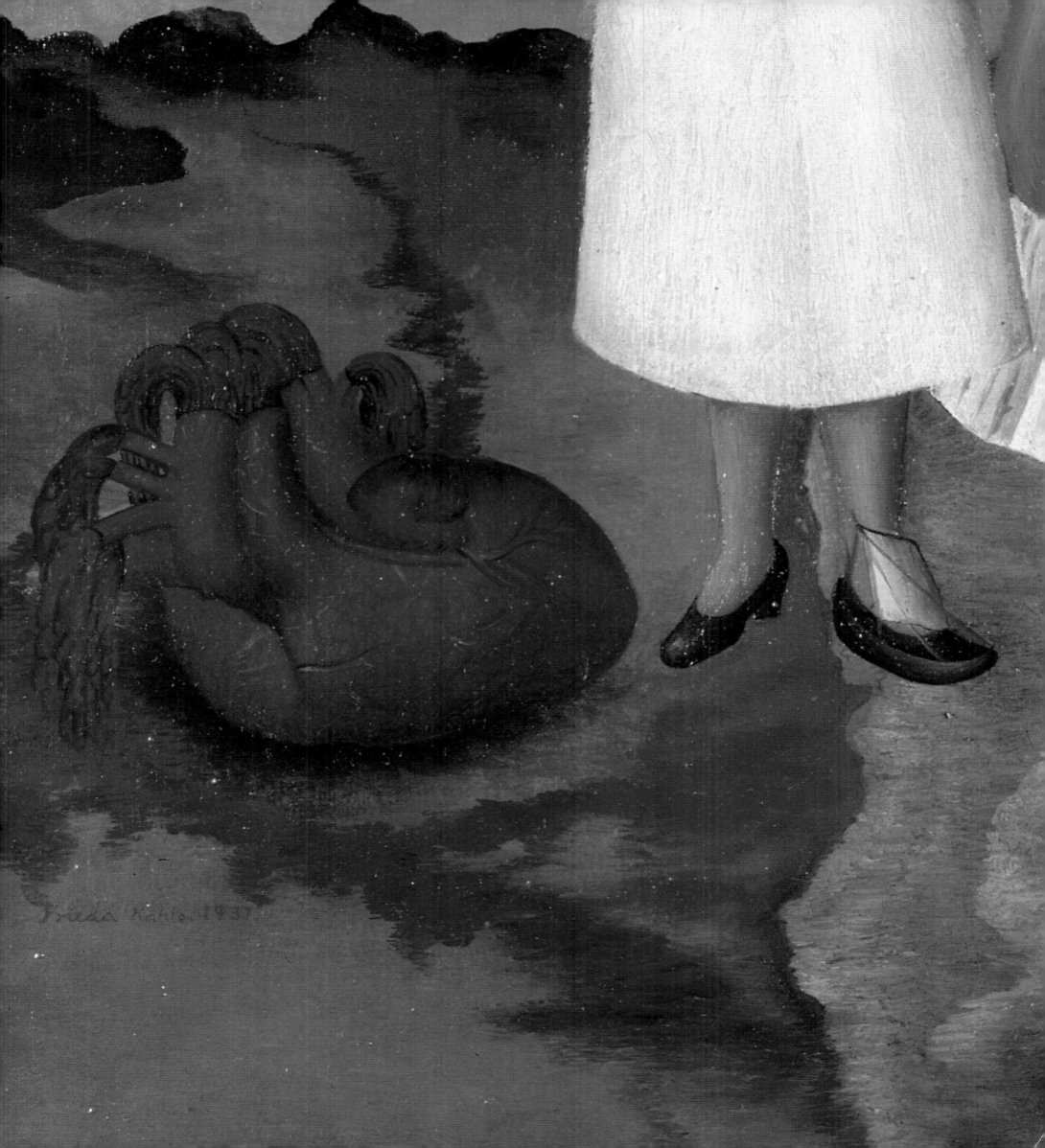

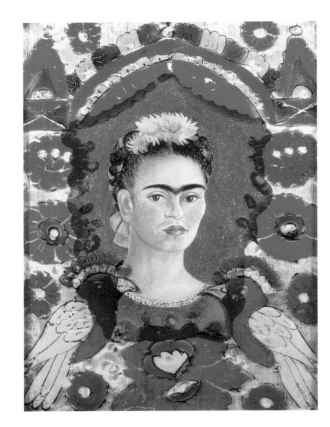

FRAMED SELF-PORTRAIT, CA. 1938.
OIL ON PLATE,
29.3 X 22 CM

PREVIOUS PAGES:
FRAMED SELF-PORTRAIT, CA. 1938
(DETAIL)

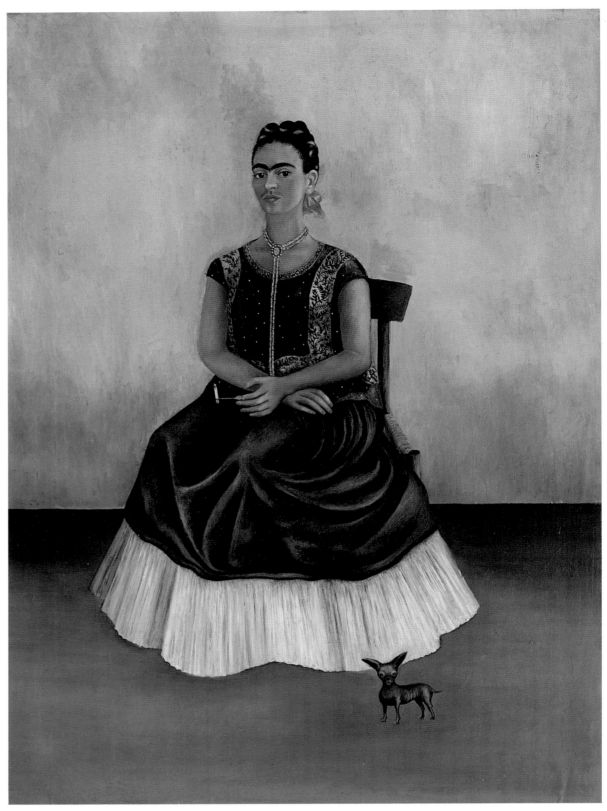

[XOLO]ITZCUINTLI-DOG
WITH ME, CA. 1938.
OIL ON CANVAS,
71 X 52 CM

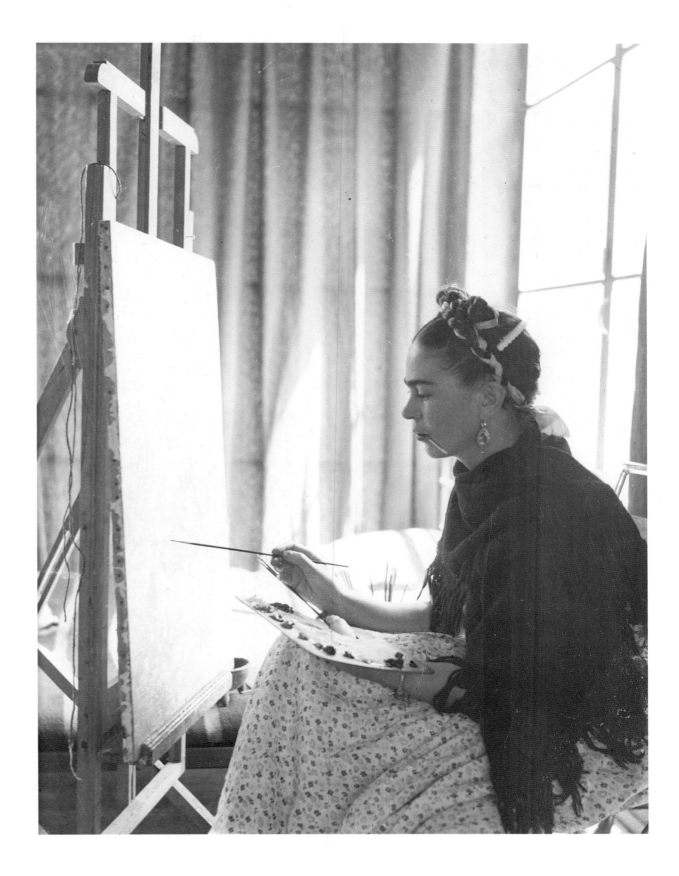

FRIDA KAHLO PAINTING
[XOLO]ITZCUINTLI-DOG,
CA. 1938

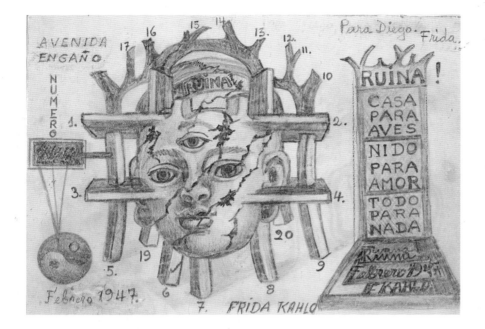

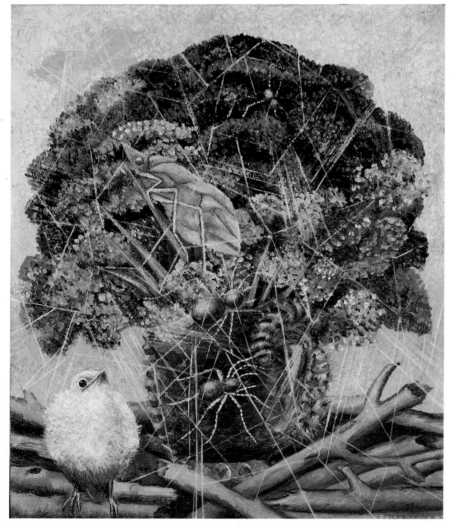

When Frida Kahlo started to paint around 1925, she did not imagine that she would cause such a sensation both as a person and as an artist. After two decades of studying and practicing, of experimentation and growth, she became a highly professional artist. After waiting—often in vain—for many events and decisions to be resolved, Kahlo finally acquired a clear vision of her esthetics and of her potential future as an artist.[56] Unfortunately fate had more obstacles in store for her, and her career became uncertain as her health deteriorated and her personal life started to collapse. Following her father's death in April 1941 and her temporary divorce from Diego Rivera, her emotional stability changed forever, and, ironically, just when she was at her peak as an artist, she became a very vulnerable being.[57] Her personal experience was reflected in her paintings in a dramatic, intense, and also conflicted manner, and they show a profound sense of anxiety; even in the paintings in which Kahlo did not portray herself her hidden fears are represented, through the use of metaphor, as in *El pollito* (The Chick), painted in 1945, in which the fragile existence of a young bird is threatened by two spiders that have stealthily

RUIN, 1947. *THE CHICK*, 1945.
PENCIL ON PAPER, OIL ON MASONITE,
16.5 x 23 CM 27.2 x 22.2 CM

[56] In this respect, I believe that Frida Kahlo lived a life of expectations: longing for the love of Alejandro Gómez Arias; hoping to be able to overcome the consequences of her accident; longing for the love of Diego Rivera; hoping uncertainly to become a painter; anxious to be free and independent; and, finally, waiting for death.

[57] Rivera and Kahlo separated in January 1940 and were remarried on December 8 of the same year. "Artistic differences were given as the reason for their divorce a year ago, but these seem to have been put aside," said a newspaper in San Francisco ("Rivera Will Wed Ex-Wife Here Sunday" [clipping without further details], Archive of the Museum of Modern Art of San Francisco). It is a fact, however, that their marriage was never the same again. In December 1939, before their divorce, she wrote him a letter from which I have selected the following significant lines: "My child of she who keeps things hidden . . . I will never forget your presence for the rest of my life. You picked up the pieces and returned me in one piece. . . . Don't let the tree go thirsty, the tree that loved you so much, that treasured your seed, that crystallized your life at six o'clock in the morning" (R. Tibol, *Frida Kahlo,* p. 65).

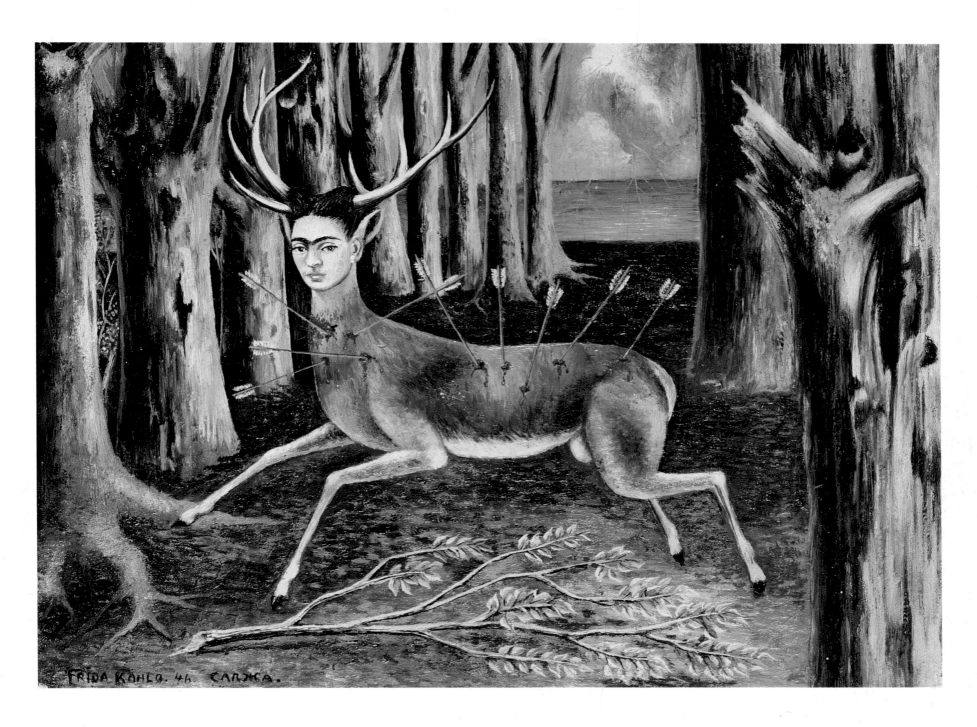

PAGES 123–124:
THE CHICK, 1945
(DETAILS)

THE LITTLE DEER, OR *THE
WOUNDED DEER*, 1946.
OIL ON MASONITE,
22.4 x 30 CM

spun a web; it is only a matter of time before the tiny creature meets its destiny. Similarly, when she finished painting *La venadita (El venado herido)* (The Little Deer, or The Wounded Deer) in 1946, she wrote to the painting's future owners:

> And so I leave you my portrait
> So you will think of me
> Every day and night
> I am far away from you.
>
> Sadness appears
> In all of my painting
> But that is my condition,
> there is no hope for me.
>
> Joy is certainly
> Carried in my heart
> For I know that Arcady and Lina
> Love me the way I am.
>
> Please accept this painting
> Painted with my love
> In exchange for your affection
> And its immense tenderness.[58]

After her first solo exhibition in 1938 in New York, followed by the presentation of her work in Paris, thanks to the initiative of André Breton in the Renou et Colle Gallery in Faubourg Saint-Honoré, Kahlo's career should have seen a meteoric rise, but that did not happen. The prolific creative period that started in about 1937 with the creation of such vital works as *Las dos Fridas* (The Two Fridas) *La mesa herida* (The Wounded Table), *El sueño* (Dream), and, above all,

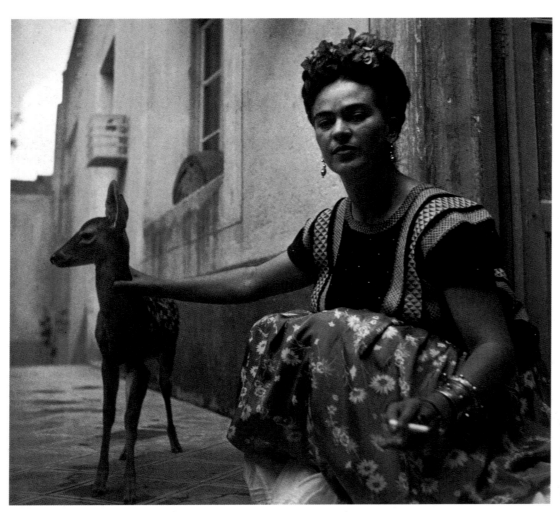

FRIDA WITH GRANIZO, 1939

[58] An interesting explanation of the complex meaning of this painting is the study by Salomon Grimberg: *Frida Kahlo: The Little Deer* (Oxford, Ohio: Miami University Press, 1997). The poem was previously published by Raquel Tibol.

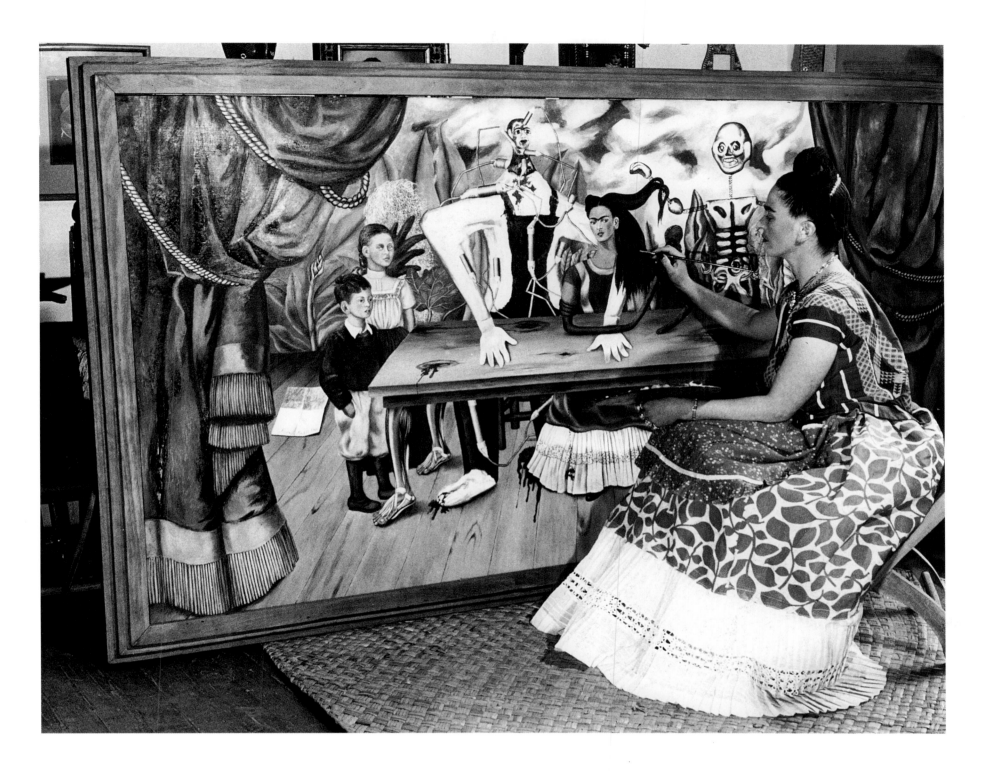

FRIDA KAHLO PAINTING
THE WOUNDED TABLE, 1940

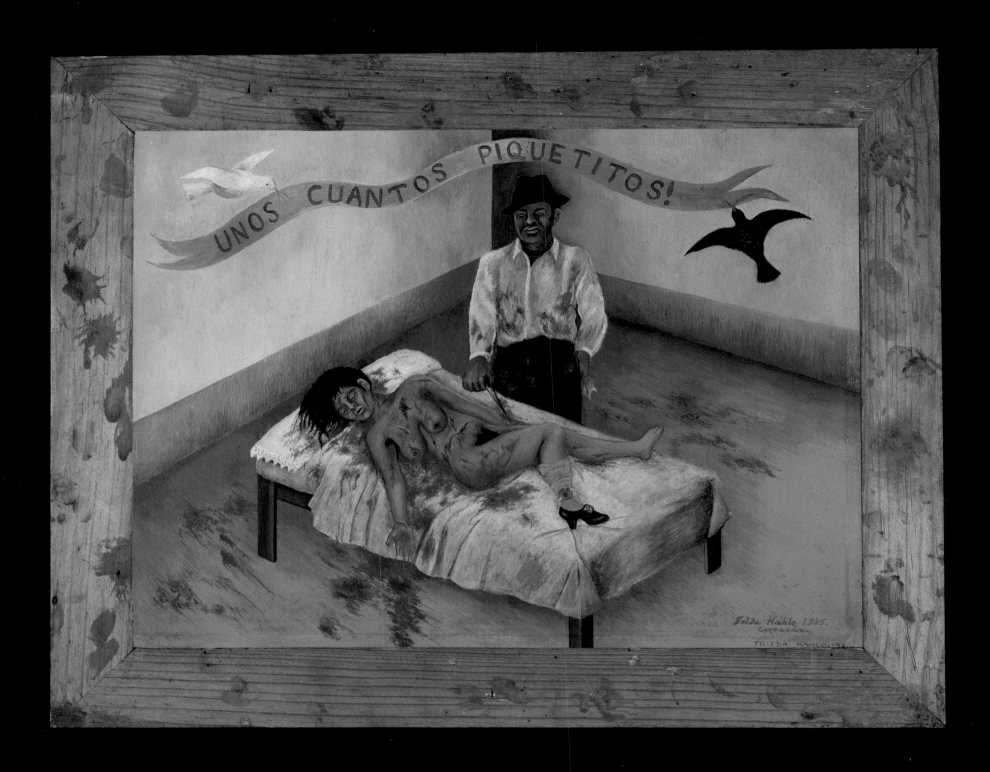

A Few Small Nips, 1935–1936.
Oil on plate,
38 x 48.5 cm (including frame)

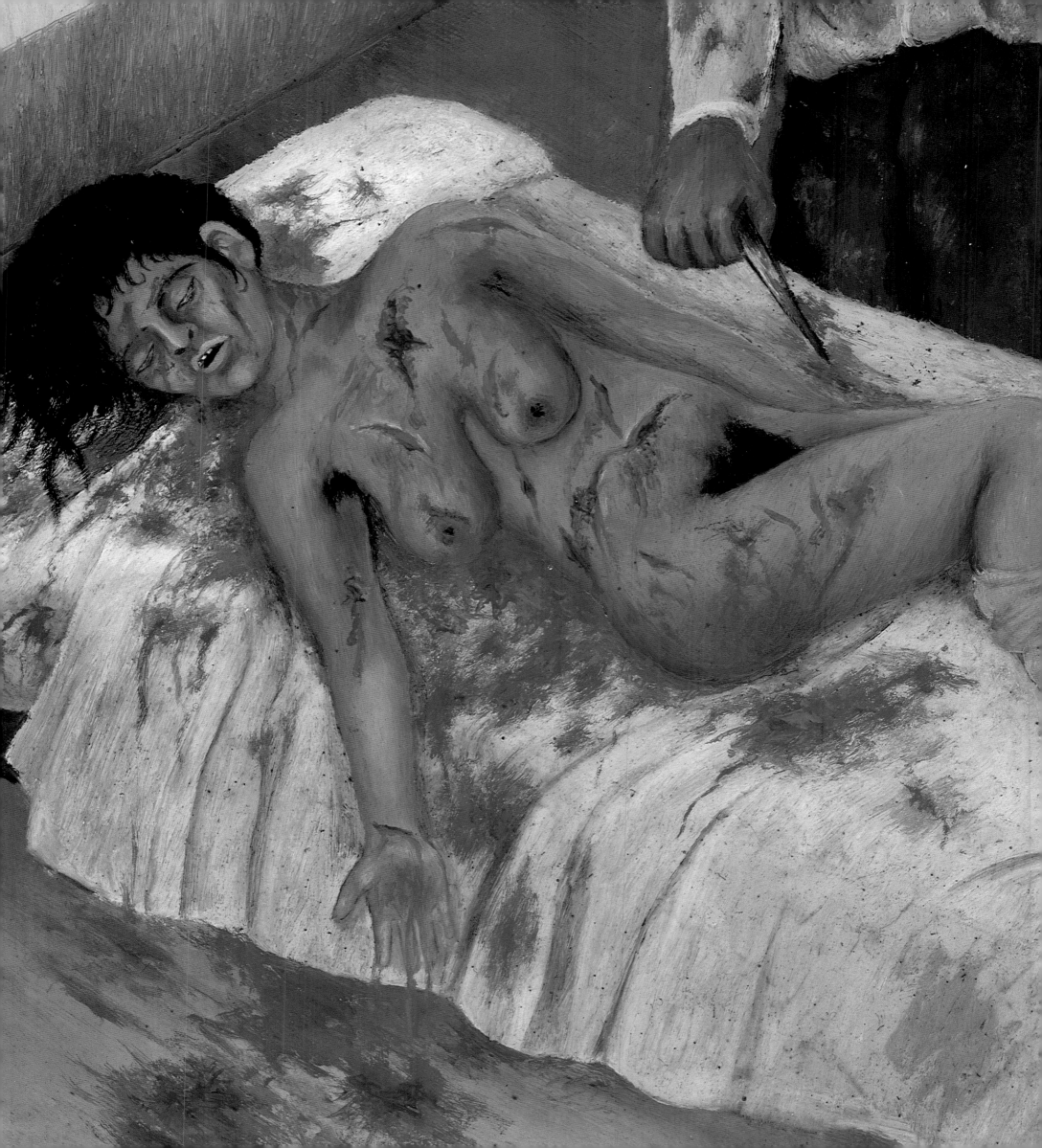

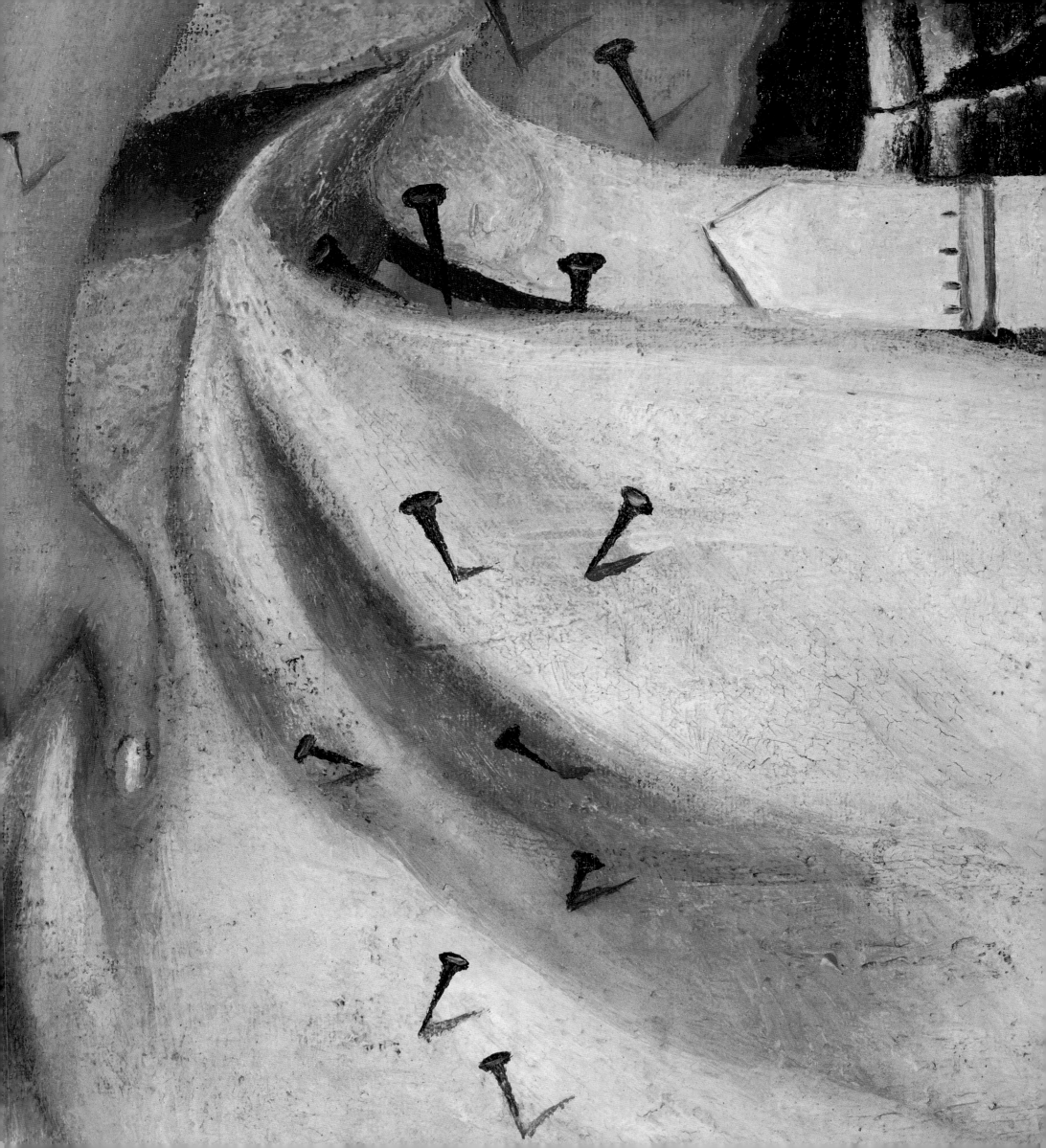

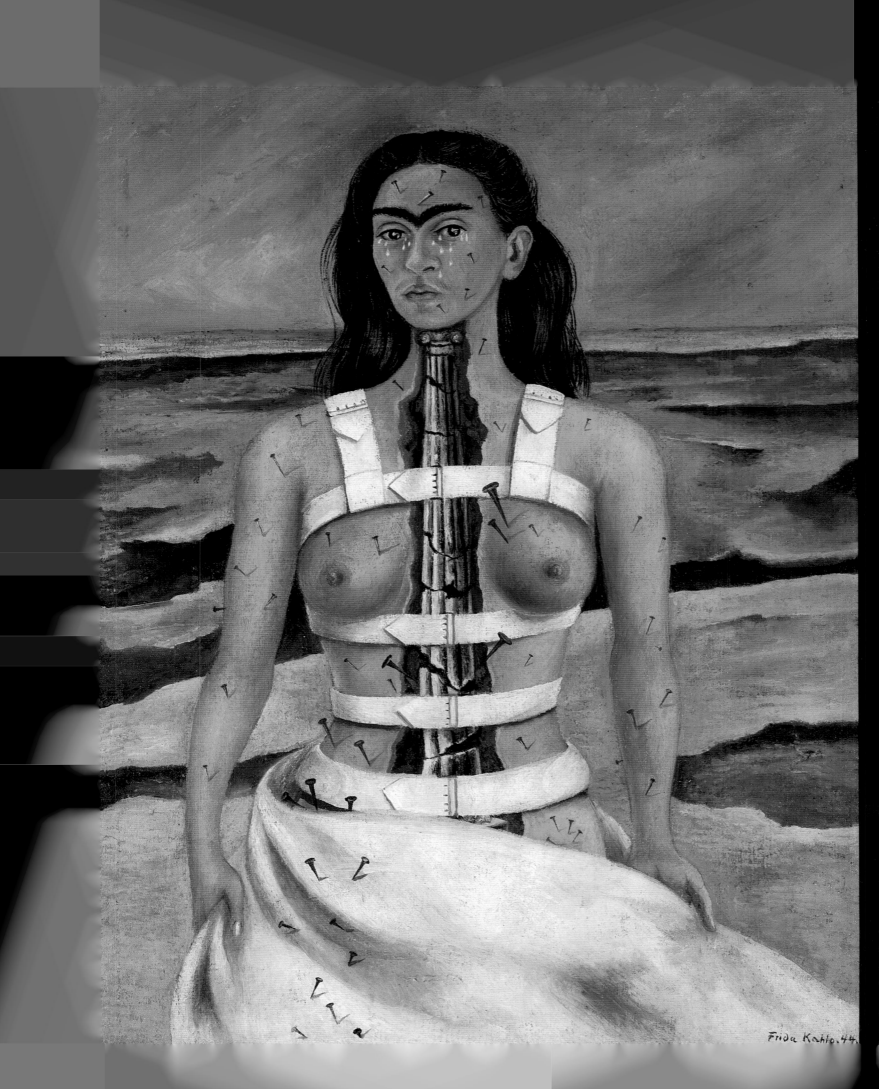

Frida Kahlo. 44.

*THE BROKEN COLUMN, 1944.
OIL ON CANVAS MOUNTED
ON MASONITE,
42 x 33 CM*

PAGES 130–132:
THE BROKEN COLUMN, 1944
(DETAILS)

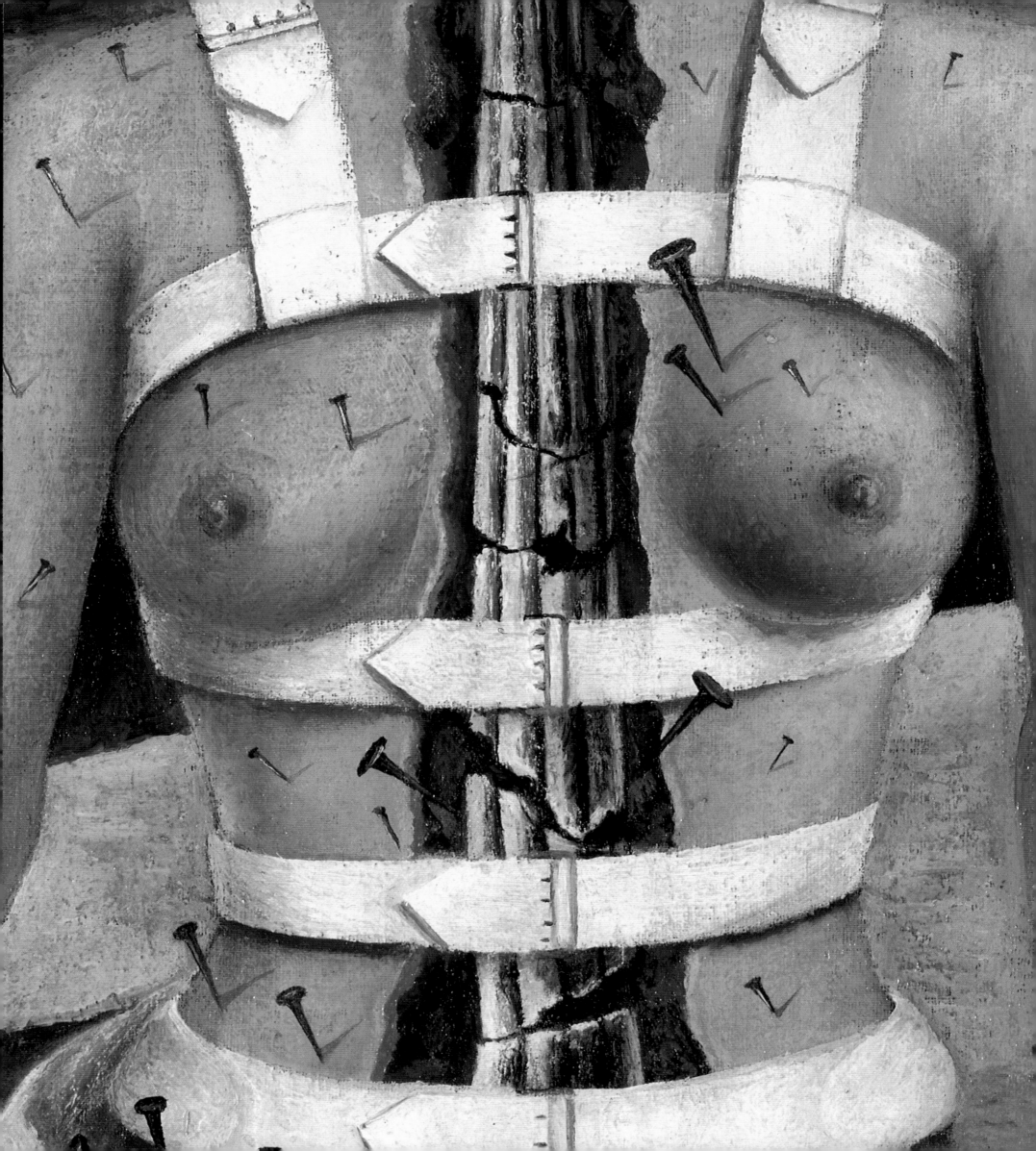

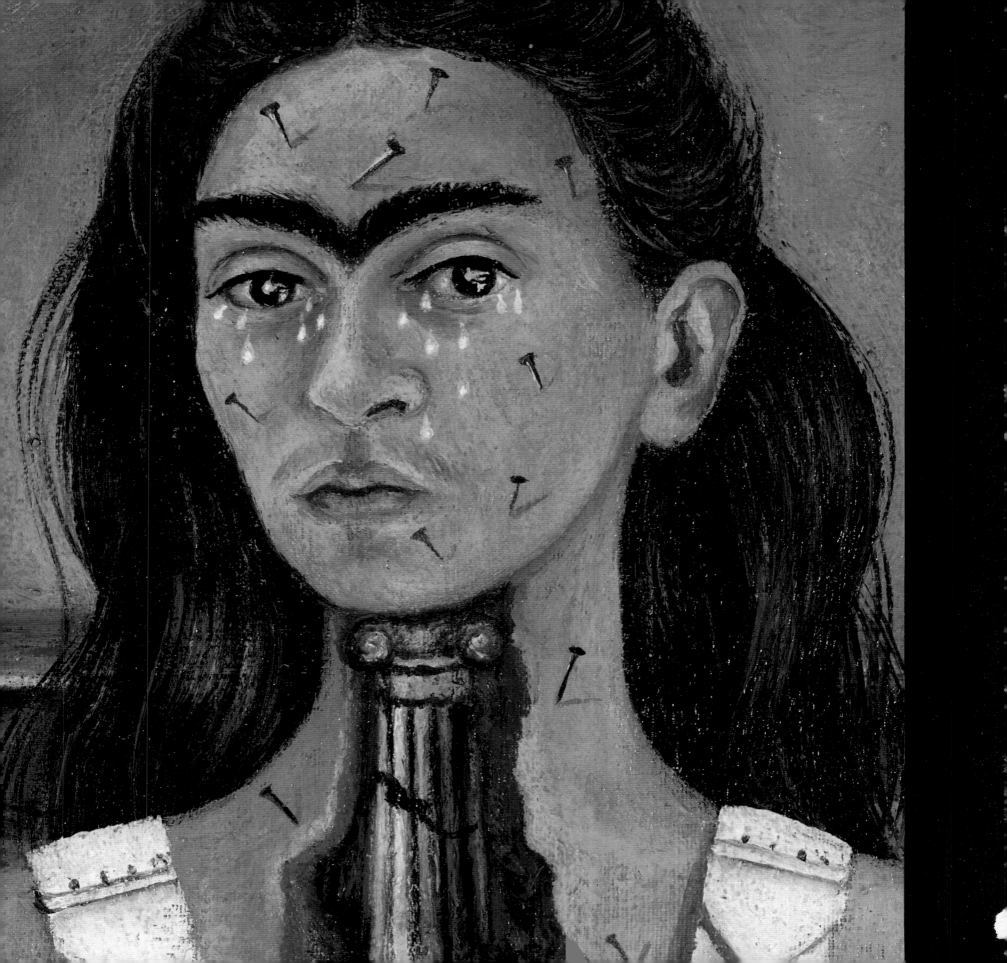

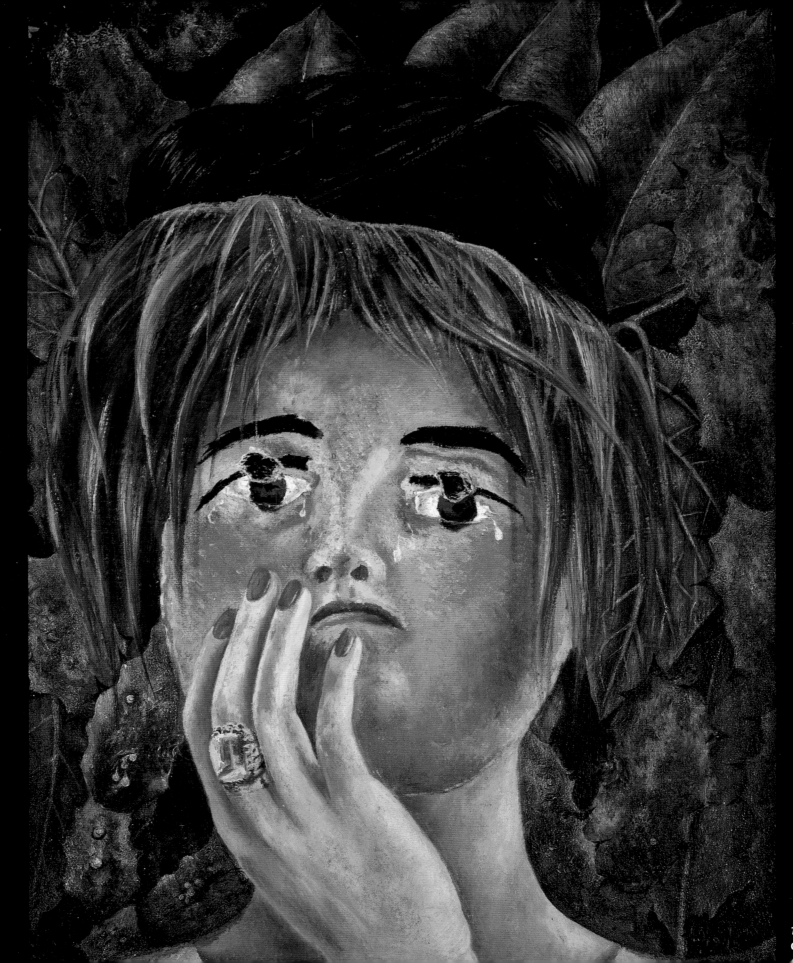

The Mask, 194

Oil on canvas

Frida Kahlo 1946

Untitled (Drawing with Cataclysmic Theme), 1946.
Sepia ink on paper,
18 x 26.7 cm

UNTITLED (DRAWING WITH SUBJECT INSPIRED
BY EASTERN PHILOSOPHY), 1946.
SEPIA INK ON PAPER,
18 x 26.7 CM

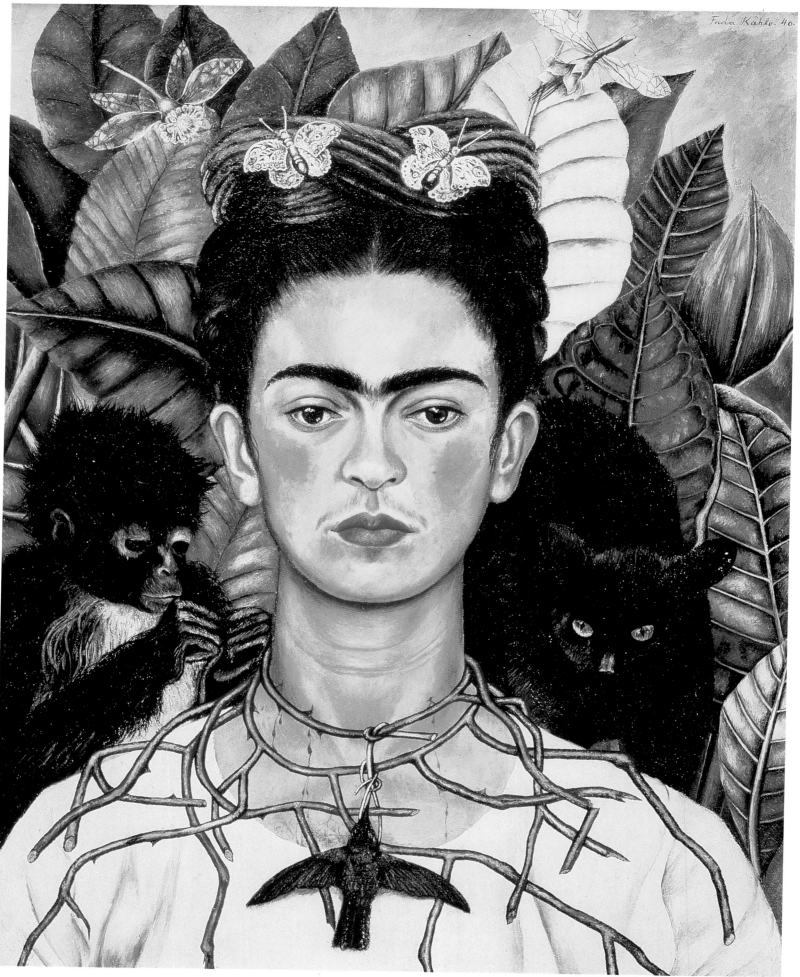

*Self-Portrait with Thorn Necklace
and Hummingbird,* 1940.
Oil on canvas,
62.2 x 47.6 cm

Autorretrato con collar de espinas y colibrí (Self-Portrait with Thorn Necklace and Hummingbird) turned out to be a journey of no return. From this moment onward, Frida started to deny her achievements. Ten years before her death, a decline in her painting set in, and in one way or another after 1944 her work would be marked by a cataclysmic self-destructiveness. When she wrote in her diary, "I am DISINTEGRATION," she was expressing not only the gradual loss of her health, and eventually of her body, but that the clear vision she had gained of herself little by little would not allow her to lie. Thus, as she was unable to hide the pain and the personal despair, her image started to undergo a process of deconstruction before the impassive eyes of the viewer: Frida showing her spine in *La columna rota* (The Broken Column), 1944; Frida without a face in *La máscara* (The Mask), 1945; Frida emptying out her insides in *Sin esperanza* (Without Hope), 1945; and, finally, headless and with her limbs chopped off in *El círculo* (The Circle), which was completed in the 1950s.

The 1940s saw an increase in the number of her self-portraits. Kahlo painted at least twenty-six between 1940 and 1950. Many were on commission and painted to order as a result of the fact that she was becoming well known as an artist;[59] for this reason, not all of them display the same degree of introspection. For example, she portrayed herself on various occasions surrounded by some of her spider monkeys—Fulang-Chang and Caimito de Guayabal—but perhaps she did so too much.[60] In some of these paintings her beauty is totally contemplative, in others she is melancholic and lost in thought; without doubt, some of them are just conventional images. Having said that, her output in this decade was also marked by surrealism, whether it was a legitimate expression of her condition as an artist or a stylistic appropriation she found helpful in projecting herself as a woman painter. Kahlo's fascination with surrealism was like a love affair, at times passionate and intense, at times cold and indifferent. What cannot be refuted is the fact that Kahlo was well acquainted with surrealism and that she most likely had read André Breton's writings before he entered her life. Her long stay in the United States would have brought her into contact with surrealism, and Diego Rivera would not have allowed Breton into his home without having some idea of his work, his theories, and whether their political sympathies were compatible. After all, Breton did not go to Mexico by chance; he went mainly to interview Leon Trotsky in his search for a joint declaration in order to defend the freedom of intellectual expression in the face of Stalin's authoritarian coercion and the advance of Nazism.[61] For her part, Kahlo would have had some natural expectations of how the father of surrealism would view her painting and must have been very pleased that Breton fell devotedly at her feet. Because of her jewelry and her Mexican clothes, Kahlo appeared to him to be a legendary princess "with spells on the tips of her fingers" and an aura similar to "a trail of light from a quetzal, which leaves opals in the sides of the rock as it flies away."[62]

For a woman painter, having her first solo exhibition in New York was an achievement in and of itself. The fact that it

[59] Frida Kahlo's correspondence with some of her collectors shows how the sale took place: "You told me . . . you thought the price was high. Listen, comrade, please do not think that I am taking advantage; on the contrary, I am selling my paintings for 3,000 *águilas*. . . . However, I do not want to force anyone either. If you don't like the deal, I could do you another smaller and less laborious [self-portrait] at a later stage, and I'll sell this one some other way." (I am grateful to B.M. for having shown me this apparently previously unpublished material.)

[60] Frida Kahlo confessed in an interview with Betty Ross, a reporter for *Excelsior*, that sometimes she did not enjoy painting her monkeys. (See L.-M. Lozano, "La pieza del mes: Frida Kahlo, *Autorretrato con monos*, 1943," in *Memoria* [Mexico City: Museo National de Arte, 1990], pp. 84–85.)

[61] Dawn Ades, "Rivera and Surrealism in Mexico, 1930–1940," in L.-M. Lozano, ed., *Diego Rivera: Art and Revolution,* exh. cat., National Institute of Fine Arts, INBA, Mexico, 1999, pp. 312–321.

[62] Preface to *Mexique*, exh. cat., Renou et Calle, Paris, 1939.

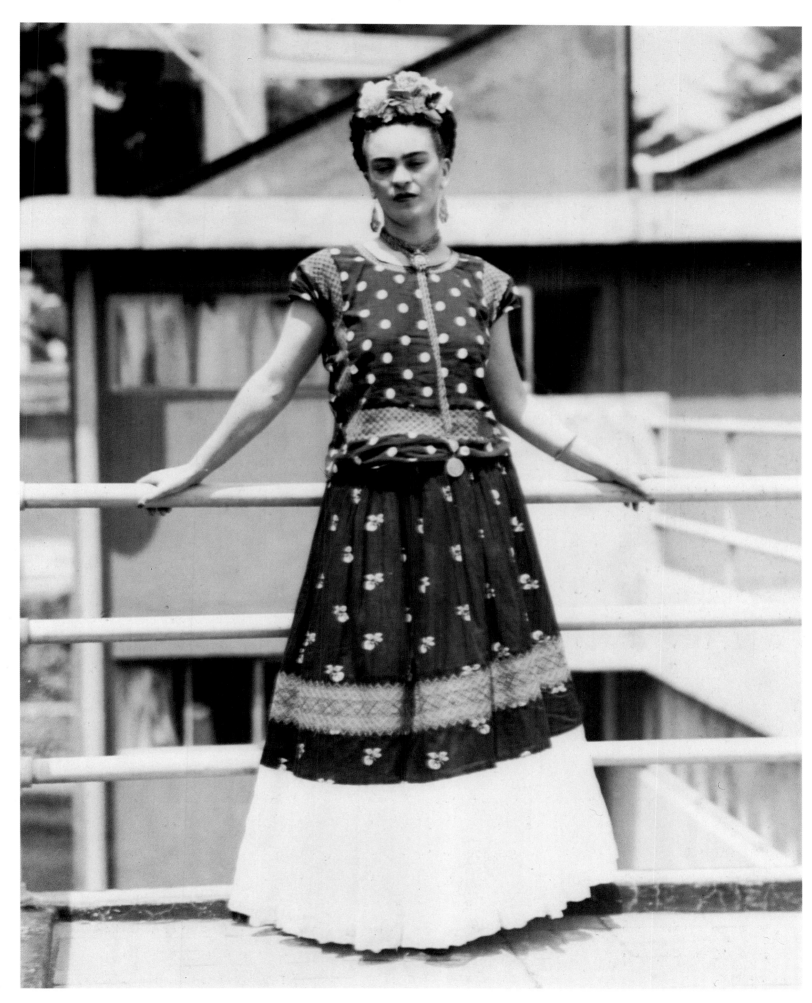

FRIDA ON THE TERRACE
OF HER HOUSE IN SAN ÁNGEL,
1941

PAGE 142:
DIEGO RIVERA AT THE
MUSEO ANAHUACALLI

PAGE 143:
FRIDA KAHLO ARRIVING
IN NEW YORK,
OCTOBER 1938

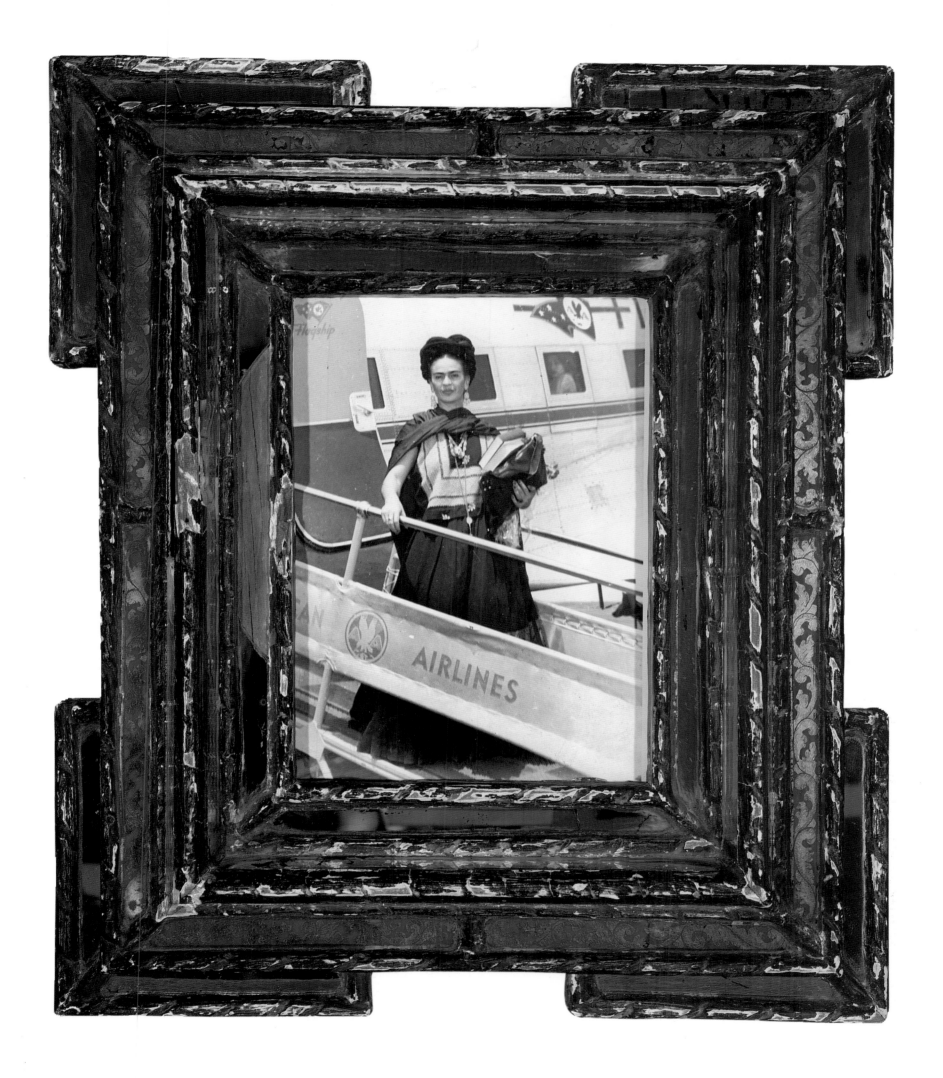

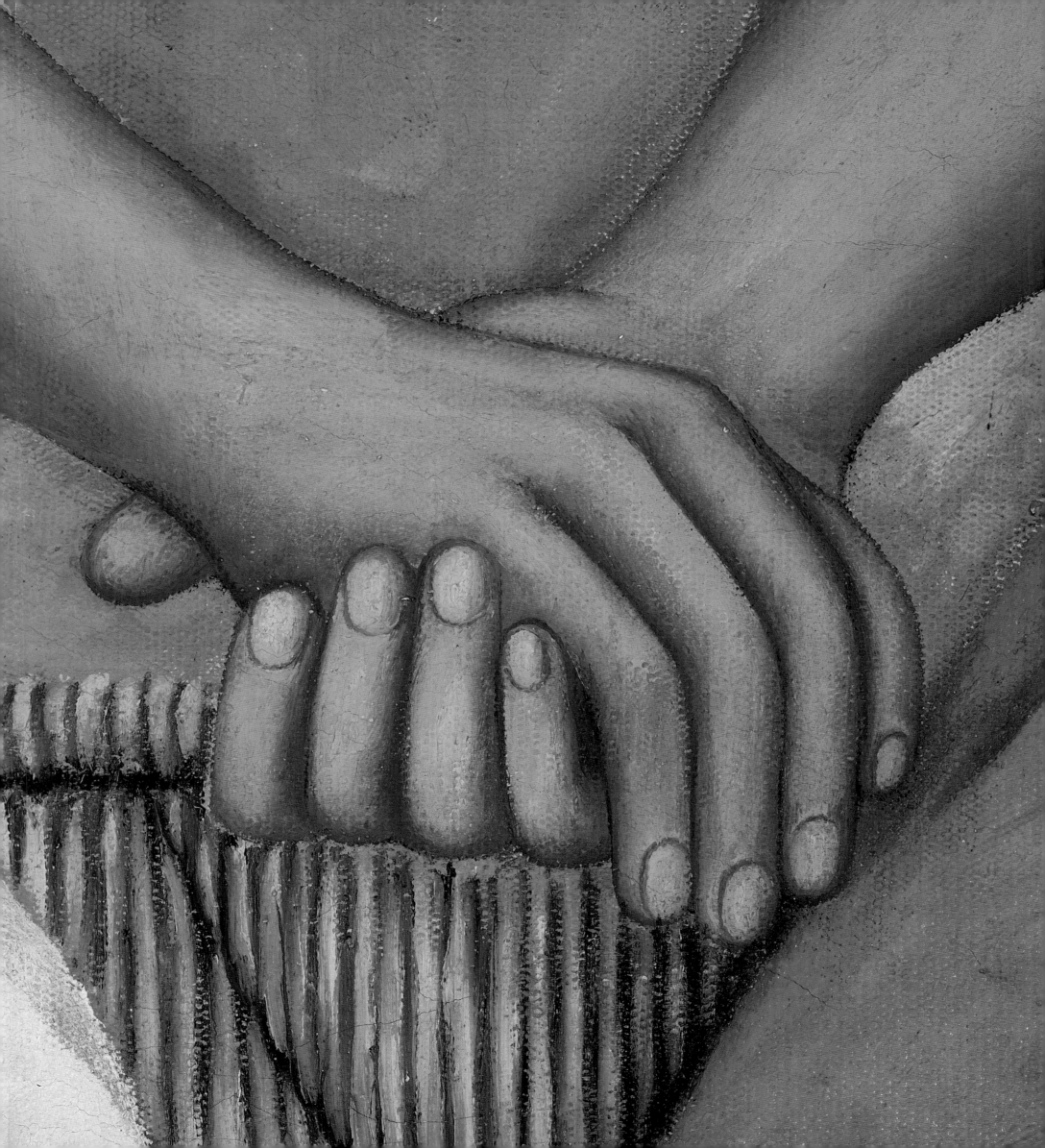

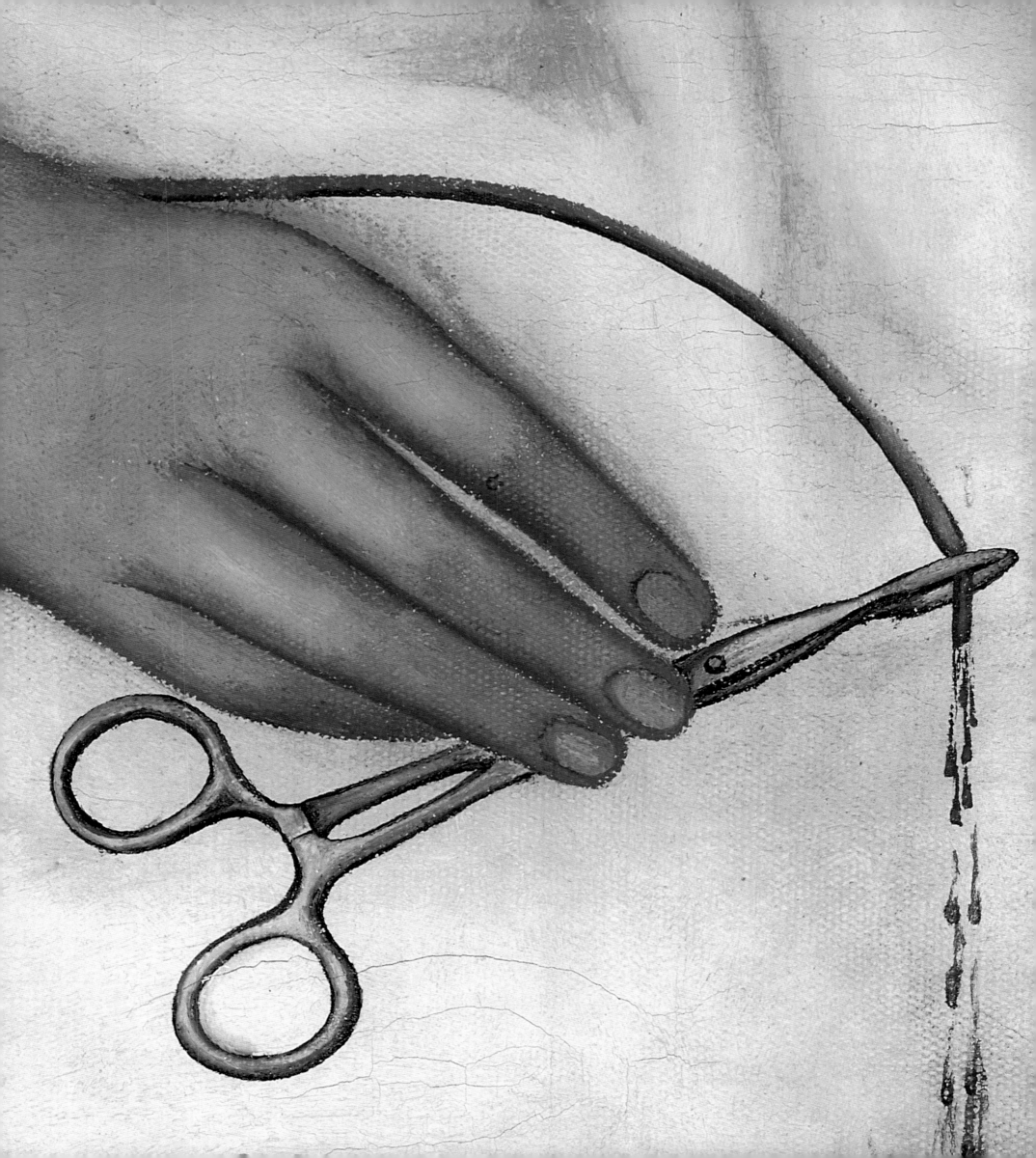

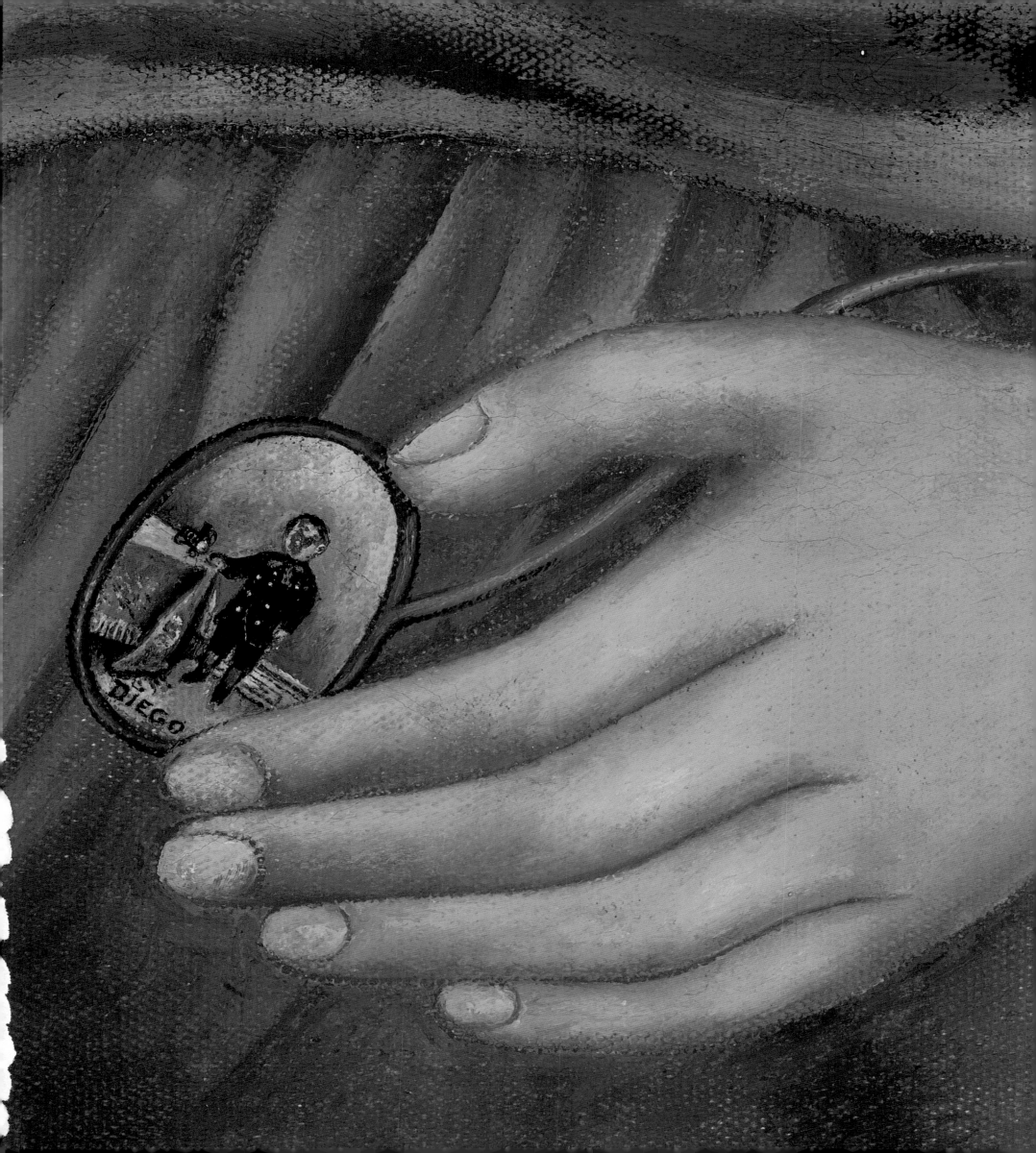

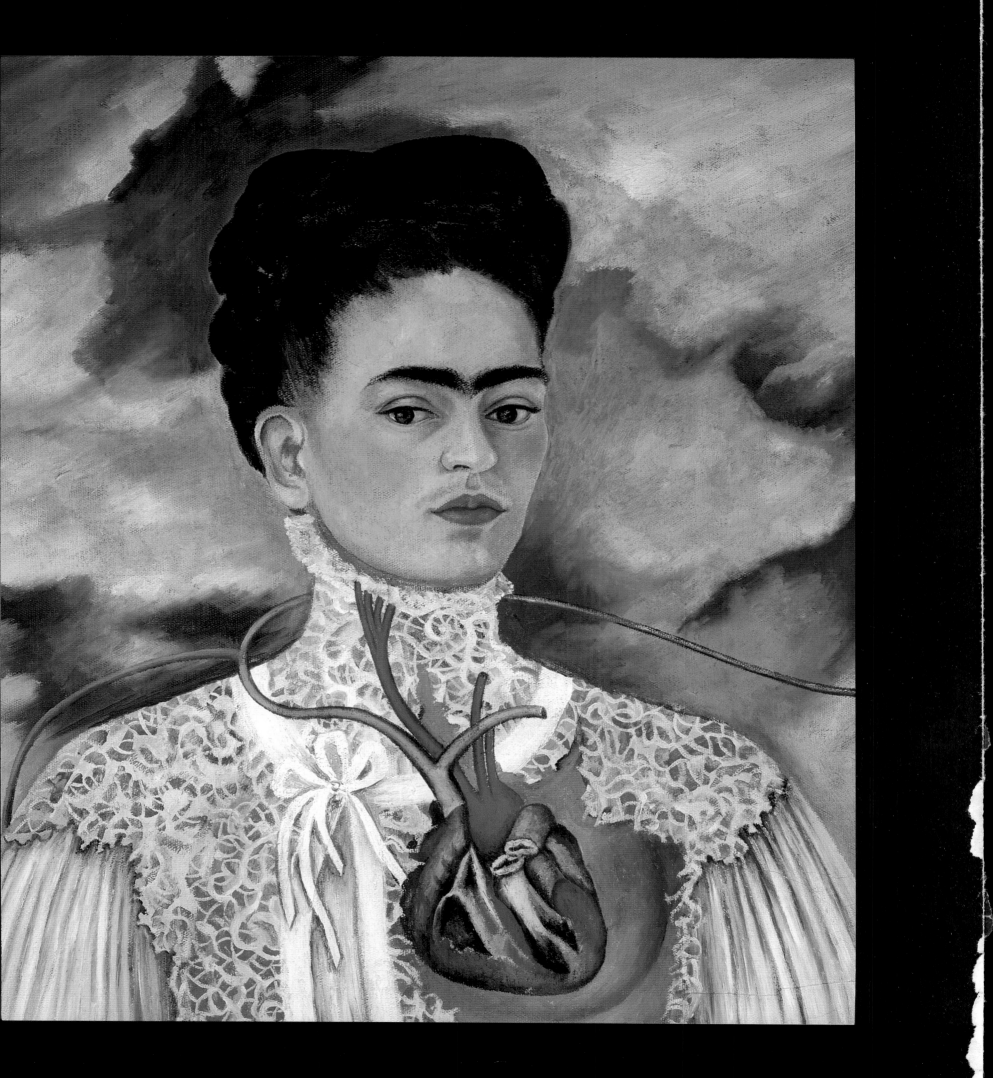

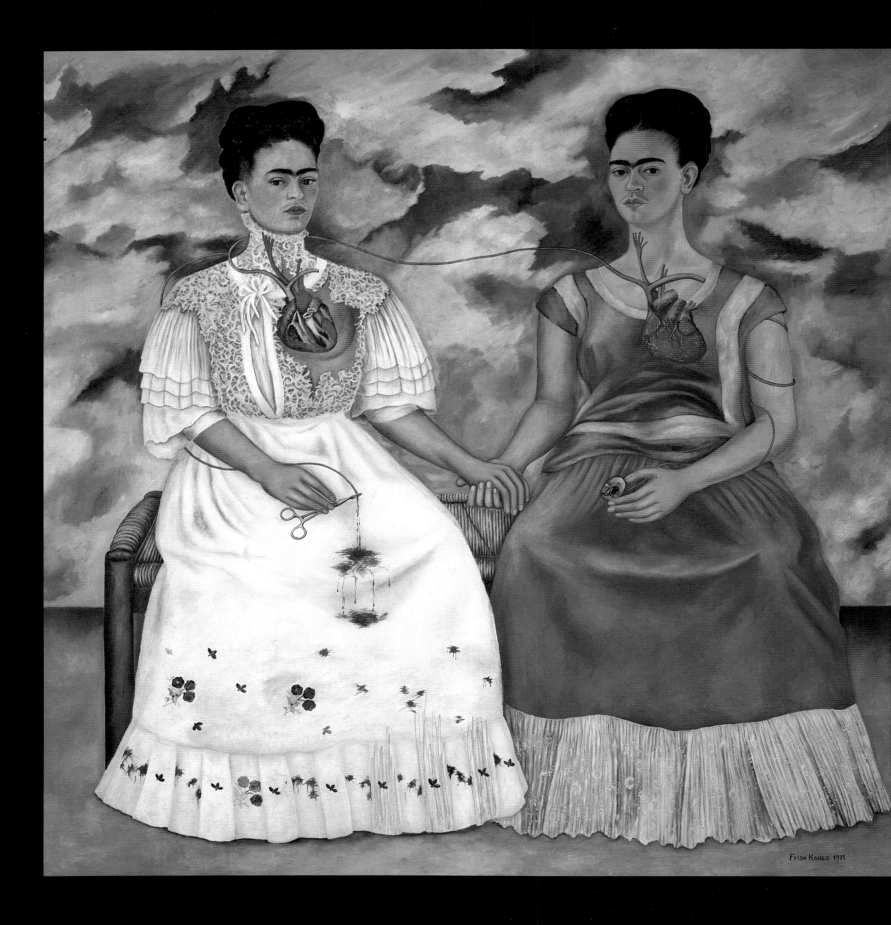

THE TWO FRIDAS, 1939.
OIL ON CANVAS,
173.5 x 173 CM

PAGES 144–147:
THE TWO FRIDAS, 1939
(DETAILS)

was held in the small but famous gallery of Julien Levy, who had taken an interest in well-known surrealist painters, was additionally impressive.[63] Moreover, the fact that André Breton wrote the presentation for her international debut was formal recognition of her years of work and effort. Despite this, after the exhibition was over and she had been celebrated in Paris, congratulated by Pablo Picasso, Wassily Kandinsky, Yves Tanguy, and other important figures, Frida Kahlo distanced herself from the surrealist movement, the reasons for which are not clear. Apart from the fact that she did not get on with Breton at a personal level, as revealed in the letters she wrote to the photographer Nickolas Muray and to her dear friend Ella Wolfe, there seem also to have been considerable political differences between them. The breakup between Diego Rivera and Leon Trotsky, due to ideological reasons, had an effect on Breton, who admired Trotsky for what he represented. When Trotsky was assassinated in Mexico, Breton and the surrealist movement ostracized Rivera for having turned his back on the Soviet revolutionary. In this respect, Kahlo's solidarity with Diego Rivera was complete, and we know she distanced herself from the Parisian avant-garde, which she ultimately found uncommitted to the social causes in which she was interested.

Having said that, it does seem something of a contradiction that, having been accepted as a surrealist with open arms, Kahlo then proceeded systematically to deny these ties. What Breton did not say about any other woman artist—not even Remedios Varo or Leonora Carrington—he stated with conviction about her work, pointing out that "from the point of view of her artistic skill, Frida Kahlo's contribution to contemporary art represents a watershed among the various pictorial trends that are emerging." In this sense, according to Breton, Kahlo's esthetic position was a starting point, the beginning of a path of expression that had no comparison at the time and that was promising in terms of the history of art. That did not occur, however, at least not during the following five years prior to her death. Today, at the dawn of a new century, the words of Breton ring prophetically, and Kahlo's work is a melting pot that encompasses many causes and new generations of artists all over the world who feel they have been touched by the esthetic universe she created through her painting.

Today, *Las dos Fridas* (The Two Fridas) has become a tremendously popular image. Of all of Kahlo's paintings, it is perhaps the only one that is such an object of reverence, being, as it is, permanently exhibited in a museum. Before being presented in the Gallery of Mexican Art for the International Surrealism Exhibition, the painting was taken to New York in 1940 and put on display in the Museum of Modern Art as a main piece of the exhibition entitled "20 Centuries of Mexican Art"; Kahlo kept it until 1947, when it was purchased by the Instituto Nacional de Bellas Artes (INBA) for the sum of 4,000 pesos. It is a fundamental piece of her iconography, and without doubt her most ambitious. It is Kahlo's summary of a long process of personal experience, both psychological and creative, and of her interpretation of herself and the vision she wanted others to have of her. She painted herself twice sitting on a long bench that crosses the composition horizontally. The space she has created is enigmatic, so desolate and solitary that the two Fridas seem to be floating in limbo; behind her the sky is full of heavy clouds that block out the light. However, despite its visual impact and emotional power, the painting was conceived intellectually and is thus easier to explain with greater objectivity.

The background is not very different from many of Kahlo's other works in that it takes its visual references and context from the history of art. The first point that needs to be made is that it is a symbolic rather than surreal image. We do not know it as the product of a dream, and hence the projection of her subconscious; in actual fact, it proves to be a very detailed realist vision that Frida seems to build completely consciously, starting from a reality she knows perfectly well in both her personal and artistic life. *The Two Fridas* is a painting in which Kahlo does not seem to want to evade reality, as she would according to the theories

[63] This is the gallery in which Joseph Cornell, Salvador Dalí, Max Ernst, Alberto Giacometti, and René Magritte all held their first exhibitions in New York; the surrealist painters Leonor Fini and Dorothea Tanning also exhibited here. (See Ingrid Schaffer and Lisa Jacobs, *Julien Levy: Portrait of an Art Gallery* (Cambridge: MIT Press, 1998.)

of surrealism, but rather the contrary: It is an emphatic reaffirmation of how she appears to herself. For example, the faces of both Fridas were executed in front of a mirror, as she often did throughout her career, and the clothes were copied realistically, as she had done in many of her previous paintings; the representation of the heart split in two, one for each Frida and attached by an artery from one body to the other, is also a detailed reconstruction by a painter with a knowledge of anatomy and medicine. It is, in any case, the product of a technical obsession, an attempt to give space to a faithful representation of that which, though impossible, becomes credible de facto.

It is also, however, a painting that draws on symbolism. In other words, the images that Kahlo paints so realistically symbolize something else; they replace the artist's concrete thought process and explain it metaphorically by making use of a code of hidden meanings. This esthetic position was a very common trend at the end of the nineteenth century, both in painting and in literature, and was typical in the approach of the Mexican high culture of the Porfiriato period. The poetry of López Velarde, which Frida knew well, as it was a model for her generation, is

somewhat symbolic. The compositions of flowers and landscapes that Wilhelm Kahlo painted also reflected the tastes at the end of the nineteenth century, and much of Frida Kahlo's painting is based on imagery of a symbolic nature. It is not surprising, therefore, that a symbolist painting was perhaps the conceptual model for *The Two Fridas*. I am referring to a dual portrait by Julio Romero de Torres (1874–1930), a Spanish painter who was representative of a whole age, that of modernism and the *noucentisme* of Eugenio d'Ors, and whose work was well known in Mexico; echoes of his work can be found in the paintings of Saturnino Herrán, and above all in those of Ángel Zárraga, whose paintings were discussed in the illustrated weeklies of the Porfiriato period. This type of painting was well established in Mexico and started to disappear after the cultural renaissance of the postrevolutionary era. In 1909, Julio Romero de Torres painted the famous *Ángeles y Fuensanta* (Ángeles and Fuensanta), which is exhibited in his museum in Córdoba, Spain. It is not a portrait in the strict sense, but rather a literary passage representing the comparison of sacred love with profane love, a faithful image of the esthetics of symbolism.[64]

It is hard to believe that the similarities in the two paintings, even though they were separated by thirty years and by the Atlantic Ocean, could be a pure coincidence. If Kahlo had not been a painter with a cosmopolitan outlook, restless and intellectually well read, with a visual culture that from the 1920s revered El Greco, Piero della Francesca, and Agnolo Bronzino equally, we might be able to believe that the painting by Romero de Torres did not influence her at all. When we compare the two paintings, however, the result is truly unsettling. In both paintings there are two identical women sitting in front of a landscape. Each model

[64] *Ángeles and Fuensanta* is not a double portrait but rather a metaphor of virtues inspired by literature; documents show that the model was the beautiful Socorro Miranda from Córdoba. Between 1907 and 1909 Romero de Torres painted various compositions with dual images of women symbolizing opposite virtues, such as *Amor sagrado y amor profano* (Sacred Love and Profane Love) and *El retable del amor* (The Retable of Love). (See *Julio Romero de Torres, desde la Plaza del Potro*, exh. cat., Museum of Fine Arts of Córdoba, Sociedad Editorial Electa, Madrid, 1994.)

takes up one side of the painting, and their bodies are depicted from the top down; all four of them, that is, the two Fridas, Ángeles, and Fuensanta, observe the viewer closely. In both compositions there is a dichotomy between the two characters, and each woman is the visual opposite of the other: They are dressed in opposite ways, and one of them is wearing a lace dress with a high neck that frames her face. Both pairs establish a visual rhetoric with their looks and their hands, and in each case one of the pair is holding something that triggers the drama of events. In Julio Romero de Torres's it is Fuensanta who is holding a letter from her beloved; in Kahlo's painting one of the Fridas is holding a pair of surgical scissors; the letter and the scissors are the visual elements that control the narrative of the image: the letter conceals the secret of a great love, while the scissors contain the blood and the breath of the two Fridas. And if all these similarities were not enough to establish the strong psychological relationship between the two paintings, we can also point out that both Ángeles and the Frida on the right are holding a tiny self-portrait: an undeniable sentimental ploy they both share and that underlines the connection once and for all.

Nothing emerges from all the research carried out to date, and from all the books that have been written on Frida Kahlo, about whether she ever spoke of having seen Romero de Torres's painting. Diego Rivera, however, did mention it and knew very well who Julio Romero de Torres was, and even met him in Madrid in around 1907. At that time Rivera was a patron of the Nuevo Café de Levante, attracted by the personality of the poet Ramón Valle-Inclán, an admirer and supporter of Romero de Torres, whose work was one of the favorite topics of discussion among the artists of Spanish modernism, among whom appeared an observant and restless Diego Rivera.[65] Whether Frida Kahlo used the composition of Romero de Torres as a basis for her

THE TWO FRIDAS,
CA. 1944

famous painting is not important, it is merely circumstantial. In either case, it only further supports the fact that her art was cultured and soundly based and in no way changes the powerful energy of the image and the emblematic dimension it represented for her at a particular moment of her life. Lastly, the duality of *The Two Fridas* does not come from Romero de Torres, but from a genuine feeling of existential anguish. In an interview with her friend Lola Álvarez Bravo, Frida Kahlo's profound dilemma emerged: "She lived surrounded by mirrors, and she actually led two lives. She could be happy and superficial, a complete person, without pain, but deep down, I believe that she felt that she was living a borrowed or stolen life."[66] This is the power of the image in the esthetic universe of Frida Kahlo: having conceived a reality more alive than life itself.

San Sebastián de Axotla, 2000

[65] Romero de Torres's painting was executed in around 1909. We know that Diego Rivera arrived in Spain in 1907 and that he stayed in Madrid until May 1909, and, like many other painters, including Ángel Zárraga and Roberto Montenegro from Mexico, he was attracted by the esthetics of the writer Ramón Valle-Inclán, who in turn had influenced Romero de Torres. This has been pointed out perceptively by Ramón Favela (*El joven e inquieto Diego María Rivera [1907–1910]* [Mexico City: Editorial Secuencia, 1991], p. 27).

[66] She was interviewed in Cuernavaca in 1989. (Cf. S. Grimberg, *Lola Álvarez Bravo: The Frida Kahlo Photographs* [Dallas: Society of Friends of the Mexican Culture, 1991], p. 9.)

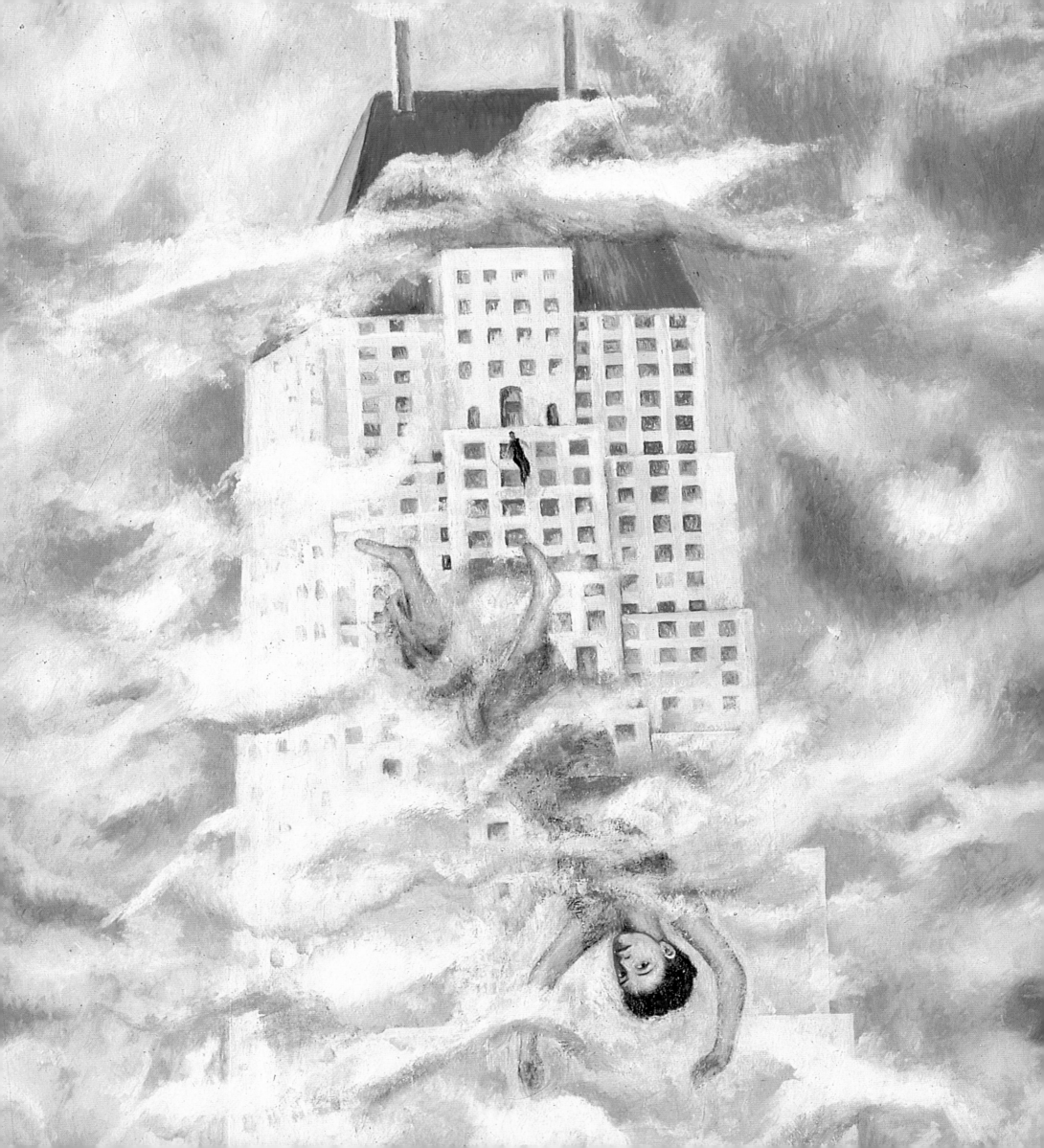

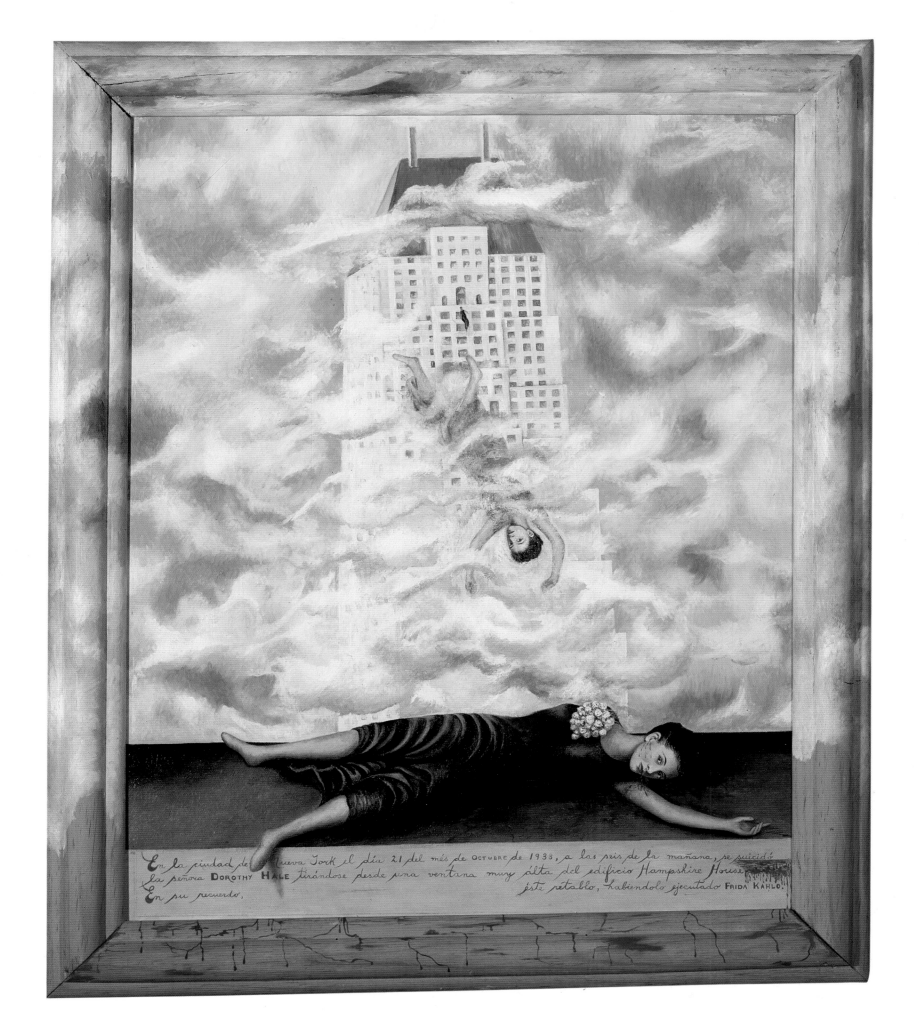

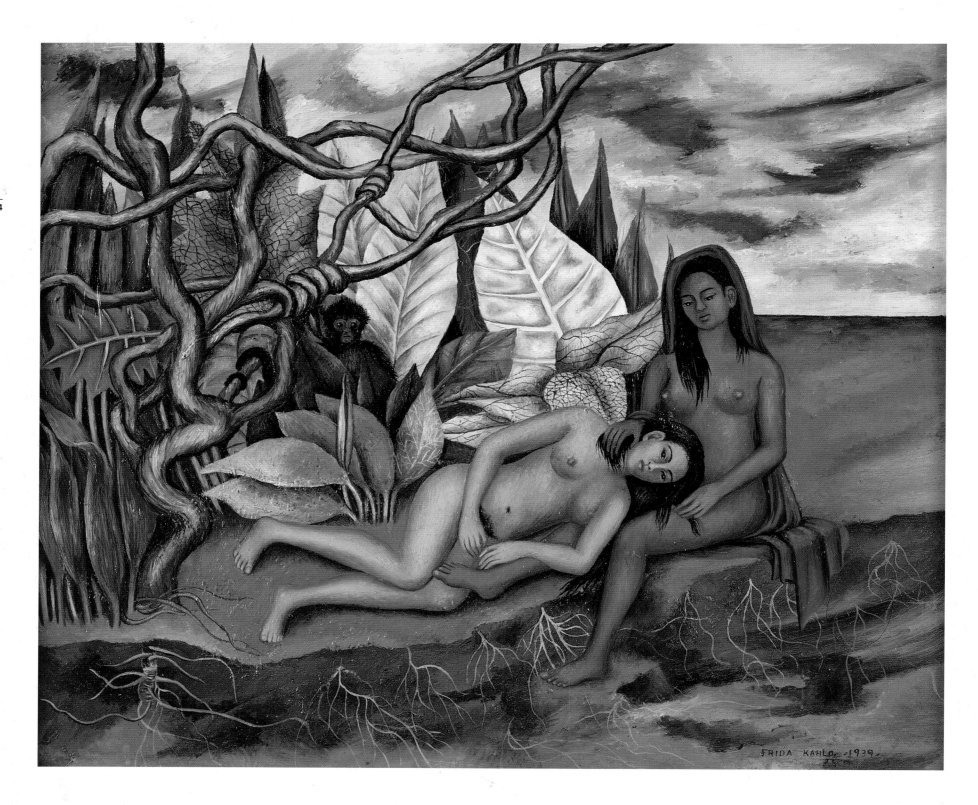

PREVIOUS PAGES:

THE SUICIDE OF DOROTHY HALE, 1938.
OIL ON MASONITE,
59.1 x 48.3 CM (INCLUDING FRAME)

EARTH HERSELF, 1939.
OIL ON PLATE,
25.1 x 30.2 CM

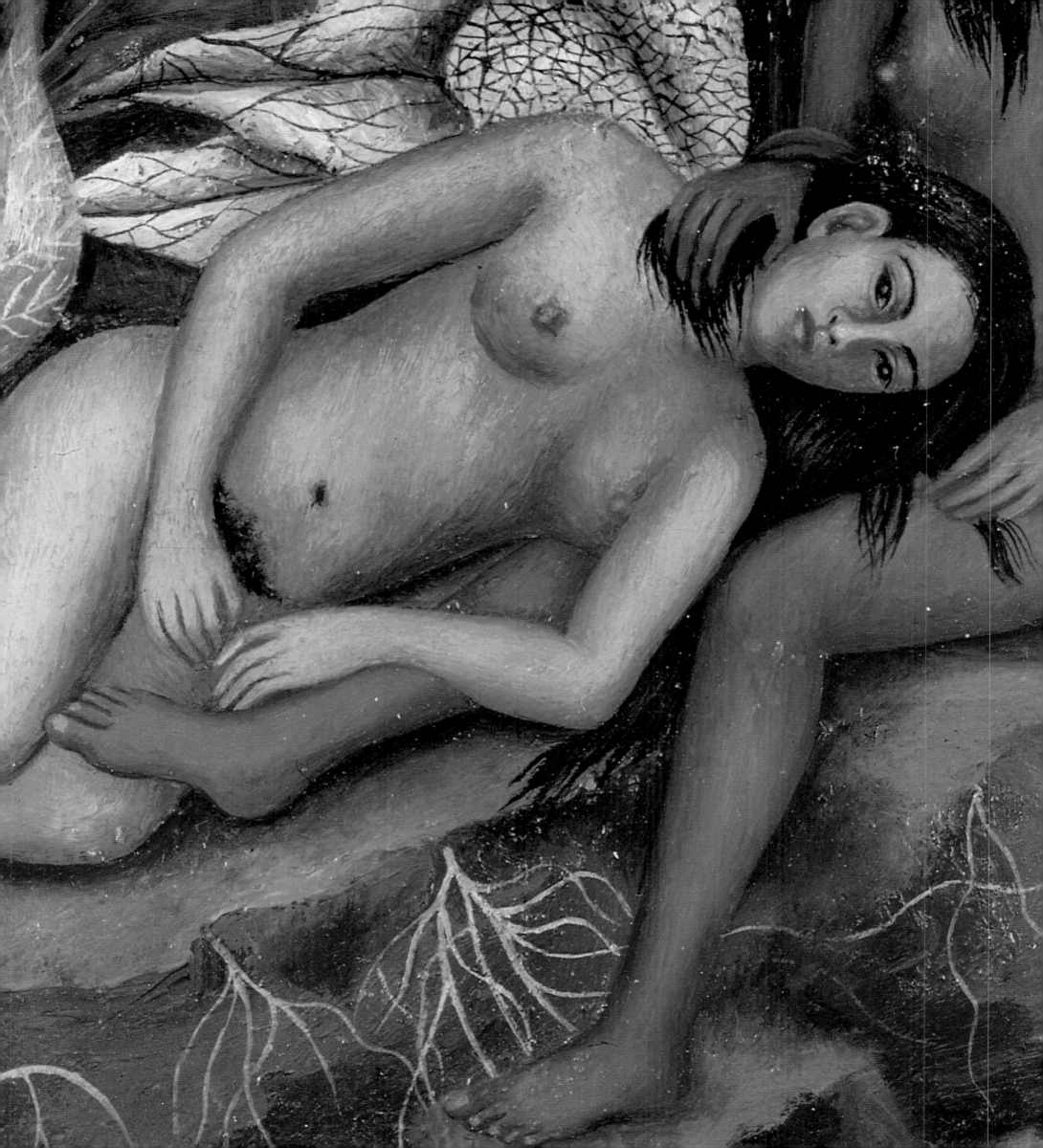

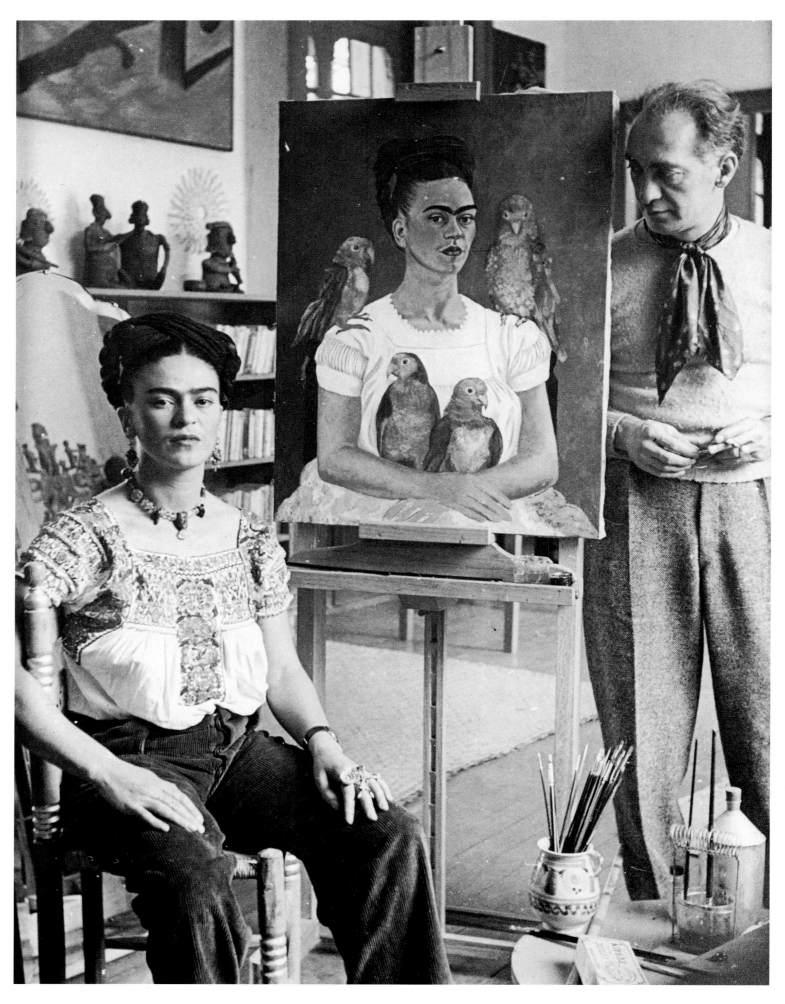

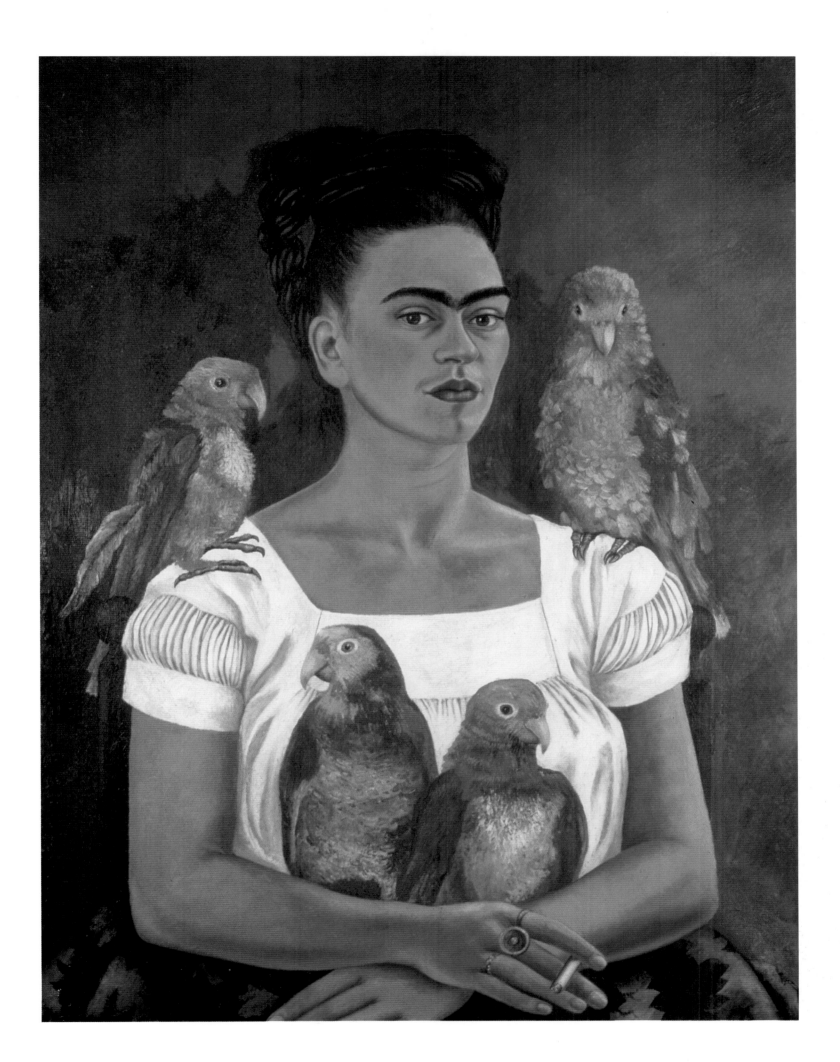

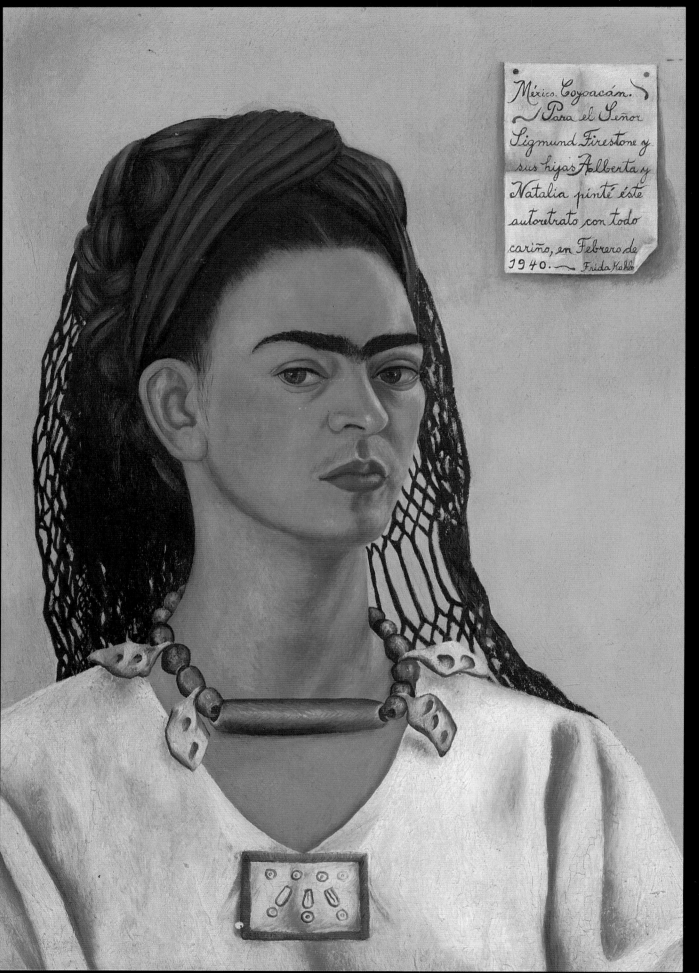

México. Coyoacán.
Para el Señor
Sigmund Firestone y
sus hijas Alberta y
Natalia pinté éste
autoretrato con todo
cariño, en Febrero de
1940. Frida Kahlo

*SELF-PORTRAIT (DEDICATED
TO SIGMUND FIRESTONE)*, 1940.
OIL ON MASONITE,
61 x 43 CM

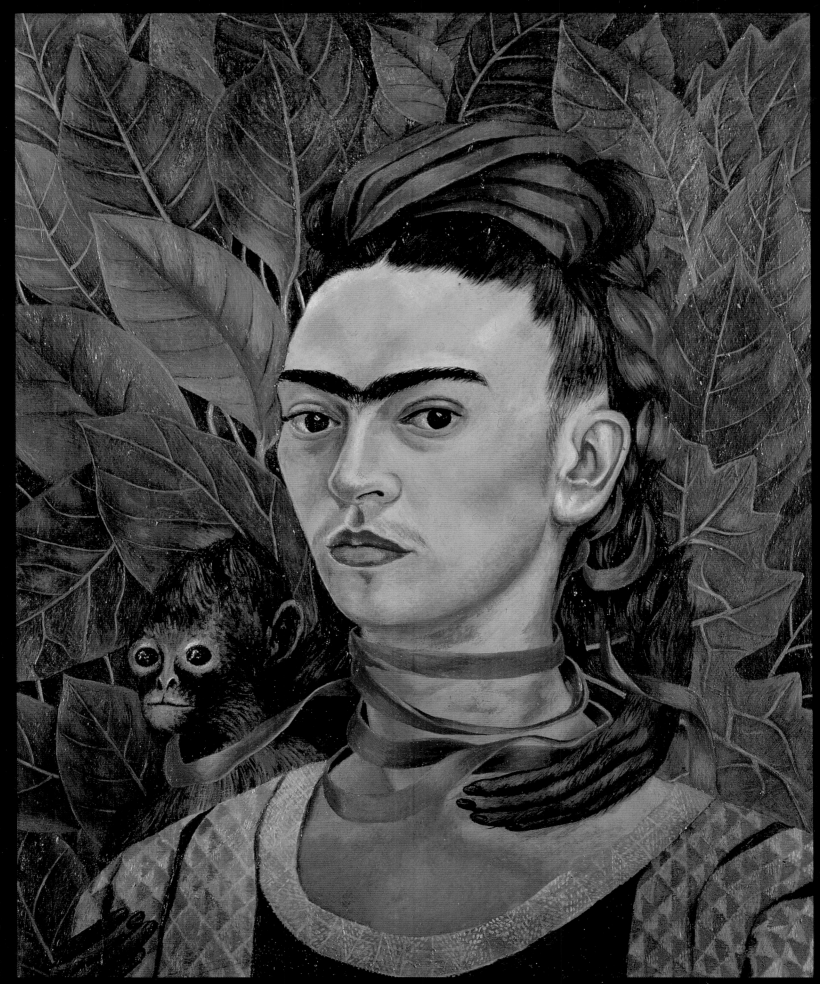

SELF-PORTRAIT WITH MONKEY, 1940.
OIL ON MASONITE,
55.2 X 43.5 CM

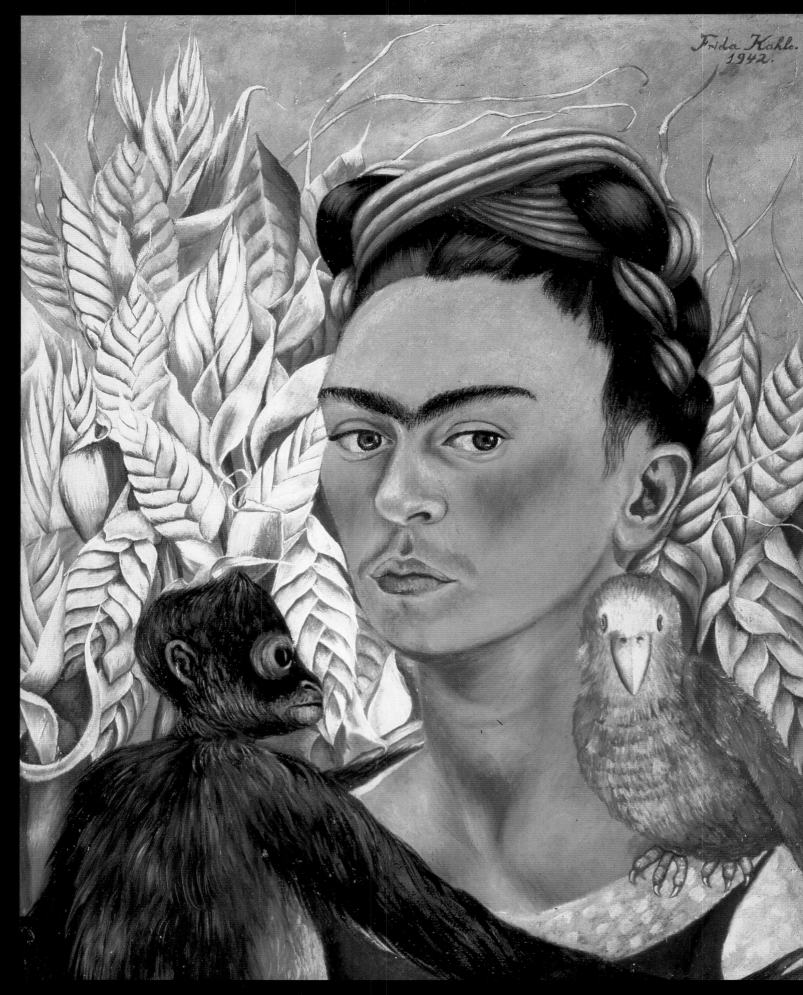

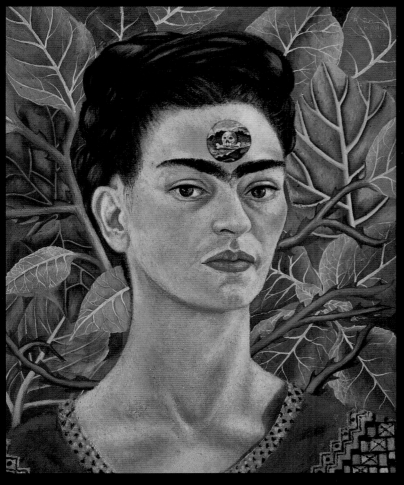

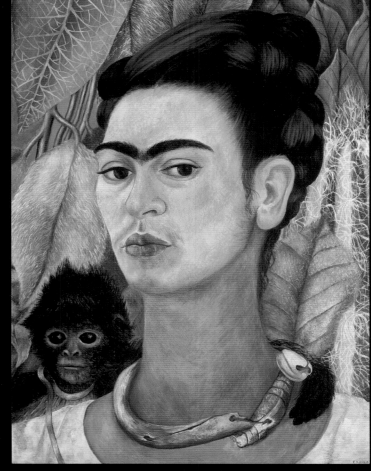

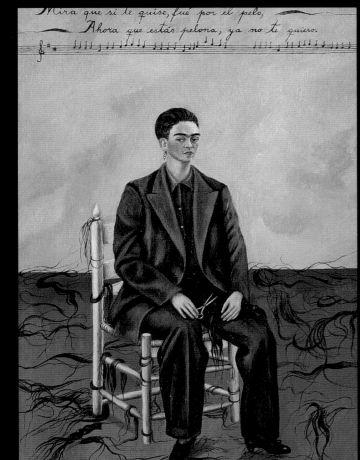

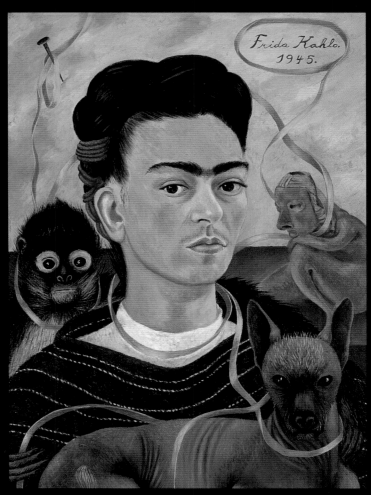

THINKING ABOUT DEATH,
1943.
OIL ON CANVAS MOUNTED
ON MASONITE,
44.5 x 36.3 CM

SELF-PORTRAIT WITH MONKEY
(PAINTED FOR CONGER
GOODYEAR), 1938.
OIL ON MASONITE,
40.6 x 30.5 CM

*SELF-PORTRAIT WITH CROPPED
HAIR*, 1940.
OIL ON CANVAS,
40 x 28 CM

*SELF-PORTRAIT WITH MONKEY
[AND SEÑOR XÓLOTL]*, 1945.
OIL ON MASONITE,
60 x 42.5 CM

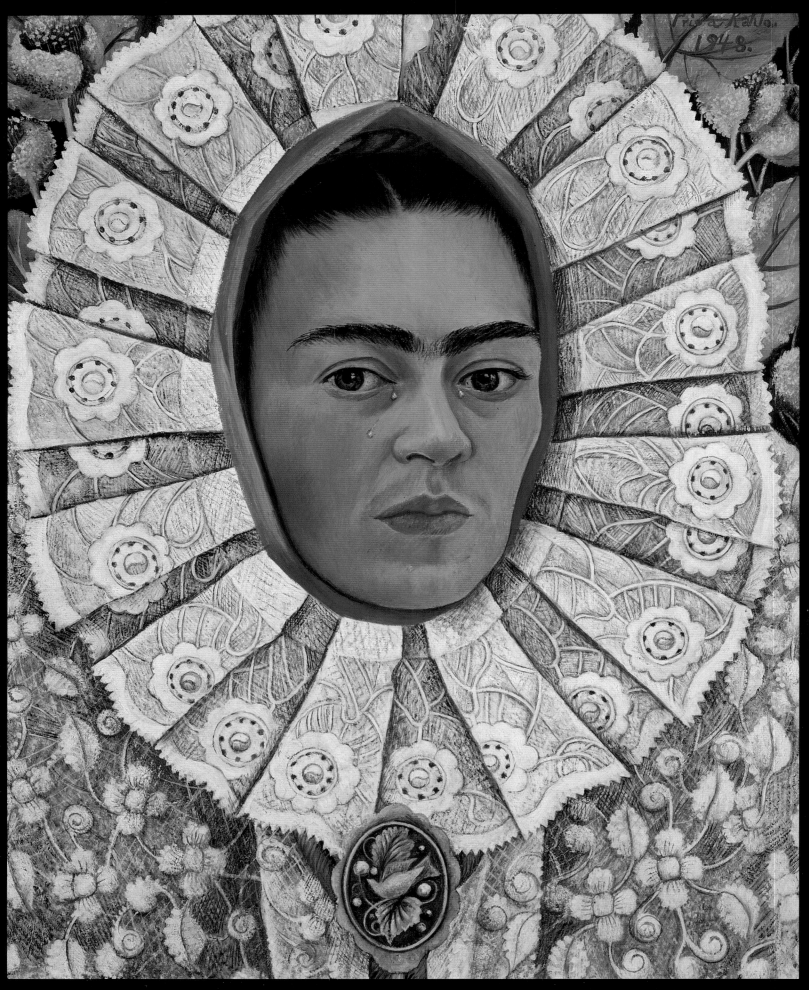

SELF-PORTRAIT (PAINTED
FOR SAMUEL FASTLICHT),
1948.
OIL ON MASONITE,
50 x 39.5 CM

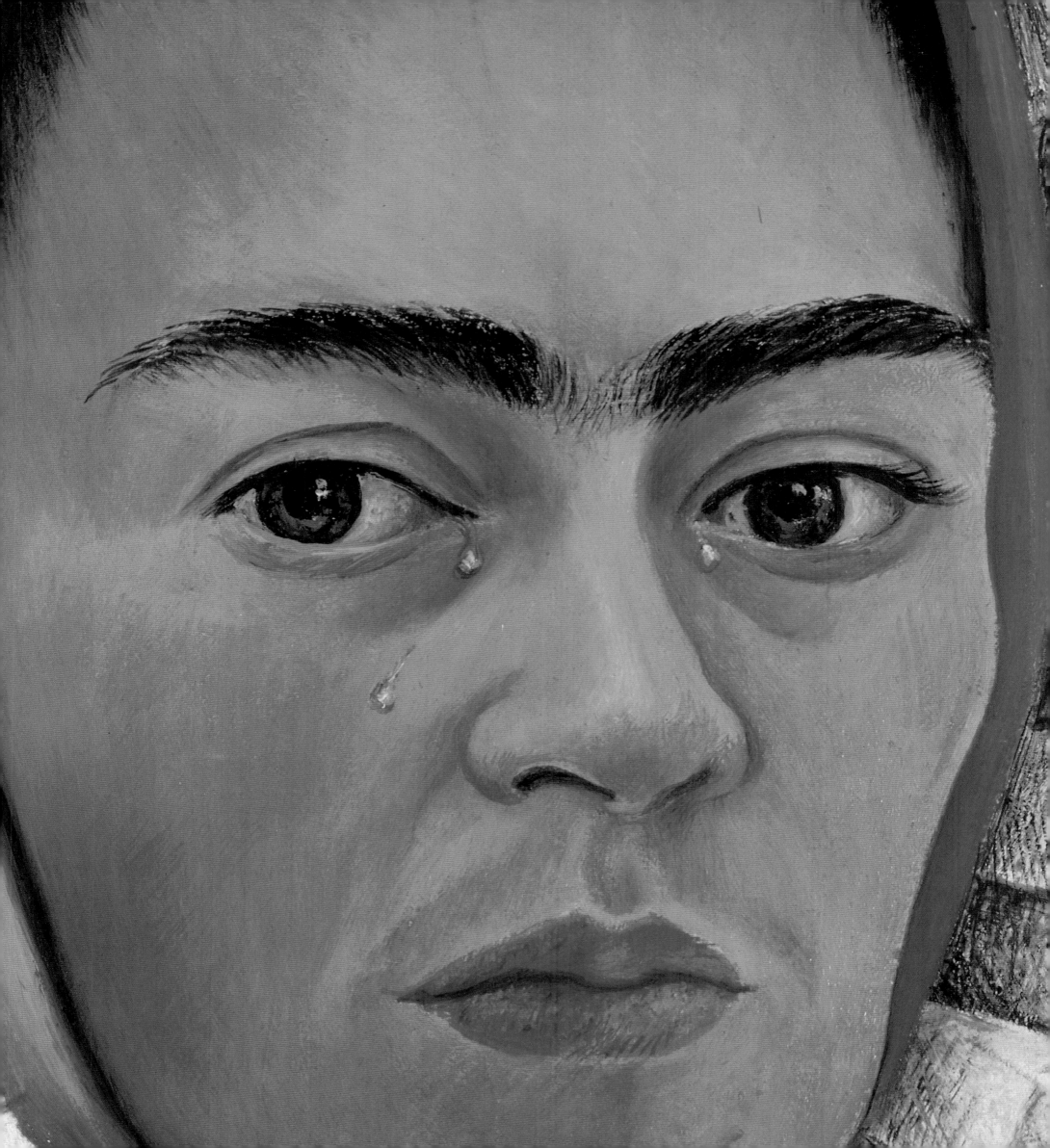

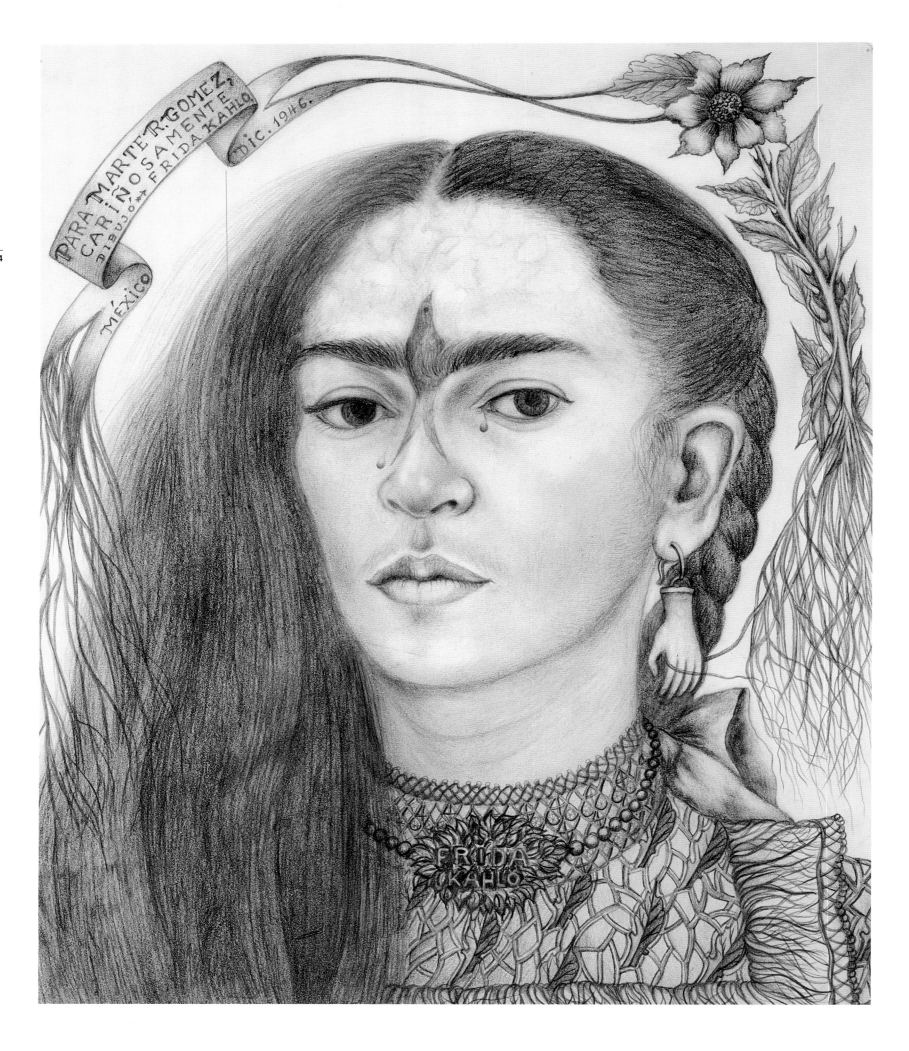

¡Ojo avi[z]or!, 1934.
PENCIL ON PAPER,
21 x 30.5 CM

Fantasy, CA. 1944.
CRAYON AND SANGUINE ON PAPER,
23.5 x 15.3 CM

PREVIOUS PAGE:
Self-Portrait (DEDICATED TO MARTE
R. GÓMEZ), 1946.
PENCIL ON PAPER,
38.5 x 32.5 CM

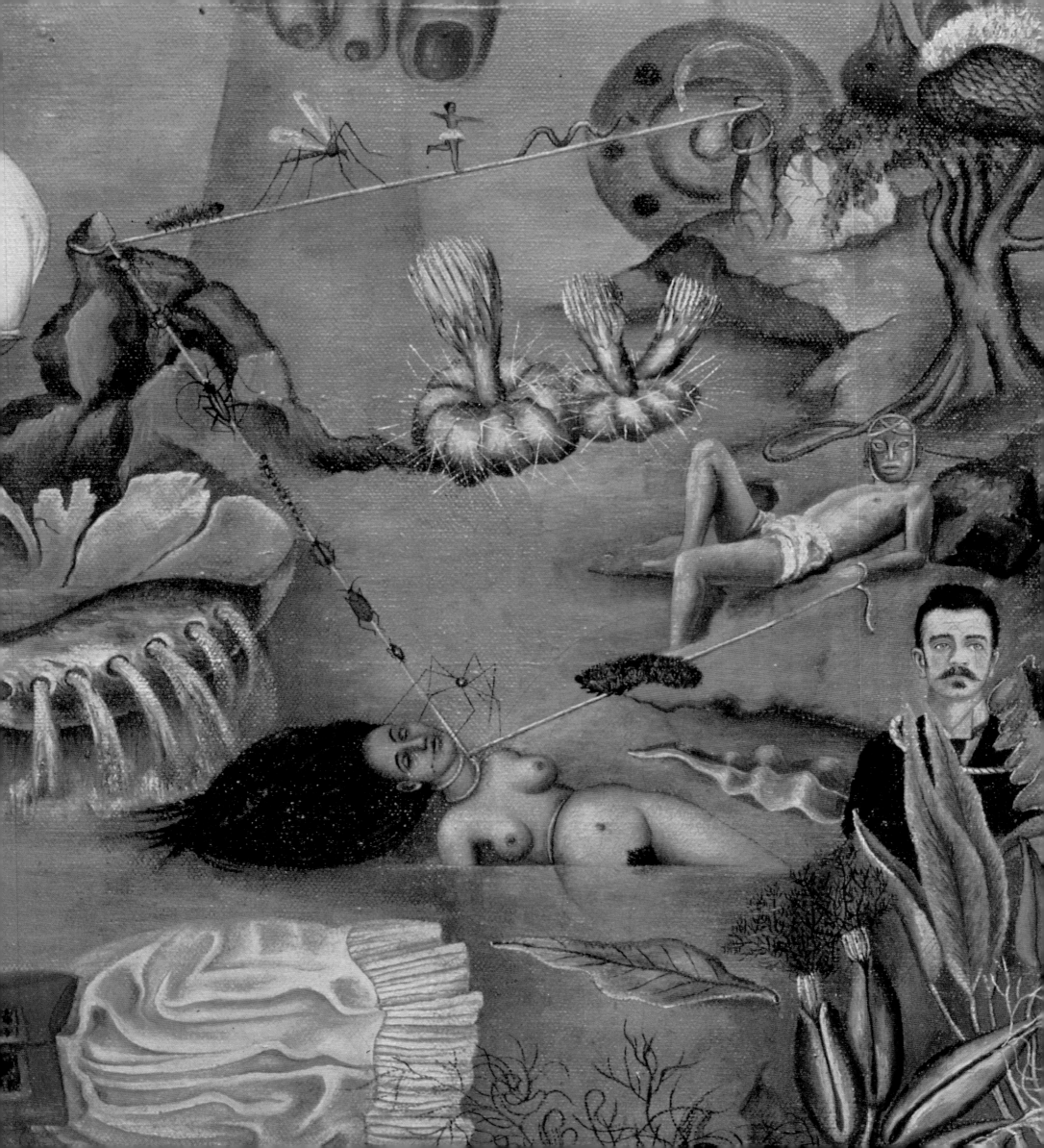

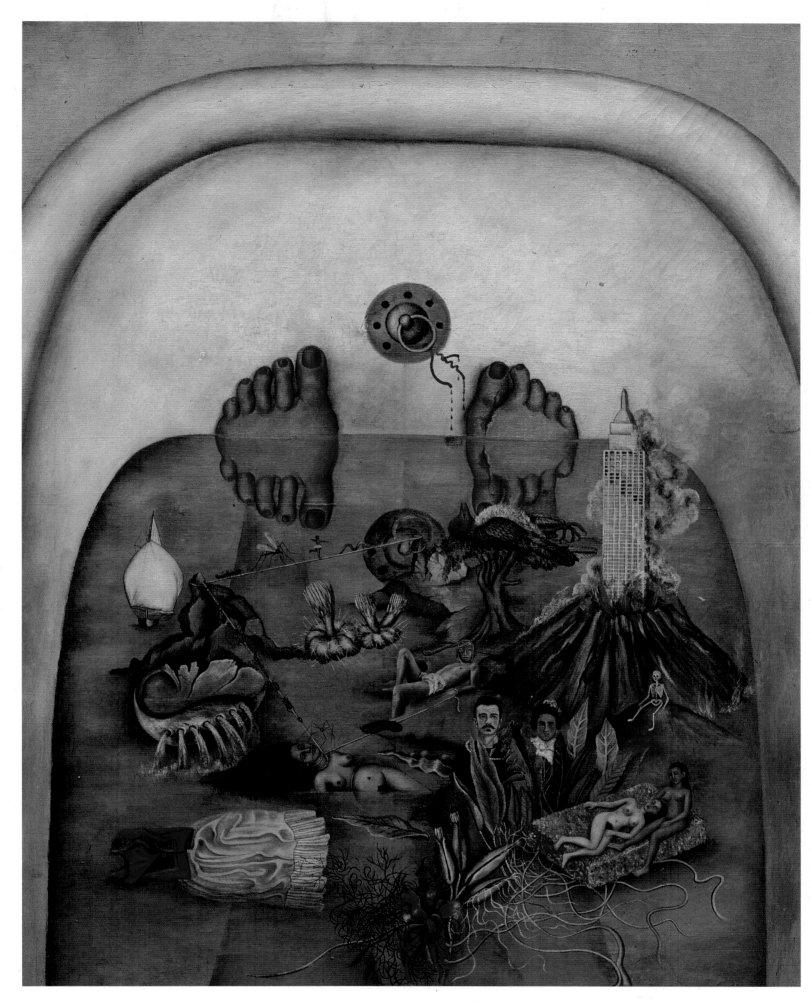

What the Water Gave Me, 1939.
Oil on canvas,
69 x 88 cm

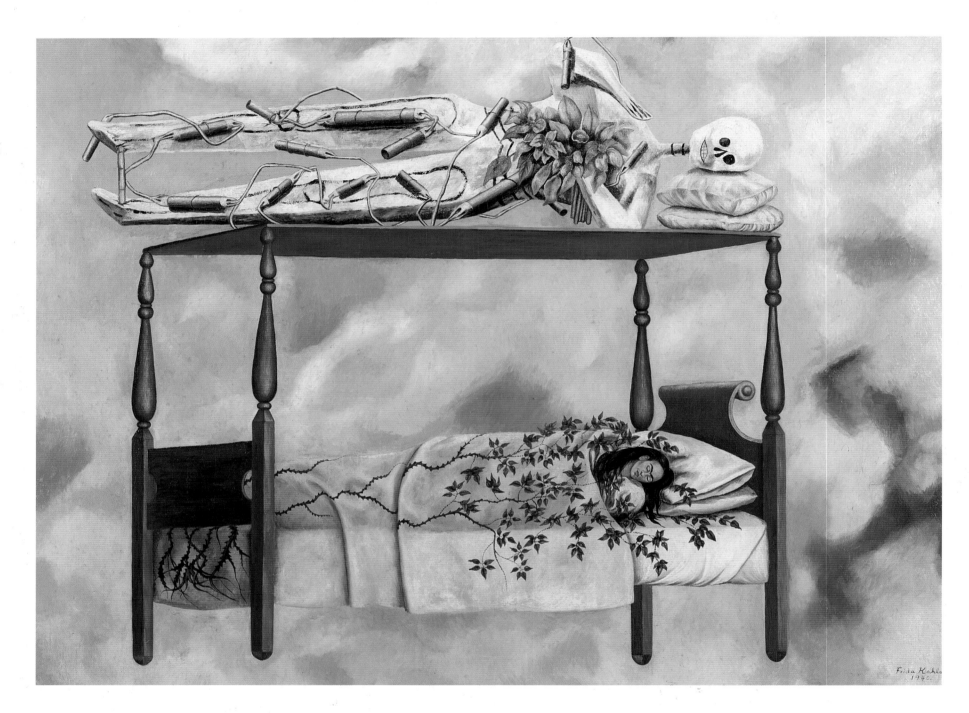

DREAM (THE BED), 1940.
OIL ON CANVAS,
74 x 98.5 CM

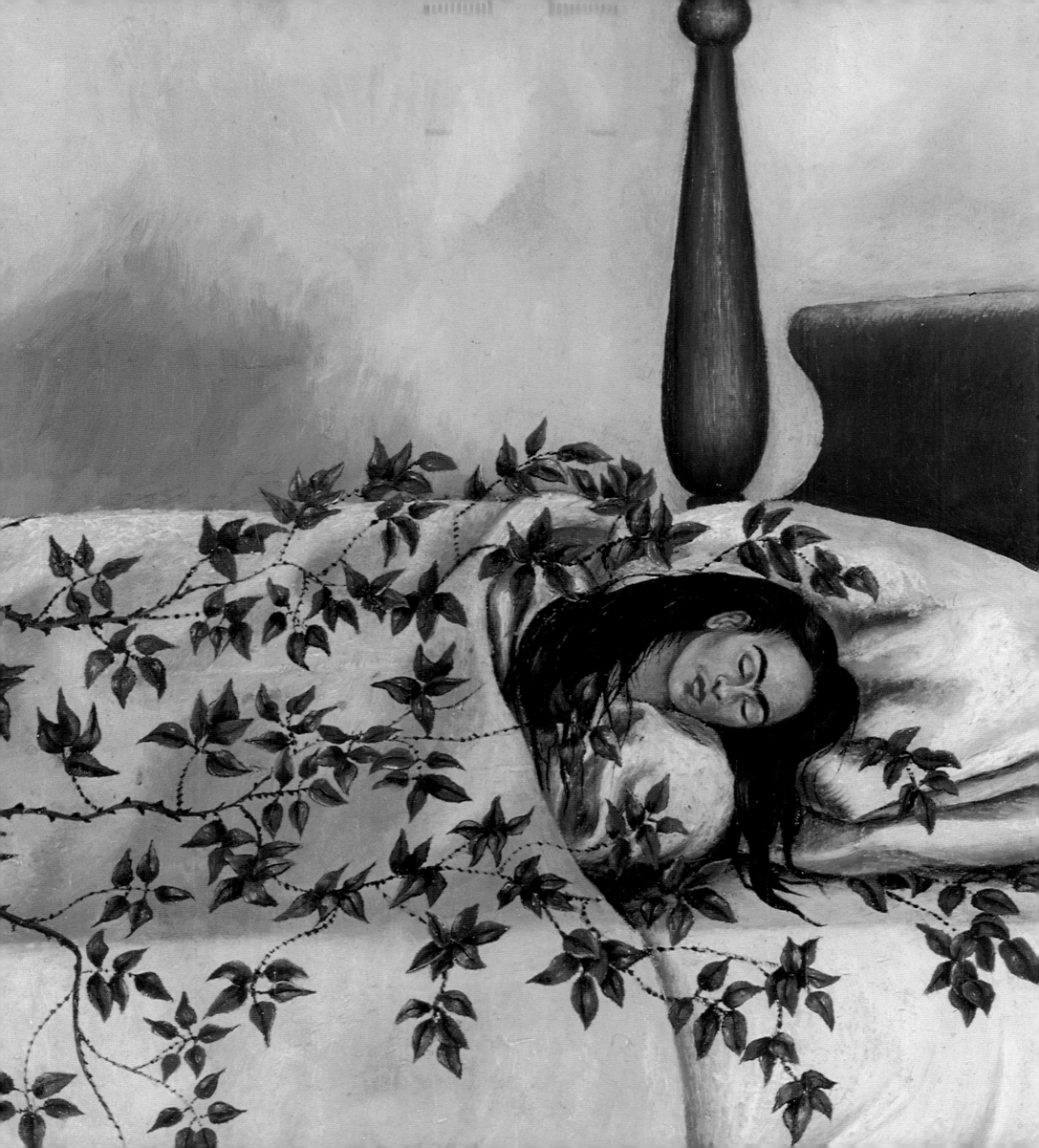

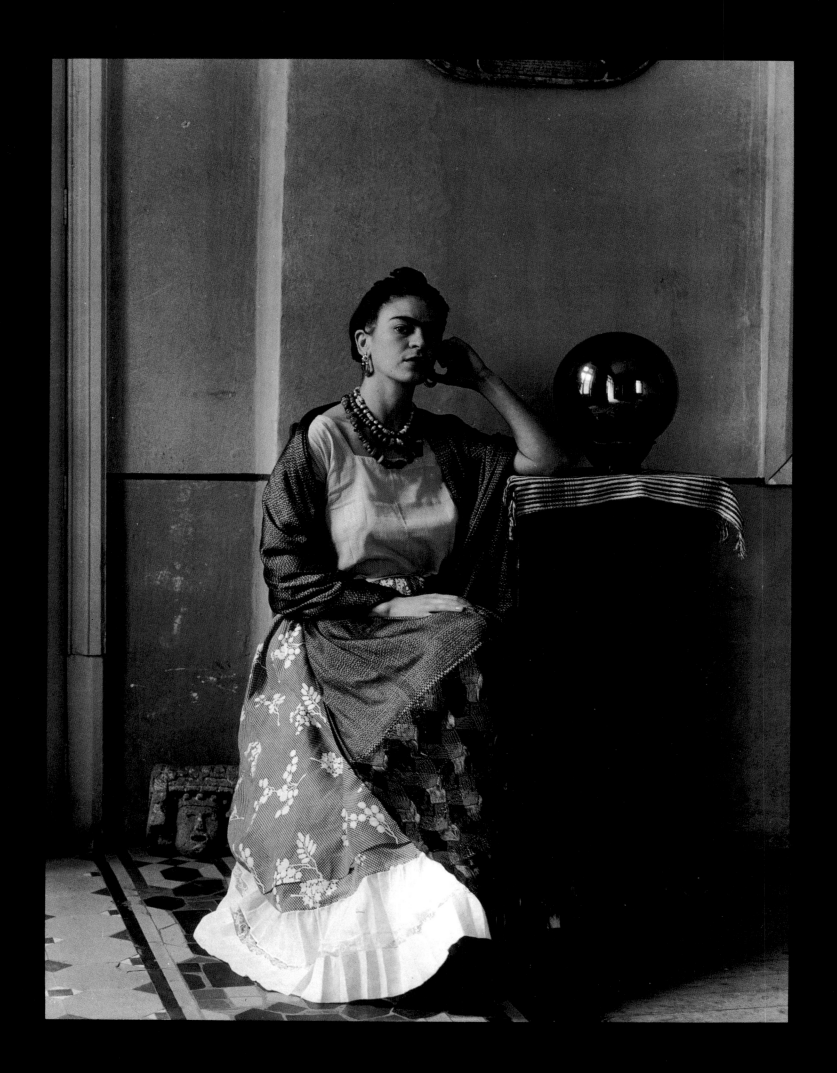

Iztaccíhuatl in the Valley of Anáhuac

Antonio Saborit

At the end of the 1920s, among the many artists and writers who walked the gay, oft-depicted streets of Mexico City, the figure of Frida Kahlo was barely visible behind the gigantic shadow thrown by the ungainly Diego Rivera. She was a slight young girl, and to the profane and uncaring eye of ordinary people her beauty was not much more than an eccentric whim in the turbulent story of a very controversial painter.

These few pages are an attempt to find the shining points of a period in the twentieth century and, through the conversations of the community of writers and artists who had settled in Mexico City between 1920 and 1930, to describe briefly the path Frida Kahlo took. During this period, allusions to how the capital city represented Paradise in the stone age of the revolution were common—allusions that were not able to survive reality or the descriptions that such writers as Malcolm Lowry and Graham Greene gave shortly after. Nevertheless, at that time, that is to say, in the 1920s, thinking of Mexico City as a kind of Paradise was a way of viewing the world and of experiencing both the period in the wake of the First World War and the internal struggle of Mexico.

Frida Kahlo appeared on the artistic and cultural stage of Mexico in the 1920s as the curtains were about to close on a scene of unusual artistic activity when people lived happily, irresponsibly, joyfully, and intensely. The following decades would pale by comparison. Like the decade itself, she was a woman in her twenties, though her age was a mystery for a long time, since her friends were as uninterested in it as they were in the diabolic pranks of the unpredictable and fortunate Diego.

In order to get a better sense of the city in which Kahlo lived—such a blessed city, yet implacable in its gossip—it might

be helpful to use the description that Manuel Maples Arce left in his memoirs. Originally from Jalapa, he arrived in the capital city to study at the Escuela Libre de Derecho (Free School of Law) at the beginning of the 1920s. He settled in an inner-city suburb of "run-down buildings, overcrowding, poverty, and stalls" and experienced the postrevolutionary city as if it were a sentimental education. It is here that his personal internal world, made up of "transcendent expectations, impulses, and nonconformist behavior, independent will and balanced memories," found channels of expression; his experience of the city led him to express himself in art.[1]

Maples Arce enjoyed the pleasures that came from living in one of the major and most complete urban spaces the country could offer in the 1920s, and he made the most of each and every opportunity the capital could offer someone like him. Thus, with the devotion of a convert, he experienced the intense political life of the performances in theaters like the María Guerrero, "in which popular *picardía* flourished"; the commotion in the editorial offices of *Revista de Revistas,* not far from the Reforma and Bucareli intersection, or in Pedro Malhabear's *Zig Zag* close to the Bellas Artes building or in *El Universal Ilustrado;* the rambling walks in Orizaba Square and toward the church next to the Sagrada Familia in the Roma suburb in the company of the very attentive Ramón López Velarde; a taste for parties on terrace roofs, like those held in the building of the Vicencio family, a rooftop reception room open to the sprawl of the urban landscape where one could find Alfonso Toro, Nicolás Rangel, the Núñez and Domínguez brothers, Ernesto García Cabral, Rubén

[1] Manuel Maples Arce, *Soberana juventud* (Madrid: Plenitud, 1967), pp. 47–49.

M. Campos, Martín Gómez Palacio, and, among others, José Dolores Frías.

A good friend of painters, Maples Arce visited the Academia de San Carlos and the crammed galleries of Mexican antiquities in the Museo Nacional de Historia, Arqueología y Etnografía (National Museum of History, Archeology, and Ethnography). His appreciation of painting led him to turn up on more than one occasion at the studio of Fernando Leal in calle Motolinía or Ignacio Rosas, which, "luxuriously furnished with a piano, rugs, and china jars, attracted those with time to spare." Maples Arce looked quite eccentric when he walked along the wood groves of trees leading from Coyoacán to San Ángel in the company of Fermín Revueltas. He was familiar with other places, too, such as "the untidy room full of paintings and music scores" where Silvestre Revueltas played for a small group of friends; José Juan Tablada's simple folk-style apartment in Ayuntamiento where Francisco Monterde, Adolfo Best Maugard, Manuel Rodríguez Lozano, Miguel Covarrubias, Jorge Juan Crespo de la Serna, and Jorge Enciso would talk; the house of Genaro Estrada, in the suburb of Santa María, which was visited by Artemio de Valle-Arizpe, Julio Torri, and Mariano Silva y Aceves; the Mixcoac hide-out of Francisco González Guerrero or even the office of Rafael López in the Archivo General de la Nación (General Archive of the Nation), which at that time was in the Palacio Nacional overlooking calle Corregidora. These visits would end with a stop at López's favorite bar, where Gilberto Bosques, Guillermo Castillo Tapia, Jesús López Velarde, and Alfonso Toro would gather until life in the cafés got under way. Maples Arce went to as many cafés as he could: the Oriental, "where teachers and artists went," he would say; El Globo, on the corner of Madero and Bolívar; Café Alemán, in calle Orizaba; Café de Tacuba, Principal, and La Flor de México, Las Olas Altas, in Bolívar; El Tupinamba, and, of course, the Café Europa, on Jalisco Avenue, renamed semi-officially Café de Nadie (No-one's Café).[2] Other somewhat important restaurants were the San Ángel Inn, the Sylvain, and the Chapultepec.

Several years ago, we would have asked whether in the urban environment of the capital during those years a girl like Frida Kahlo would have experienced the same kind of enthusiasm described by Maples Arce. It was certainly a gratifying sensation that sent him into the crowded streets, where he believed he could "discover motives and psychological perspectives" that would enrich him with "valuable experiences." The answer is yes, in as much as certain streets and avenues of the city surrendered themselves to the girl in the company of her friends and companions of the Preparatoria Nacional who belonged to the informal group of *Los Cachucas*: Alejandro Gómez Arias, Miguel N. Lira, Manuel González Ramírez, José Gómez Robleda, Agustín Lira, Alfonso Villa, Jesús Ríos y Valles, and Carmen Jaime.[3] Most of *Los Cachucas* came from inland Mexico and had been forced into the capital by the upheaval caused by the prolonged, seemingly unending armed struggle, as was the case with the young Maples Arce. "The affinities were the agglutinating agent of friendship," wrote Lira. The different personalities of the nine members complemented each other, and they ended up sharing an anarchic tendency to rebel against authority and rise up against injustice. "Anarchists and carefree, we found in the world of letters and the spirit the only possible world,"[4] Lira wrote. They lived intensely: Some of them collected books, which turned into libraries, while others collected images, which they transformed into memories. Life was a game, and art, in its youth, an ingenious roulette of parodies and plagiarism.

Alongside *Los Cachucas* were the editors of the satirical leaflets of *Policromías:* Antonio Helú, Miguel Covarrubias, Hugo Tilghmann, and Xavier Villaurrutia. We should also mention Salvador Novo and Renato Leduc, who were responsible for creating *El Chafirete.*

The experience of the urban capital, which was much closer to the habits, rites, and rhythms of city life just a step away from the countryside, was cruel to Kahlo, as she herself set out to show

[2] Ibid., passim.

[3] See Alfredo O. Morales, "Introducción," in Miguel N. Lira, *Cartas escogidas, 1921–1961,* comp. Jeannie Gaucher-Morales and A. O. M. Tlaxcala (Tlaxcala: Consejo Estatal de Cultura/Gobierno del Estado de Tlaxcala, 1991), p. 24.

[4] Miguel N. Lira, "Frida Kahlo o el imperativo de vivir" (Frida Kahlo and the will to live), in *Huytlale* 18: p. 8, and Ibid., p. 25.

FRIDA KAHLO,
CA. 1932

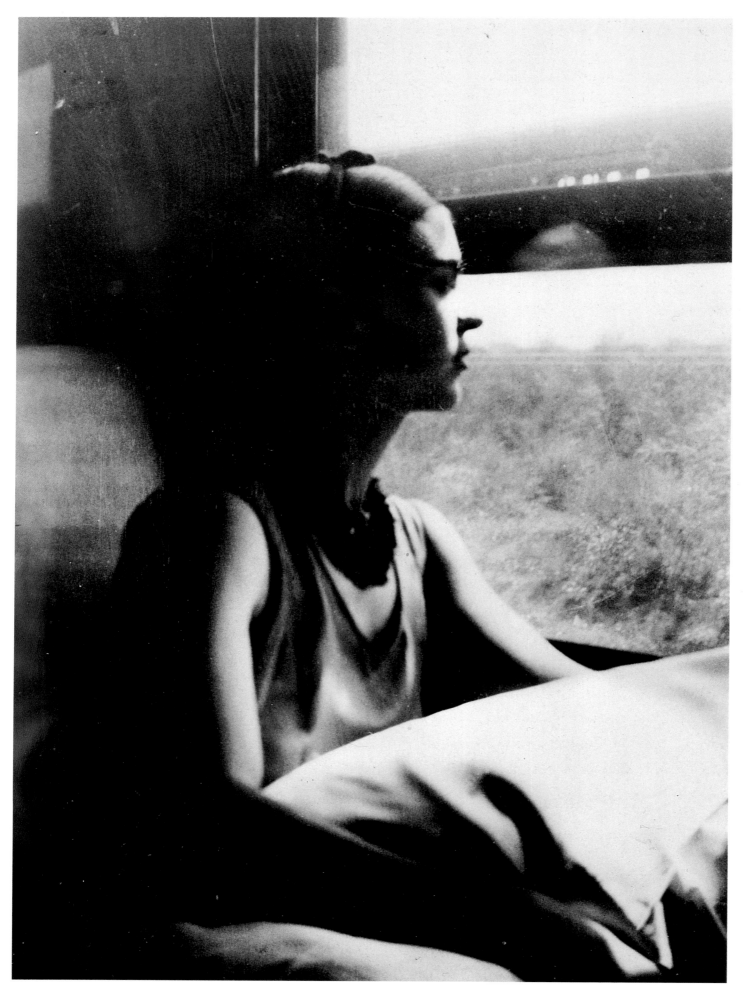

FRIDA ON THE TRAIN
FROM DETROIT
TO MEXICO, 1932

by immortalizing the event that left its mark on her for life: the spectacular bus accident that pierced her and condemned her.

Among her circle of friends, the clear and short-lived literary temperament of the *estridentismo* movement emerged; it was a type of dressed-up and romantic modernism, which also drove Maples Arce and which decreed the death of formal study in the lecture hall of the Preparatoria and in the group's proclamations.[5] For some, the *estridentismo* movement took on a special meaning, as in the case of the poet and critic José Juan Tablada, insofar as its assumptions seemed to answer—at least at the time—the question of how to include Mexico in the world of contemporary culture as it was already understood in New York, Paris, and Rome. Today I am of the opinion that it posed a more important question: How did women in general, and not a particular woman, experience life in the capital of a postrevolutionary country, women who, like Antonieta Rivas Mercado, Nahui Olin, Helena Torres, and so on, had broken the constraints of tradition and crossed the borders to build a world that was closer to their needs than the one society had in store for them?

In the geography of Maples Arce's memory, a privileged place is occupied by Mixcalco 12, the address of Germán and Lola Cueto. The Cuetos, unlike most of the inhabitants on their private road, modeled clay, beat sheets of metal for engravings, made paste for their masks—and did so supremely well. "Sometimes," wrote Maples Arce, "the arrival of Concha Michel with her guitar would transform the workshop into a party in which the painters Francisco Díaz de León and Gabriel Fernández Ledesma took part and sang songs and *corridos* chosen by Concha." The Cuetos' house, "open at all times to friends," was a noisy meeting place, "poor only in the material sense"; it was where another typically idiosyncratic venture of the decade was born, where both men and women, work and play came together. I am referring to the short-lived puppet theater to which Graciela Amador, Leopoldo Méndez, Ramón Alva de la Canal, the Cuetos, Elena Huerta, and

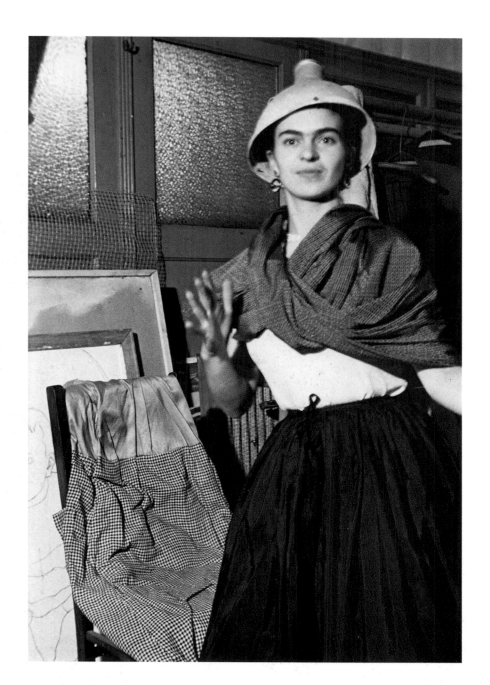

AT THE NEW WORKERS'
SCHOOL OF NEW YORK,
1933

[5] See Salvador Novo, "12 December [1953]," in *La vida en México en el periodo presidencial de Adolfo López Mateos* (Memorias mexicanas vol. 1) (Mexico City: Conaculta, 1996), p. 264.

ADOLFO BEST
MAUGARD,
SELF-PORTRAIT,
1923.
OIL ON PAPER,
214 × 123 CM

PAGE 180:
FRIDA AND DIEGO,
CA.1945

available for fifty cents to thousands and thousands of readers; Don Julián Carrillo held concerts.[7]

At that time, however, nobody could have guessed what the following week held in store for the group of friends.

José Dolores Frías, "the bard," brought Salvador Novo to the "unforgettable, enormous, dark house at Mixcalco 12," where Diego Rivera and Lupe Marín were living at the beginning of the 1920s. Many years later, Novo himself would recall "this house with its enormous rooms, which were filling up with [Diego's] paintings, and where one could also see, in simple frames, those which he had painted in Europe and brought back."

The leather chairs and the tulle ones, the folding beds covered in serapes, which we have no doubt were comfortable, were folded away as Diego arrived to preside over the party and to surprise us with the blatant lies that triggered his booming laugh, and I would imitate him and say "Didn't you know, I was there when Hindenburg said no to the Kaiser!" Then Lupe would take us to the dining room at the back of the house to eat some of the succulent *tapatías* and *antojadizas,* preceded by pomegranate punch.[8]

Did Novo read his *Diegada* sitting in one of those leather chairs? Did his satire have an extra edge when he read his poem in this beehive of his talented peers? Is this where Novo posed like a sort of Saint Sebastian for the photographer Smartt, who also took a picture of him in profile with one of the Cuetos' masks?

The struggle for power among the triumphant revolutionary armies set a series of deadly traps around the capital. This meant long, dark hours for the population. However, life went on and people adapted their routines.

Germán List Arzubide all contributed their different talents and experience. Was it also where they discussed other plans, such as the satirical *Policromíal*? It was a Mexico in which all the creative people knew each other. Diego Rivera and Lupe Marín also lived there, upstairs at Mixcalco 12; Ignacio Asúnsolo and Alva de la Canal lived at the end of the corridor.[6]

They all shared in a cultural commitment that would later be thought of as a golden age of education:

. . . with an ardent, illuminated, continental Vasconcelos at the lead, delegating to the best the most generous tasks: Jaime Torres Bodet was made responsible for the public libraries; Diego Rivera for mural painting; Eulalia Guzmán was put in charge of the literacy campaign; Julio Torri edited the classics that were made

[6] All information concerning life at Mixcalco 12 can be found in chapter 15 of M. Maples Arce's *Soberana juventud,* pp. 173–181.

[7] S. Novo, "26 January [1957]," in *La Vida,* vol. 3, p. 17.

[8] "14 December [1957]," in *La Vida,* vol. 3, p. 206.

The young American journalist Katherine Anne Porter, for example, moved to Mixcoac and set up her studio on the top floor, from where she could see the horizons of the valley and where she wrote the *Outline of Mexican Popular Arts and Crafts* (the first book, now completely forgotten, by the author of the short story collection *Flowering Judas* and the novel *Ship of Fools*). The English teachers Ella and Bertram Wolfe moved to the Roma suburb—like Manuel Maples Arce, the talented Silvestre, Fermín, Rosaura, and José Revueltas, and the solitary Ramón López Velarde—from where they would set out for their meetings with their party comrades or friends at *Sanborn's* in Madero Avenue. Tina Modotti and Edward Weston set up their home, studio, and roof terrace in Condesa; Manuel Rodríguez Lozano worked in his studio in calle Mina; Nahui Olin set herself up in the house on the corner of Uruguay and Cinco de Febrero; Doctor Atl at times lived in the ruins of the Convento de la Merced; Xavier Villaurrutia, Salvador Novo, and Gilberto Owen had their den in calle Brasil; Antonieta Rivas Mercado set up a literary parlor in her house in Monterrey. However, the really famous gatherings, especially for their touch of extravagance, were the exclusive avant-garde meetings on art, science, and letters that took place in the magnificent residence of Tomás Braniff on the north side of Paseo de la Reforma, practically at the foot of the Columna de la Independencia.

The Braniffs' place was popular among the community of writers and artists who had settled in Mexico City, from the members of the old intellectual guard, like the poet Ricardo Gómez Robelo and the novelist Federico Gamboa—who ensured the meetings took place "after lunch in the garden"[9]—to the new artists and writers or those who were simply passing through Mexico, like Weston. I will not discuss at length the photographer's notes about one of these meetings, but I will mention one of his observations: the preeminence of sex as a topic in the after-lunch conversations in the house of the millionaire.[10] Frequent visitors to this house were Gómez Robelo, the talentless poet and civil servant of the arts, the artists Adolfo Best Maugard, Xavier Guerrero, Jean Charlot, Diego Rivera, and Doctor Atl, and the models Guadalupe Rivera, Nahui Olin, and Tina Modotti. The academic Alfonso Reyes gave this account of the community in 1924 upon returning from eleven years abroad. This is what he wrote to Antonio Solalinde:

The group of friends has broken up slightly as a fatal consequence of the use of power. Back in the days of Bohemian youth in which I left them, they were all brothers. Now each of them is going his own way. The intellectuals of my generation, although they are all still friendly toward me, do not see eye to eye among themselves, they don't take part in anything, they behave as if they were tired and in hiding; I do not understand them. They did not accompany me at all in my small conference tour. I have had to rely on those of the new generation, who are much more aggressive, though slightly primitive and very uneducated. It would seem that they are more in agreement with me than my old friends are. I always believe that young people are right. They are conspicuously gay, a new sickness here, which keeps me away from many people and makes me suffer, though I am not as skeptical and indifferent as I thought I was. The most important names are Xavier Villaurrutia, who is mainly a prose writer and also a poet, a critic, and the only educated one among them all, and highly intelligent; Carlos Pellicer, an uneducated poet, friendly, full of tricks, who believes he is original because he knows nothing of what men have written and who, apart from having a natural flair, runs the risk of drowning in an ocean of expressions of admiration and in a storm of vulgar words; Salvador Novo, ingenious, though still lacking in direction; Daniel Cosío, a follower of P.[Pedro] H.[Henríquez] Ureña, a precise and elegant writer, excessively concerned with going into politics; [Eduardo] Villaseñor, disciple of the same, concerned about the same thing, a careless and

[9] Federico Gamboa, *Mi diario* (Memorias mexicanas vol. 7 [1920–1939]), (Mexico City: Conaculta, 1996), pp. 86, 135.

[10] See Edward Weston, *The Daybooks of . . . I: Mexico*, ed. Nancy Newhall (New York: Aperture, 1973), pp. 31–34.

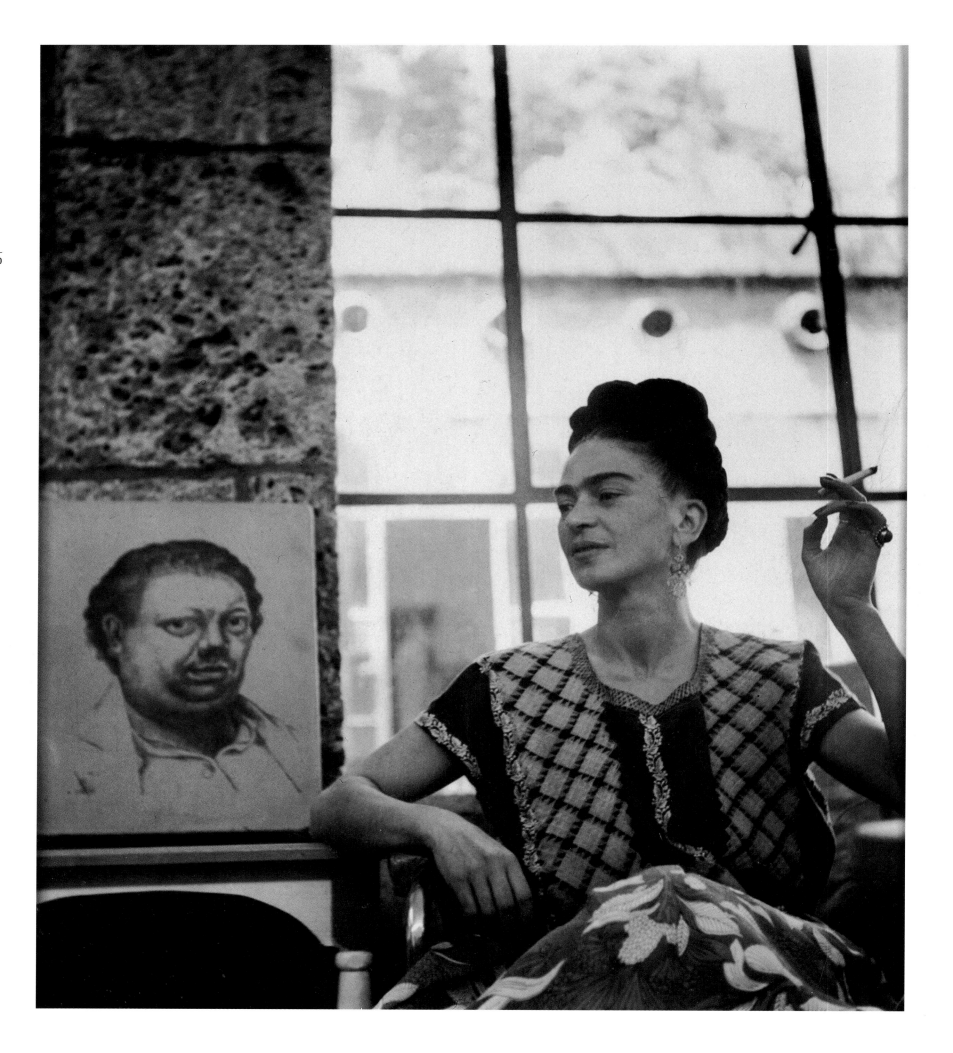

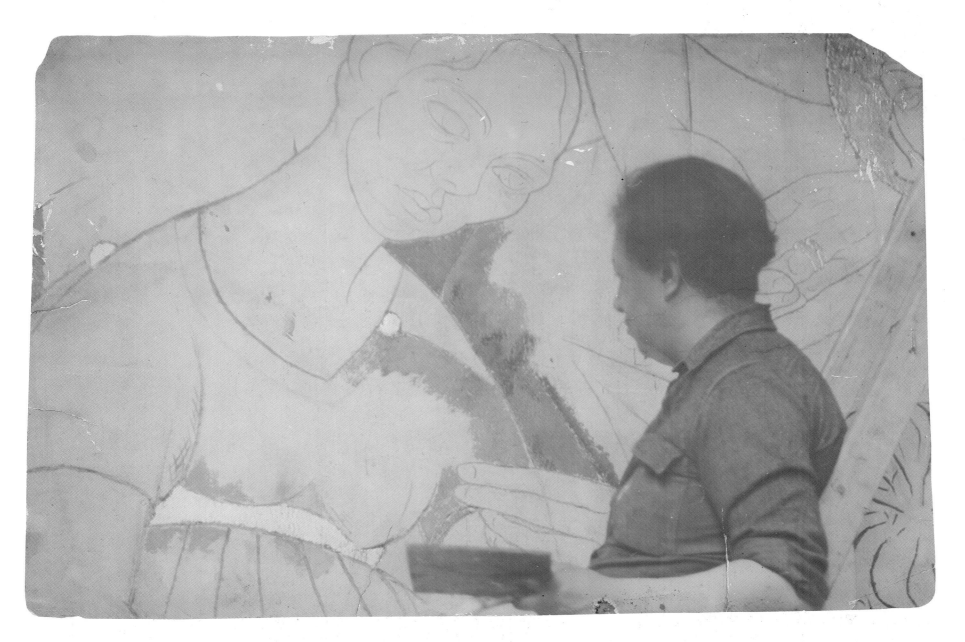

DIEGO RIVERA PAINTING
THE FRESCO *THE CREATION,*
IN THE SIMÓN BOLÍVAR AMPHITHEATER
OF THE ESCUELA NACIONAL
PREPARATORIA, CA. 1922–1923

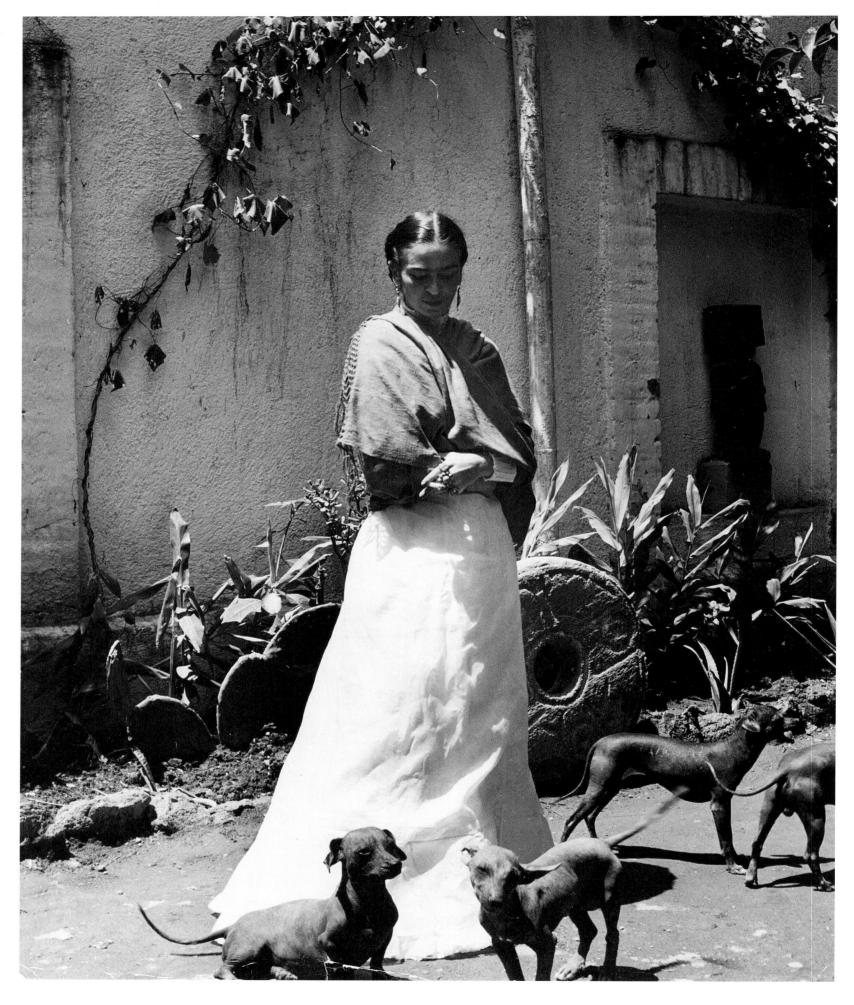

In the garden
at the Casa Azul
in Coyoacán,
1951

vague writer; Xavier Icaza, a novelist by training, nephew of our old Icaza, a young lawyer in the lucrative oil business, who made money in Veracruz and who ran away from the capital because he couldn't stand this pseudointellectual environment; he is quite young; Francisco Monterde García Icazbalceta, who started out under the weight of his name in the unhappily academic and colonialist tradition and is now drifting toward appreciable brevity, virtuous young man that he is.[11]

I once wrote that the new artistic tendencies of these strange young temperaments were just as conspicuous as their sexual themes. Gómez Robelo, upon returning from political exile at the beginning of the 1920s, spread the fame of his creative friends who had settled in Southern California and in whom he had found more than just a receptive audience for his literary attempts: the batiks of Roubaix de L'Abrie Richéy, and the photographs of Jean Reece, Arnold Schröder, a certain Horwietz, Margarethe Mather, and Weston. This material was exhibited in the gallery of the Escuela Nacional de Bellas Artes in March 1922.[12] Many viewers saw the exhibition as the first "show" of one of the models, Tina Modotti. It had a certain sophistication. On the other hand, it is difficult to overlook the story of the film critic, playwright, and editor Carlos Noriega Hope, who was famous among his friends for his "seraglio of splendid portraits," a collection of bathing beauties by Mack Sennett that he kept in a small cardboard case.[13]

Frida Kahlo married Diego Rivera in August 1929, and the atmosphere of this intimate chapter is captured by a photo of the couple taken to remember the occasion that is similar in style to a picture taken of the photographers Edward Weston and Tina Modotti a few years earlier. This photo of Frida with Diego is a parody of a popular genre of studio photography—and of a lifestyle that had nothing to do with theirs. In the picture Frida is seated, wearing a long skirt and crossing her legs; a slovenly Diego is standing slightly behind her, between the back of the wooden chair and the backdrop. The couple in this photograph is, however-

er, different not only from other people in general but also from their friends and companions. Tina Modotti—the person who had introduced Frida Kahlo to the Communist Party, its members, and activities—gave the news of their marriage to Weston, her dear mentor and friend in California, in a letter written in Mexico City and dated September 17, 1929: "Have I told you that Diego has gotten married? Well, that's what he has done. To a charming young girl of nineteen whose father is German and mother is Mexican; she's a painter. We'll see what comes of it! His new address is Paseo de la Reforma 104."[14]

Twenty-two, not nineteen, was Frida's age when she married Diego, who at the time was well into his thirties; and it was on the roof terrace of the Zamora building, where the already independent photographer Tina Modotti lived, that they celebrated the event. It was quite common for people to feel surprised by the couple. They would have looked so unusual, just as Doctor Atl and Nahui Olin did. The initial surprise came from witnessing the exuberant expressions of love on the groom's part. There were few if any reports of concern and reservation among the members of the bride's family. Most of the attention and respect paid to Frida—including the interest in performing surgery on her expressed by the medical profession—was merely the result of people's desire to make a good impression on Diego. As was the case for many other women of the day, Frida was the one who counted less.

Much the same can be said of Nahui Olin and her private life—but not of her work or her hours spent thinking and studying—which from the beginning was a topic of conversation among people whom she did not know even vaguely. As Victor Hugo put it, whatever is said about us, whether it's true or not,

[11] Letter from Alfonso Reyes to Antonio Solalinde, 1924 (Archivio General de la Nación, Mexico, section 24 [Colección Felipe Teixidor], box 16, file 1).

[12] See Rafael Vera de Córdoba, "Las fotografías come verdadero arte," in *El Universal Ilustrado,* March 13, 1922.

[13] See Francisco Zamora, *El mundo de las sombras. El cine por dentro y por fuera* (Mexico City: Andrés Botas and Son, c. 1922), p. 10.

[14] Antonio Saborit, *Una mujer sin país. Las cartas de Tina Modotti a Edward Weston. 1921–1931* (Mexico City: Cal y Arena, 1992), p. 119.

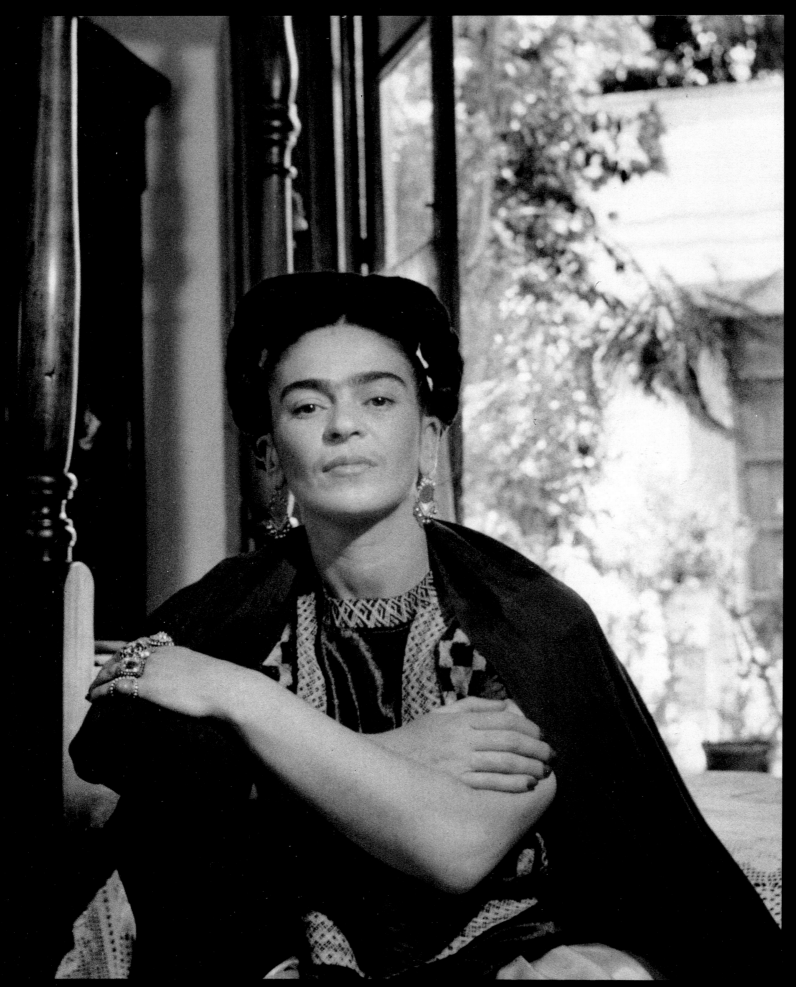

FRIDA KAHLO
CA. 1945

PAGE 187:
IN COYOACÁN, 1941

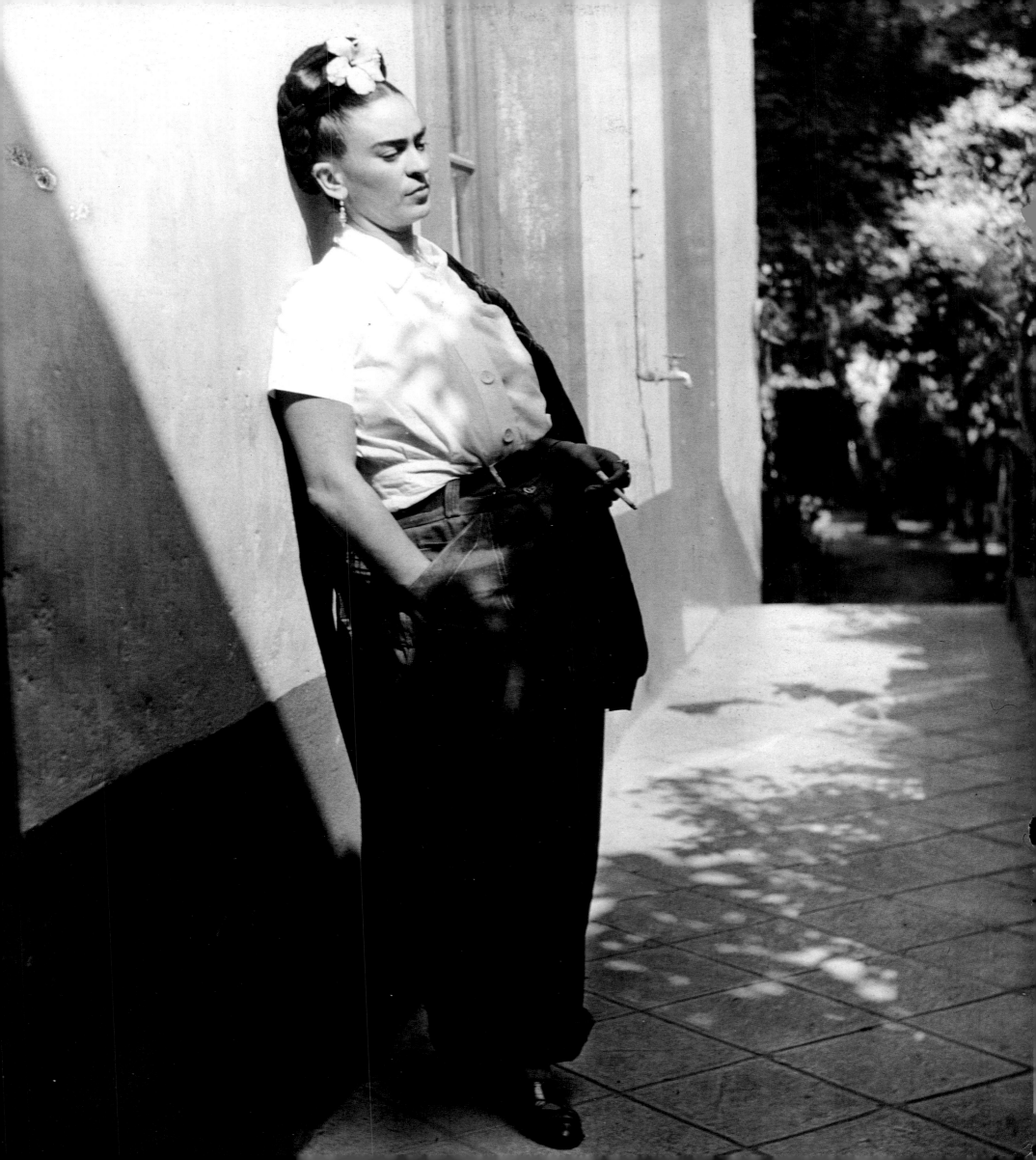

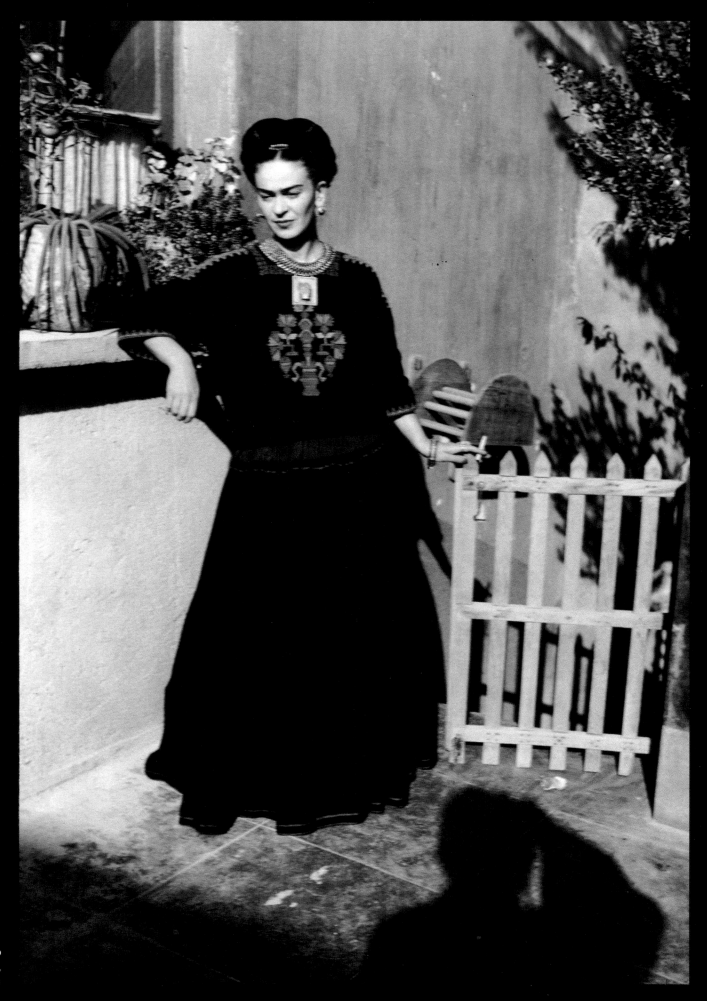

FRIDA KAHLO
IN COYOACÁN,
1941

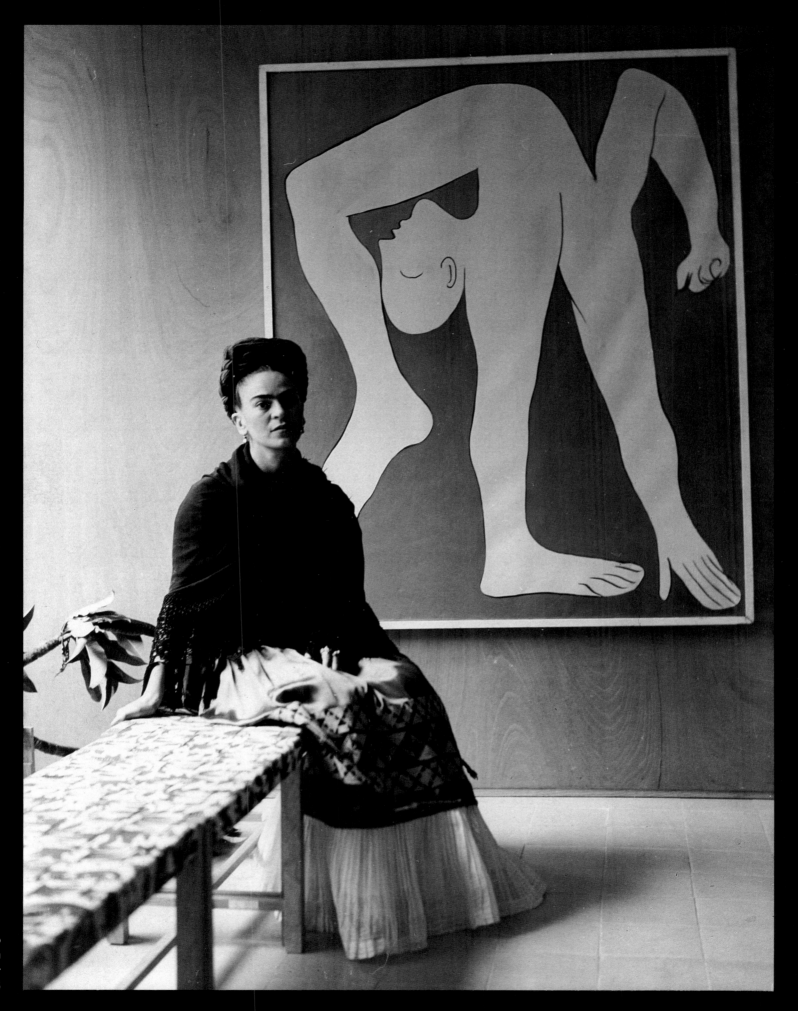

holds the same place in our destiny, and especially in our lives, as what we actually do. People talked about Nahui Olin behind her back, they added episodes to the agenda of her dark deeds, they whispered ruthlessly. All of this, which is certainly no minor thing, added to her reputation and turned it into an unmistakable mark of distinction, or rather, condemnation.

Olin's experience as a model for Diego Rivera also contributed to this. He chose Olin to represent Erotic Poetry in the mural of the main lecture hall of the Preparatoria, together with three other girls, María Dolores Asúnsolo, Palma Guillén, and Guadalupe Rivas Cacho. By posing as models, they broke away from the sentimental education of the Porfiriato period. It is said that Frida liked to hide in the shadows of the doorway and shout to the painter, "Hey Diego, here comes Nahui!" when Lupe was with him on the scaffolding.[15] It is a fact, however, that at the age of eighteen Frida actually wrote the following to her boyfriend, Alejandro Gómez Arias, at the end of 1925: "I will never forget that you, whom I have loved as I love myself and more, thought of me as a sort of Nahui Olin, who is an example of all of them, or worse."[16]

For many years, as an illustration of how unsuitable a marital choice Diego was for Frida, my maternal grandmother and her two sisters, childhood friends of Kahlo's from Coyoacán, used to say in their conversations around the dinner table that since Frida was intelligent and pretty, of her many memorable whims, the least necessary of all was her marriage to Diego. I once overheard one of my aunts, having described the letters from the young Frida, reach the same conclusion as the poet and art critic Luis Cardoza y Aragón: "Frida was already what she would always be: a magnificent woman."[17]

As a couple, Frida and her husband were actually quite unbalanced not only in their appearance but also in more essential traits. Cardoza y Aragón wrote; "I see Diego and Frida in the spiritual landscape of Mexico as Popocatépetl and Iztaccíhuatl in the valley of Anáhuac."[18] I firmly believe that Diego often represented her taste, that of a young eccentric woman, as the frequent use of mineral and vegetable elements in her self-portraits was an expression of her artistic taste and style. Hayden Herrera, in his detailed biography, explained it quite well as follows:

From the moment of their marriage, Frida and Diego began to play important roles in the theatrical scenario of each other's life. Wearing Tehuana costumes was part of Frida's self-creation as a legendary personality and the perfect companion and foil for Diego. Delicate, flamboyant, beautiful, she was the necessary ornament to her huge ugly husband—the peacock feather in his Stetson hat. Yet while she happily played the role of Indian maiden for Diego, hers was an authentic artifice. She did not change her personality merely to suit Diego's ideal. Rather she invented a highly individualistic personal style to dramatize the personality that was already there and that she knew Diego admired. In the end, she was so extravagantly dashing that many people felt the peacock feather was more compelling (or more fetching) than the hat.[19]

Rivera gave his young and pretty partner a public dimension. I can't imagine any male figure except Diego with Frida. With another partner Frida would have invented another persona and another direction for herself.

Painting interested her less than her enormous and powerful vitality, for which she was mocked. Living to the fullest was her greatest impetus. This is perhaps understandable, given in the first place the childhood polio she suffered and, later on,

[15] In Hayden Herrera, *Frida: A Biography of Frida Kahlo* (New York: Harper & Row, 1983), p. 32.

[16] Ibid., p. 59.

[17] Luis Cardoza y Aragón, *El río. Novelas de caballerías* (Mexico City: FCE, 1986), p. 466.

[18] Ibid.

[19] H. Herrera, *Frida*, p. 112.

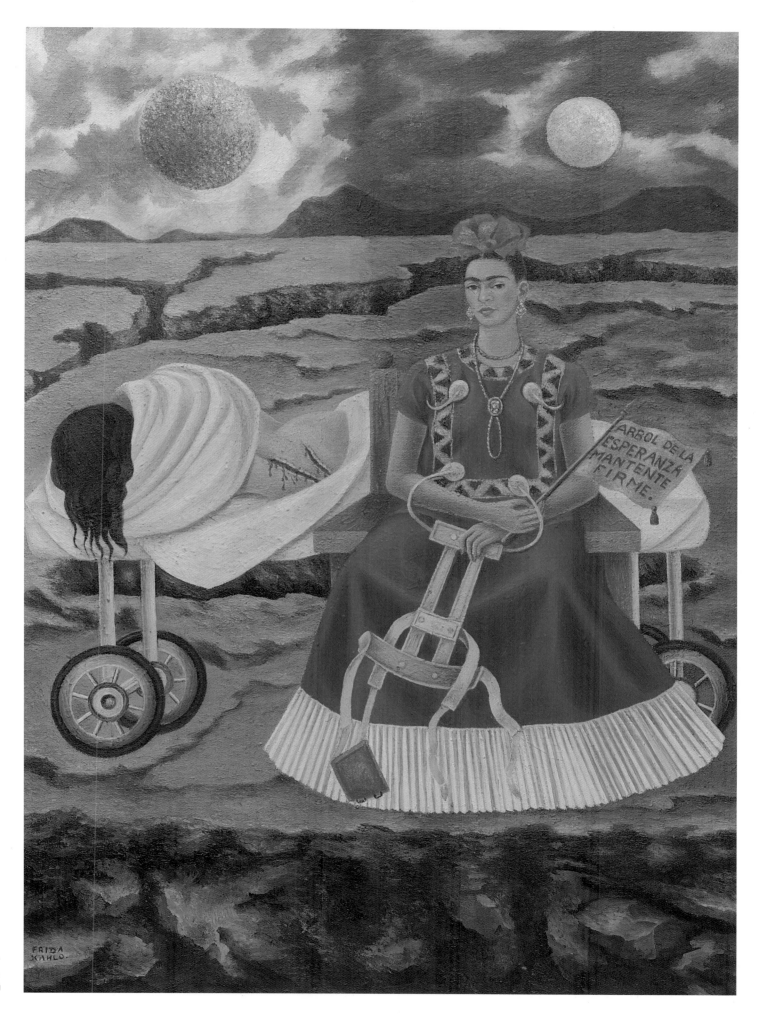

Tree of Hope, 1946.
Oil on masonite,
56 x 41 cm

Frida Kahlo
and Juan O'Gorman
in Coyoacán, 1947

the spectacular accident that occurred during her adolescence, which changed the course of her life. Over the years, the irreversible aggravating factors of both of these incidents were compounded in the body of the girl. It is hard to say how much of her defiant attitude was brought on by her degenerating physical conditions, just as it's hard to define the particular course of her expressiveness. Shortly after her marriage, in a cruel twist of fate, she began having gynecological problems, too. Each new attack of pain reduced her defenses. It is also difficult to say for sure how much her art was connected to her illness and acute physical suffering; her periods of intense creativity may or may not have coincided with an increase in physical pain. How can one distinguish the creative impetus in her painting if her physical ailments were a pressing and unrelenting permanent condition?

One might say that the treatment of her illnesses and her pain enabled Frida to create, for herself, a real and sound vocation for painting. But one could also say the opposite, that the concentration Frida put into her painting was the key to a new way of experiencing pain and, most of all, the despair and anxiety caused by pain. After having painted for more than ten years, she explained in a letter she wrote in 1939 to her friend the musician and composer Carlos Chávez how she had begun painting during her convalescence from the accident that had confined her to her bed for nearly all of 1925:

I started to paint twelve years ago, during my convalescence from an accident which forced me to stay in bed for about a year. During all these years I have always worked following the spontaneous impulse of my feelings. I have never followed any school or worked under anyone's influence, and I don't expect anything from my work except for the feeling of satisfaction I get from painting itself and from being able to express things I cannot express in any other form. I have done portraits, compositions of figures and painted things in which landscapes and still-lifes emerge above all. Without being driven by any kind of prejudice, I have managed to

achieve a personal expression in my painting. For ten years my work has consisted in eliminating anything which didn't come from the inner lyrical motives which gave me the impulse to paint.
Seeing that my topics have always been my sensations, my moods and the deep relationships life has produced in me, I have often objectified all this in images of myself, which were as honest and real as I could make them in expressing what I was feeling through me and before me.
I had my first exhibition last year (1938) in the Julien Levy Gallery in New York, where I had twenty-five paintings on show.

Twelve of the paintings on show in this gallery were bought for around ten private collections, including those of Conger Goodyear, the Sam Lewison ladies, Clare Luce, and Solomon Sklar, as well as Dr. Roose, the photographer Nickolas Muray, Edgar Kauffman, the critic Walter Pach, and the actor Edward G. Robinson. This event gave meaning and prestige to Frida Kahlo's work.

I later held a show in Paris, organized by André Breton at the Renou et Colle Gallery from 1 to 15 March, 1939. (The only exhibitions I have had in my life). The critics in Paris were interested in my work and so were the artists. The Louvre Museum (jeu de paume) bought one of my paintings.[20]

If anyone's work is packed with stories, Frida's is; in her work she talks and represents—she talks about herself and she represents herself. Her work is more than a diary of her life.
During the 1920s, some Western cities turned into natural refuges following the calamities provoked by World War I. In

[20] *Epistolario selecto de Carlos Chávez,* Selection, introduction, notes, and bibliography Gloria Carmona, trans. Hero Rodríguez Toro and Gloria Carmona (Mexico City: FCE, 1989), pp. 287–288.

these cities, writers and artists created their own space, just as in the 1930s one might say that Berlin, New York, Madrid, and Moscow, to cite a few examples, were temporary paradises. This was also true of Mexico City, the capital of a country that was trying in the 1920s to emerge from its own civil war.

The legendary display of vitality was so great that the inhabitants of those paradises neglected to tell us about those who died in the midst of the party in that decade—victims of their ailments, problems, and old age. Death soon visited the older generations and in this decade took away the antiques dealer Antonio Peñafiel (1839–1922), the poet Salvador Díaz Mirón (1853–1928), and those larger-than-life spirits of past parties: Rosario de la Peña y Llerena (1847–1924) and the Madero writer Dolores Jiménez Muro (1850–1925). Francisco Sosa (1848–1925) died in bleak conditions: the last years of his life were sad and spent in poverty, as he was slowly forced to sell his books for food; the same happened to Manuel Caballero (1849–1926), who had a long career in national journalism and who, at the beginning of the century, undertook the unforgivable job of refounding the *Revista Azul*. The subsequent generations lost the writers José López Portillo y Rojas (1850–1923) and Emilio Rabasa (1856–1930) and the learned bibliophile Nicolás León (1859–1929). The old newspaper publisher Rafael Reyes Spíndola (1860–1922), the musician Carlos J. Meneses (1863–1929), the poet Jesús Urueta (1867–1920), and the guitar player Fermín Pastrana (1867–1925) all passed away peacefully; unlike the literary critic Antonio de la Peña y Reyes (1869–1928), consumed by tuberculosis, the poet José Peón del Valle (1869–1924), who died of cancer of the tongue and throat, the novelist Heriberto Frías (1870–1925), and Ricardo Flores Magón (1873–1922). Among the younger generations, the painter Alberto Fuster (1872–1922), Ricardo Gómez Robelo (1884–1925), and Severo Amador (1886–1928) all died as a result of suicide or a sophisticated form of self-destruction. To say that Federico Gamboa lived through the decade "decorated with black arm bands and dejected inside and out"[21] was no exaggeration. In the twenties young men like Ramón López Velarde (1888–1921), Miguel Othón Robledo (1890–1922), and Álvaro Pruneda (1892–1927) all died.

In general, we don't tend to think about what might have been, if death had not occurred. The ideas writers and artists never got around to accomplishing, however, are certainly of interest to the essay writer or the scholar, because it is through these ideas that one can get closer to places full of both hope and fear. An example of this is the assassination of the young student leader Germán de Campo (1904–1929). Antonieta Rivas Mercado, at the height of her enthusiasm for Vasconcelos, before anyone understood the meaning of the death of this young boy, expressed it very clearly and directly: "His young age, his fiery innocence, the fact that he departed and left intact the state of grace that created Mexican moral unity, have made him a symbol of sacrificed youth."[22]

Each period creates its own fables around a handful of formal, emotional, and moral concerns. As an example of the literary trend that was known as *prosaismo*,[23] one of the tales that was popular during Frida Kahlo's formative years was the story of a novel-river and its boatman: *Ulysses* and James Joyce. The English literary critic Cyril Connolly talked about a "Ulysses generation" in the 1920s when discussing the widespread veneration of James Joyce among writers who were anxious to experiment with literary forms.[24] Joyce had published several excerpts of *Ulysses* between 1918 and 1920, stopping only when the book was accused of being obscene. Sylvia Beach, of Shakespeare and Company in Paris, published a private edition of the manuscript at the beginning of 1922, and the book survived underground despite the zeal of customs authorities.

The magazine *Ulises* is one example of such intellectual exchange. Like Jorge Luis Borges in Argentina, in Mexico, at least

[21] F. Gamboa, *Mi diario*, p. 49.

[22] Antonieta Rivas Mercado, *Obras completas* (Lecturas mexicanas, part 2) (Mexico City: SEP, 1987), p. 143.

[23] See José Emilio Pacheco, "Nota sobre la otra vanguardia," *Revista Iberoamericana* (Pittsburgh International Institute of Iberian-American Literature) (January–June 1979 [no. 106–107]): pp. 327–334.

[24] See Cyril Connolly, *Cien libros clave del movimiento moderno. 1880–1950*, (Colección popular), trans. Aurelio Major (Mexico City: FCE, 1993), p. 485.

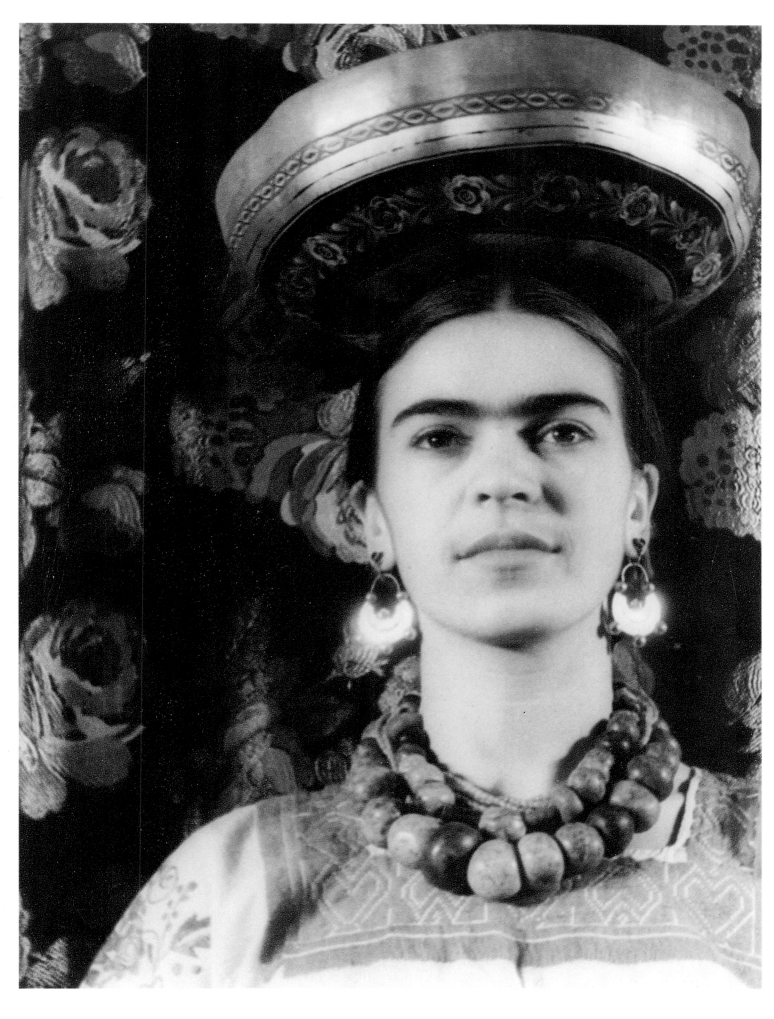

AT THE NEW YORK
APARTMENT OF
BERTRAM WOLFE,
1932

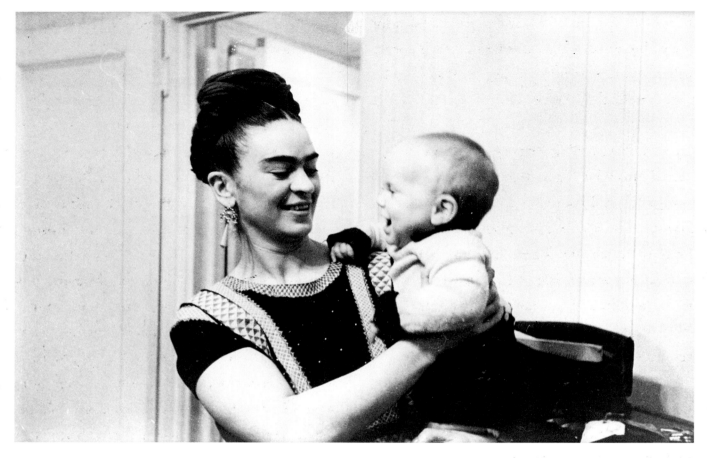

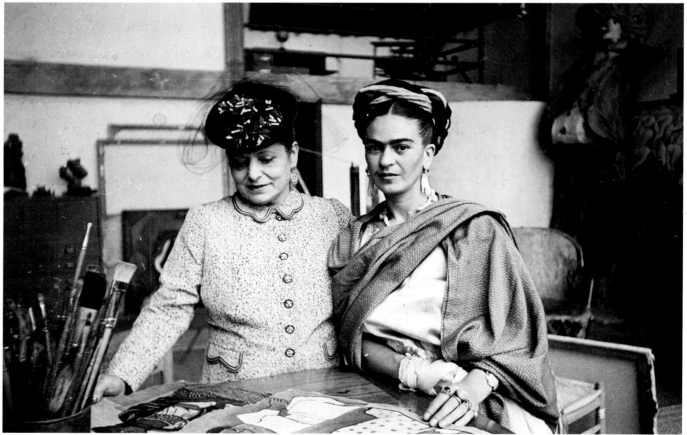

FRIDA WITH THE SON WITH HELENA RUBINSTEIN
OF LUCIENNE BLOCH IN THE STUDIO OF
IN NEW YORK, CA. 1939 DIEGO RIVERA, 1941

during the 1920s, one of the writers of this magazine, Salvador Novo, echoed some of Joyce's formal adventures. In *El Universal Ilustrado,* he published a chronicle of a journey in March 1927. "Dear editor," he wrote to Carlos Noriega Hope:

> I am sending you the latest thing I have written. It's an account of a car trip from Puebla to Mexico and back in the company of John Dos Passos (the famous author of *Manhattan Transfer,* which nobody has noticed in this Mexico he loves so much and where his numerous, excellent books do not arrive) and other people who appear in the Kodak photo I am also sending you. I realize this is slightly Joycean, but I don't think it'll be an obstacle. With fondest regards from Salvador Novo.

In May of the same year, Novo and his friend and co-disciple Xavier Villaurrutia managed to publish in the magazine *Ulises,* the subtitle of which was *Revista de curiosidad y crítica* (Review of curiosities and critical essays). José Vasconcelos, who, unlike Novo and Villaurrutia, is synonymous with pretentious classical erudition and whose historiographical role was as the cultural leader of the decade, imposed an unusual slant on the title of this magazine by using it in the first volume of his memoirs. As it happens, the name of the magazine suggests Homer less than Joyce: *Ulises* was published in October, introduced by a sentence by Joyce, and the November issue reproduced five poems from *Pomes Penyeach.* The Joycean element of this publishing venture was, without doubt, only in the strictest sense of the word, as it also included emblematic suggestions by André Gide about Simbad and Ulysses.[25] The fact that the first translations of some of Joyce's short stories appeared in Mexico in the *Revista de Revistas* in 1928 is certainly significant. In addition to this, Efraín González Luna translated an excerpt from *Ulysses* for *Bandera de Provincias,* the same excerpt that was published in the September 1929 issue. The editors of this bimonthly cultural review pointed out, without naming anyone, that there were only four men of letters in Mexico who had read this work by Joyce. In the face of new cultural norms and dictates, this type of information meant "honorable mention; a hidden file for a prisoner; a hearth."[26]

On the other hand, Edward Weston and Tina Modotti—definitely subscribers to *The Little Review,* the magazine in which Joyce had published previews of his novel—tried to obtain a copy of *Ulysses* in Mexico; in actual fact, they came across a copy in April 1924 belonging to a certain Rubicek. Soon after, a close friend of Weston, Miriam Lerner, sent them a copy from Paris, and Weston noted in his diary that by Christmas 1925 he had received another. Later on, as we know from her personal papers, Tina Modotti had trouble selling the extra copy in San Francisco since there were by now so many copies on the black market that there was no demand for the one she had. According to Connolly, Modotti did not personally find the sought-after novel by Joyce entertaining; however, some of the distinct images she created in her photographs indicate that she did appreciate the evocativeness of the prose. In accordance with the *estridentista* canon, she used images of all kinds—from corn cobs, cartridge belts, and clasps on a guitar case or luggage to the symbolic breath in the image of the mirror or a razor over a bowl, which appears in the first sentence of the novel.

We may debate the significance of the travels of Joyce and his work in Mexico as much as we wish, but what is certain is that in ascribing specific and local meaning to the work, and to Joyce himself, many distinguished literary temperaments acted as mediators for Joyce. What else were *The Little Review, El Universal Ilustrado, Ulises,* and *Bandera de Provincias* if not intermediaries? What were the Shakespeare and Company bookshop in Paris, *Cultura* and the bookshop of Pedro Robredo in Mexico City, and *Fonte* in Guadalajara? What else were the publishers Margaret Anderson, Jane Heap, and the already mentioned Beach, Noriega Hope, Novo, and Villaurrutia, as well as Alfonso Gutiérrez Hermosillo and Agustín Yáñez? What of the translator González Luna, the

[25] Guillermo Sheridan, *Los Contemporáneos ayer* (Mexico City: FCE, 1985), p. 281.

[26] C. Connolly, *Cien libros,* p. 107.

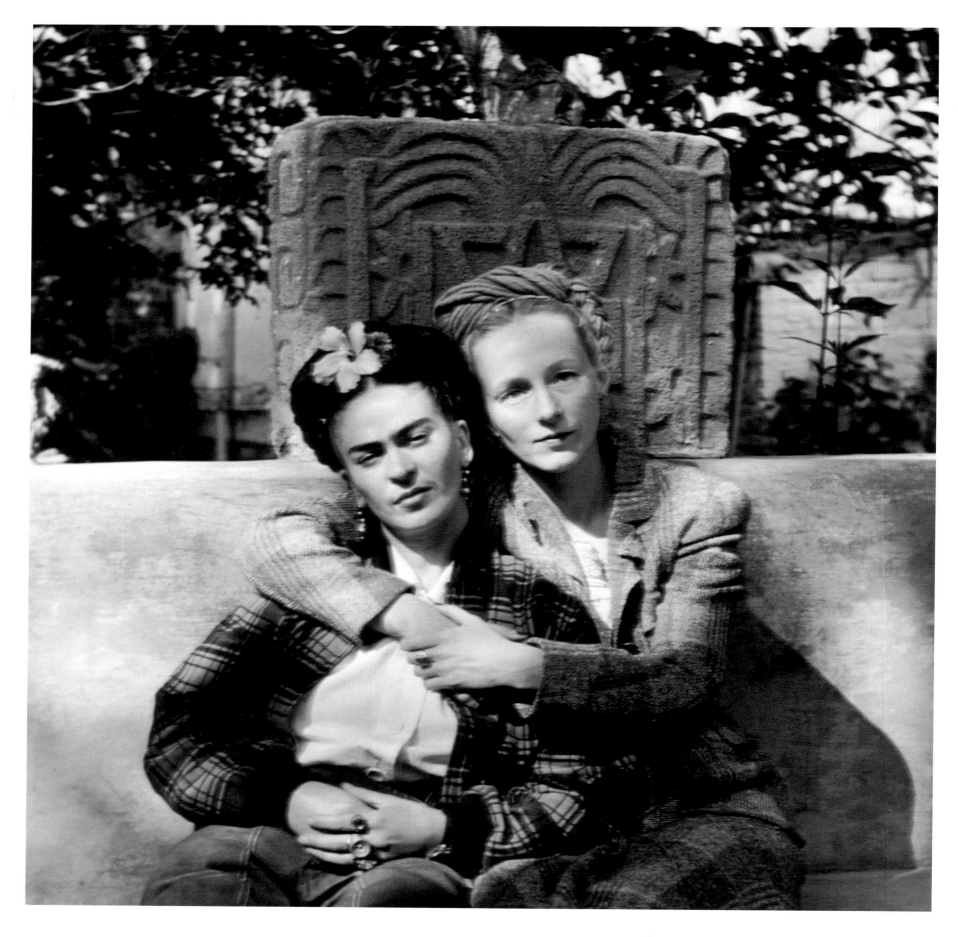

FRIDA AND EMMY LOU PACKARD
IN THE GARDEN AT THE CASA AZUL,
COYOACÁN, 1941

NEXT PAGE:
FRIDA KAHLO,
1940

photographers Weston and Modotti, and Vasconcelos and his good memory? And this list is certainly not complete. We need to point out emphatically that one of the characteristics of this generation of writers and artists, who started off their careers in Mexico in the 1920s, was their desire to pass things on to future generations. Their mediation was perhaps another trait that distinguishes them from preceding generations—namely, that they acted as a bridge to the following generations. Indeed, those who attended literary parties at the Braniffs, or rather at Mixcalco 12, included among their creative tasks pursuits that were no less demanding, such as translating, editing, adapting theater or cinema productions, and promoting music and art through the creation of orchestras, galleries, and so on.

The careers of these writers and artists is certainly marked by the need to create an audience of their own. And, in order to obtain it, they decided to enlarge the role of the creator, making him also a mediator, with the job of maintaining a suitable degree of tension that traditionally exists between the artistic works and the world—not only as far as the experience is concerned, but also in the appreciation of individual and subsequent replicas.

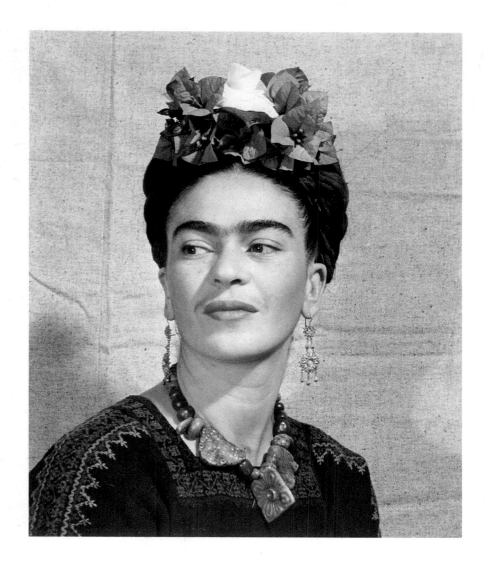

The tales that shook Frida Kahlo's heart were of another sort, perhaps not less attentive to form than in the case of the *Ulysses* generation, but certainly much more sharply aware of the Mexican subsoil and its culture.

The subject is more complex than it would appear at first sight, for the interpretations of Frida's work in her day barely took note of the elements, themes, and motives that were closest to her art; instead, they assigned new meanings to her paintings, meanings that were as wide and full as the original meaning in Kahlo's imagination. Take, for example, the opening to the poem written in 1934 about the young Kahlo by Salvador Novo, himself a very "Ulysses generation" author in many ways: "When the paintbrushes become forceps, the possibilities of her belly . . . ," says Novo at the beginning of this piece.[27] At the same time the style or school that in the arts was called primitivism was popular, and Frida Kahlo was influenced by the taste for folk culture and an interest in the artistic expressions of those people who are called primitive.

Perhaps it was about then that Frida Kahlo started to create her unique artistic universe, and of course we must not ignore the immediate influence of the work of people like Doctor Atl and Katherine Anne Porter, and also of the thoughts of such diverse personalities as the writer Roger Fry, the artist and writer Marius de Zayas, the poet José Juan Tablada, the historian Elie Faure, the anthropologist Franz Boas, and the caricaturist and curator Holger Cahill.

Zayas was one of the first to see the artistic merits of and a series of useful formal traditions for the esthetics of modernism in the art of African Negroes and in Amerindian art, just as Roger Fry had written about in "The Ancient Art of America" and "Negro Sculpture," both published in *Vision and Design* (1920).

[27] S. Novo, *Antología personal. Poesía, 1915–1974* (Lecturas mexicanas, part 3 [37]) (Mexico City: Conaculta, 1991), pp. 215–216.

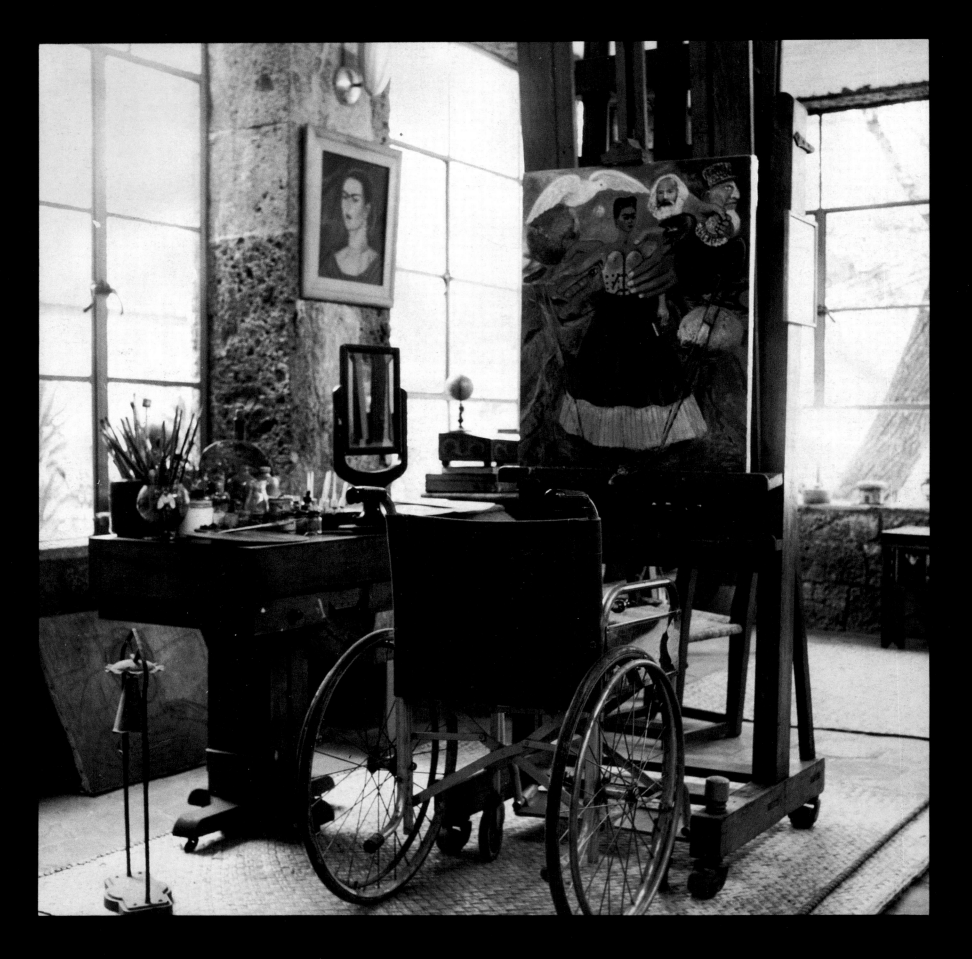

FRIDA KAHLO'S STUDIO
IN COYOACÁN, CA. **1958**

PAGE 199:
WITH HER DOG IN
COYOACÁN, **1949**

PAGE 200:
IN HER HOUSE IN COYOACÁN,
1952

PAGE 201:
FRIDA WITH *THE EMBRACE* . . . ,
IN THE CASA AZUL IN COYOACÁN,
CA. **1949**

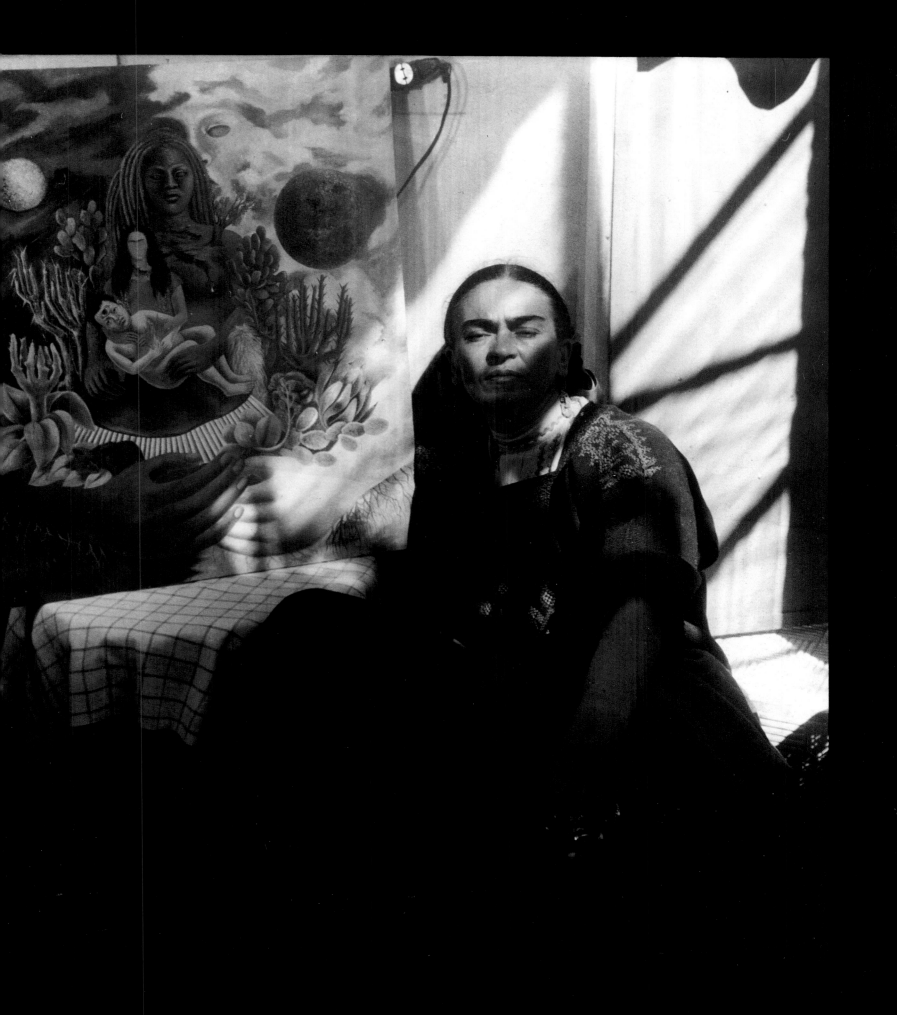

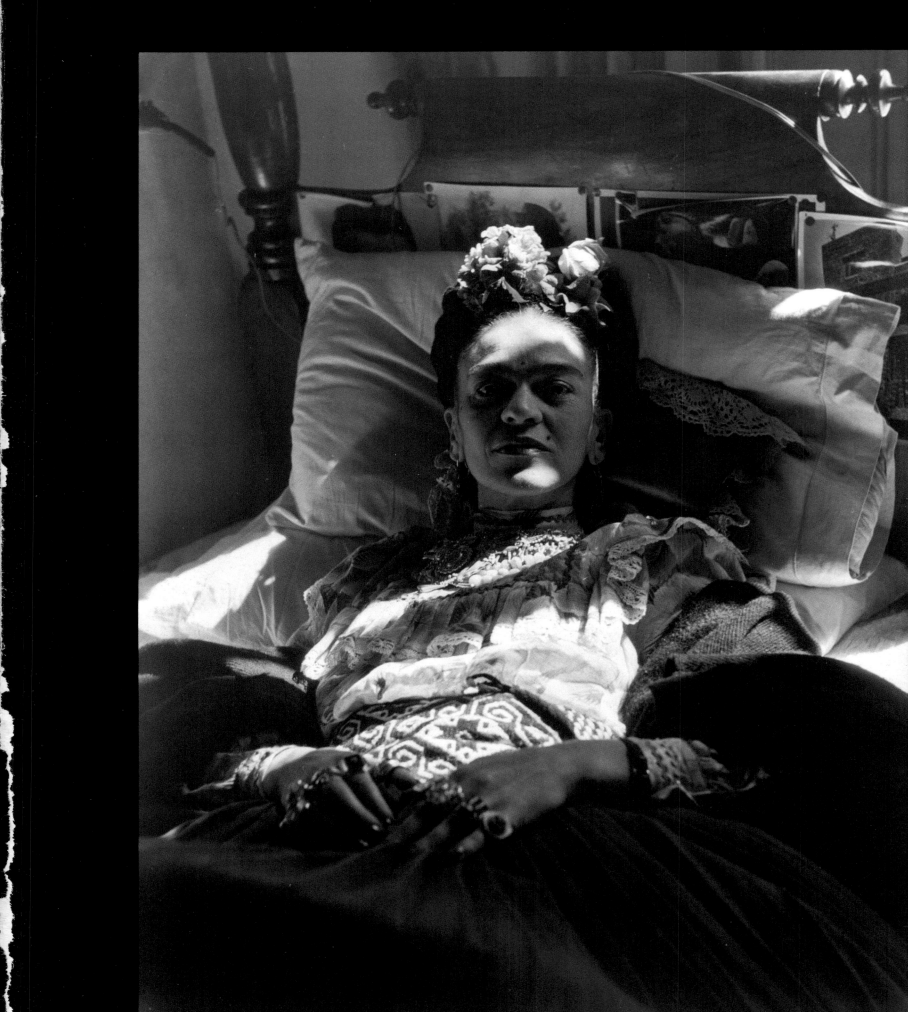

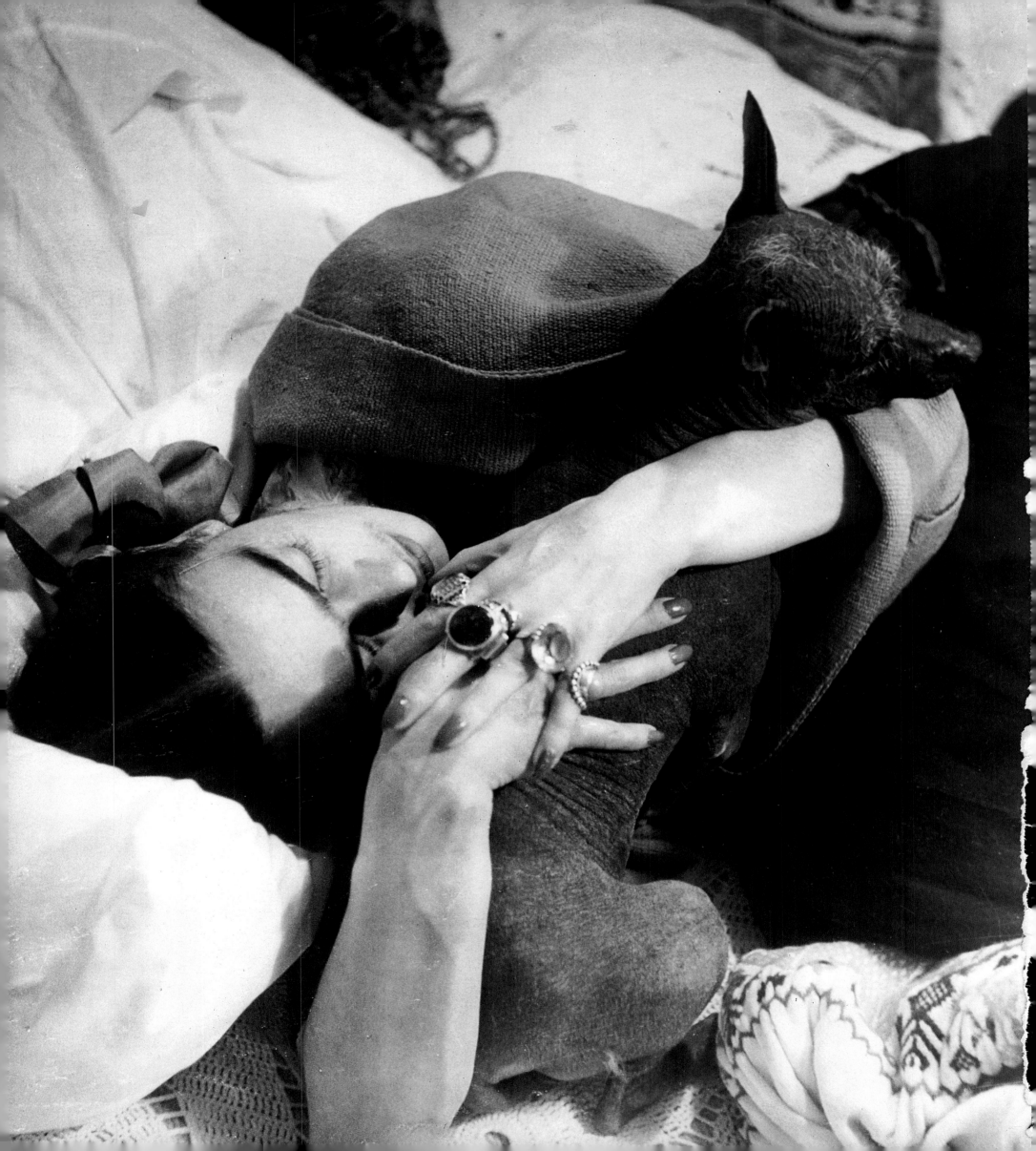

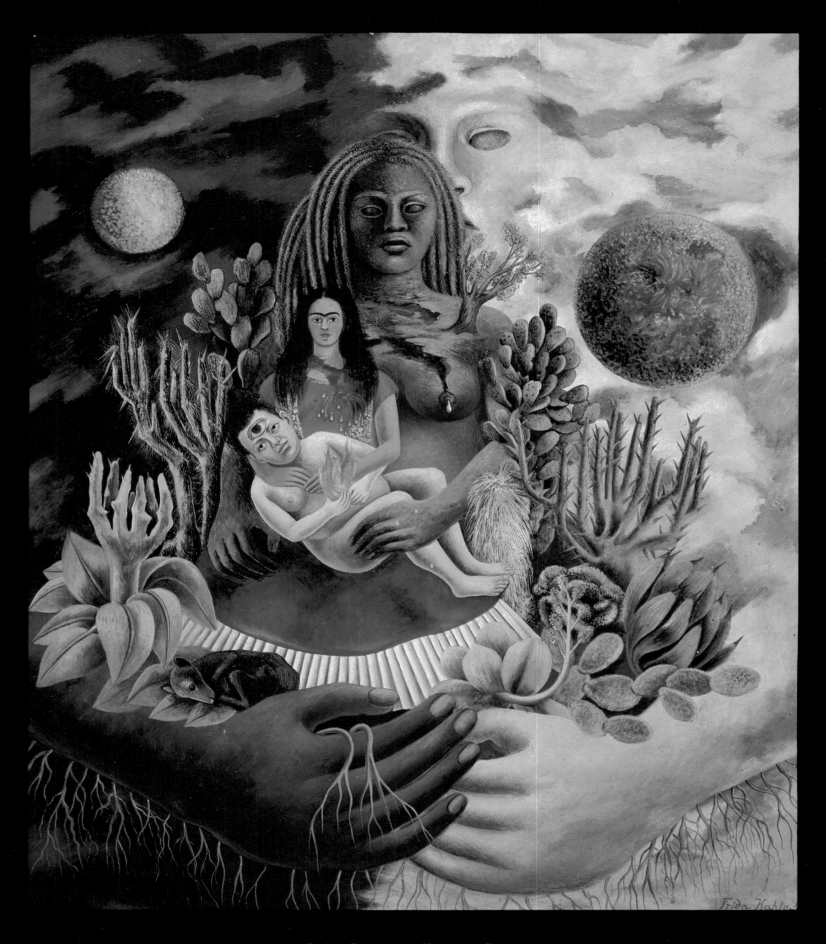

*THE LOVE EMBRACE OF THE UNIVERSE, THE EARTH
(MEXICO), DIEGO, ME, AND SEÑOR XÓLOTL, 1949.
OIL ON CANVAS,
70 X 60.5 CM*

Zayas and Fry recognized at the same time the beauty of African and Amerindian art. "This, of course, is the result of the general esthetic awakening following the rebellion against the tyranny of the Greek and Roman tradition," wrote Fry.[28] The same note was struck by Holger Cahill, who was very close to Diego Rivera, as was Zayas, but was, perhaps, slightly more significant in Frida Kahlo's education. Apart from his work as a caricaturist, Cahill was responsible for the Amerindian collection at the Newark Museum at the beginning of the 1930s. He was also an advisor to Abby Rockefeller on primitive American art, and in 1932 he took over from Alfred Barr, Jr., at the Museum of Modern Art of New York. There he was responsible for several exhibitions, which are of interest to us as they attracted the attention of Frida Kahlo, "American Folk Art: The Art of the Common Man in America, 1750–1900" and "American Sources of Modern Art." In a certain sense, the taste for popular and primitive art contributed to the contemporary belief, which exists more or less in every age, that all artists, whatever their merits may be, contribute to culture in some way.[29]

Frida Kahlo's painting naturally contains to a considerable degree elements from her personal life and universe. There are some who, at the center of the scene of her artistic expression, saw her only as a "little woman, who was fragile and sick, an invalid painting her wounds," as Salvador Novo wrote on Frida's death.[30] Indeed, there is evidence of this in the work. In her painting we see innumerable nearly empty rooms, as desolate as their protagonist—who nonetheless lends them a certain warmth—her face in its many guises in the shifting frame of each new self-portrait; the cold instruments of physical pain and hope needed to dominate muscles that are inept, stiff, and sick; the nine arrows piercing the ribs of Saint John of the Cross's little hart; the germinal beginnings of life and the dry desert flower next to the sun and moon; enveloping hands like protective skies: these are paintings that raise popular religious crafts—*santos* and *milagros*—to the level of art. The vast territory of her art, which developed according to a very firmly rooted tradition among the men and women of this century, not only includes but also melds with other elements that do not belong originally to art. Take, for example, the geometrical shapes of the Casa Azul in Coyoacán and the chaos of the garden plants, her collection of ex-votos, and the functional glass doors of her studio, the waterlike surface of the mirror on the balcony and the stone supporting the mirror. In addition to this, if we venture beyond the paintings and living areas, we cannot forget the large number of scattered personal papers, the garish silver and gold decorations of her clothes, and the lace of her silver and decorative stones.

An important piece of the artistic universe of Frida Kahlo was Rivera in all his human complexity. As is well known, he appears in the paintings that were most important to the artist; he shares in moments of enormous creative happiness and anguish, as in *Autoretrato como tehuana* (Self-Portrait as a Tehuanan), 1943, and *Diego y Yo* (Diego and I), 1949, and he is also part of Frida's own expressive development. On more than one occasion, it has been said that Rivera's physical size—as if it were something despicable—seems to overwhelm or diminish her completely. However, rather than Rivera or any other element, Frida herself was always the real center of this artistic domain.

The story of her foundation as an artist may have started in her student days, among the group of friends who called themselves *Los Cachuchas*. Or, quite naturally, in the family environment where she is depicted in a photograph taken by her father, Wilhelm Kahlo, as an adolescent wearing a man's three-piece suit in the mid-1920s. Her entry into the Preparatoria Nacional, which was a departure from deeply rooted family

[28] Roger Fry, "Ancient American Art," in *Vision and Design* (London: Penguin, 1961), p. 92.

[29] See Alice Goldfarb Marquis, *Alfred H. Barr, Jr: Missionary for the Modern* (New York: Contemporary Books, 1989), Alan Moore, "Holger Cahill's Inje-Inje. The Story of Modernist Primitivism" (Ph.D. diss., Hunter College, 1996).

[30] S. Novo, "24 July [1954]," in *La vida en México en el periodo presidencial de Adolfo Ruiz Cortines*, vol. 1, p. 409.

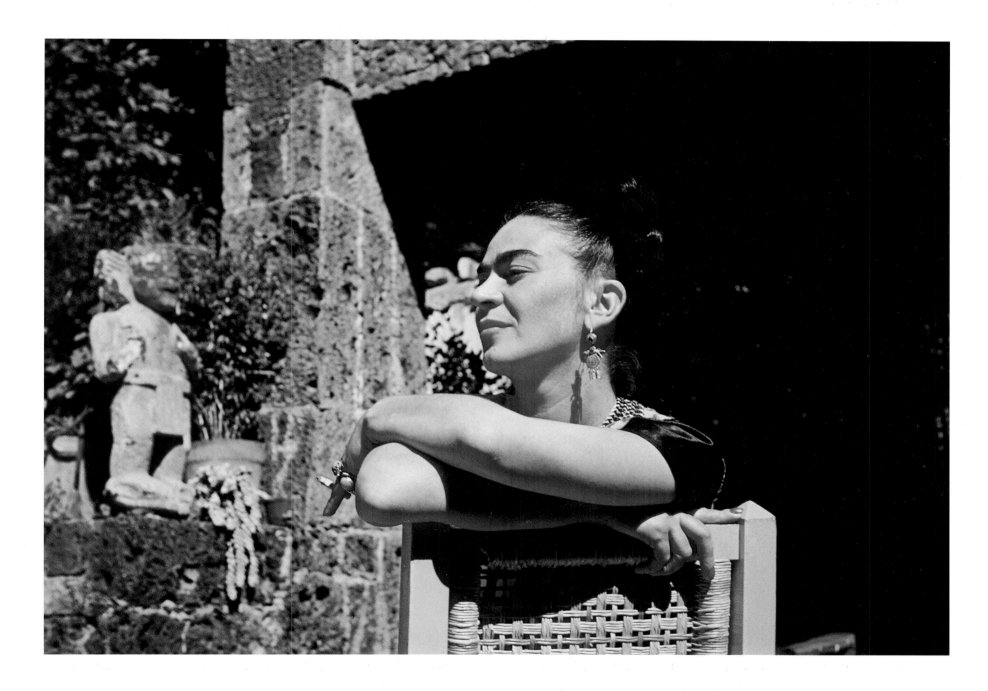

FRIDA IN COYOACÁN,
1941

customs, led her to define herself as an individual. Her face is glowing in one of the rare pictures of her as one of *Los Cachuchas;* she is an enthusiastic accomplice in the rebelliousness that she shared with her beloved companions at the Preparatoria. Her attitude is quite different, however, in the image the writer Alejandro Gómez Arias presents, describing the lovers' agreement that existed between them before her accident in 1925. "We were young lovers," explains Gómez Arias. "Our relationship was destroyed by the accident."[31]

A few pages back I mentioned a photograph of Frida Kahlo and Diego Rivera that is reminiscent of a picture taken in Mexico in around 1924 of Edward Weston and Tina Modotti. In both cases their appearances are the sum total of their relationships.

A clearly nineteenth-century atmosphere dominates the photo of Weston and Modotti. A branch of roses between them, for example, highlights the playful and calm image in which the lovers are holding hands, as if they were sealing an agreement that seems to have more to do with business than love. Despite this, the entire atmosphere of the studio is attempting to portray the idyllic quality of the couple—and any couple in this situation. The theatrical feel to the studio seems to have been created in order to avoid looking at the studio, though nothing is unique except the man and woman who are in it.

The atmosphere that prevails in the photo of Frida Kahlo and Diego Rivera is quite different, and the first impression is that it is less playful and rather more artistic and studied. This photo is also taken inside, but not in a studio as such. Perhaps the forced improvisation of the situation was the only thing that embarrassed the careful photographer in the house of the Riveras. The atmosphere of the photo preserves a slightly more domestic rather than theatrical touch—although everyday life does have its dramatic rules—and the attitude of the characters moves away from the tone of the photo of Weston and Modotti. Instead of their being an artificial and traditional country scene, the backdrop consists of a wooden statue, two candle holders, and a picture of a large fish on the chimney, with Frida Kahlo and Diego Rivera in the forefront looking directly into the lens of the camera.

Here, more than in any other photo, Frida seems tiny and light. She sits with Diego, below him and to his side. We ought, therefore, to ask whether it is not precisely here that we can first appreciate the girl in her own territory and artistic domain.

[31] Alejandro Gómez Arias and Víctor Díaz Arciniega, *Memoria personal de un país* (Testimonios)(Mexico City: Grijalbo, 1990), p. 83.

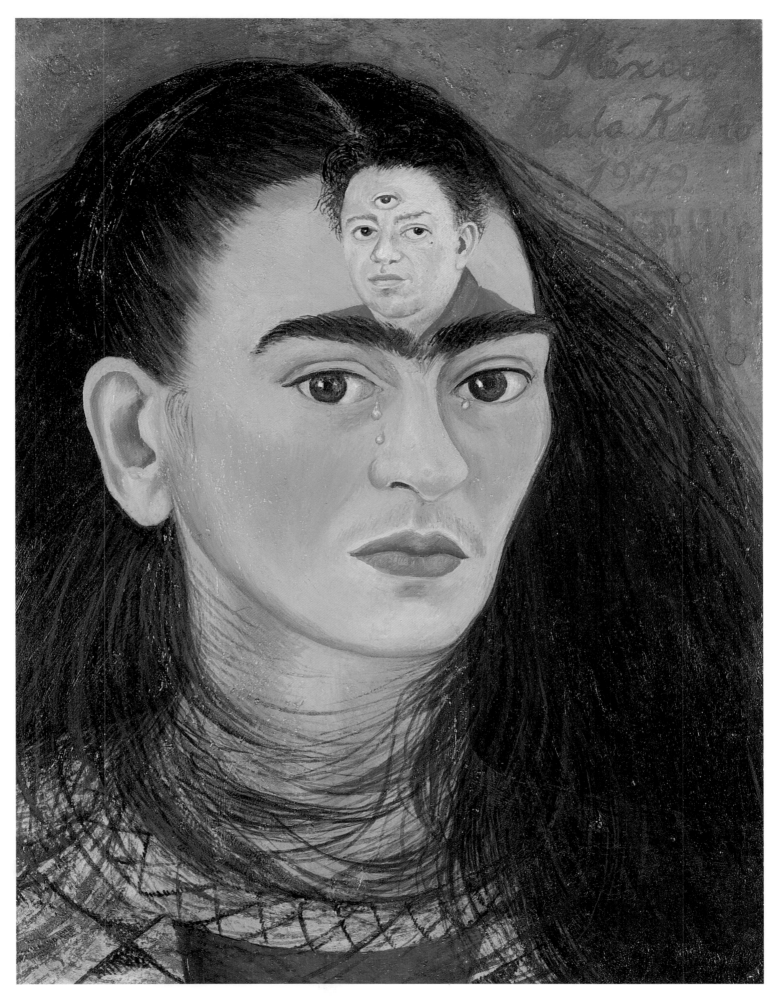

DIEGO AND I, 1949.
OIL ON CANVAS,
29.8 x 22.4 CM
(DEDICATED TO FLORENCE
ARQUIN AND SAM WILLIAMS)

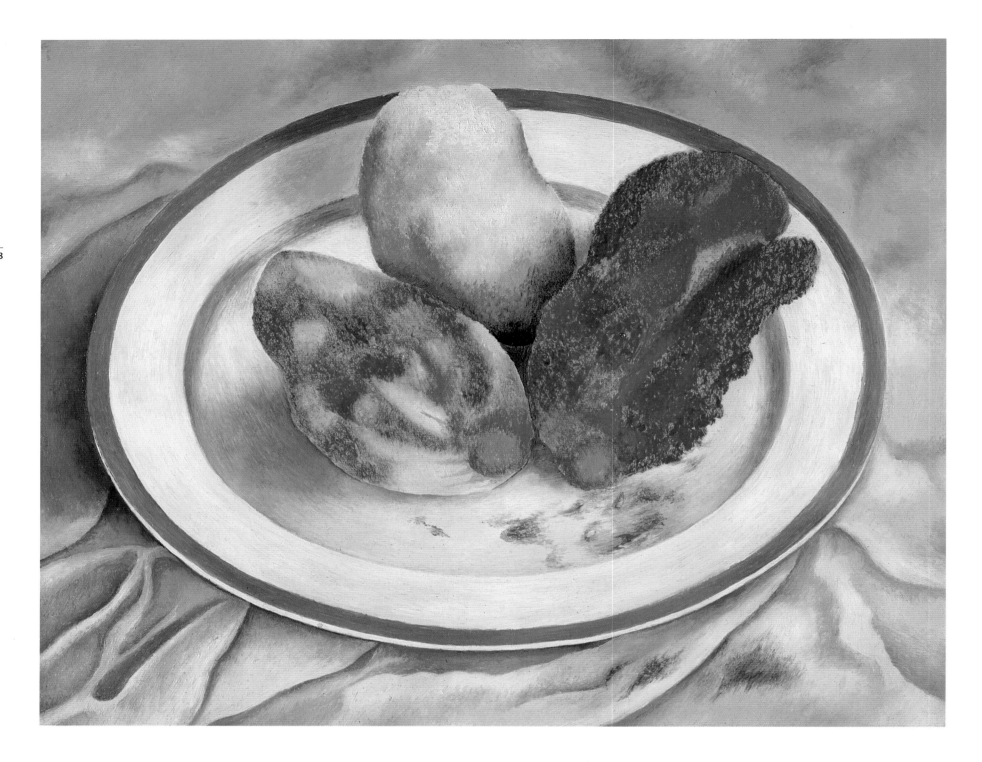

TUNAS (STILL LIFE WITH
PRICKLY PEAR FRUIT), 1938.
OIL ON PLATE,
19.7 X 24.8 CM

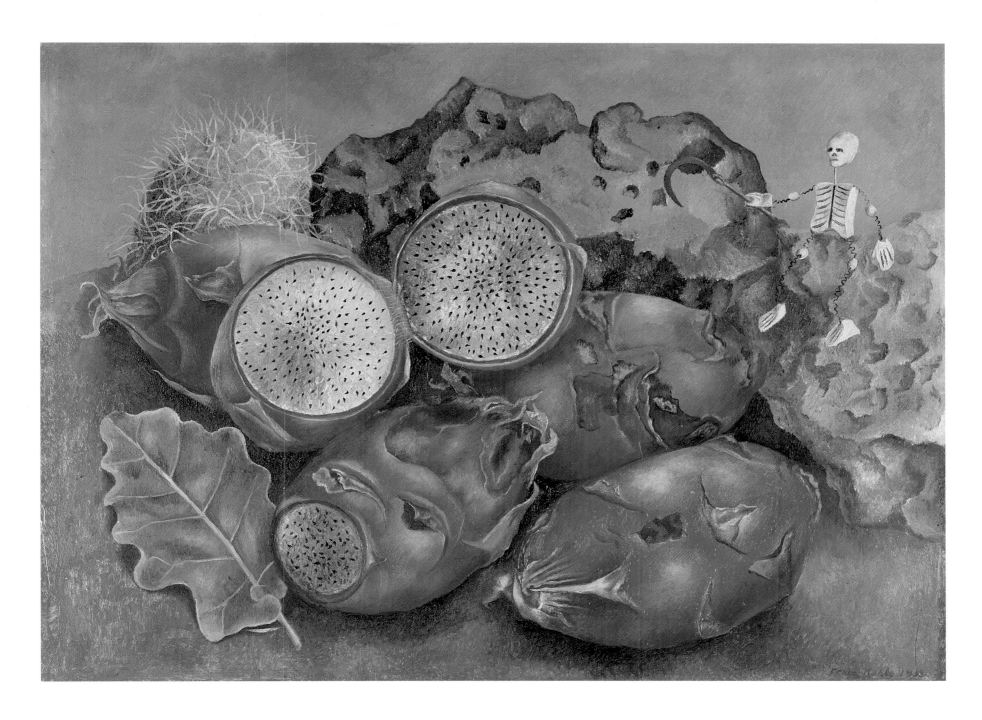

STILL LIFE WITH PITAHAYAS, 1938.
OIL ON PLATE,
25.4 × 35.6 CM

PAGES 210–211:
STILL LIFE WITH PITAHAYAS, 1938
(DETAIL)

Xòchitl, Flower of Life, 1938.
Oil on plate,
18 x 9.5 cm

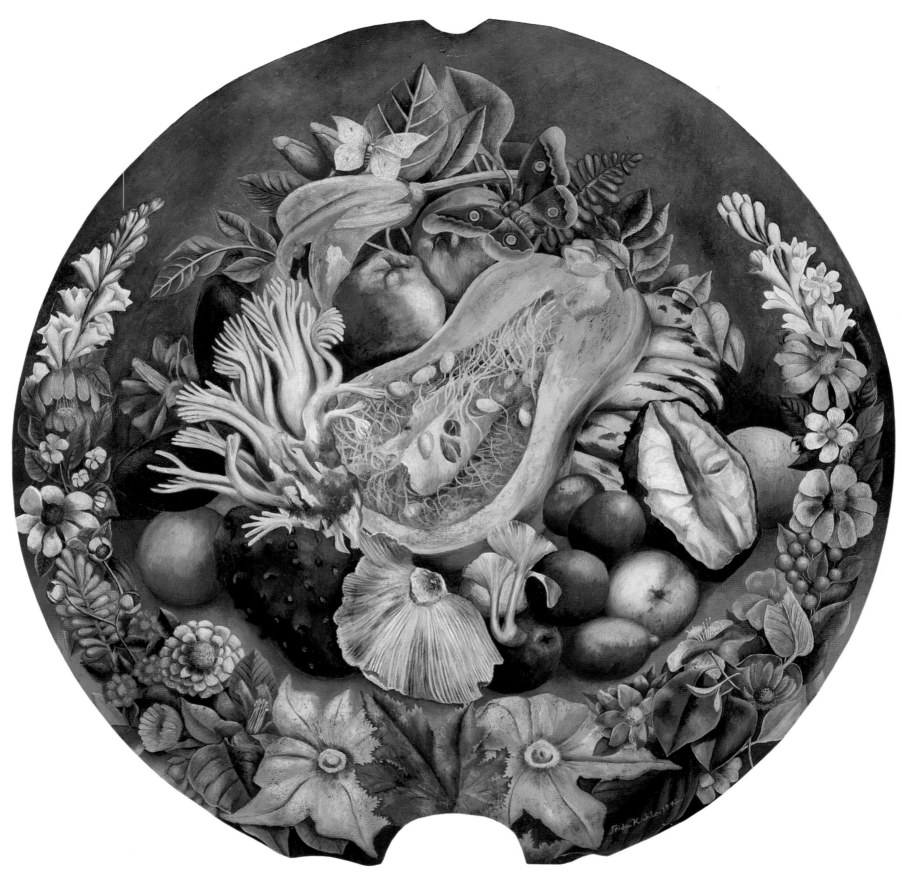

STILL LIFE, 1942.
OIL ON COPPER PLATE,
63 CM DIAMETER

PAGES 212–213:
STILL LIFE, 1942
(DETAIL)

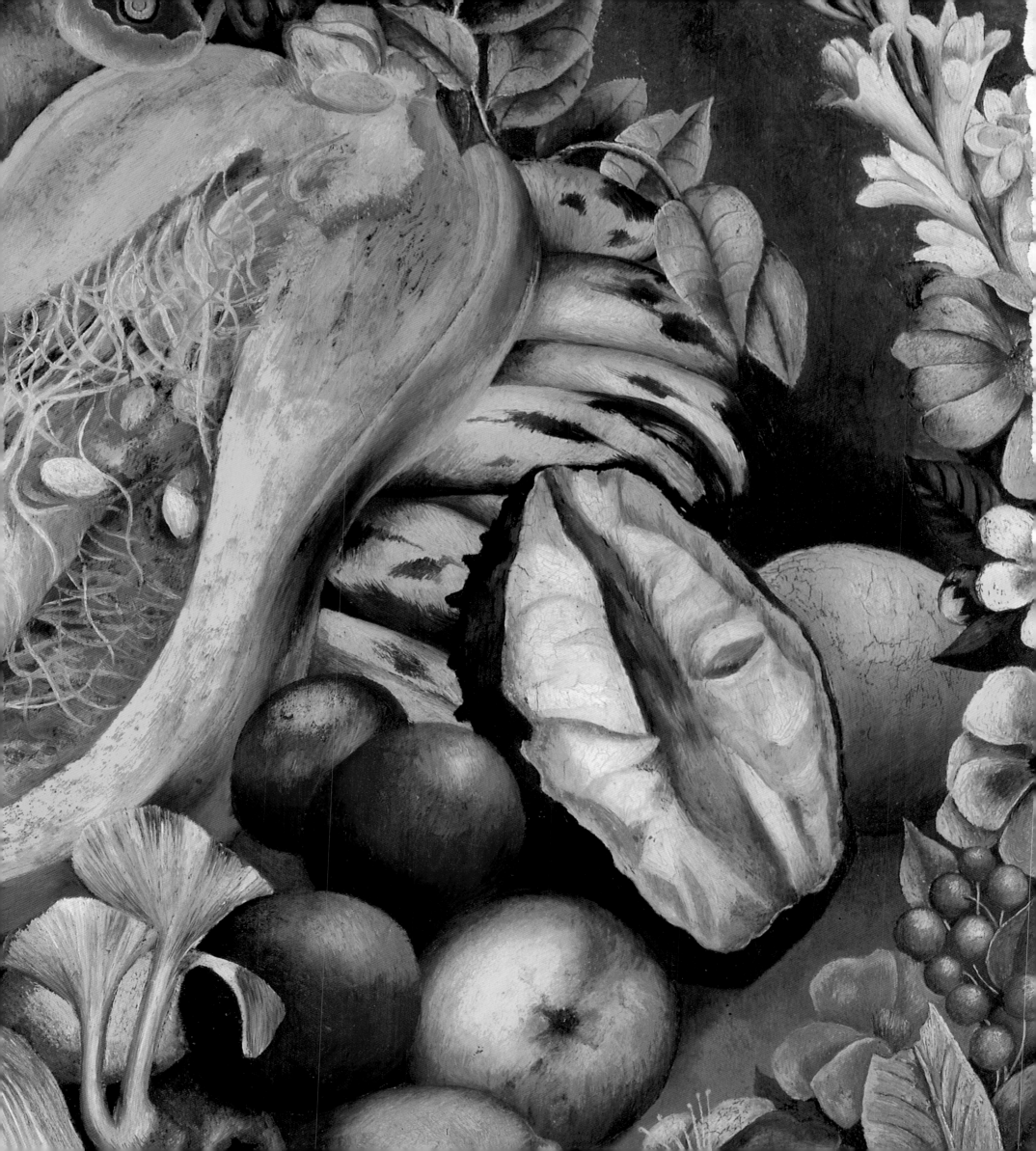

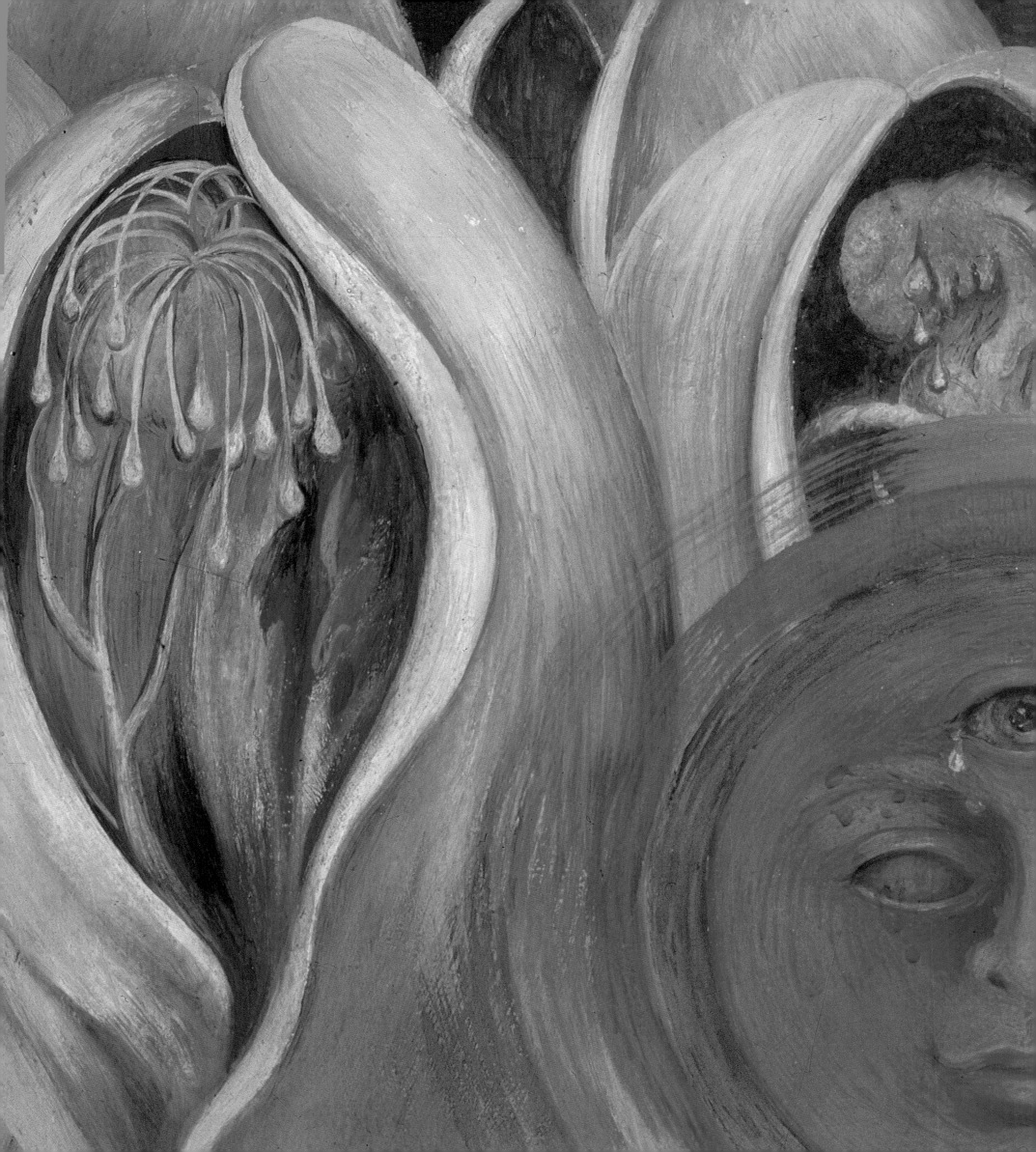

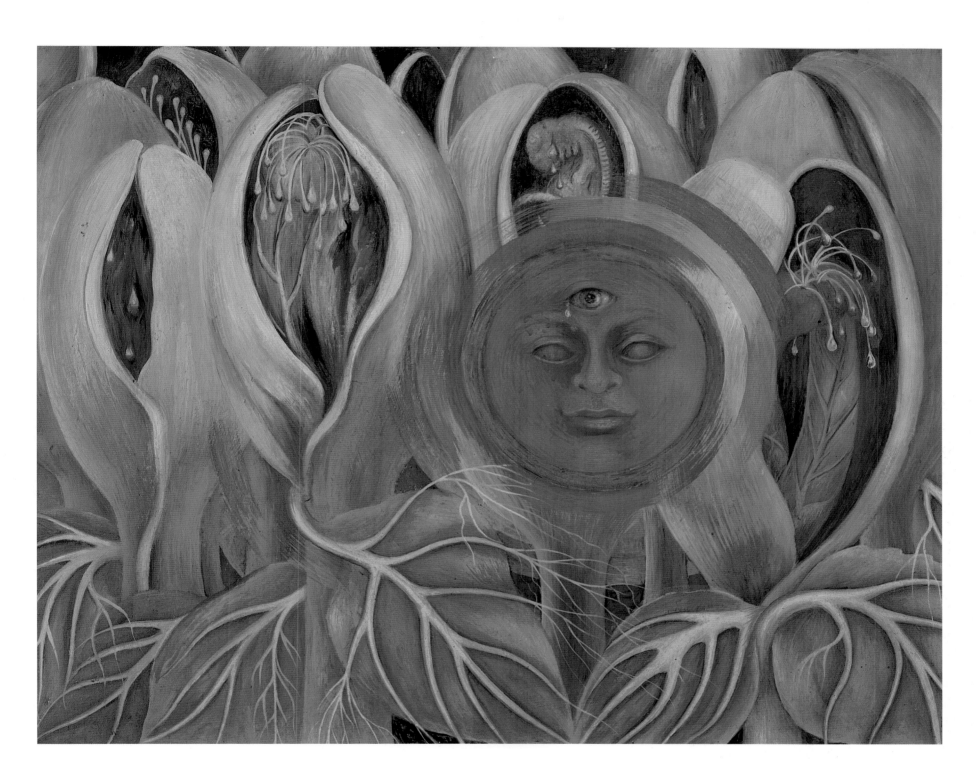

Sun and Life, 1947.
Oil on masonite,
40 x 50 cm

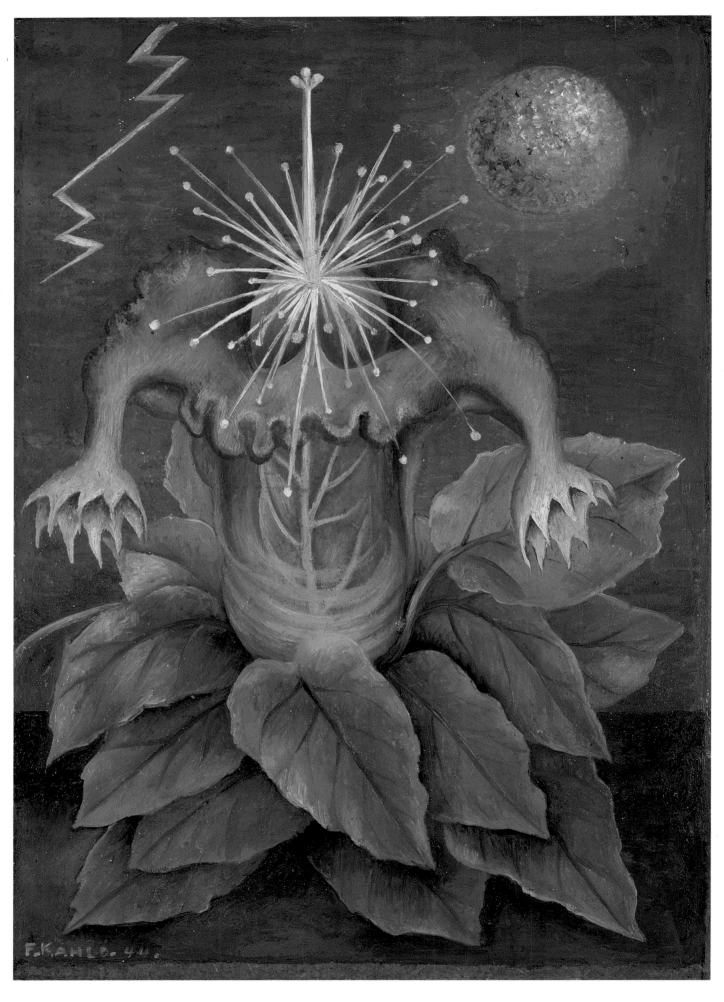

FLOWER OF LIFE, 1944.
OIL ON MASONITE,
27.8 x 19.7 CM

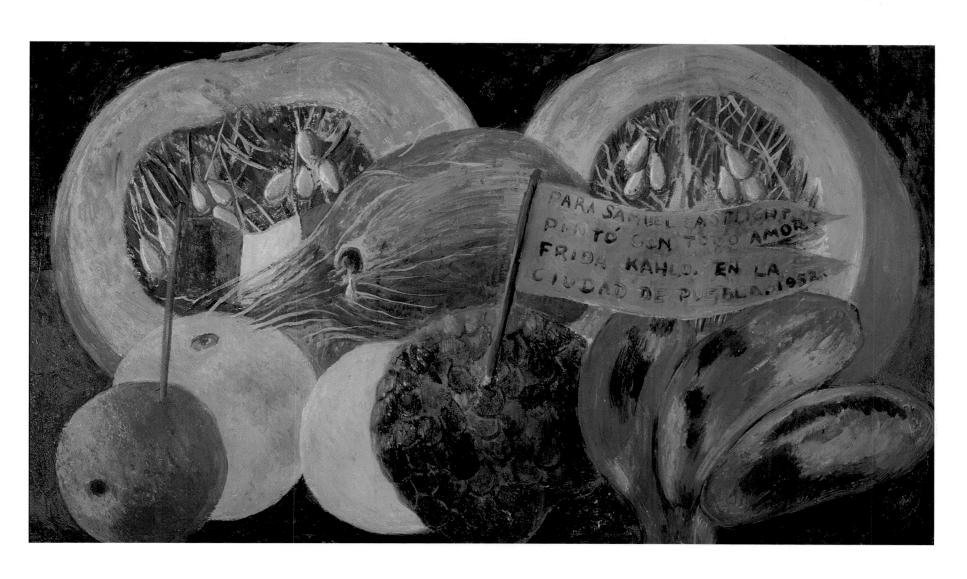

Still Life
("For Samuel Fastlicht, painted with
all my love"), 1952.
Oil on canvas mounted on wood,
25.8 x 44 cm

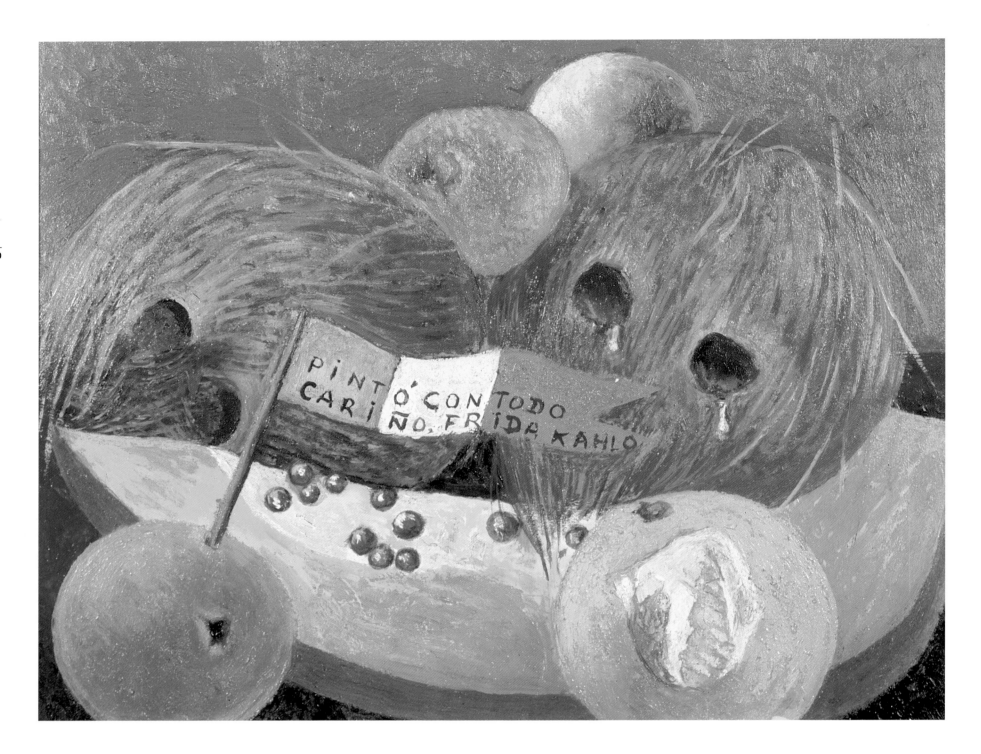

Coconut Tears (Crying Coconuts), 1951.
Oil on masonite,
23.2 x 30.5 cm

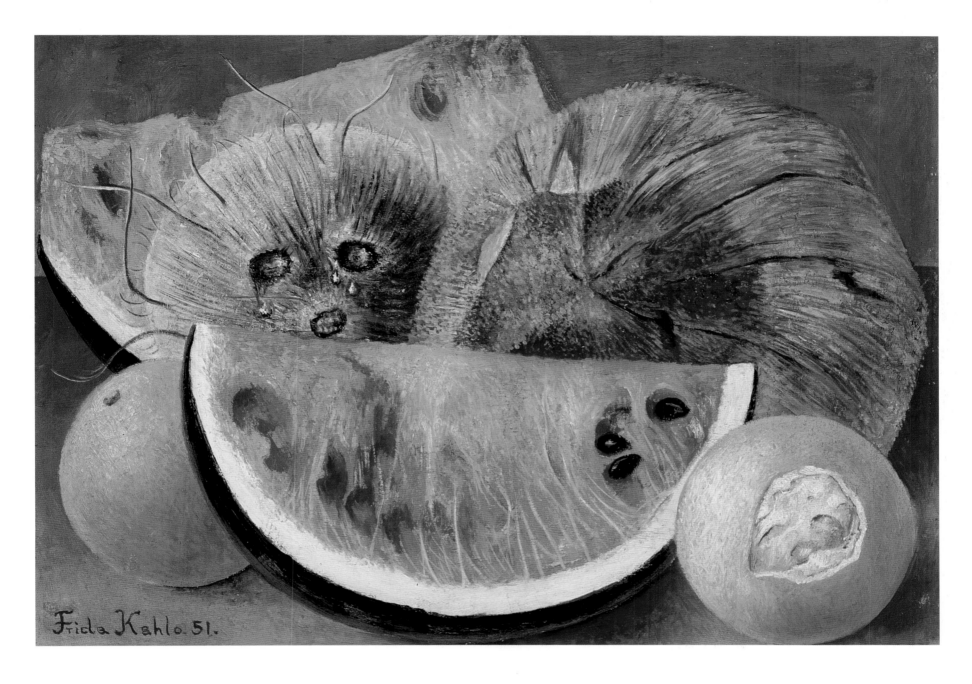

Coconuts (Glances), 1951.
Oil on masonite,
25.4 x 34.6 cm

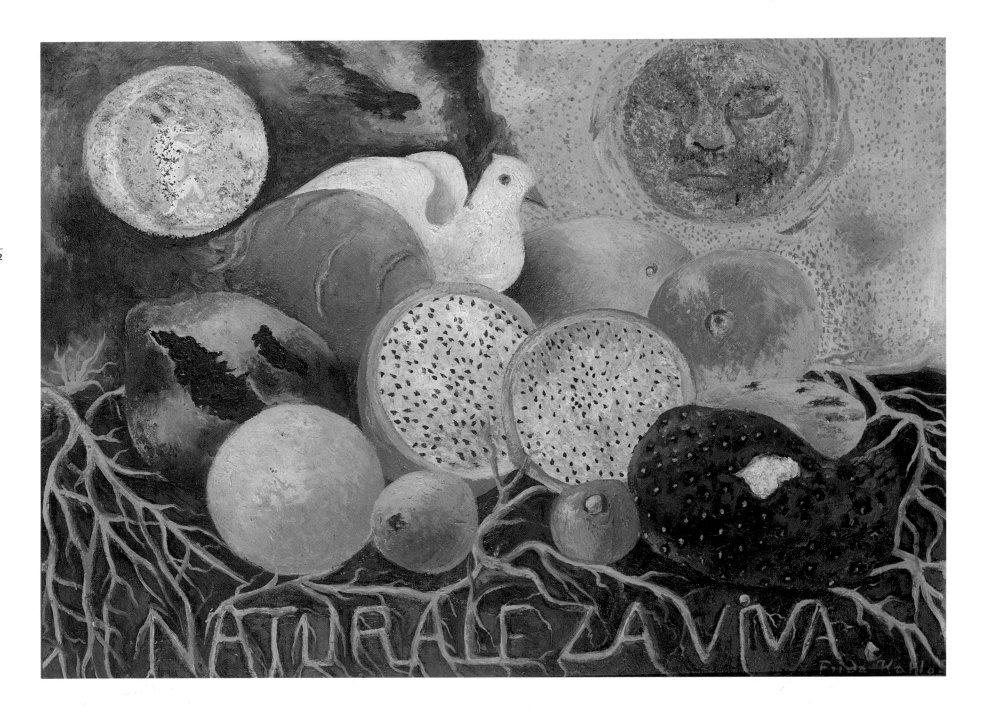

LIVING STILL LIFE, 1952.
OIL ON WOOD,
61 X 45 CM

NEXT PAGE:
STILL LIFE
WITH PARROT
AND FLAG, 1951
(DETAIL)

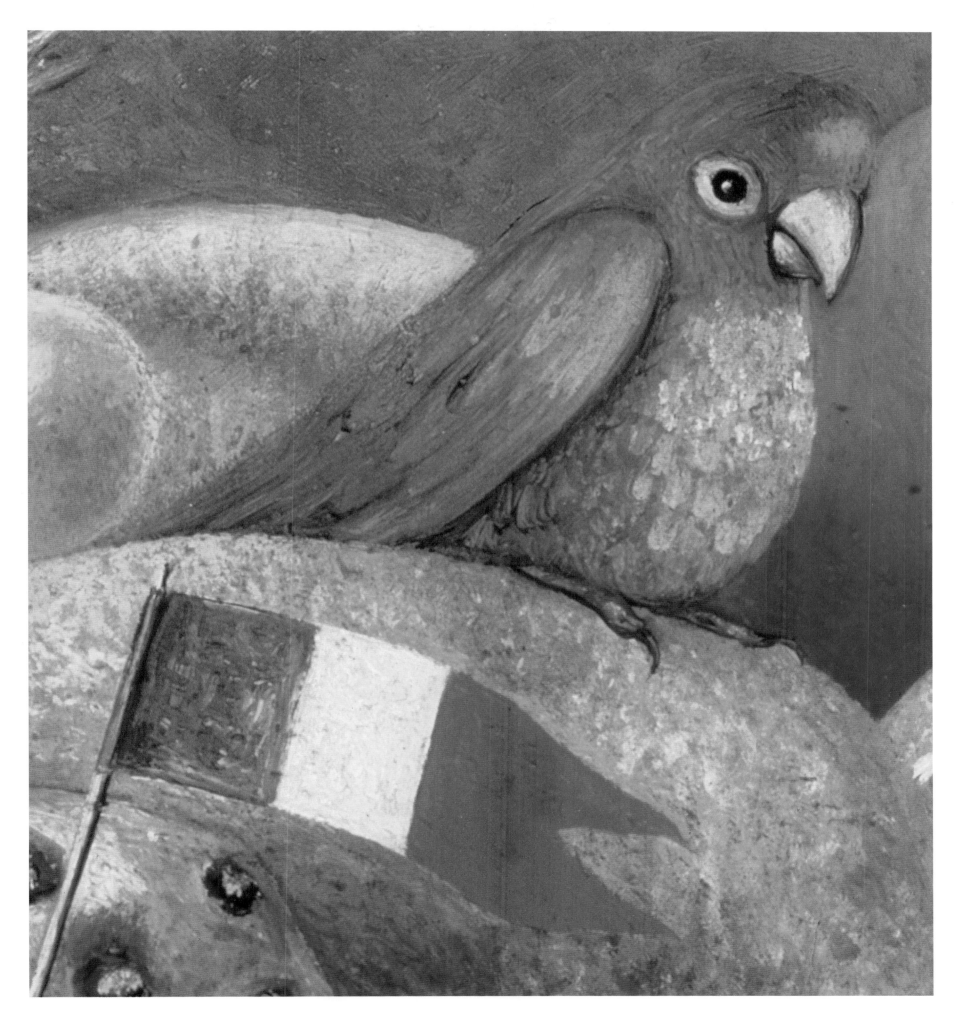

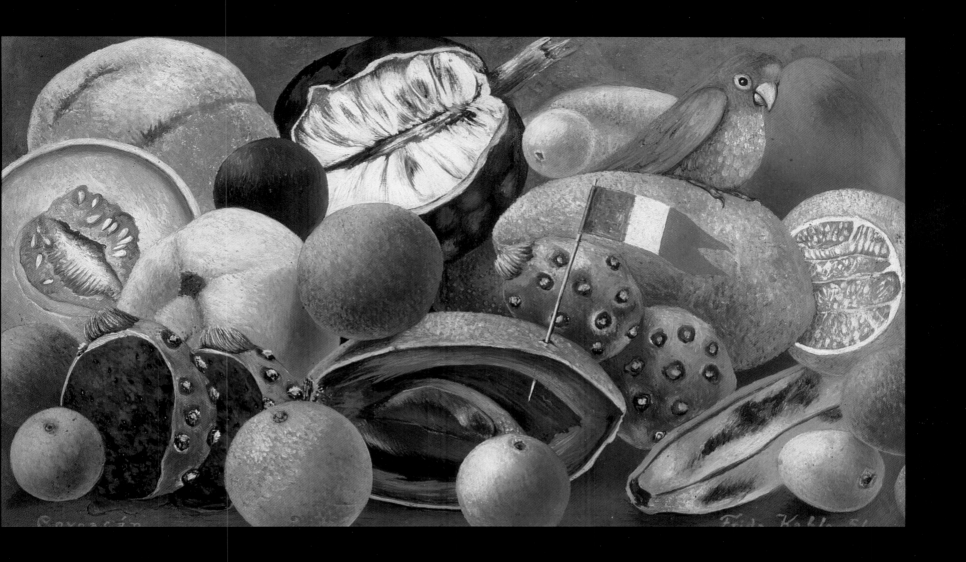

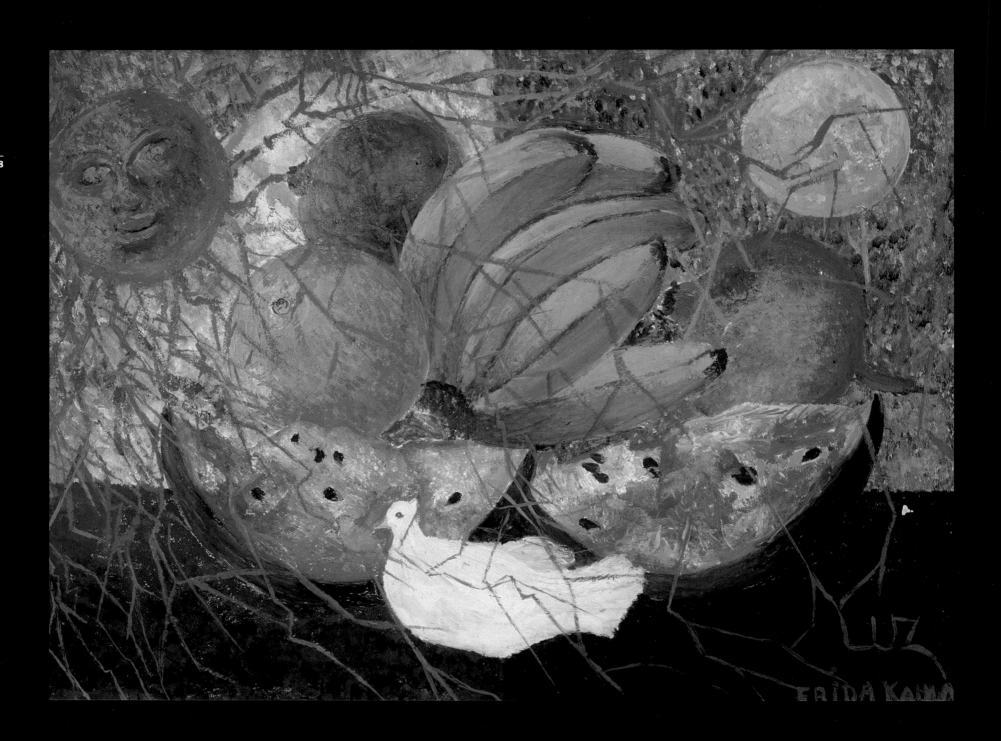

LIGHT. FRUIT OF LIFE, CA. 1953.
OIL ON MASONITE,
45 X 61 CM

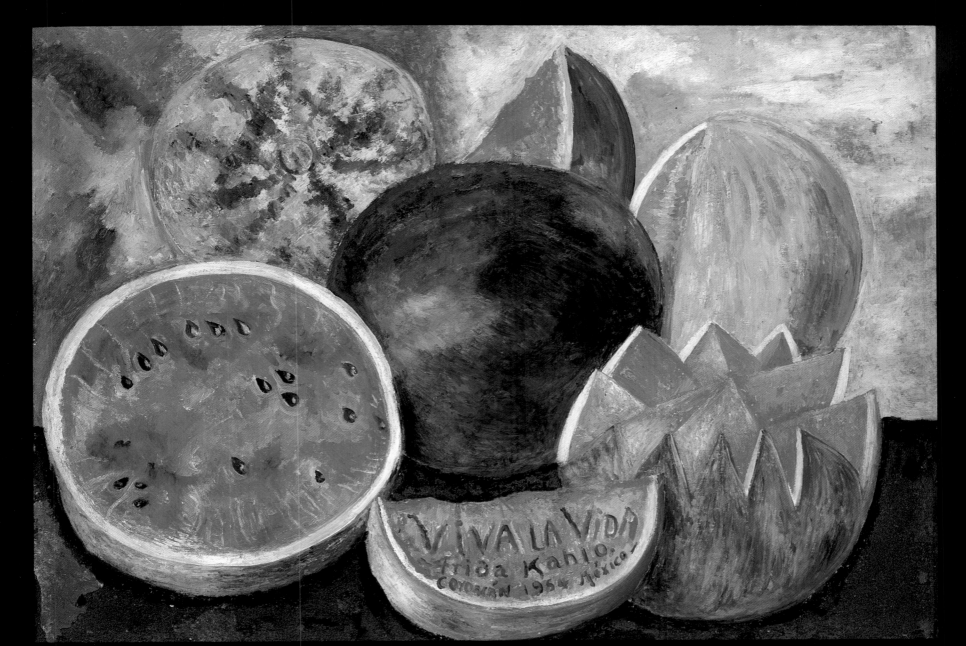

VIVA LA VIDA
Frida Kahlo.
Coyoacán 1954 México.

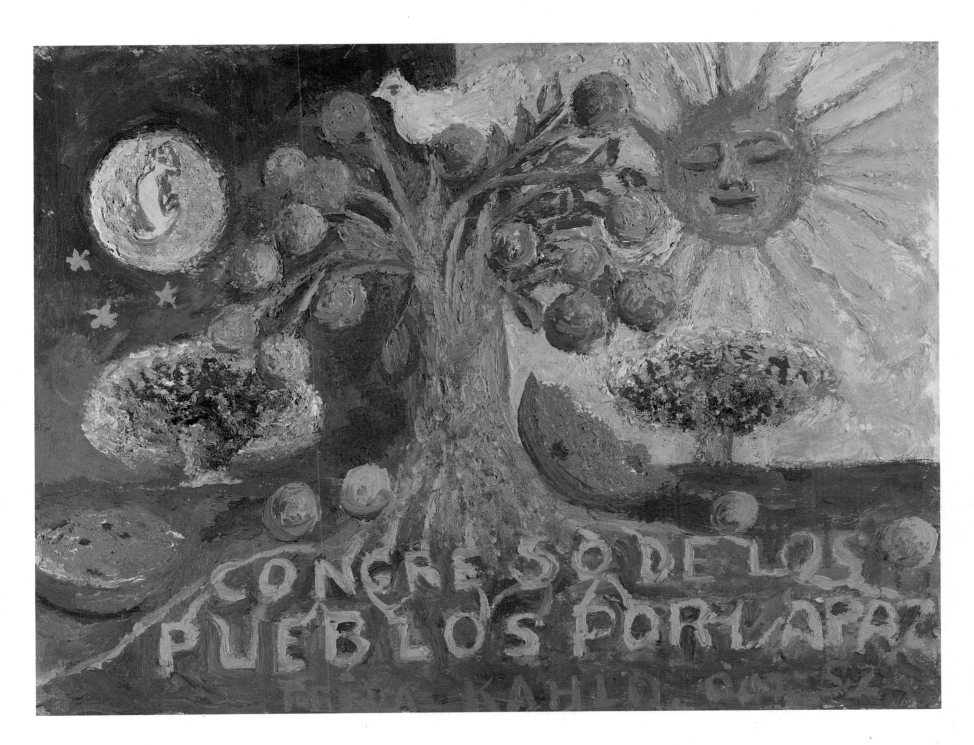

*Congress of Peoples
For Peace,* 1952.
Oil and tempera on masonite,
19.1 x 25.1 cm

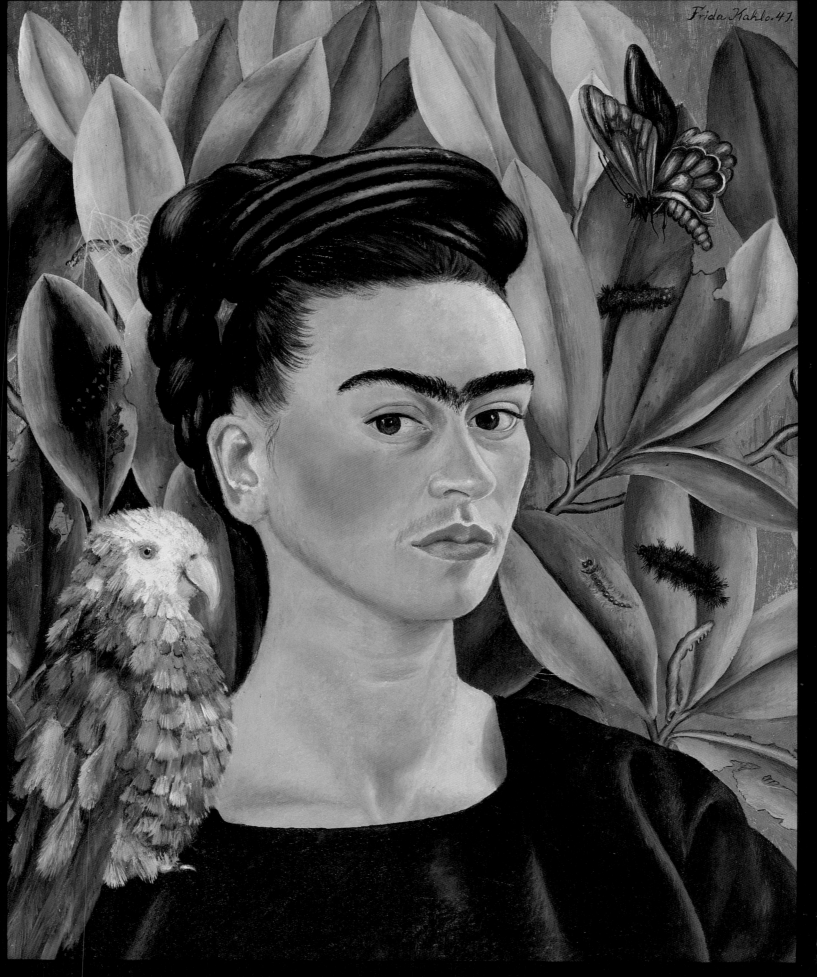

Frida Kahlo and Mexican Art

Diego Rivera

In the middle of the panorama of all the finest Mexican art produced over the last twenty years, like a diamond in the very center of a great jewel, clear and hard, precious and sharp, shines the painting of Frida Kahlo Calderón. Christ, the Virgin, and the saints disappear from the *retablo,* and in place of any old miracle, we find the permanent miracle that makes up the theme of painting—in other words, the vital, everflowing content, at once different and the same in its cosmic circulation. A life contains the elements of all lives, and if one penetrates to the bottom of it, one comes across abysmal depths, dizzying heights, and infinite ramifications that spread into the centuries of light and shadow of life.

Frida's *retablo* constantly paints her own life because the two Fridas are both the same and different. Her father's German genes—analytical, constructing and deconstructing, skeptical—prevailed over and purified the genes of her mother, a combination of Spanish and Indian elements. Behind the door of the sky, left wide open, is the relentless and wonderful space from where the sun and moon both shine on the magnificent pyramids, microscopically small in comparison with the star and the planet, yet immense in their universal proportions. The little girl sitting in the center of the world is holding a toy plane that goes at the same speed, much faster than lightning, like imagination-reason, which recognizes stars and cities before reaching them by telescope and locomotives. That speed resides in Frida, alone in machine-operated space, stretched out on a bed from where she can see, on the surface crying that the life-fetus is the flower-machine, a slow snail, a dummy, and an armor made of bone, while in reality her imagination-reason is traveling faster than light.

The recurring self-portrait never resembles another and is more and more like Frida, changeable and permanent, like universal dialectics.

Her monumental realism shines; her hidden materialism is present in the heart cut into two, blood flowing from tables, bathtubs, plants, flowers, and arteries closed by the hemostatic forceps of the artist.

Her monumental realism is expressed through her small size, the tiny little heads accurately sculpted as if they were enormous, in the same way as the images from a projector are magnified on the wide surface of a wall. When "photo-microscopy" increases the ocular background of Frida, reason appears. The tissue of veins and the networks of cells are different; what is lacking are the elements needed to increase, with a new perception, the total of the art of painting.

Frida's *retablos* are unlike anybody else's and anything else. Frida's art is collective-individual. Her realism is so monumental that everything possesses universal dimensions, and, as a consequence, she paints the outside, the inside, and the very bottom of herself and the world. In the sky, oxygen and hydrogen and carbon, compressed electricity, the spirits of space, Hurakán, Kukulkán, and Gukumatz are all alone with their parents and grandparents, while Frida is on Earth and organic, thunder, lightning, and the ray of light that finally creates man; however, for Frida, the tangible element is the mother figure, the matrix; the sea, a storm, nebula, woman.

Frida is the only example in the history of art of a woman who tears open her womb and her heart to recount the biological truth of what she feels inside them. She possessed the faster-than-light reason-imagination to paint her mother and

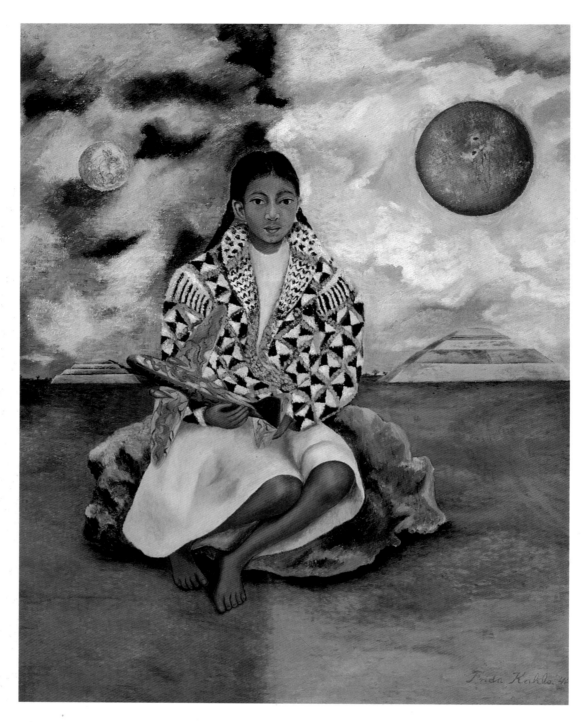

Portrait of Lucha María, a Girl from Tehuacán, (Sun and Moon), 1942. Oil on masonite, 54.6 x 43.1

her nurse, knowing that she did not actually know their faces: her wet nurse is an Indian mask made of stone, and her glands are full of milk, which is falling like earth-nourishing rain, like a pleasure-nourishing tear; and her mother is the seven knife wounds of pain that enable the child Frida to emerge, the only human energy since the great Aztec master who created a sculpture in black basalt to give plastic form to birth—a birth that produced the only woman to express, in her art, the feelings, the functions, and the creative power of women, with unsurpassable *kalis-technica;* a birth that produced the ultimate painter and the greatest testimony to the reality of the artistic Renaissance in Mexico.

Excerpt from an essay originally published in *Boletín del Seminario de Cultura Mexicana,* 1(no. 2 [October 1943]) in Diego Rivera, *Arte y Politica,* selection, introduction, notes, and biographical information by Raquel Tibol (Mexico City: Grijalbo, 1979), pp. 239–248.

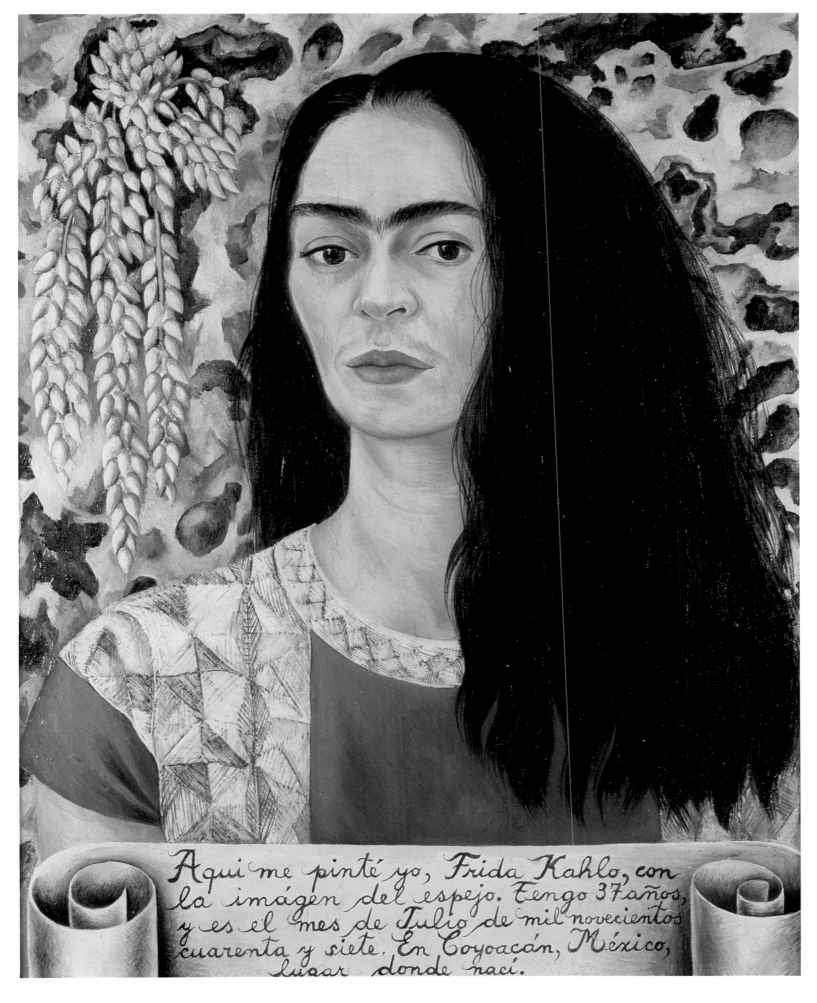

SELF-PORTRAIT WITH
LOOSE HAIR, 1947.
OIL ON MASONITE,
61 X 45 CM

Brief Biography

The daughter of the photographer Wilhelm Kahlo and Matilde Calderón, Frida Kahlo is born in the house in Coyoacán on July 6, 1907. Her maternal grandmother, Isabel González, whose married name is Calderón, registers her at the Civil Registry Office under the name of Magdalena Carmen Frida. Her father is thirty-six and her mother thirty.

She contracts poliomyelitis as a child and has to spend a lot of time at home; her right foot is affected by the disease.

Around 1920 she joins the League of Young Communists.

By 1922 she is attending the Escuela Nacional Preparatoria with the intention of eventually qualifying to study medicine. It is here that she meets contemporaries who will one day be among the writers and intellectuals of Mexico, like Salvador Novo, and she joins a group of restless young people called *Los Cachuchas*.

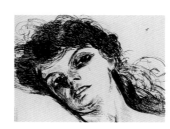

The first record of her encounter with formal artistic training dates from around 1925, when Frida Kahlo takes drawing lessons in the workshop of the engraver Fernando Fernández. Here she trains her hand and her eye in detailed copies of the engravings of the artist Anders Zorn.

Her life takes an unexpected turn on September 17, 1925, when she is involved in a terrible accident. The bus she is traveling on is hit by a street trolley, and the adolescent Frida Kahlo is seriously injured. A handrail pierces her abdomen and injures her spine, her pelvis, and her uterus. Her life will never be the same again.

The convalescence period forces her, yet again, to remain in bed for a long time. To distract her, she is given paints and paintbrushes; she remembers that it was around then that she started to long to paint formally.

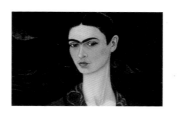

She dedicates her first oil self-portrait to her boyfriend at the time, Alejandro Gómez Arias, in September 1926.

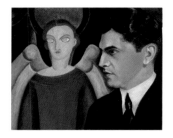

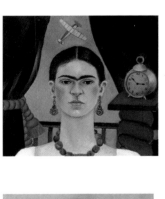

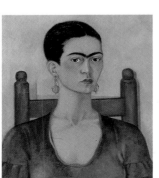

On July 18 she gives her friend Ángel Salas a watercolor entitled *Échate l'otra* (Have Another One), and in the same style she paints a scene from a café for Miguel N. Lira, which is dated 1927. Both works reveal the influence of the Adolfo Best Maugard drawing method.

By 1927 her painting has become more intellectually sophisticated, and under the influence of the *estridentismo* movement she paints *Retrato de Miguel N. Lira* (Portrait of Miguel N. Lira).

In 1928 the photographer Tina Modotti and the revolutionary ideologue Julio Antonio Mella join the circle of Frida Kahlo's friends. She meets Diego Rivera for the second time, as it seems they already met while he was painting the mural entitled *La creación* (The Creation) in the Simón Bolívar lecture hall at the Escuela Nacional Preparatoria, where Frida was studying.

In 1928 she paints the highly refined portrait of her sister Cristina Kahlo.

On August 21, 1929, she marries Diego Rivera in Coyoacán. She paints her second self-portrait—entitled *El tiempo vuela* (Time Flies)—the first portrait in which she establishes her own style and her role as a painter independent of Rivera.

By the end of 1929 and the beginning of the following year she has settled in Mexico City and Cuernavaca, where she stays while Diego Rivera is painting the

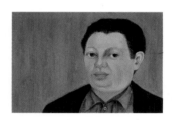

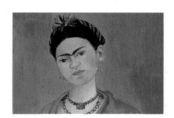

mural *Conquista y Revolución* (Conquest and Revolution) in the Palacio de Cortés.

After carrying a child for three months, she has her first miscarriage.

Frida Kahlo travels to the United States with Diego Rivera, who is to paint murals in California. On November 10, 1930, they arrive in San Francisco, where Kahlo meets the sculptor Ralph Stackpole, the painter Arnold Blanch, and Blanch's wife, Lucile, and becomes a personal friend of Dr. Leo Eloesser; she visits museums and galleries and broadens and enriches her esthetic horizons considerably. She paints a self-portrait, holding hands with Diego, for the American art collector Albert Bender.

The couple return to Mexico on June 8, 1931, but only for a short period. In November of the same year they sail to New York. They stay at the Barbizon Plaza Hotel on Sixth Avenue.

On March 31 she travels with Rivera to Philadelphia; they then move on to Detroit, arriving on April 21, 1932. Between New York and Detroit she starts painting *Aparador en una calle de Detroit* (Window Display in a Street of Detroit), dated 1931. The painting is strongly influenced by the metaphysical paintings of Giorgio de Chirico.

Kahlo misses Mexico and starts to question the values and the lifestyle in the United States; while experiencing this

FRIDA KAHLO AT THE AGE
OF FOUR, SEPTEMBER 11, 1911

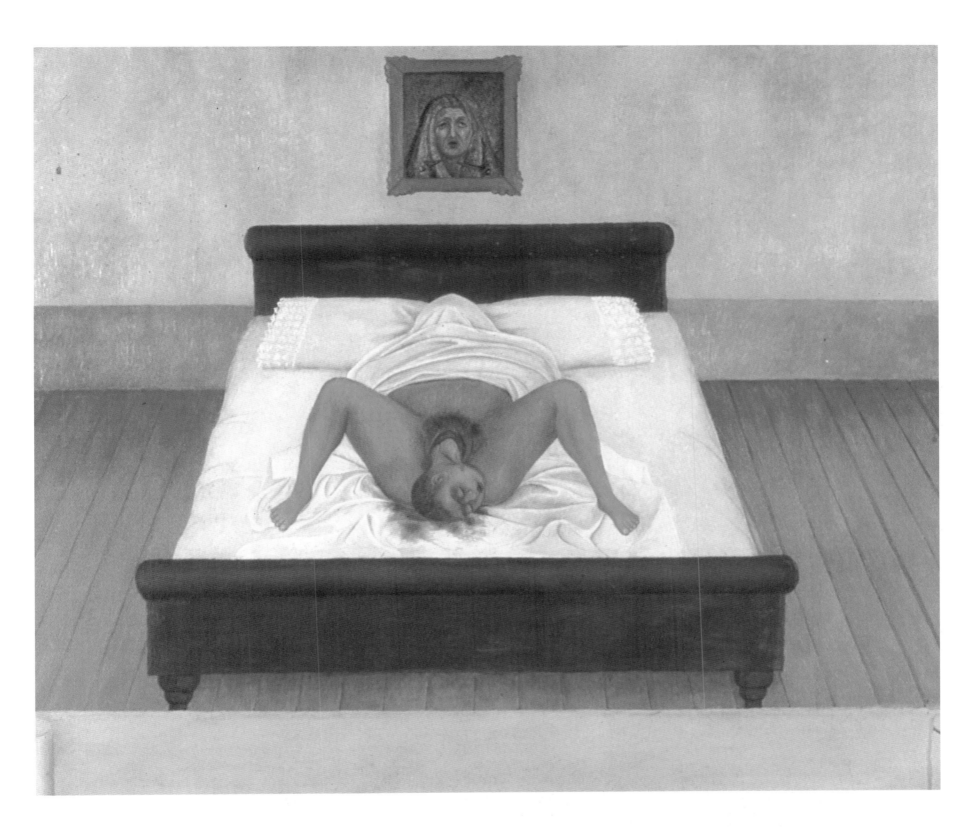

My Birth, 1932.
Oil on plate,
30.5 x 35 cm

turmoil, she paints *Autoretrato en la frontera de Mexico y los Estados Unidos* (Self-Portrait on the Borderline between Mexico and the United States).

On July 4, 1932, she has a second miscarriage at four months; she is treated by Dr. Pratt at the Henry Ford Hospital in Detroit. Her terrible experience is reproduced in a lithograph entitled *El aborto* (The Miscarriage), and her severe depression leads her to paint her naked and bleeding body lying on a hospital bed.

On August 31, from the roof of the Detroit Institute of Arts, she sees an eclipse of the sun. The duality of night and day will become a recurring iconographic theme in her art.

For September and October 1932, she goes back to Mexico briefly, due to her mother's deteriorating health and subsequent death. She decides to paint her own birth as a dead fetus; from then on her work takes on greater autobiographical emphasis.

In March 1933, she moves back to New York with Diego Rivera, who has been invited to paint a mural for the Rockefeller Center. Censorship and the subsequent destruction of Rivera's mural lead Frida Kahlo to paint an apocalyptic vision of capitalism and bourgeois society in the United States, a collage and oil entitled *Allá cuelga mi vestido, Nueva York, 1933–1938* (My Dress Hangs There, New York, 1933–1938).

On December 20, 1933, the Riveras decide to leave New York.

Frida Kahlo experiences a third miscarriage at four months in 1934; this time she is treated by Dr. Zollinger, in Mexico. Diego Rivera has an affair with Frida's younger sister, Cristina. Hurt by their betrayal, Frida paints *Unos cuantos piquetitos* (A Few Small Nips).

A year later she decides to leave Rivera and the San Ángel house and move to a flat on Avenida Insurgentes. In July 1935, she travels to New York without Rivera.

A month later she moves back in with Diego Rivera, but they agree on a more independent lifestyle. Frida Kahlo has a brief affair with the sculptor Isamu Noguchi, who gives her a case decorated with butterflies.

Mexico gives political asylum to Leon Trotsky, and, encouraged by Diego Rivera, on January 9, 1937, Kahlo goes to greet the political leader and his wife at the port of Tampico. Although she has never shared Trotsky's political vision, her political awareness increases. Following an affair with Trotsky, she paints a self-portrait entitled *Entre cortinas* (Between the Curtains), which she dedicates to him and gives him on his birthday.

On September 23, 1937, Kahlo takes part in the inaugural exhibition of the Art Gallery of the UNAM Department of Social

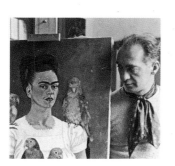

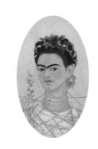

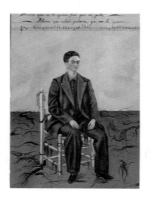

Action, run by Julio Castellanos. This will prove to be the most prolific period of Frida's creative life as an artist, lasting until the 1940s. During this year, she paints *El difuntito Dimas Rosas a los tres años* (The Deceased Dimas Rosas at the Age of Three), *Mi nana y yo* (My Nanny and I), *Yo y mi muñeca* (Me and My Doll), *Fulang-Chang y yo* (Fulang-Chang and I), *Cuatro habitantes de la ciudad de Mexico* (Four Inhabitants of Mexico City), and *Recuerdo* (Memory) or *El corazón* (Heart), among other paintings.

In 1938, the actor Edward G. Robinson visits Mexico and buys four of Kahlo's paintings. Her emotional attachment to the photographer Nickolas Muray, whom she had met the previous year, encourages her independence and self-esteem.

Amy Conger Goodyear, trustee for the Museum of Modern Art of New York, commissions a self-portrait. Kahlo receives an invitation for a solo exhibition at the Julien Levy Gallery in New York.

In March 1938, André Breton and his wife, Jacqueline Lamba, arrive in Mexico. Breton is taken with Kahlo's painting and considers her a surrealist in her own right.

In October, Kahlo travels to New York for the opening of her first solo exhibition, at the Julien Levy Gallery on East Fifty-Seventh Street. The exhibition consists of twenty-five of her most acclaimed works, such as *Entre Cortinas, Soy de mi dueña* (I Belong to My Owner, whereabouts unknown), *Naturaleza muerta con pitahayas* (Still Life with Pitahayas), *Tunas* (Still life with Prickly Pear Fruit), and *Lo que el agua me dio* (What the Water Gave Me), among others.

In January 1939, she sets sail for France. In Paris she visits her friend Jacqueline Lamba. She also catches a kidney infection, which leads to her hospitalization.

Her work goes on display in the collective exhibition entitled "Mexique," which André Breton organizes at the Renou et Colle Gallery. She is introduced to surrealism and meets Pablo Picasso, Wassily Kandinsky, Marcel Duchamp, Paul Éluard, and Max Ernst.

The Louvre purchases a self-portrait by Frida Kahlo. She leaves Paris for New York on March 25.

She agrees to separate from her husband. Their divorce papers are drawn up. In January and February 1940, she takes part in the International Exhibition of Surrealism at the Gallery of Mexican Art; she presents *Las dos Fridas* (The Two Fridas) and *La mesa herida* (The Wounded Table), the current whereabouts of which is unknown.

In February 1940, she dedicates a self-portrait to the American art collector Sigmund Firestone. She takes part in the International Golden Gate Exhibition of San Francisco, and *Las dos Fridas* (The Two Fridas) is displayed in the Museum of Modern Art of New York.

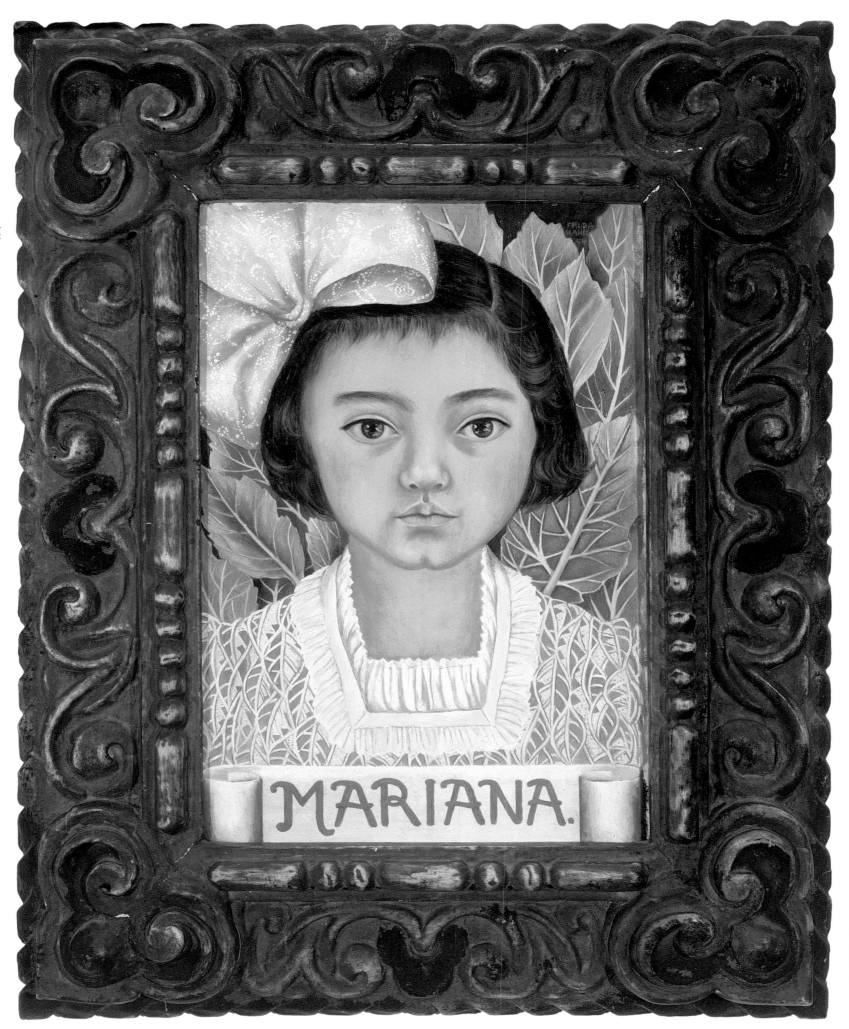

Mariana [Morillo Safa],
CA. 1944.
OIL ON CANVAS,
40 x 28.5 CM

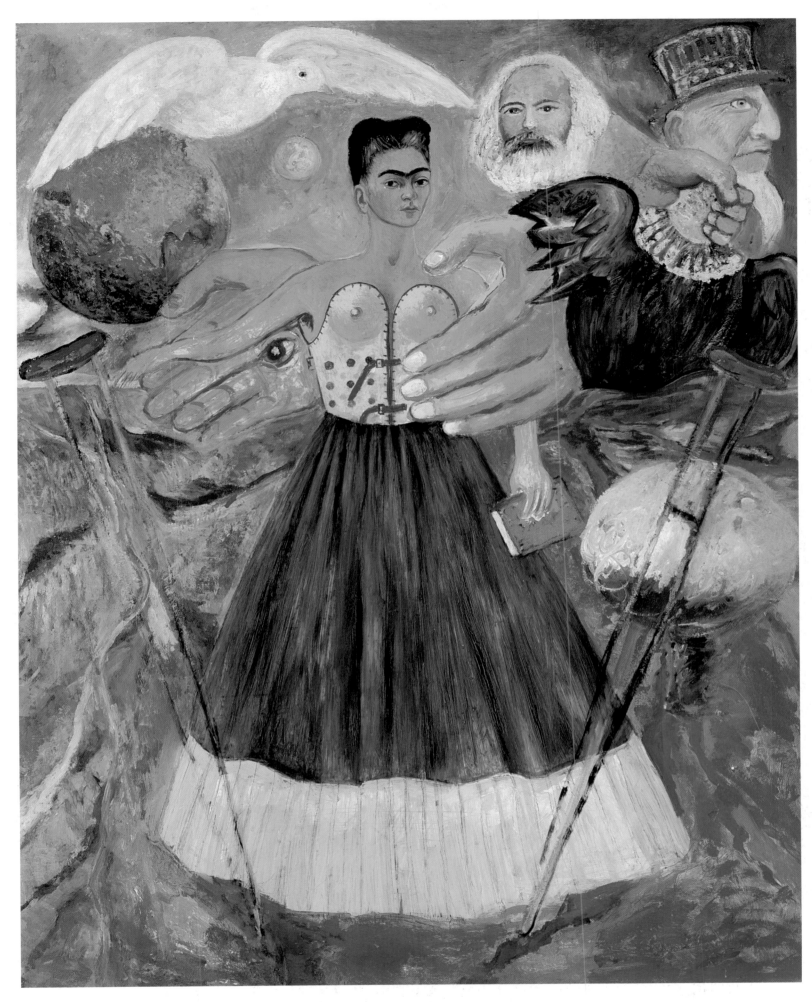

Marxism
Will Give Health
to the Sick,
CA. 1954.
OIL ON MASONITE,
76 X 61 CM

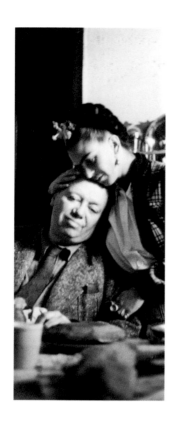

She fails to obtain a grant from the John Simon Guggenheim Memorial Foundation.

An attempt on the life of Leon Trotsky is made in Mexico; Kahlo's house is searched, and she and her sister are questioned by the police.

In September, she travels to San Francisco and meets up with Rivera and friends. In November, she moves to New York to discuss the terms of a second solo exhibition with Julien Levy (the exhibition would never take place).

On November 28, she returns to San Francisco, and on December 8 she marries Diego Rivera for the second time. They both return to Mexico and move to the Casa Azul in Coyoacán.

In 1941, her work is shown at the Institute of Modern Art of Boston as part of the exhibition "Modern Mexican Painters."

On February 28, 1942, she initiates and takes part in the Seminar of Mexican Culture.

Her work begins to win public acclaim in Mexico. She takes part in the collective exhibition entitled "Un siglo de retrato en México. 1830–1942" (A Century of Self-Portraiture in Mexico: 1830–1942), which opens at the Benjamin Franklin Library on January 14, 1943. In May of the same year, she takes part in the *Primer Salón de la Flor*.

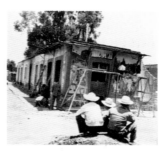

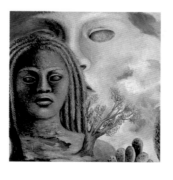

The industrialist José Domingo Lavín gives her a copy of *Moses and Monotheism* by Sigmund Freud and suggests she represent it in a painting.

In 1943, three of her paintings are included in the exhibition "Mexican Art Today," held at the Philadelphia Museum of Art.

She is named Professor of Painting by the Ministry of Public Education at the Esmeralda National School of Painting, Sculpture, and Engraving. On June 19, 1943, the decorative murals on the *pulquería La Rosita* are completed in Coyoacán, painted by Frida together with her students.

Because of her poor health, she is unable to continue teaching at La Esmeralda, and some of her students begin to go to her house in Coyoacán; these students, known as *Los Fridos*, were Fanny Rabel, Arturo García Bustos, Guillermo Monroy, and Arturo Estrada.

She paints one of her main works, *La venadita* (The Little Deer) or *El venado herido* (The Wounded Deer), and on May 3, 1946, gives it to the newlywed couple Lina and Arcady Boitler.

In June she undergoes an operation in New York. Upon her return home, she receives the National Painting Prize, awarded by the Government of Mexico through the Ministry of Education.

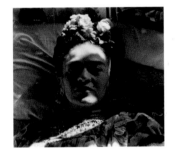

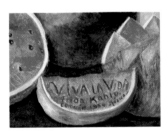

The following year, in 1947, she takes part in the exhibition "45 autoretratos de pintores mexicanos de los siglos XVIII al XX" (Forty-five Self-Portraits of Mexican Painters from the Eighteenth to the Twentieth Century) in the Palacio de Bellas Artes.

In 1949, she takes part in the inaugural exhibition of the Salón de la Plástica Mexicana (Hall of Mexican art) with her painting entitled *El abrazo de amor entre el universo, la tierra (México), yo, Diego y el Señor Xólotl* (The Love Embrace of the Universe, the Earth [Mexico], Diego, Me, and Señor Xólotl).

Unwell and in pain caused by her right foot, she is treated throughout 1950 by Dr. Juan Farill in the Hospital Inglés. During her convalescence she continues to paint.

Five of Frida's works are shown in the exhibition "Mexican Art," held in the Tate Gallery in London from March 4 to April 26, 1953. She is acclaimed as an artist both at home and abroad.

On April 13, 1953, she holds her only solo exhibition in Mexico at the Lola Álvarez Bravo Gallery of Contemporary Art. She is carried to the preview on a bed.

In August, her doctors decide that her right foot must be amputated. Following a severe depression, she picks up her brushes again to paint some of her last works, like *Naturaleza muerta ("Viva la vida")* (Still Life ["Viva la vida"]), among others.

On July 2, 1954, in a wheelchair, she takes part in the protest against U.S. intervention in Guatemala.

She dies on July 13, 1954.

Sources: Hayden Herrera, *Frida: A Biography of Frida Kahlo* (New York: Harper & Row, 1983), and Raquel Tibol, *Frida. Una vida abierta* (Mexico City: Oasis, 1983).

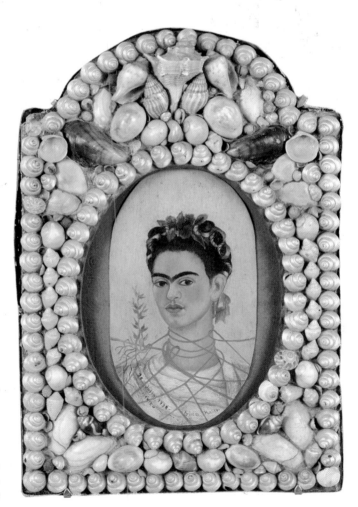

SELF-PORTRAIT, 1938. OIL ON PLATE, 12 x 7 CM

PHOTO CREDITS

ILLUSTRATION CREDITS

THROCKMORTON FINE ART, INC., NEW YORK
PAGES: 11, 12, 19, 22*a*, 35*b*, 44*a*, 54, 65*a, c, e*, 66, 72*a*, 94, 95*a*, 102, 103, 109, 121, 126, 127, 141, 151, 156, 171, 175, 176, 177, 180, 182, 184, 185, 186, 187, 190, 193, 194*a, b*, 196, 197, 198, 199, 200, 201, 205, 238, 244*c*, 245*b*

SALOMON GRIMBERG
PAGES: 35*a*, 41, 42*a*, 69*b*, 72*b*, 114*a, c*, 116, 117, 120*b*, 220, 223–227, 235, 239, 242, 245*e*

MARY-ANNE MARTIN FINE ART, NEW YORK
PAGES: 42*b*, 43, 73, 136, 137, 154, 155, 207, 208, 230, 231, 232; COURTESY OF V. GERSHENSON: 108, 158

CONSEJO NACIONAL PARA LA CULTURA Y LAS ARTES

BIBLIOTECA DE LAS ARTES
PAGE: 86*b*

INSTITUTO NACIONAL DE BELLAS ARTES

CENTRO NACIONAL DE INVESTIGACIÓN, DOCUMENTACIÓN E INFORMACIÓN DE ARTES PLÁSTICAS (CENIDIAP)
PAGES: 51*a*, 52

MUSEO DE ARTE INTERNACIONAL RUFINO TAMAYO (COURTESY OF THE HEIRS OF THE ARTIST AND THE FUNDACIÓN OLGA Y RUFINO TAMAYO, A. C.)
PAGE: 71*a–c*

MUSEO DE ARTE MODERNO
PAGES: 26*a, c*, 28

MUSEO NACIONAL DE ARTE
PAGES: 44*b*, 126*c*, 178

ISIDORE DUCASSE FINE ARTS, NEW YORK
PAGES: 166, 167, 168, 169, 189

SCALA/ART RESOURCE, NEW YORK
PAGES: 33*b*, 38*a, c, d*

SEGUROS COMERCIAL AMÉRICA, S. A. DE C. V.
PAGES: 40, 84–85, 86*a*, 87

THE MUSEUM OF MODERN ART, NEW YORK
PAGES: 92 (GIFT OF ALLAN ROOS, M.D., AND B. MATHIEU ROOS), 115 (MARY SKLAR BEQUEST), 159*c* (GIFT OF EDGAR KAUFMANN, JR.)

ART COLLECTION, HARRY RANSOM HUMANITIES RESEARCH CENTER, UNIVERSITY OF TEXAS AT AUSTIN
PAGES: 138, 139

BANCO NACIONAL DE MÉXICO
PAGES: 106*b*, 107

FUNDACIÓN EDUARDO F. COSTANTINI, BUENOS AIRES
PAGES: 51*a*, 160

MADISON ART CENTER, WISCONSIN (BEQUEST OF RUDOLPH AND LOUISE LANGER)
PAGES: 209, 210–211

PHOENIX ART MUSEUM, ARIZONA
PAGES: 152, 153

THE NATIONAL MUSEUM OF WOMEN IN THE ARTS, WASHINGTON, D.C. (GIFT OF THE HONORABLE CLARE BOOTHE LUCE)
PAGES: 89, 90*b*

ALINARI/ART RESOURCE, NEW YORK
PAGE: 38*b*

CARLOS PELLICER
PAGE: 95*b*

CAROLYN FARB
PAGE: 125

ERICH LESSING/ART RESOURCE, NEW YORK
PAGE: 32*b*

JUAN CORONEL RIVERA
PAGE: 181

LUIS-MARTÍN LOZANO
PAGE: 99

MUSEO JULIO ROMERO DE TORRES, CÓRDOBA, SPAIN
PAGE: 150

NAGOYA CITY ART MUSEUM
PAGES: 110–112

RAMIS BARQUET GALLERY, SOTHEBY'S, NEW YORK
PAGE: 67

UNIVERSITY OF CALIFORNIA, SAN FRANCISCO, SCHOOL OF MEDICINE, SAN FRANCISCO GENERAL HOSPITAL
PAGE: 59

Acknowledgments

José Antonio Aguilar Durán

Leesha M. Alston

Linda Ashton

Susan Backman

Ramis F. Barquet

Malin Barth

Karen Bell

María Eugenia Bermúdez de Ferrer

Andrés Blaisten

Walther Boelsterly

Mikki Carpenter

Bertha Cea

Manuel Centeno Bañuelos

Rosita Chalem

Teresa del Conde

Jessie Cork

Juan Coronel Rivera

Shaula Coyl

Helen Doyle

Mireya Escalante

Mariela Fandiño

Carolyn Farb

Consuelo Fernández Ruiz

Rosa María Fernández de Zamora

Edith Fey

Leopoldo Flores

Jesús Galván

Mónica García Postigo

Violet Gershenson

Judith Gómez del Campo

Marte Gómez Leal

Marcela González Salas

Martha González Vega

Verónica Granados Juárez

Randi Jean Greenberg

Emeterio Guadarrama

Mary Hunter-Ross

Isabella Hutchinson

Claudia Jasso Apando

Andrea Kettenmann

Sofía Lacayo

Mary-Anne Martin

Skye McGinnes

Carmen Melián

Beatriz Mendivil

Christine Murray

Dolores Olmedo Patiño

Adrián Páez

Francisco Ricardo Pedroza Pérez

Carlos Pellicer López

Juan Carlos Pereda

Mariana Pérez Amor

Carlos Phillips Olmedo

Manuel Pijuán

Anne Radcliffe

Cheryle Robertson

Lilia Rodríguez

Leah Ross

Ana Sepúlveda

Marcela Solís

Harold Stream

Daisy Stroud

Bruce Tarver

Spencer Throckmorton

Catheryn Thurow

Graciela de la Torre

Françoise Toutain

Ludmilla Valadez

Mercedes Valverde Candil

Delia Velázquez

Christine Vigiletti

Angela Webster

Sandra Weisenthal

Leslie Wrarb Alston

Satoshi Yamada

Rosa María Zaldívar Díaz López

The Albright Knox Art Gallery, Buffalo, New York

Art Resource, New York

Ayuntamiento de Cordova, Spain

Banco Nacional de México

Biblioteca de las Artes, CNA

Biblioteca Nacional de México, UNAM

Centre d'Art Moderne Georges Pompidou, Paris

Centro Nacional de Conservación y Registro del Patrimonio Artístico Mueble, INBA

Centro Nacional de Investigación, Documentación e Información de Artes Plásticas, INBA

Fundación Andrés Blaisten, A.C.

Galería de Arte Mexicano

Galería Ramis Barquet, New York

Harry Ramson Humanities Research Center, University of Texas at Austin

Instituto Mexiquense de Cultura

Instituto Tlaxcalteca de Cultura

Inter Art, Mexico

Isidore Ducasse Fine Arts, New York

Los Angeles County Museum of Art, California

Madison Art Center, Wisconsin

Mary-Anne Martin Fine Art, New York

Museo de Arte Internacional Rufino Tamayo, INBA

Museo de Arte Latinoamericano de Buenos Aires, Fundación Eduardo F. Costantini

Museo de Arte Moderno, INBA

Museo de Arte Moderno, Toluca, State of Mexico

Museo Dolores Olmedo Patiño

Museo Frida Kahlo

Museo Julio Romero de Torres, Cordova, Spain

Museo Nacional de Arte, INBA

Museum of Fine Arts, Boston, Massachusetts

The Museum of Modern Art, New York

Nagoya City Art Museum

The National Museum of Women in the Arts, Washington, D.C.

Phoenix Art Museum, Arizona

Réunion des Musées Nationaux, Paris

San Francisco Museum of Modern Art, California

Seguros Comercial América, S.A. de C.V.

Sotheby's Department of Latin American Art, New York

Throckmorton Fine Art, Inc., New York

University of California, San Francisco, School of Medicine

Kahlo
WAS PRINTED IN MILAN, ITALY,
June 2001.